EARLY ITALIAN PAINTINGS
in the Yale University Art Gallery

A Catalogue by Charles Seymour, Jr.

Published for the Yale University Art Gallery by
Yale University Press, New Haven and London, 1970

Library of Congress catalog card number: 71–99841. Standard book number 300–01222–5. Designed by Marvin Howard Simmons, set in Garamond type by Connecticut Printers, Inc., Hartford, Connecticut, and printed in the United States of America by The Meriden Gravure Co., Meriden, Connecticut. Distributed in Great Britain, Europe, Asia, and Africa by Yale University Press Ltd., London; in Canada by McGill University Press, Montreal; and in Latin America by Centro Interamericano de Libros Académicos, Mexico City.

CONTENTS

LIST OF ILLUSTRATIONS

FOREWORD

As Charles Seymour, Jr., has explained in more detail in his preface, Early Italian paintings are among the most difficult in Western art to pinpoint as to authorship and geographical origin. Mr. Seymour has attempted in this catalogue to serve both the student and the general viewer by providing, within a limited compass, as much relevant material as possible about each Early Italian painting in the Yale collection. For the general reader's perusal, the illustrations of the paintings Mr. Seymour considers most important have been inserted in the text of the catalogue and as close to the appropriate catalogue entry as space permits; the less important paintings are reproduced on a smaller scale at the back of the volume, merely for identification purposes, and are intended to serve the needs of the student of Italian painting. Such a student will always be in a position to order a larger photograph of a particular picture when his scholarly interests demand one.

The publication of this catalogue has been made possible in part by a grant from The Ford Foundation, under its Program for Catalogues of American Fine Arts Collections.

ANDREW CARNDUFF RITCHIE

Director

PREFACE

The form of this catalogue follows that established for the *Catalogue of French and School of Paris Paintings in the Yale University Art Gallery* (New Haven and London, Yale University Press, 1968). Fifty-eight of the paintings have been selected for a fairly full critical commentary and have been given reasonably full, yet still selective, bibliographical notes. The choice has been made, after considerable thought, on the basis of two principles: first, with regard to quality and historical importance, and second, with regard to a fair representation of the various regional schools of early Italian painting in the Yale Art Gallery. The main divisions have been established as: (1) Dugento Tuscany; (2) Trecento Tuscany with the addition of the schools of Pisa, Pistoia, Umbria, North Italy (the Marches and Emilia), and Venice; (3) Quattrocento Tuscany with the addition of Umbria, North Italy (Emilia, Ferrara, the Marches), and Venice. The Venetian representation extends into the Cinquecento with Titian's Giorgionesque *Circumcision* and the Bellinesque *Madonna* attributed to Bissolo, but the stylistic links with the art of the late Quattrocento are such as to warrant their inclusion in this volume rather than in the volume projected to cover the later periods of European art. The same may be said of the brilliant late panel by Luca Signorelli which in date is actually a good bit beyond the year 1500 but in form and spirit reflects earlier habits of imagery and pictorial style. The famous Jarves portrait of a *Lady with a Rabbit,* now attributed to Ridolfo Ghirlandaio, though datable about 1504–05, if not a few years later, was included in Offner's *Italian Primitives at Yale University;* it certainly seems more at home with the earlier paintings in the Jarves Collection than with the later 16th-century ones and so is presented in this volume.

The remainder of the 186 items catalogued here, including miniatures that once illuminated manuscripts, are presented mainly without commentary and with drastically reduced bibliography; the illustrations for these pictures are on

a smaller scale than that used for the reproductions of the paintings retained in the first category. The cutoff date here, as for the first category, has been a flexible interpretation of 1500.

The scheme adopted for each entry is designed to provide the maximum of information within a minimum of space. Short biographies are given for the named artists since the majority, even though they may be old friends to specialists, are not likely to be nearly so familiar to the wider audience at which the publication is aimed. Then comes the title of the painting followed in the same line by the date (catalogue and plate numbers are the same). Next is given the source of acquisition and the Art Gallery accession number (the first four digits indicating the year of acquisition), then the data on medium, support, condition (dates of cleaning, etc.) and the dimensions (in both centimeters and inches). The Provenance is followed by the sections on Exhibitions and Bibliography. At the end is a critical note providing pertinent information of the painting's history, imagery, and the more important opinions on attribution, with occasional citation of comparable paintings. It is to be emphasized once again that the bibliographies provided are highly selective; they are not in the least comprehensive, and are designed to give a quick idea of the object's location in the literature and a minimal basis for further study. A list of abbreviations for the most frequently cited references, an index by artist, iconographical guides, and a concordance of the numbers given the Jarves paintings in the various catalogues since 1860, are provided.

It is hoped that the present compilation, although necessarily condensed, will serve a useful purpose in bridging the gap between the last catalogue of the Jarves Collection of 1916, for years out of print, and that time in the future when a larger, more completely documented, and more elaborately illustrated catalogue of the early Italian paintings at Yale can be put together and published for the use of specialists in the field. The author hopes that this day will not be too much delayed. Meanwhile in its comprehensive scope, and in its succinct presentation of essential data, even though necessarily abridged, the present catalogue may attract a broader audience.

No catalogue can ever be called finished; knowledge and opinion are con-

stantly changing. This is particularly true of the category of paintings which are generally known as "Early Italian." Many of the attributions given here are still far from definite. Although every effort has been exerted to make use of up-to-date methods and tools of research, many conclusions about authorship or date are frankly tentative. In some cases, earlier pinpointing by scholars of an artistic personality under a specific identity has been abandoned, for the time being at least, in favor of a more generic attribution. For example, rather than "Deodato Orlandi" read "Tuscan School, ca. 1300 (Pisa?)"; or instead of "Pseudo-Pierfrancesco Fiorentino" read "Florentine School, ca. 1460, distant follower of Pesellino." Of course, where space allows, the reasons for this more conservative identification will be suggested, and in every case the earlier attribution and its published source will be provided. In a period of transition in knowledge and approach in scholarly circles as well as in museums, to err on the side of caution today may well be the better choice. Of course any error of judgment or error based on lack of knowledge is to be laid at the author's door and not to his assistants, who have been as numerous as they have been devoted.

It is impossible to list all the sources of indebtedness incurred in putting together this work. The curator's files contain material going back for generations; verbal opinions by visiting scholars over the decades are there recorded along with first drafts of items for earlier contemplated catalogues. In this last category, the author wishes to acknowledge especially the use of research done by Alice Wolfe under the direction of Theodore Sizer, and iconographical help from A. Elizabeth Chase. For personal assistance in his own research and in compilation, he wishes to thank particularly Bianca Hatfield and Sherwood Fehm for their faithful work in checking bibliography and attributions and Lawrence Lowic for his help in editing; for an enormous amount of basic groundwork in the 1950s, John Pancoast; for help in assembling data connected with the conservation and physical analysis of the paintings, particularly Andrew Petryn, in charge of conservation at Yale; also John Riley, Lawrence Majewski, Charles Tauss; for help in photography, Caroline Rollins, Emiddio DeCusati, Laurance Coles, Michael A. Febbroriello, Joseph Szaszfai, William J. Grego, Richard Croteau; in the Art Library, Helen Chillman, Lydia Wentworth, Paul Covington; in the Registrar's Office, Moussa Domit, Virginia M. Haggin, Aaltje

Schreuder. I make a special point of listing students in the graduate seminar in Renaissance Art as well as undergraduate honors students at Yale who have made solid contributions toward solving problems of attribution, iconography, and dating: Nancy Gaylord Thompson, Elizabeth Bassett Welles, Ellen Gross, Gloria Keach, Frances and David Robb, Carole Slatkin, Carol Stamatis, Wendy Stedman, Gordon Moran, Michael Mallory, John Hills, John Bender, Arnold Lehman, Robert Irving, Paul Watson, David Brown. Among colleagues thanks for counsel and information are due Ellen Callmann, Mary Davis, Elizabeth Gardner, Elizabeth Jones, Elizabeth Packard, the late Richard Offner, the late Bernard Berenson, Millard Meiss, Martin Davies, Enzo Carli, Cesare Gnudi, Ugo Procacci, Sydney Freedberg, Hellmut Wohl, Theodore Rousseau, Everett Fahy, Alessandro Contini-Bonacossi, Federico Zeri. Among the many at Yale University Press I thank particularly its director, Chester Kerr, for his interest in this catalogue and Mrs. Anne Wilde for her constant cooperation and help in preparing the manuscript. I would like, especially, to thank Katharine B. Neilson for her work in seeing the manuscript through the press. Finally last but certainly not least this curator would like to thank for their support in his work his former Director, Lamont Moore, and his present Director, Andrew C. Ritchie; the latter has shown admirable patience and restraint as the deadlines for submission of the present catalogue text assumed in the recent past increasingly elastic mobility.

<div align="right">C. S., Jr.</div>

New Haven, Connecticut
November 1969

PRELIMINARY EXPLANATIONS

Attributions

An artist's name is given as author of a picture without qualification, whenever (1) the historical evidence or stylistic evidence is believed today to be conclusive, or (2) there has been substantial scholarly agreement on the attribution over approximately the past fifty to seventy-five years.

The artist's name with question mark in parentheses after it is used whenever there still remains some reasonable doubt either in the literature or in the compiler's mind as to the factual validity of such an attribution. For example: "Pseudo-Ambrogio di Baldese (?)."

The words "attributed to" are used in all cases in which the attribution without qualification has a good chance of being correct, but in which the stylistic evidence is either in some way inconclusive or has been open to serious disagreement.

In the case of an artist who is known to have been an entrepreneur and leader of a large bottega, "shop of" is used to indicate a production in which his personal guidance to large extent, but not his personal hand, may be assumed.

In the case of paintings by a still unnamed artist working in the shadow of a greater named master the degrees of closeness to the style of the named master are indicated in descending order as follows: (1) "close follower of"; (2) "follower of"; (3) "imitator of"; (4) "in the style of."

In the case of paintings for which an attribution to a known personality or personal style is in the compiler's mind not tenable without a good deal of qualification today, the attribution is simply to school and date. For example: "Florentine School, ca. 1400."

In all cases the names of fictitious artistic personalities created for temporary classification of works of art are given in quotation marks. For example:

"Alunno di Domenico." These names, however useful, are not to be confused with historically recorded names of painters.

Measurements

All measurements are given in centimeters and inches. In each case it is to be understood that the overall measurements of the panel or canvas are recorded, exclusive of frame unless otherwise noted. In the case of original frames, these are the basis for measurement, not the panel alone, although frame and panel measurements frequently coincide. Height measurements precede those of width.

Technical Terminology

The following definitions are not intended to be scientific but attempt to put into plain language the meaning of a number of terms frequently employed in the cataloguing of early Italian paintings and so used here:

Egg tempera: Normal painting medium in early Italian painting consisting in simplest form of a beaten egg mixed with water to form an emulsion with which a pigment was brushed onto the ground.

Ground: Prepared surface of the support (see below).

Panel: Wooden support for normal purposes of painting, except for wall, or miniature painting, in the early Italian period. Except where noted to the contrary the wood used for these paintings is poplar.

Body color: Opaque color applied to parchment in miniature painting.

Gesso: Mixture of whiting, glue, and water applied in thin coats to panel in order to build up a smooth white ground to draw and paint upon.

Pigment: Ground up color in a more or less fine powder form, or a dye. Applied with (1) glue size for body color in manuscripts, (2) with egg tempera in panel painting, (3) with water and sometimes fig juice in fresco and wall painting.

Fresco: General term for early Italian wall painting. From the Italian meaning "cool and damp." It applies in the strict sense of "buon fresco" to applying color on wet plaster. The technique of applying paint to a dry wall is called "secco."

Restored: Used here to indicate an earlier ideal of treating old pictures, by which the original effect of the painting was optimistically to be recovered, often by adding new paint and varnishes to the painting's surface.

Cleaned: Indicating removal of all elements that have been added over the course of time to an old painting's surface.

Inpainting: Application of modern color within the area of a loss in an older painting's surface in order to minimize the discords between losses and well-preserved areas. Ideally it should be neutral in color and value.

Overpainting (repainting): Earlier method of disguising pigment losses by covering a loss and adjacent areas with new paint.

Varnish (varnishing): Older method of protecting painted surfaces and adding luster through a coat or repeated coatings of a natural resin such as copal or damar. Largely replaced today by synthetic resins and plastics.

Gold leaf (gilding): In early Italian painting, technique of applying gold to backgrounds or frames.

Punchwork: Ornamental pattern punched into gilding.

Cradled (cradling): Older method, now on the whole discredited, of keeping a panel from warping by applying a structure of crossed wooden members to the back of the panel. The French word is *parquetage*.

Transferred: Said of a surface of a painting which has been removed from
 its original support and reapplied to a new one; for exam-
 ple from wood panel to a new canvas or linen support (as
 in 1871.42).

Warping: Action of wood in panel which under natural stresses tends
 to bend or curve.

Blistering Most frequent cause of loss of pigment from the surface of
 (cupping): an old panel. As the panel moves or warps the paint is in
 some places detached, and, rising like a blister, it may be
 broken and fall away from the surface.

Flaking: Loss of small areas of pigment through blistering.

Rubbing: Loss of uppermost and thinnest layers of paint, generally
 through abrasion or harsh cleaning in an earlier period.

Note: In reporting condition of the paintings listed here the follow-
ing criteria are observed: (1) excellent (less than 10% loss); (2)
good (less than 15% loss); (3) fair (up to 25% loss); (4) poor
(more than 25% loss). Naturally these percentages represent a
rather vague approximation but they may prove useful as a general
indication of state.

Earlier Restorations and Technical Records

The records kept by those who have worked on the pictures since 1915 are
preserved in the curator's and in the conservation files in the Art Gallery. Since
1950 full and detailed photographic records have been made whenever a paint-
ing has been cleaned.

The names of those who worked on the earlier restorations as well as the
more recent program of rehabilitation are as follows:

ca. 1852–60: Jarves' friend and agent, the painter Mignaty, Florence.
ca. 1867: Howorth, Boston.
ca. 1890: New Haven, not recorded.

1915: Hammond Smith, New York.

1928–32: Charles Durham, Boston and Cambridge (Fogg Art Museum).

1945–46: Anthony Riportella, New York.

1950–: Andrew Petryn, with the assistance at various times of Law-
 rence Majewski, Carroll Wales, Charles Tauss, John Riley.
 Technical consultants: Daniel V. Thompson (formerly of the
 Yale faculty), Morton C. Bradley, Jr. (Arlington, Mass.), and
 William R. Young (Boston Museum of Fine Arts).

Descriptive Abbreviations

E. Early; used in placing a painting chronologically in a painter's career.

L. Late, as above.

l. Left, from the viewpoint of the observer.

r. Right, as above.

Abbreviations of Most Frequently Cited References

AB	*The Art Bulletin.*
AiA	*Art in America.*
BdA	*Bolletino d'arte.*
Berenson 1932	Bernard Berenson, *Italian Pictures of the Renaissance,* Oxford, 1932 ("Lists").
Berenson 1957	Bernard Berenson, *Italian Pictures of the Renaissance, Venetian School,* London, 1957.
Berenson 1963	Bernard Berenson, *Italian Pictures of the Renaissance, Florentine School,* London, 1963.
Berenson 1968	Bernard Berenson, *Italian Paintings of the Renaissance, Central Italian and North Italian Schools,* London, 1968, 3 vols. (All references are to 1.)
BurlM	*Burlington Magazine.*
Garrison 1949	Edward B. Garrison, *Italian Romanesque Panel Painting. An Illustrated Index,* Florence, 1949.

Jarves 1860 James Jackson Jarves, *Descriptive Catalogue of "Old
 Masters," collected by James J. Jarves, to Illustrate
 the History of Painting from* A.D. *1200 to the Best
 Periods of Italian Art,* Cambridge, 1860.

Jarves 1871 *Catalogue of the Jarves Collection of Early Italian Pic-
 tures Deposited in the Galleries of the Yale School of
 Fine Arts,* Boston, 1871.

Offner 1927 Richard Offner, *Italian Primitives at Yale University,*
 New Haven, 1927.

Offner *Corpus* Richard Offner, *A Critical and Historical Corpus of
 Florentine Painting,* New York, 1930, and later.

Rabinowitz Coll. 1945 Lionello Venturi, *The Rabinowitz Collection,* New
 York, privately printed, 1945.

Rabinowitz Coll. 1961 Charles Seymour, Jr., *The Rabinowitz Collection of
 European Painting,* New Haven, 1961.

Rankin 1895 William Rankin, "Some Early Italian Pictures in the
 Jarves Collection of the Yale School of Fine Arts at
 New Haven," *American Journal of Archaeology, 10*
 (1895), pp. 137–51.

Sirén 1916 Osvald Sirén, *A Descriptive Catalogue of the Pictures
 in the Jarves Collection Belonging to Yale University,*
 New Haven, 1916.

Sturgis 1868 Russell Sturgis, Jr., *Manual of the Jarves Collection,*
 New Haven, 1868.

Van Marle Raimond Van Marle, *The Development of the Italian
 Schools of Painting,* The Hague, 1923–36.

A. Venturi Adolfo Venturi, *Storia dell'arte italiana,* Milan, 1901–
 37.

L. Venturi Lionello Venturi, *Pitture italiane in America,* Milan,
 1931.

Y.U.A.G. 1952 *Rediscovered Italian Paintings,* Yale University Art
 Gallery, Exhibition Catalogue, New Haven, 1952.

INTRODUCTION

The heart of the early Italian paintings at Yale is of course the well-known collection formed in the mid-19th century by James Jackson Jarves. A self-educated critic and author, both "idealist and eye," as he was once characterized by the late Theodore Sizer, Jarves was the first American to create a collection of Italian painting as an instrument of education.[1] It was his aim to bring back from Italy to his native country a group of approximately 150 pictures to illustrate, in the original, what he called the "progress" of Western painting from the Byzantine Middle Ages to what was then considered by the Ruskinians its "decline" about 1650. Jarves had moved with his family to Florence in 1852, and soon thereafter, as we gather from a letter addressed to the Boston *Transcript* by the Hon. Charles Sumner, his ambitious undertaking was well started with the acquisition of representatives of the "early schools of Florence and Siena . . . an admirable beginning."[2] Already at that time also, as the same source makes clear, Jarves had evolved a plan to make of his collection the nucleus of a public museum of art in Boston.

Ultimately, as the story has been told many times over, the Jarves Collection, after being transported from Italy in 1860 and shown publicly in New York, found no taker despite Jarves' efforts in Boston, or in New York or Washington either. Instead, it was deposited, as security for a three-year loan of $20,000 made to Jarves by the Trustees of Yale College, in the recently completed

1. See F. Steegmuller, *The Two Lives of James Jackson Jarves,* New Haven, Yale University Press, 1951; T. Sizer, entry in *Dictionary of American Biography,* "Jarves," expanded into "A Forgotten New Englander," *New England Quarterly, 6* (1933).

2. Quoted in part by Jarves in his catalogues of 1860 and 1871 (see List of Abbreviations). The date "August 2, 1850" should evidently read "August 2, 1856." Sumner was in Europe in that year, not in 1850, which in any event antedates by two years Jarves' arrival in Florence.

(1866) art building, now called Street Hall. In 1871 it was acquired by the College for $22,000. The College Treasurer was the only bidder when the entire collection was put up at auction in New Haven in order to raise the money needed by Jarves to repay the loan, already a year overdue.[3]

In this unusual but perfectly legal way the College, soon to take the title of University, became the possessor of what was at that time by all odds the largest and finest group of Italian paintings in the Western Hemisphere.[4] In 1868 a handbook was published by the College under the name of Russell Sturgis though the material was patently Jarves' own. This *Manual of the Jarves Collection of Early Italian Pictures* was preceded by Jarves' *Descriptive Catalogue of "Old Masters" collected by James Jackson Jarves to Illustrate the History of Painting from* A.D. *1200 to the Best Periods of Italian Art* (Cambridge, H. O. Houghton and Co., Riverside Press, 1860). It was succeeded briefly in somewhat abridged form by the auction catalogue, *Catalogue of the Jarves Collection of Early Italian Pictures Deposited in the Galleries of the Yale School of Fine Arts* (Boston, W. F. Brown and Co., Printers, No. 50 Bromfield Street, 1871). In the 11-year interim between the catalogue of 1860 and those of 1868 and 1871 the collection had shrunk by 26 paintings, but of the 119 pictures acquired in 1871 no fewer than 76 were painted between 1250 and 1510—in other words they were pictures that in the mid-19th century were just beginning to be prized by the minority avant-garde as "Pre-Raphaelite Primitives" and which may be classified as early Italian.

"The collection contains no world masterpieces," wrote the distinguished spe-

3. Steegmuller, *Two Lives,* pp. 227–53.

4. There was at the time some feeling on Jarves' part that he had not been given a fair deal by the College in the terms of the auction, a feeling to some extent reflected by Steegmuller, and more violently by Michener in the recent best seller, *Hawaii.* It should be noted that the College extended the length of the loan by one year, to January 2, 1872. The auction took place in New Haven on November 9, 1871. To protect its equity, the College insisted that the paintings be sold en bloc, rather than singly. It was largely this stipulation that roused Jarves' negative reaction to the auction results—which were, as an auction with only one bidder, from his point of view unsatisfactory, to say the least. There had been rumors both in New York and in Boston that the pictures were not as good a buy as Jarves' claims would indicate; nothing is available to prove that such rumors were planted by the Yale officials, as sometimes has been hinted.

cialist Richard Offner in 1927, "nor again any blatant curiosity to attract the profane or restless interest; it nevertheless possesses distinctions that are both unique and important."[5] He went on to say that "for academic purposes it is perhaps the most useful of all university collections for its fairly even distribution of illustrations of Tuscan painting" and that it "is more adequately supplied in fine and rare examples of the thirteenth century of this than any other public museum outside of Italy." These words are taken from the long essay entitled *Italian Primitives at Yale University* which made important revisions of attributions provided by the basic "modern catalogue" by Osvald Sirén: *A Descriptive Catalogue of the Pictures in the Jarves Collection Belonging to Yale University* (New Haven, Yale University Press; London, Humphrey Milford, Oxford University Press, 1916). While Sirén was making his notes and writing in 1915, the University hired a reputable restorer, Hammond Smith, to clean and where "needed" repaint the surfaces of the Jarves paintings.[6] Sirén changed many attributions. Though fairly soon outdated, his catalogue reflects the new trends of scholarship and more rigorous standards of connoisseurship of the last decade of the 19th and the first years of the 20th centuries, made familiar to the English-speaking world by Bernard Berenson's authoritative yet appealing style.

Berenson, at least to the author's knowledge, never saw the Jarves Collection though he much admired Jarves' acumen as a collector.[7] He took a far more than casual interest in the pictures, however, as attested by their inclusion in all the editions of the famous "Lists" from 1932 onward; and in certain specific

5. Offner 1927, p. 2.

6. Manuscript report and related correspondence in curator's files. Hammond Smith was a prominent New York restorer who worked for the Metropolitan Museum of Art.

7. In a letter to Jarves' daughter Flora, written in 1915 apparently by Secretary Anson Phelps Stokes for the University, there is a statement that both Berenson and Sirén made surveys of the paintings for the University's guidance. It would appear that the University was considering Berenson as the cataloguer and counted on a survey from him, but there is no evidence that Berenson ever came to New Haven to make the survey. Mrs. Berenson (Mary Logan Berenson), a fine scholar in her own right, did, however, visit the Jarves Collection for study before World War I (as indicated by Frank Jewett Mather in 1926 and confirmed in conversation by the late Miss Nicky Mariano).

cases, such as the cleaning in 1928 of the *Circumcision* now attributed to Titian, he played an active part in spurring research.

But closer to the scene and close, as was Berenson also, to such collectors as Maitland F. Griggs of the Class of 1896 at Yale, Richard Offner was the more influential in the development of the Yale collection along the lines of Jarves' original ideal as a teaching instrument. In the period between the late 1920s and World War II, with his prestige as a respected collector of art and benefactor of the arts at Yale, Maitland Griggs spearheaded the formation of the Associates in Fine Arts who began to acquire works of art in the Medieval and Renaissance fields for the Gallery. When the new building for the Art Gallery at Yale was designed in 1928 an impressively long and broad exhibition hall with a coved ceiling suggesting the Italian Quattrocento manner was specially reserved for the Jarves Collection; in 1930 it was moved there from the dusty and crowded conditions of Street Hall.[8] In 1953 the Italian paintings were once more to be moved to Louis Kahn's new partially air-conditioned addition to the Art Gallery (Fig. 1).

Under the enthusiastic curatorship and later directorship of Theodore Sizer, interest in the Jarves paintings blossomed. Approximately 15 of the more prominent pictures were then restored by Charles Durham, of the Boston Museum of Fine Arts and the Fogg, and attractively reframed. Maitland Griggs meanwhile had been unobtrusively giving Italian works of art to the Gallery for some time. At his death in 1943 he bequeathed to Yale the larger portion of his own collection of early Italian paintings, many of which he had purchased on advice from Professor Offner. In 1943, 64 of his Italian paintings came to join the Jarves Collection. While the gems of the Griggs Collection went to the Metropolitan in New York—Griggs was a New Yorker and a prominent member of the Metropolitan's board—the paintings that ended up in New Haven helped greatly to round out and to enhance the Jarves Collection.[9]

Individual gifts continued to come in from such alumni as Robert Lehman of the Class of 1913, Richard M. Hurd of the Class of 1888, and Richard C.

8. See the series of photographs (1871–1930) in the curator's file.

9. *Y.U.A.G. Bulletin, 13* (Nov. 1944).

The 13 pictures left to the Metropolitan Museum are listed in that Museum's *Bulletin* for January 1944.

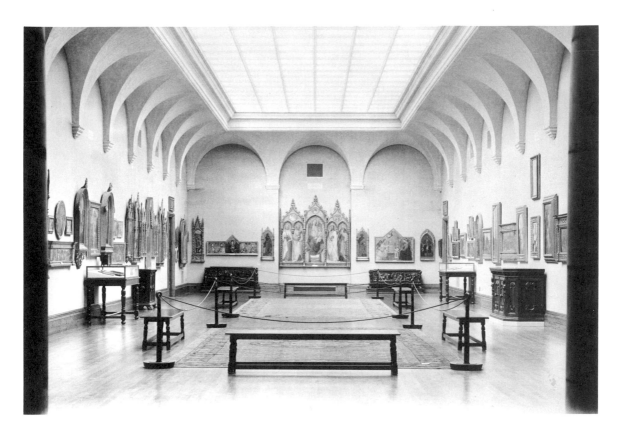

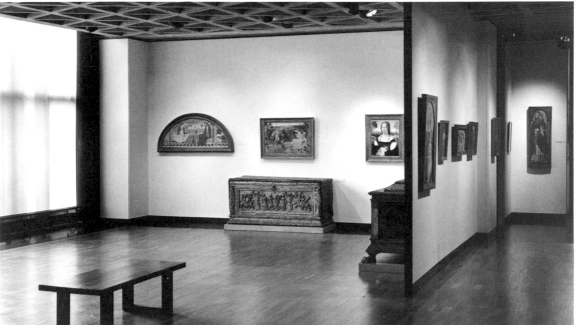

Fig. 1. The Jarves Collection installed in the "Italian Gallery" of the Gallery of Fine Arts, 1930 (above). The Jarves Collection in its present setting in the Yale University Art Gallery (below).

Hunt, L.L.B., 1908.[10] Meanwhile, in the Edwin Austin Abbey Collection, accessioned in 1937, among the muralist's own work and studio properties were discovered one late 14th century Florentine panel and two others, one close to Fra Angelico in style, of the mid-15th century.[11] Among occasional purchases made on the fund left by Maitland F. Griggs with his pictures was bought from the collection of Lord Southesk in Scotland the cassone panel as companion to one in the Jarves Collection on the story of Actaeon; and in the 1950s a few of the lesser Griggs panels were sold or exchanged for better objects which of course carry the Griggs Collection label. On the whole, however, changes in the Yale holdings remained minimal until 1959 when a sizable portion of the private collection of Hannah D. and the late Louis M. Rabinowitz was presented to the Gallery.[12] A noted industrialist and philanthropist, Louis Rabinowitz—though not a graduate—was a recipient of the Yale Alumni Medal in recognition of his extraordinary loyalty to scholarly ideals and generosity to the University in previous years. In the Rabinowitz gift of paintings were represented such important Tuscan painters as Pietro Lorenzetti and Sassetta, the Bolognese Francia by a splendid signed and dated Madonna, and the Venetian Bartolommeo Vivarini by a large and handsome Madonna. In all, there are 19 early Italian panels from the Rabinowitz Collection. Since 1959 there have been no major additions to the Art Gallery in this area of art, where first-rate examples, even if findable in the market, have now climbed in price beyond the reach of most collectors and all but the best-endowed museums.

This detailed account of the growth of the University's holdings in early Italian paintings is necessary to correct some widely held misapprehensions. One of them is that the Yale Collection is still limited to the Jarves paintings, which

10. From Robert Lehman in several separate donations have come paintings by Sellaio, Vittorio Crivelli, and Benvenuto di Giovanni, together with a set of miniatures and illuminated initials; from Richard C. Hunt (in 1937) a *Crucifixion* by Bicci di Lorenzo, and a *Last Supper* by Niccolò di Tommaso; from Richard M. Hurd (also in 1937) an Italo-Byzantine icon, evidently rather late.

11. For the Abbey Collection, see G. H. Hamilton, *Catalog: Paintings, Drawings, and Pastels by Edwin Austin Abbey,* Yale University Art Gallery, 1939. The Italian paintings did not form part of that exhibition.

12. *Y.U.A.G. Bulletin,* 23 (Sept. 1957); *Rabinowitz Coll.* 1961.

were acquired as far back as 1871. Justly famous as they have become, the early Italian paintings in the Jarves Collection represent quantitatively only a trifle more than a third of the items treated in this catalogue. Only between a third and a quarter of the early Italian paintings can be exhibited at one time in the exhibition space allocated to them in the 1953 addition to the Art Gallery. In compensation, however, storage space immediately adjacent to the exhibition area permits a virtual unification for purposes of study. In this scheme of "study-storage" all the early Italian panels not on exhibition are shelved on permanent wooden racks, each panel with its own allocated space, very much as icons are stored on Mt. Athos when not in liturgical use. In this system each panel is constantly available for study by accredited members of the University and visiting scholars and, except in unusual circumstances, need not be handled or disturbed.[13]

The condition of these panels, which may in the course of the centuries of their existence deteriorate physically in an alarming fashion and are constantly vulnerable to changes in temperature and humidity, is a matter of the utmost concern. The Yale University Art Gallery maintains a laboratory for conservation of the works of art in its possession. Since 1950, under the direction of Andrew Petryn, in consultation with the author, a program of rehabilitation of the early Italian paintings has been in progress. All panels have been X-rayed, and the wood of each support has been analyzed and identified. In most cases the procedure has been to clean the surfaces (backs, sides, and fronts) of later repaints and dirt; then to consolidate the islands of original pigment against further losses; finally to apply an appropriate synthetic-resin coating as a protection against dirt or other harmful substances in the atmosphere or from handling.

Since the Yale Collections are for study, damages or losses which the paintings may, in greater or lesser measure, have suffered in the past are in theory left unretouched. For example, if a fragment at some date was "made up" to look like a complete picture, it is left after treatment as a fragment, in its authentic state. In some cases, however, damage to an important painting may be so slight, yet at the same time so disfiguring, that it has been found advisable to

13. *Yale Alumni Magazine, 31* (6) (March 1968), 41.

inpaint the losses, but in such a way that the additions are clearly differentiated in tonality and texture from the authentic portions. This is in line with the most recent procedures in Italy. As indicated also in the preface, the author is particularly indebted to Dr. Ugo Procacci, the distinguished Soprintendente alle Gallerie in Florence, for information and advice in this connection.

It is hoped that the program of rehabilitation of the early Italian paintings at Yale will be completed by 1971, the centenary of the acquisition of the Jarves Collection by the College. Meanwhile, the pertinent information regarding state or condition that has been thus far obtained through the conservation program will be summarized for each painting in the pages to follow.[14]

14. Paintings of major importance or special interest are illustrated in the body of the text. All others, including those of secondary importance or in poor state and normally not all on exhibition, are identified in the catalogue entry by an asterisk immediately following the subject and date and are reproduced in small scale at the back of the book, each numbered to correspond with the catalogue entry. The illustrations are for rapid reference only; for closer study photographs will be needed. But most important of all is acquaintance with the originals. Nothing can take their place. No words can adequately describe them. This catalogue can be at best only a factual footnote to their glowing presence.

XIII CENTURY

Tuscan Schools

"MAGDALEN MASTER"

Temporary name for a style in Florence from roughly 1250 to 1290 rather than a specific artistic personality. In other words the "Magdalen Master" in art history today refers not so much to a man as to a workshop in which several masters worked in close association, a corporate style with links to mosaics.

1. MADONNA AND CHILD WITH SAINTS, ca. 1270

University purchase from James Jackson Jarves. 1871.3.

Egg tempera on panel reinforced by linen. 104.9 × 160 cm. (41¼ × 63 in.) including frame. Restored 1915; restored and cradled, 1929; cleaned 1954 (in part).

CONDITION: On the whole and for its type good. There have been considerable losses in the lower portions, revealing fully the structure of the painter's technique; these have been left as found. Two large separation cracks run horizontally. There has been considerable loss by rubbing in the gold areas of the background and halos. The frame is in part original.

INSCRIPTIONS: At halo of St. Leonard, $\overline{\text{SCS}}$ LEONARDUS; at halo of Virgin, $\overline{\text{MR}}$ $\overline{\theta\text{V}}$; at halo of St. Peter, $\overline{\text{SCS}}$ PETRVS. Over scenes at sides: at l., . . . PETRUM ET ANDREAM (over Calling of Peter and Andrew); MIRACULUM BEATI PETRI (over Peter and Simon Magus); SICUT ANGELUS LIBERAVIT PETRUM (over Freeing of Peter from Prison); at r., . . . [illegible] (over Peter Meeting with Christ); (5) MIRACULUM PETRI . . . (over Peter Cures the Paralytic); PASSIO BEATI PETRI ET PAULI (over Martyrdoms of Peter and Paul).

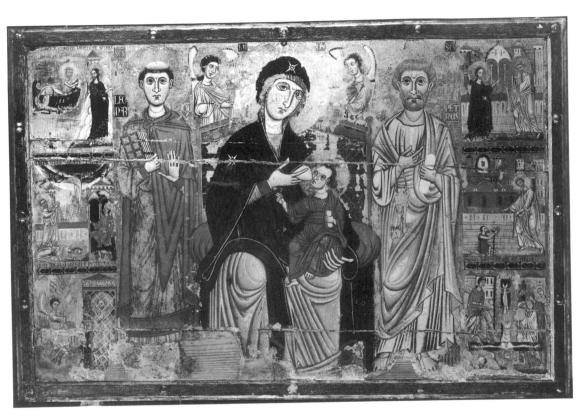

I

PROVENANCE: James Jackson Jarves Collection, Florence.

EXHIBITIONS: New York "Institute of Fine Arts," 625 Broadway, 1860; New-York Historical Society, 1863 (both times as Margaritone d'Arezzo).

BIBLIOGRAPHY: Jarves 1860, p. 42 (as Margaritone d'Arezzo); Sturgis 1868, p. 25 (as Margaritone d'Arezzo); Sirén 1916, pp. 11–13 (as manner of Margaritone d'Arezzo); Van Marle *1* (1923), pp. 336, 351–53, 355 (as Florentine, mid-13th century); Offner 1927, pp. 11–14 (as "Magdalen Master"); Garrison 1949, no. 366, p. 142 (as "Magdalen Master").

Since its cleaning the light clear colors of the artist's palette have emerged. At best one can say that this style which combines lightness of color tonality with a rather wooden heaviness of types and forms belongs to a bottega style—the workshop which goes under the quite broadly inclusive name of the "Magdalen Master" (from the large panel of the Magdalen in the Accademia, Florence). Cleaning revealed that the figure of St. Leonard was originally shod—not barefooted. Given the prominence of that saint at the Virgin's r. hand here, it seems highly probable that this was originally the high altar dossal of the little Romanesque Church of S. Leonardo in Arcetri just outside the Porta S. Giorgio in Florence.

"MAGDALEN MASTER"

2. MADONNA AND CHILD WITH SAINTS, ca. 1270

University purchase from James Jackson Jarves. 1871.4.

Egg tempera on panel. 22.9 × 36 cm. (9 × 14⅜₆ in.) overall with shutters opened; central panel, 22.9 × 18.9 cm. (9 × 7⅟₁₆ in.); l. and r. wings each, 21 × 8.9 cm. (8¼ × 3½ in.). Cleaned 1958–60.

CONDITION: On the whole good for this type of portable painting. There is damage by candle flame in the l. wing; repairs in modern wood to lower l. corner and l. wing and entire lower edge of central panel. Damages have been filled and modern wood surface covered with same material as the fill. The exteriors of the shutters have been cleaned; the hinges are original.

INSCRIPTIONS: On cross, l. shutter, IC. (XC); by Virgin's halo, \overline{MR}-$\overline{\Theta V}$.

PROVENANCE: James Jackson Jarves Collection, Florence.

EXHIBITIONS: New York "Institute of Fine Arts," 625 Broadway, 1860; New-York Historical Society, 1863 (both times as early Italian, A.D. 1200).

BIBLIOGRAPHY: Jarves 1860 (as early Italian, A.D. 1200); Sturgis 1868, p. 19 (as unknown Italian artist, 11th–13th century, "in bad imitation of the Byzantine manner"); Sirén 1916, p. 15 (as school of Margaritone d'Arezzo); Van Marle, *1* (1923), pp. 336, 354–58 (as Florentine artist after 1250); Offner 1927, pp. 2, 13 (as Florentine master, ca. 1270); Garrison 1949, no. 330, p. 125 (as Florentine 1275–80).

This is a rare and unusually well-preserved example of a Dugento portable triptych, presumably commissioned by a Dominican for his private devotions in the monastery or for his travels. This inference is more or less required by the prominence of figures in the Dominican Order. St. Dominic appears in the position of honor on the Virgin's r., while St. Francis is on her l.; in the lower portion of the l. shutter below St. Michael stands another Dominican, with a martyr's palm (St. Peter Martyr?) beside a crowned female saint who has been tentatively identified in the literature as St. Margaret but is more likely St. Catherine of Alexandria. The character of the style has emerged much more clearly since the recent cleaning. Given differences in scale and the practice of collaboration between different artists in the bottega, this little triptych is close enough in style to the large dossal, 1871.3, to be classified as coming from the same workshop. The inscriptions on either side of the Virgin's halo are remarkably similar in form to those flanking the Virgin's halo in 1871.3; and the fact that the inscription on the cross in the Crucifixion scene of the l. shutter is also in Greek letters would indicate a fairly early date as well as implying a Byzantine model for the composition. From the point of view of iconographic interest, the depiction of the two Dominican saints appears to be among the earliest in Italian painting (see G. Kaftal, *Iconography of the Saints in Tuscan Painting,* Florence, 1952, col. 311–12).

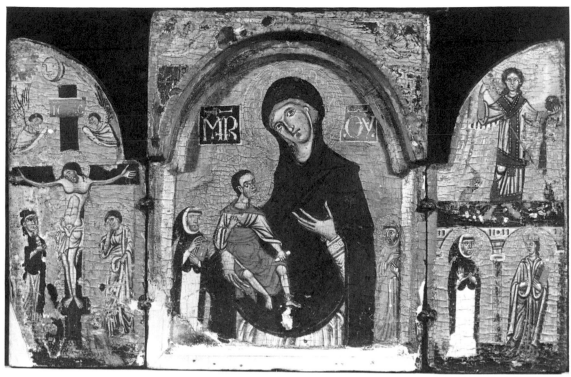

2

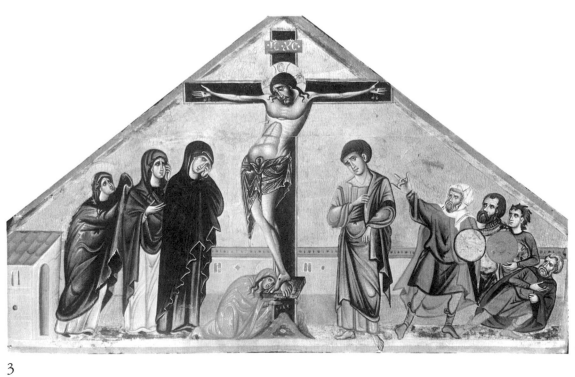

3

GUIDO DA SIENA (shop of)

Sienese art history ranks Guido as the principal founder of its school of painting. His own work and shop production have been reconstructed on the basis of the style of the large *Madonna,* signed and dated 1271, from S. Domenico which is now in the Palazzo Pubblico, Siena. Guido's birth and death dates are not known but his activity is now generally considered to have covered most of the last half of the 13th century. Berenson called him "all but Byzantine."

3. CRUCIFIXION, ca. 1260–70

University purchase from James Jackson Jarves. 1871.2.

Egg tempera on panel. 65.1 × 96.5 cm. (22⅝ × 38 in.). Cradled, 1930; cleaned, 1954.

CONDITION: Good to excellent. Slight losses along a separation crack just above the Virgin's head, in the background, have been filled and inpainted; there is a uniform loss of pigment, evidently originally a vegetable dye green, on the border.

INSCRIPTION: On cross, IC̄. X̄C̄.

PROVENANCE: James Jackson Jarves Collection, Florence.

EXHIBITIONS: New York "Institute of Fine Arts," 625 Broadway, 1860; New-York Historical Society, 1863 (both times as Giunta da Pisa).

BIBLIOGRAPHY: Jarves 1860, p. 42 (as Giunta da Pisa); J. J. Jarves, *Art Studies,* New York, 1861, p. 42 (as Giunta da Pisa) with engraving by V. Stanghi, p. 114; Sturgis 1868, pp. 24–25 (as Giunta da Pisa); Sirén 1916, pp. 7–9 (as Guido da Siena); R. Van Marle in *Rassegna d'arte antica e moderna,* 7 (1920), p. 270 (as shop of Guido da Siena); Offner 1927, pp. 2, 3, 7 (as Guido da Siena); Berenson 1932, p. 268 (as Guido da Siena); Garrison 1949, p. 116 (as shop of Guido da Siena); M. Meiss, *Painting in Florence and Siena after the Black Death,* Princeton, 1951, p. 56, and New York, 1964, p. 150 (as school of Guido da Siena); G. Coor, in *Gazette des Beaux-Arts,* 43 (1953), pp. 257–58 (as shop of Guido da Siena); J. H. Stubblebine, *Guido da Siena,* Princeton,

1964, pp. 16, 91, 92, 102 (as shop of Guido da Siena); Berenson 1968, *1,* p. 205 (as Guido da Siena).

This strikingly well-preserved panel was evidently originally a pediment top to an altarpiece, possibly a seated Madonna. The scholarly literature (see above) on 1871.2 has veered, since Van Marle's important article on Sienese painting before Duccio in 1920, almost unanimously toward an attribution to the workshop of Guido da Siena. This is tantamount to an attribution to the master himself since collaboration in the shop in the Dugento was the rule, and the division between the personal style of Guido and his best assistants despite valiant effort in recent years has not been conclusively defined (if indeed such a definition is within the limits of historical possibility at this time). In any event, 1871.2 is a central document for our ideas about the early development of Sienese painting. It shows clearly the strong ties between Siena and the Byzantine tradition which ca. 1250 appears to have brought Eastern painters to Siena itself. In our panel the iconography of the groups on either side of the cross is taken virtually without change from the Byzantine repertory of images, and the inscription, it is to be noted, is in Greek letters, not Latin.

"MASTER OF S. MARTINO" (attributed to)

Anonymous master active at the end of the 13th century mainly at Pisa.

4. MADONNA AND CHILD ENTHRONED WITH TWO ANGELS, ca. 1290

Bequest of Maitland F. Griggs, B.A., 1896. 1943.202.

Egg tempera on wood panel. 76.7 × 40.6 cm. (30³⁄₁₆ × 16 in.). Cleaned, 1960–68.

CONDITION: Fair; gold much abraded; scattered losses, especially in the face and tunic of the Virgin and in the throne; fragments of the original frame remain embedded in modern wood frame. There had been considerable repaint.

PROVENANCE: Maitland F. Griggs Collection, New York.

EXHIBITION: New York, Century Association, 1930.

BIBLIOGRAPHY: L. Venturi, pl. IX (as Florentine, end of 13th century); H. Comstock, in *The Connoisseur, 118* (Sept. 1946), pp. 45, 47 (as Tuscan school, ca. 1300); Garrison 1949, p. 82 (as "Varlungo Master"); G. Previtali, *Giotto e la sua bottega,* Milan, 1967, pp. 28, 30 (as "Varlungo Master").

In the Griggs Collection, New York, it was called "Tuscan, ca. 1300." Verbally in 1927 R. Offner suggested the attribution, with question, of Deodato Orlandi, but in a lecture in 1944 he placed the artist closer to Florence as in "the tradition of Coppo di Marcovaldo." The present attribution, based on the cleaned state of the panel, is tentative; it is intended to suggest the mingling of Pisan and Florentine stylistic properties which appear here more in the wake of Cimabue than of Coppo.

TUSCAN SCHOOL (Pisa?), ca. 1290–1300

5. MADONNA AND CHILD WITH SAINTS

University purchase from James Jackson Jarves. 1871.5.

Egg tempera on panel. 55.4 × 172.9 cm. (21$\frac{3}{16}$ × 68$\frac{1}{16}$ in.). Restored, 1915; cleaned 1966.

CONDITION: On the whole very good; losses occur mainly in the gold background; there is a separation crack running across the upper part of the head of the Virgin, which has not been filled. No inpainting has been attempted. Much of the understructure of the original frame exists, the poplar covered with linen; on the linen some traces of original pigment remain. New pieces of wood have been added at the top of the gable, along the sides, and at the bottom; crude repairs have been made along the sides. These data on the frame give assurance that the altarpiece has not been cut down, except possibly slightly at the r. side.

INSCRIPTIONS: Beside the halos of the saints: S[ANCTUS] IACHOB[US]; S[ANCTUS] IOH[ANNES]; S[ANCTUS] PETRU[S]; S[ANCTUS] FRA[N]CIS-[CUS].

PROVENANCE: James Jackson Jarves Collection, Florence.

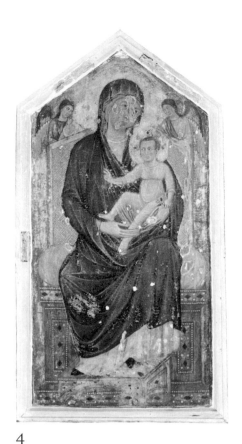

4

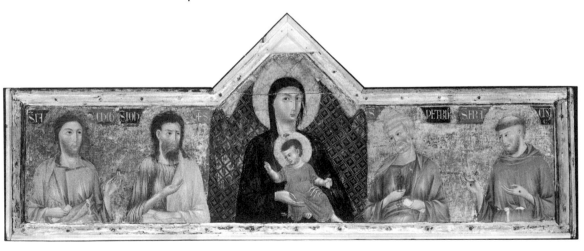

5

EXHIBITIONS: New York "Institute of Fine Arts," 625 Broadway, 1860; New-York Historical Society, 1863 (both times as Cimabue).

BIBLIOGRAPHY: Jarves 1860, p. 43 (as Cimabue); J. J. Jarves, *Art Studies,* New York, pl. 100, opp. p. 162, engraved by V. Stanghi (as Cimabue); Sturgis 1868, pp. 26–27 (as Cimabue); Rankin 1895, p. 139 ("not characteristic of Cimabue"); Sirén 1916, pp. 17–18 (as Deodato Orlandi); Van Marle, *1* (1923), p. 306 (as Deodato Orlandi); Offner 1927, p. 2 (as Pisan school); Garrison 1949, p. 161 (as "Varlungo Master"); M. Meiss, *Painting in Florence and Siena after the Black Death,* Princeton, 1951, and New York, 1964, p. 47 (as "anonymous late Dugento work").

The style of this important altar dossal falls between a number of influential trends of the late 13th century. There are echoes of Cimabue (as interestingly enough Jarves saw almost too clearly); and there are also traces of the influence of the Berlinghieri in Lucca and Deodato Orlandi in Pisa. The style is perhaps closest to that of the center and l. half of a panel representing St. Michael with Saints recorded as in the Fiammingo Collection, Rome (Anderson, 41607), and there attributed to Deodato Orlandi (the bishop-saints on the r. are by a different hand). The Yale panel, however, is clearly homogeneous in style. It is much gentler and softer in its formulation of the traditional imagery and in color than are the documented paintings by Deodato Orlandi: beginning with the Lucca Crucifix dated 1288 and proceeding through the Crucifix in S. Miniato al Tedesco of 1301 to the dossal in Pisa dated 1301 and to the panel of 1308 formerly in the Hurd Collection. What we seem to have in the Yale 1871.5 dossal is a watering down of a stronger heritage; but its delicacy of drawing and chromatic interest make a noteworthy contribution to late Dugento painting in Tuscany. The master is more likely to have worked in Pisa than in Lucca or Florence.

TUSCAN SCHOOL, mid-XIII century

6. SCENES FROM THE PASSION, ca. 1250

University purchase from James Jackson Jarves. 1871.1a,b,c.

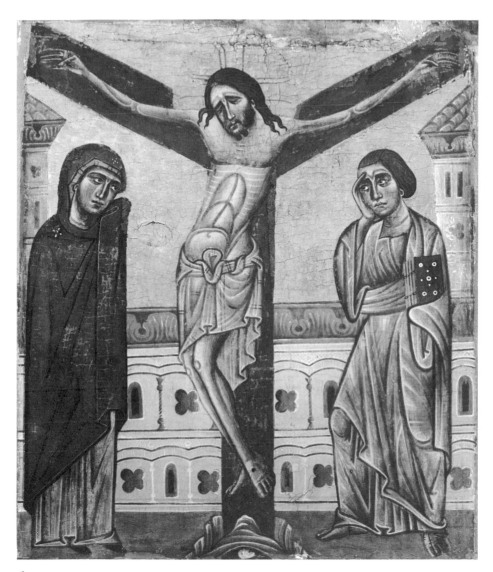

6a

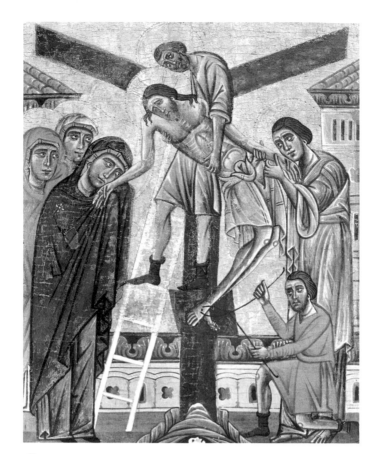

6b

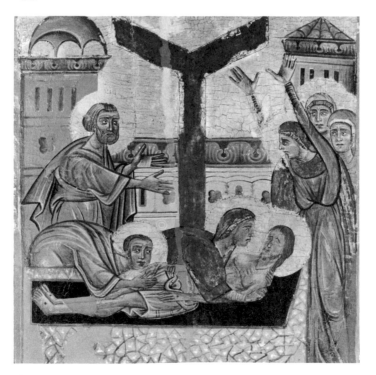

6c

Egg tempera on panel, linen reinforcement under the gesso.

The Crucifixion: 42.2 × 35.5 cm. (16⅝ × 14 in.). Cradled, 1915; cleaned, 1950–52.

CONDITION: On the whole good; some losses in cross, in drapery of Virgin through rubbing, and upper edge of panel through chipping; the latter is left untouched to show the structure and the first two areas mentioned are inpainted. The gold background had been entirely regilded in modern times, the modern overlay removed.

The Deposition: 43.7 × 36 cm. (17³⁄₁₆ × 14⁵⁄₁₆ in.). Cradled, 1915; cleaned, 1950–52.

CONDITION: Good; some losses in the areas of the cross and the hole in drapery of the Virgin have been inpainted; modern gold overlay on halos and background removed.

The Lamentation: 37.2 × 36 cm. (14⅝ × 14³⁄₁₆ in.). Not cradled in 1915, because of precarious condition; cleaned 1956–58.

CONDITION: Only fair; the panel had been cradled badly in the 19th century and had split through the center longitudinally. The old cradle has been in part removed and a temporary reinforcement applied to the reverse. The surface condition of this panel was not in as good shape as were the other two panels of the series; losses had occurred in much of the gold background and halos through rubbing in the flesh tones of most of the figures and in five areas in the drapery and halo of Peter, the legs of the Christ, and adjacent areas of the pavement and lower l. corner of the panel. At one time evidently cut at the bottom. For structural reasons considered at this time too delicate for public exhibition.

PROVENANCE: James Jackson Jarves Collection, Florence.

EXHIBITIONS: New York "Institute of Fine Arts," 625 Broadway, 1860; New-York Historical Society, 1863 (both times as unknown painter, not later than the 13th century).

BIBLIOGRAPHY: Jarves 1860, p. 42 (as unknown Italian painter); Sturgis 1868, p. 18 (as unknown painter, Italian, 11th century); Jarves 1871, p. 11 (as un-

known painter, Italian 11th century); Sirén 1916, pp. 3–6 (as Bonaventura Berlinghieri); O. Sirén, *Toskanischer Maler im XIII Jahrhundert,* pp. 84–86, 89 (no change); Van Marle, *I* (1923), pp. 322–24, 327 (as school of Berlinghieri); Offner 1927, pp. 2, 9–11 (as Tuscan Master, ca. 1250); E. S. Vavalà, *La Croce dipinta italiana e l'iconographia della passione,* Verona, 1929, pp. 558–59 (as shop of Berlinghieri, with strong Lucchese elements); L. Venturi, pl. IV (as Tuscan Master, mid-13th century, not Berlinghieri); Garrison 1949, p. 239 (as Lucchese, provincial follower of Berlinghieri); *Y.U.A.G.* 1952, pp. 12–13 (as Tuscan school, artist unknown, second half of 13th century).

The three pictures were originally superimposed on one panel beginning at the top, according to the chronology of the Passion, with the Crucifixion and ending at the bottom with the Lamentation. Exactly when the scenes were sawed apart is not known, but when first shown by Jarves the scheme of superimposition was used. Garrison (see above) considered the three pictures originally to have formed a tabernacle shutter and suggested a rather large-scale Madonna and Child now in the Accademia, Florence, as the main subject. Stylistically, there is something to be said in favor of this hypothesis, but there is no physical evidence available to show that the Yale panels were parts of a shutter, and precedents for this kind of tabernacle with shutters are not provided by Garrison. One must accordingly treat this theory of origin with considerable caution. So, too, the attribution. Garrison's characterization of the style as "provincial Lucchese" does not seem warranted by the panels in their cleaned state. It is indeed difficult to isolate their origin, even so far as to say that they came from Lucca or its environs. The style seems to fall between Florence and Lucca, and to some extent Arezzo. Within this triangular area there may be found more evidences of the master's activity; in a recent visit (1968) to the Yale University Art Gallery where he was able to study the originals, Ugo Procacci felt that there were some interesting connections between the style of our unknown Tuscan master and that of the so-called "Master of Vico l'Abbate," whose impressive altar frontal of St. Michael originated in the mid-13th century either in Florence or close to that center. For the time being, until more information is accumulated, the attribution used here is essentially a return to Offner's opinion of 1927.

TUSCAN SCHOOL, late XIII century

7. MADONNA AND CHILD (in the initial letter *C*), manuscript illumi-
nation, ca. 1290–1300*

Gift of Robert Lehman, B.A., 1913, in the name of Mr. and Mrs. Albert E.
Goodhart. 1954.7.9.

Body color and gilt on parchment. Fragment cut from a manuscript page. 11.2
× 10.6 cm. (4⅜ × 4⅛ in.).

CONDITION: Fairly good (some losses in gilding).

PROVENANCE: Lehman Collection, New York (acquired in Paris, 1953).

BIBLIOGRAPHY: Unpublished as far as is known.

XIV CENTURY

Florentine School

BICCI DI LORENZO (shop of)

An artist who bridged the Trecento and Quattrocento, but whose style up to 1430 remains on the whole in the older manner. Born in Florence in 1373; died there 1452.

8. CRUCIFIXION, ca. 1410*

Gift of Richard Carley Hunt, L.L.B., 1908. 1937.200a.

Egg tempera on panel. 49.5 × 32.9 cm. (19½ × 12⁵⁄₁₆ in.). Cleaned in 1964.

CONDITION: Relatively good, but there are losses in the draperies of all the figures.

INSCRIPTIONS: On top of cross, I.N.R.I.; on scroll carried by saint on right, [ET] RESPICE IN FACIEM XPI [TUI] (Psalm 83 [84]:10, [And] look on the face of [thy anointed]).

PROVENANCE: Collection of Richard Howland Hunt, New York (father of the donor and son of the well-known architect, Richard Morris Hunt).

BIBLIOGRAPHY: *Y.U.A.G. Bulletin*, 8 (Feb., 1938), pp. 51–52.

BERNARDO DADDI

He was perhaps the most distinguished painter of the second quarter of the Trecento in Florence. Enrolled in the guild in Florence between 1312 and 1320, and a founder of the Compagnia di San Luca (a religious organization of paint-

9

ers), in 1347 he was given the commission for the Madonna of the great shrine by Orcagna in Or S. Michele. He was dead by August 1348, presumably of the plague.

9. VOCATION OF ST. DOMINIC, 1338

University purchase from James Jackson Jarves. 1871.6.

Egg tempera on panel. 38.1 × 35.2 cm. (15 × 13⅞ in.). Restored and cradled 1915; cleaned 1957.

CONDITION: Poor; the panel was once split horizontally across the middle after being shaved in thickness and faultily cradled (the cradle has now been removed and the two portions firmly joined together). On at least two occasions the surface was all but completely repainted and the background was regilded before 1915. The recent cleaning has revealed several details hitherto covered or obscured; no attempt, however, has been made to "restore" the portions lost, particularly the head and hands of the saint.

PROVENANCE: James Jackson Jarves Collection, Florence.

EXHIBITIONS: New York "Institute of Fine Arts," 625 Broadway, 1860; New-York Historical Society, 1863 (both times as Taddeo Gaddi); London, The Royal Academy, Burlington House, "Exhibition of Italian Art," 1930 (as Bernardo Daddi); Chicago Art Institute, "A Century of Progress Exhibition of Painting and Sculpture," 1933; Cleveland, Museum of Art, "Twentieth Anniversary Exhibition," 1936; Boston, Museum of Fine Arts, "Arts of the Middle Ages," 1940 (last three as Bernardo Daddi).

BIBLIOGRAPHY: Jarves 1860, p. 44 (as Taddeo Gaddi); Sturgis 1868, p. 34 (as Taddeo Gaddi); Sirén in *BurlM, 14* (1908), pp. 188–93 (as Bernardo Daddi); Sirén 1916, pp. 21–23 (as Bernardo Daddi); Van Marle, *3* (1924), pp. 370–75 (as Bernardo Daddi); Offner 1927, pp. 3–4, 16 (as Bernardo Daddi); *Exhibition of Italian Art 1200–1960* [catalogue] London, Royal Academy, Burlington House, 1930, p. 38 (as Bernardo Daddi); Offner *Corpus,* sec. 3, vol. 3, pp. 36–39 (as Bernardo Daddi); Berenson 1932, p. 167 (as Bernardo Daddi); Berenson, *1* (1963), p. 56 (no change).

This panel, still beautiful despite its ruined surface, belonged presumably to an

altarpiece painted in 1338 for the Dominican church of S. Maria Novella in
Florence and signed by Daddi. 1871.6 was part of the predella, of which three
other panels depicting incidents from the legends of SS. Dominic and Peter Mar-
tyr are depicted (Posen, Paris [Musée des Arts Décoratifs] and Berlin). The
incident in our panel, taken from the *Legenda Aurea* version of the saint's life,
is that in which St. Dominic in prayer in St. Peter's in Rome beheld a vision of
SS. Peter and Paul who proffered him a book (symbol of his Order's intellectual
interests) and a sword (symbol of the Dominicans' role in suppressing heresy).
The altarpiece was removed from the church in 1570 according to Rosselli. It
was referred to in 1657 as being in a cloister of S. Maria Novella, appended to
a wall (Rosselli, *Sepoltuario Florentino, 2,* 729 [Florence, Archivio di Stato]).
Its subsequent history until the predella sections began to turn up in the 19th
century is not recorded.

BERNARDO DADDI (follower of)

10. CRUCIFIXION, ca. 1340*

University purchase from James Jackson Jarves. 1871.7.

Egg tempera on panel. 87 × 48.9 cm. (34¼ × 19¼ in.). Restored in 1915;
cleaned, 1967.

CONDITION: Poor; much rubbed and abraded; only fragmentary areas of the
original paint surface remain.

PROVENANCE: James Jackson Jarves Collection, Florence.

EXHIBITIONS: New York "Institute of Fine Arts," 625 Broadway, 1860; New-
York Historical Society, 1863 (both times as Spinello Aretino).

BIBLIOGRAPHY: Jarves 1860, p. 45 (as manner of Spinello Aretino); Sturgis
1868, p. 41 (as manner of Spinello Aretino); Sirén 1916, p. 25 (as manner
of Bernardo Daddi).

BERNARDO DADDI (remote follower of)

11. STANDING MADONNA AND CHILD, ca. 1350*

Bequest of Maitland F. Griggs, B.A., 1896. 1943.208.

Egg tempera on panel. 91.8 × 50.3 cm. (36⅛ × 19⁹⁄₁₆ in.). Cleaned, 1960–68.

CONDITION: Fair to good; somewhat rubbed, but the blue of the Virgin's robe virtually intact.

PROVENANCE: Ex-Canessa Collection (sale, New York, 1924); Maitland F. Griggs Collection, New York.

BIBLIOGRAPHY: Berenson 1932, p. 549 (as Spinello Aretino).

The motif of the standing Madonna at this time is relatively rare. The present attribution is based on an unpublished report to Maitland Griggs by R. Offner at the time of the Canessa sale (winter of 1924).

BERNARDO DADDI (attributed to)

12. MADONNA AND CHILD, ca. 1335*

Gift of Mrs. Hannah D. Rabinowitz. 1965.124.

Egg tempera on panel. 55.8 × 46 cm. (21¹⁵⁄₁₆ × 18⅛ in.). Cleaned in 1965.

CONDITION: Poor; major losses of pigment and gesso throughout. The painting had been transferred at an unknown date to a new panel.

PROVENANCE: Booth Tarkington, Indianapolis, Indiana; Rabinowitz Collection, Sands Point, Long Island.

BIBLIOGRAPHY: B. Berenson, *Pitture italiane del rinascimento,* Milan, 1936, p. 143 (as Daddi); *Rabinowitz Coll.* 1945, p. 5 (as Daddi).

Despite the ruinous damage suffered by the picture, the quality of the original design is quite evident. The date of ca. 1335 corresponds roughly to the artist's

middle period. A later undated copy formerly in the Hurd Collection, New York, testifies to the relative completeness of our panel as well as to its importance for its period.

FLORENTINE SCHOOL (style of Pacino di Bonaguida ?)

Pacino di Bonaguida was a contemporary of Giotto's, influenced by him and also by the so-called "St. Cecilia Master." His career spanned a little more than the first quarter of the Trecento (ca. 1303–39).

13. ST. FLORA, ca. 1310 (?)

Bequest of Maitland F. Griggs, B.A., 1896. 1943.203.

Egg tempera on panel. 90.6 × 57 cm. (35^{11}/₁₆ × 22^{7}/₁₆ in.). Cleaned, 1966–67.

CONDITION: On the whole good; a crack down the l. side of the figure's face; scattered losses through flaking which have been largely inpainted. The l. side of the frame was a modern addition and has been removed; the other three sides of the frame are authentic. The upper portion with angels in roundels in the spandrels is on a separate piece of wood, which apparently extended in a single piece over the whole polyptych. When the panels were dispersed, this upper portion was evidently sawed through the roundels so that the panels might be presented as separate units.

INSCRIPTION: On base of frame, $\overline{\text{SCA}}$ + FLORA.

PROVENANCE: Maitland F. Griggs Collection, New York; acquired from Giuseppe Volterra, Florence, 1926.

EXHIBITION: Florence, "Mostra Giottesca," 1937.

BIBLIOGRAPHY: Offner *Corpus,* sec. 3, vol. 2, pt. 2, pp. 215, 216, 220 (as "Associate of Pacino di Bonaguida"); *Mostra Giottesca* (catalogue), Bergamo (1937) (as "Maniera di Pacino di Bonaguida"); G. Sinibaldi and G. Brunetti, *Mostra Giottesca di 1937,* Florence, 1943, p. 419 (as "Maniera di Pacino di Bonaguida"); P. P. Donati, "Pittura Aretina del Trecento," *Paragone, 221* (July 1968), pp. 12–15 (as "Maestro delle Sante Flora e Lucilla").

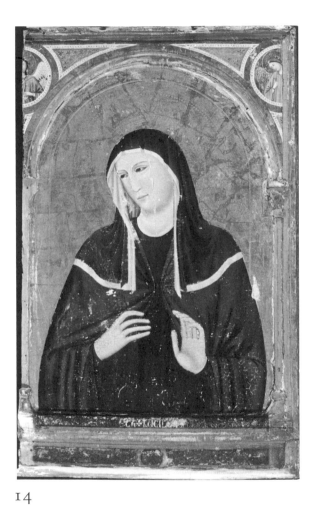

13 14

With its companion in the Griggs Collection depicting St. Lucilla, 1946.13 (see below), this panel formed part of a polyptych of which the central Madonna and Child exists in fragmentary and much repainted condition in the Loeser Collection now housed in the Palazzo Vecchio, Florence (Offner *Corpus,* sec. 3, vol. 2, pt. 1, p. 6). In 1930 Offner attributed all three panels to an "Associate of Pacino di Bonaguida," an attribution adopted by the compilers of the "Mostra Giottesca" in 1937, published in 1943. In the Griggs Collection in New York the St. Flora was listed as by Pacino di Bonaguida. Recently P. P. Donati has proposed to call the painter "Maestro delle Sante Flora e Lucilla," active in Arezzo, to whom he also attributes a fresco of Christ with saints and angels in S. Domenico, Arezzo, and a small panel now in private hands in Florence showing a scene from the life of St. Mary Magdalen (illustrated; see Bibliography, above). After cleaning in 1967 it has become apparent that the two panels now at Yale are by different hands: of the two the *St. Flora* is closer to what is known as Pacino's style (or better, bottega style), but it is equally close, if not closer, to the style of the "St. Cecilia Master." Because of its bad state the Madonna in Florence is not attributable with confidence to either of the hands responsible for the panels now at Yale. A recent reconstruction of the altarpiece was published by M. Cammerer-George, *Die Rahmung der Toskanischen Altarbilder in Trecento,* Strasbourg, 1966, pl. 9. From the evidence of the framing, the Griggs-Yale panels were the terminal panels (St. Flora at the l. extremity) of the original polyptych. The subjects are listed among the early Christian martyrs in Rome, but are shown here in nuns' habits of the Benedictine Order. The Badia (or Benedictine Church) in Arezzo is dedicated to SS. Flora and Lucilla and it may be inferred provisionally that the polyptych was painted for that church. The question of this provenance and the subsequent history of the panels before 1926 are now being investigated further.

FLORENTINE SCHOOL (style of Pacino di Bonaguida ?)

14. ST. LUCILLA, ca. 1310 (?)

Bequest of Maitland F. Griggs, B.A., 1896. 1946.13.

Egg tempera on panel. 90.3 × 57.3 cm. (35⁹⁄₁₆ × 22¾ in.). Cleaned 1960–67.

CONDITION: Similar to 1943.203 except that the gilt background is more rubbed and there are more numerous scattered losses through flaking.

INSCRIPTION: On base of frame, $\overline{\text{SCA}}$ + LUCILLA.

PROVENANCE: Ex-Collection Dr. Hans Wendland, Lugano (there in 1926); Edward Hutton, London (there in 1937); Maitland F. Griggs Estate (transferred from England to Yale University in 1946).

BIBLIOGRAPHY: As above under 1943.203 with the exception that the Offner *Corpus* reference is to pp. 218, 220 of sec. 3, vol. 2, pt. 2.

The forms of this panel are more sculpturesque, the paint enamel finer and denser than that of its companion, 1943.203; the style appears in general stiffer and apparently more provincial in relation either to Pacino or to the "St. Cecilia Master."

FLORENTINE SCHOOL, second half XIV century

15. CRUCIFIXION, ca. 1385*

Edwin A. Abbey Memorial Collection. 1937.342.

Egg tempera on wood panel. 29.2 × 53 cm. (11½ × 20⅞ in.). Cleaned in 1963.

CONDITION: Continuous losses along top and bottom edges, otherwise the condition is excellent.

PROVENANCE: Edwin A. Abbey Collection, London.

BIBLIOGRAPHY: Unpublished.

FLORENTINE SCHOOL (follower of Orcagna ?)

16. MADONNA AND CHILD, ca. 1370*

Bequest of Maitland F. Griggs, B.A., 1896. 1943.214.

Egg tempera on panel. 75.1 × 42.7 cm. (29%₁₆ × 16³⁄₁₆ in.). Cleaned in 1960–61.

CONDITION: Ruinous; greatest loss in lower half, which had been completely re-gessoed and repainted; damage was evidently from fire.

PROVENANCE: Maitland F. Griggs Collection, New York; acquired in Paris (as Nardo di Cione).

BIBLIOGRAPHY: Berenson 1932, p. 275; Berenson 1963, p. 105 (both times as Jacopo di Cione ?).

FLORENTINE SCHOOL, second half XIV century

17. SORROWING VIRGIN, ca. 1375*

Bequest of Maitland F. Griggs, B.A., 1896. 1943.212.

Egg tempera on panel. 38.2 × 32.7 cm. (15¹⁄₁₆ × 12⅞ in.). Cleaned in 1959–60.

CONDITION: Fair; much rubbed.

PROVENANCE: Dan Fellows Platt, Englewood, New Jersey; Maitland F. Griggs Collection, New York; acquired 1923.

BIBLIOGRAPHY: Unpublished.

A fragment of a Pietà, this panel of the Virgin has been attributed to the school of Gerini by Perkins and to the Florentine school of about 1360 by Offner (*in litteris*).

FLORENTINE SCHOOL, second half XIV century

18. ST. LOUIS OF TOULOUSE AND ST. CLARA, ca. 1380*

Bequest of Maitland F. Griggs, B.A., 1896. 1943.211.

Egg tempera on wood panel. 68.8 × 29.4 cm. (26⁵⁄₁₆ × 11⁹⁄₁₆ in.). Cleaned in 1962–63.

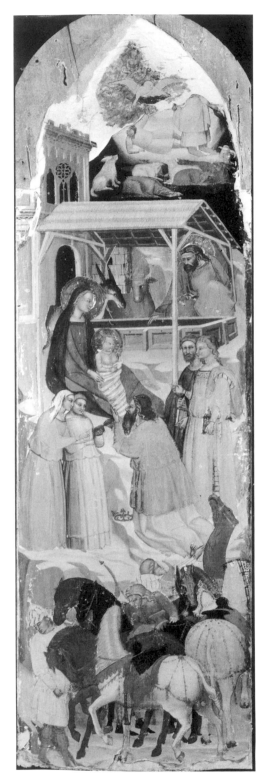

20a

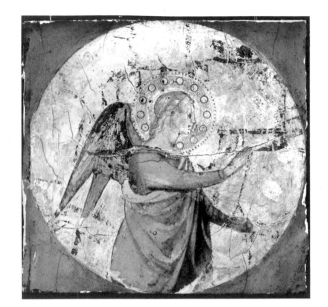

20b

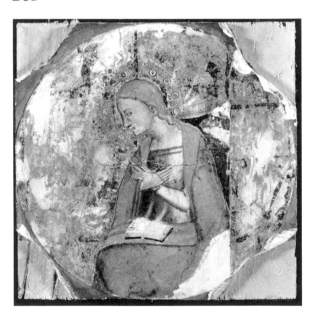

20c

CONDITION: Good, though somewhat rubbed in the flesh tones.

PROVENANCE: Maitland F. Griggs Collection, New York.

BIBLIOGRAPHY: Unpublished.

This panel was originally part of the same polyptych as was 1943.210. It has been variously attributed in the past to: Lorenzo di Niccolò Gerini by Van Marle, the tradition of Taddeo Gaddi by Offner, and Lorenzo di Bicci by Berenson (all *in litteris* to Maitland F. Griggs).

FLORENTINE SCHOOL, second half XIV century

19. ST. ELIZABETH OF HUNGARY AND ST. ANTHONY OF PADUA, ca. 1380*

Bequest of Maitland F. Griggs, B.A., 1896. 1943.210.

Egg tempera on wood panel. 67.3 × 25.9 cm. (26½ × 10³⁄₁₆ in.).

CONDITION: Good.

PROVENANCE: Maitland F. Griggs Collection, New York.

BIBLIOGRAPHY: Unpublished.

FLORENTINE SCHOOL, late XIV century

20a,b,c. ADORATION OF THE MAGI, ca. 1395–1400

University purchase from James Jackson Jarves. 1871.15.

Egg tempera on panel reinforced with linen. Adoration of the Magi, 83.2 × 25.9 cm. (32¾ × 10⅜ in.); Angel of the Annunciation (roundel), diameter 13.7 cm. (5⅜ in.); Virgin Annunciate (roundel), diameter 13.7 cm. (5⅜ in.). Cleaned 1968.

CONDITION: On the whole good to excellent. Recent cleaning has revealed that the summit was badly overpainted, distorting the shape of the painted area.

PROVENANCE: James Jackson Jarves Collection, Florence.

EXHIBITIONS: New York "Institute of Fine Arts," 625 Broadway, 1860; New-York Historical Society, 1863 (both times as Simone Martini).

BIBLIOGRAPHY: Jarves 1860, p. 46 (as Simone Martini); Sturgis 1868, p. 29 (as Simone Martini); Jarves 1871, p. 13 (as Simone Martini); W. Rankin, in *American Journal of Archeology,* 9 (1905), p. 143 (as not Sienese); Sirén 1916, pp. 41–42 (as Andrea Orcagna); Offner 1927, p. 17 (as later imitator of Orcagna); Van Marle 3 (1924), p. 515 (as "compagno di Orcagna"); Berenson 1963, p. 215 (as artist between Jacopo di Cione and Antonio Veneziano).

The two small roundels of the Annunciation (1871.15 b and c) were inserted into the base of its modern frame when the *Adoration* came to New Haven; they were much overpainted, but on cleaning they seem to have belonged to the same ensemble as the *Adoration.* As indicated above, the process of cleaning has recently provided evidence that the Adoration panel which in Jarves' day had a rounded arched summit originally terminated in a pointed Gothic arch. It was probably the l. wing of a small triptych (other parts still not identified). The imagery derives ultimately from Giotto and his immediate follower Taddeo Gaddi; the frescoes of the Baroncelli Chapel in S. Croce ascribed to Taddeo may have provided the model for this rather unusually elongated regrouping of Taddeo's motives. From the proportions of the figures and the movement and gaiety of color in the lower portion a date very late in the Trecento may be inferred. In fact, the picture may date from as late as 1400; it illustrates both the longevity of the Giottesque tradition in Florence and ways in which it was being modified about 1400 by currents of the International Gothic Style. The drawing mentioned by Jarves as "preparatory" for the upper portion of the Adoration has not been mentioned in the literature since.

FLORENTINE SCHOOL (style of Spinello Aretino)

Spinello, as his name indicates, was a native of Arezzo; born ca. 1346, he was trained in the Florentine style of Orcagna and worked in Florence, Pisa, and Siena. Died 1410–11.

21. A LEGENDARY SUBJECT AND ST. MICHAEL FIGHTING
 THE DEMON, predella panel, ca. 1390*

University purchase from James Jackson Jarves. 1871.23.

Egg tempera on panel. 31.3 × 70.3 cm. (12⁵/₁₆ × 27¹¹/₁₆ in.). Cleaned in 1960.

CONDITION: Only fair; several areas seriously rubbed. Had been virtually completely overpainted.

PROVENANCE: James Jackson Jarves Collection, Florence.

EXHIBITIONS: New York "Institute of Fine Arts," 625 Broadway, 1860; New-York Historical Society, 1863 (both times as Spinello Aretino).

BIBLIOGRAPHY: Jarves 1860, p. 45 (as school of Spinello Aretino); Sturgis 1868, p. 40 (as in the manner of Spinello Aretino); Sirén 1916, pp. 63–64 (as in the manner of Spinello).

AGNOLO GADDI

Son of Taddeo Gaddi; active from 1369 to his recorded death in 1396. The most prominent and influential Florentine master of the 1380s and 1390s.

22. SS. JULIAN, JAMES, AND MICHAEL, ca. 1390

University purchase from James Jackson Jarves, 1871.20.

Egg tempera on panel. 86.8 × 74.6 cm. (34³/₁₆ × 29³/₈ in.). Restored in 1915 and cleaned in 1958.

CONDITION: With the exception of glaring losses in background and drapery of St. James, excellent. Presented as a fragment after removal of 19th-century additions including modern gesso and gilt of background.

PROVENANCE: James Jackson Jarves Collection, Florence.

EXHIBITIONS: New York, "Institute of Fine Arts," 625 Broadway, 1860; New-York Historical Society, 1863 (both times as Taddeo Gaddi).

BIBLIOGRAPHY: Jarves 1860, p. 44, no. 25 (as Taddeo Gaddi); Sturgis 1868,

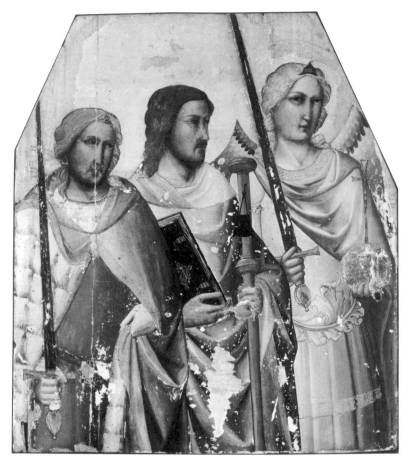

22

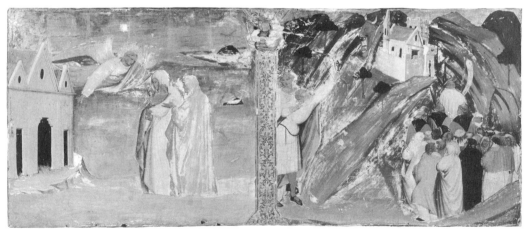

23

pp. 22 (as attributed to Taddeo Gaddi); Sirén 1916, pp. 51–53 (as Starnina); Offner 1927, pp. 20–21 (as shop of Agnolo Gaddi); Berenson 1932, p. 214 (as Agnolo Gaddi); G. Gronau, in *Proporzioni, 3* (1950), pp. 41–47 (as Agnolo Gaddi); Berenson 1963, p. 68 (as Agnolo Gaddi).

Evidently part of the l. wing of an important altarpiece, so far not identified. Gronau's suggestion that this altarpiece had as its central panel a Madonna now in the Contini-Bonacossi Collection, Florence (see 1943.213 below) does not seem plausible.

AGNOLO GADDI

23. SCENES FROM THE LEGEND OF THE ARCHANGEL
MICHAEL, ca. 1380

Bequest of Maitland F. Griggs, B.A., 1896. 1943.213.

Egg tempera on panel. 42.2 × 90.5 cm. (16⁹⁄₁₆ × 35⅝ in.). Cleaned in 1960–61.

CONDITION: Fair; the modern lateral elements of the framing have been removed; there is much rubbing in the dark areas; serious abrasion in upper part of gilt divider between the scenes.

PROVENANCE: Masi Collection, Capannoli presso Pontedera; Achillito Chiesa Collection, Milan; Ex-Hendecourt Collection, Paris (sale, Sotheby's, 1929); thence directly to the Maitland F. Griggs Collection, New York.

EXHIBITION: New York, Century Association, 1930.

BIBLIOGRAPHY: T. Borenius, in *BurlM* (1921), p. 154 (as "Compagno di Agnolo"); Van Marle, *3* (1924), p. 573, n. 2 (as Starnina); B. Berenson, in *Dedalo, 11* (1931), pp. 1304–05 (as Agnolo Gaddi [?]); Berenson 1932, p. 242 (as Giovanni del Biondo); H. D. Gronau, in *Proporzioni, 3* (1950), pp. 41–47 (as Agnolo Gaddi); Berenson 1963, p. 68 (as Agnolo Gaddi).

In 1929 A. Van Marle stated (*in litteris*) that he then thought the panel looked "very much like a fine and fairly early Agnolo Gaddi." R. Offner is reported in the Griggs Collection file to have said that it was "probably Agnolo Gaddi."

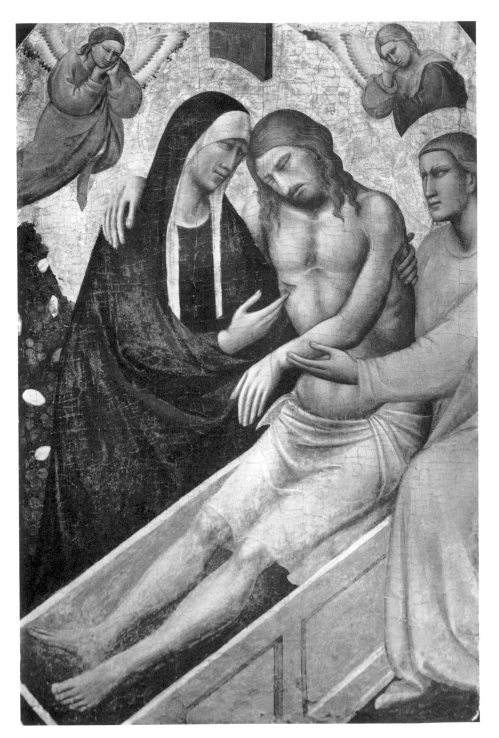

24

Recent study in both Italy and America has resulted in the proposal that our 1943.213 was originally the predella panel immediately below the central Madonna panel of a triptych reunited with what appear to be its lateral panels since 1931 in the Contini-Bonacossi Collection, Florence. (Two lateral panels of saints with their predella scenes now in the Alte Pinakothek, which were associated by Berenson with the Contini-Bonacossi *Madonna,* do not appear to have belonged with it.) For a reconstruction of the supposed appearance of the Yale panel in this context, published by Gronau, see Berenson 1963, *1,* pl. 336. Gronau in 1950 associated the fragment of *SS. Julian, James, and Michael* in the Jarves Collection (1871.20) with the Contini-Bonacossi *Madonna,* but this theory runs into unsurmounted difficulties because of the coexistence mentioned above of the original lateral panels with the *Madonna* in the Contini-Bonacossi Collection. Evidently the whole question must be reexamined.

TADDEO GADDI

According to Vasari he was the godson of Giotto and his pupil for almost 24 years. He entered the painters' guild in 1327. The earliest independent works by Taddeo are the frescoes for the Baroncelli Chapel in S. Croce, Florence, painted between 1327 and 1332. In 1342 he was active in Pisa. In 1347 he is mentioned in a document as being one of the best painters in Florence. He was at various times a member of the commission for the construction of the Florentine Duomo. He died in 1366.

24. ENTOMBMENT OF CHRIST, ca. 1345(?)

University purchase from James Jackson Jarves. 1871.8.

Egg tempera on panel. 115.4 × 75.4 cm. (45⅝ × 29¹¹⁄₁₆ in.). Cleaned and restored in 1954.

CONDITION: Painted surfaces on the whole better than fair, though not up to good; considerable loss of paint on the lower r. of panel. The panel has evidently been drastically cut down at the top and along the sides as well as at the bottom.

PROVENANCE: James Jackson Jarves Collection, Florence.

EXHIBITIONS: New York "Institute of Fine Arts," 625 Broadway, 1860; New-York Historical Society, 1863 (both as Giotto); Boston, Museum of Fine Arts, "Arts of the Middle Ages," 1940 (as Taddeo Gaddi); Y.U.A.G., "Rediscovered Italian Paintings," 1952 (as Taddeo Gaddi).

BIBLIOGRAPHY: Jarves 1860, p. 43, no. 16 (as Giotto); Sturgis 1868, pp. 32–33 (as Giotto); Jarves 1871, p. 14 (as Giotto); O. Sirén, in *BurlM., 14* (1908), pp. 125–26 (as Taddeo Gaddi); Sirén 1916, pp. 27–28; Van Marle *3* (1924), p. 342; Offner 1927, p. 19; L. Venturi, p. 17; Berenson 1932, p. 215; M. Meiss, *Painting in Florence and Siena after the Black Death,* Princeton, 1951, p. 56; G. Francastel, *Italian Painting,* London, 1956, p. 146; Berenson 1963, *1,* p. 71 (all above from Sirén, 1908, on as Taddeo Gaddi).

Acc. No. 1871.8 in its original uncut, and evidently noticeably larger, format was probably an altarpiece; and the prominence of the cross behind the figures suggests a commission for the Florentine Franciscan Church of S. Croce. The Virgin's robe also suggests a monastic habit. There can be no doubt about Taddeo's authorship of the painting. But as is frequently the case in dealing with his oeuvre, it is not easy to date. In general the Yale panel has been assigned a position at the end of Taddeo's career (see above, Sirén, Van Marle, and Meiss). This conclusion is based upon stylistic similarities noted between 1871.8, the polyptych at Pistoia (dated some time after 1350), and the *Madonna and Child* in the Uffizi (signed and dated 1355). On the other hand the Jarves-Yale panel is more intense in feeling and severe in execution than the works of Taddeo's late style, such as the Uffizi *Madonna.* Its composition shares striking similarities with the *Entombment with Female Donor* in the Cappella Bardi di Vernio, S. Croce, dated by Berenson as no later than 1342, and the facial types are reasonably close to those of the *Last Supper* in the refectory of S. Croce generally dated ca. 1350. The Yale painting may then be dated between 1340 and 1350 rather than after 1353, and appears to represent the artist at the height of his powers.

TADDEO GADDI (shop of)

25. MADONNA AND CHILD ENTHRONED, ca. 1360*
Bequest of Maitland F. Griggs, B.A., 1896. 1943.205.

Egg tempera on panel. 86.7 × 52.4 cm. (34⅛ × 20⅝ in.). Cleaned, 1967–68.

CONDITION: A fragment which had been "restored" to look like a whole painting. The modern framing has been removed and the restored portion above the throne exposed; somewhat rubbed, there are minor losses in the Virgin's tunic; her robe has been repainted completely.

PROVENANCE: J. Kerr-Lawson, London; Maitland F. Griggs Collection, New York.

EXHIBITIONS: New York, Century Association, 1930; Florence, "Mostra Giottesca," 1937; New York, World's Fair, 1939.

BIBLIOGRAPHY: R. Offner in *L'Arte, 24* (1921), p. 117 (as Taddeo Gaddi); Van Marle, *3* (1924), p. 342; Offner, in *Studies in Florentine Painting,* New York, 1927, fig. 4, opp. p. 66; Berenson 1932, p. 215 (as Taddeo Gaddi); L. Venturi, *Italian Paintings in America,* Milan, 1933, pl. L (as Taddeo Gaddi).

While in the Griggs Collection, New York, the painting was called "School of Giotto." Though a much degraded version, it evidently descends from Taddeo Gaddi's *Madonna Enthroned,* dated 1355, in the Siena Pinacoteca.

GIOVANNI DEL BIONDO

One of the most prominent of the Florentine painters of the second half of the Trecento, Giovanni del Biondo appears to have been trained in the general tradition of Taddeo Gaddi. He was active in Florence from about 1356 to 1399. His work has a good deal in common with Orcagna and Nardo di Cione and he may have worked as an assistant to Orcagna early in his career.

26. CHRIST AND THE VIRGIN ENTHRONED, ca. 1370

University purchase from James Jackson Jarves. 1871.19.

Egg tempera on panel. 182.8 × 79.2 cm. (72 × 31³⁄₁₆ in.). Partially restored, 1915; cleaned (beginning) in 1963—still incomplete (1968).

CONDITION: Only fair; modern glazes were noted in 1915 which have been largely removed; the original frame is present but completely overgessoed and overgilded.

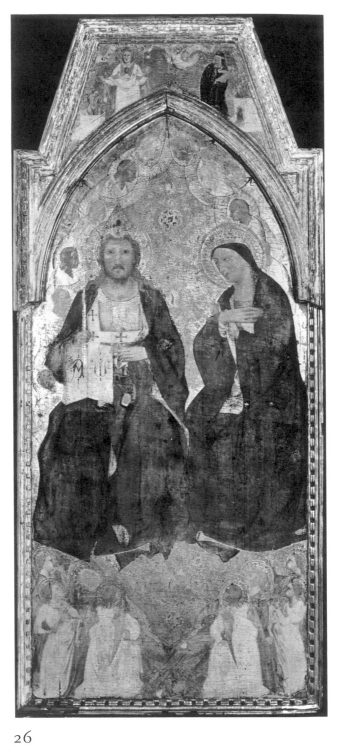

26

INSCRIPTIONS: 1. Summit, l., on scroll over figure of Ecclesia, ECCE NOVA FA-
CIO (Revelation 21:5, Behold I make all things new); summit, r., on scroll
held by the angel near the figure of Synagoga, H(?)ABEBIS DEO(S) (Exodus
20:3 (?), Thou shalt have no other gods before me).

PROVENANCE: James Jackson Jarves Collection, Florence.

EXHIBITIONS: New York "Institute of Fine Arts," 625 Broadway, 1860; New-
York Historical Society, 1863 (both times as unknown Greco-Italian artist).

BIBLIOGRAPHY: P. Fumagalli, *Museo di Pittura e Scultura delle Gallerie d'Eu-
ropa,* Florence, *13* (1845), pl. 1500–01; Jarves 1860, p. 42 (as Greco-Ital-
ian); Sturgis 1868, pp. 20–21 (as Greco-Italian); Sirén 1916, pp. 47–49 (as
Giovanni del Biondo); Offner 1927, pp. 18–19 (as Giovanni del Biondo);
Van Marle, *3* (1924), pp. 520–21 (as Giovanni del Biondo); R. Offner, in
Mitteilungen des Kunsthistorischen Instituts in Florenz, 7 (1956), p. 183 (as
Giovanni del Biondo, E.); Berenson 1963, *1*, p. 86 (as Giovanni del Biondo).

As first pointed out by Sirén (in *AiA, 4* (1916), pp. 215–16) our picture was
originally the central panel of an impressive triptych of which the lateral panels
are now in the Vatican Pinacoteca (nos. 13, 15). Jarves' wild guess at the paint-
ing's authorship, which missed the mark in a way unusual for him, may be ex-
plained by the picture's inclusion in the 1845 publication of Fumagalli's volume
13 of "lists" of works of art (above) which he followed. This is the only previ-
ously published painting that Jarves acquired for his first collection, and though
his attribution does not speak well for his impressionability the fact that it ap-
pears to be unique in this respect speaks much more strongly for his courage and
faith in his own eye as a rule. Stylistically the Yale-Vatican triptych is an early
work, coming, according to Offner writing in 1956 (see above), immediately
after the *St. Jerome* in Altenburg.

JACOPO DEL CASENTINO (attributed to)

Active in Florence 1330–58, he may have been a pupil of Meo da Siena and was
later influenced by Bernardo Daddi.

27. MADONNA AND CHILD, ca. 1340*

Bequest of Maitland F. Griggs, B.A., 1896. 1943.209.

Egg tempera on panel. 60 × 39.4 cm. (23⅝ × 15½ in.). Cleaned in 1965–67.

CONDITION: Fair only; original surfaces are uniformly rubbed. The panel has been drastically cut into an irregular shape and encased in modern wood and a modern frame. A part of this modern work is left to show the character of the "restoration."

PROVENANCE: Dan Fellows Platt, Englewood, New Jersey; Maitland F. Griggs Collection, New York.

BIBLIOGRAPHY: R. Offner, *Studies in Florentine Painting,* New York, 1927, p. 31 (as shop of Jacopo del Casentino); Offner *Corpus,* sec. 3, vol. 2, pt. 2, pp. 93, 181–82 (as following of Jacopo del Casentino); Berenson 1932, p. 272 (as Jacopo del Casentino); Berenson 1963, p. 102 (no change).

Although the panel in its present condition is fragmentary, the design and figure types are clearly consonant with Jacopo's early phase (see above, Offner *Corpus*).

JACOPO DEL CASENTINO (shop of?)

28. CORONATION OF THE VIRGIN, ca. 1340*

Gift of Maitland F. Griggs, B.A., 1896, through the Associates in Fine Arts. 1939.557.

Egg tempera on wood panel. 32.5 × 24.3 cm. (12¾₁₆ × 9⁹₁₆ in.). Cleaned in 1967.

CONDITION: Poor; extensive losses in center.

PROVENANCE: J. Fuller Russell, England (sale, Christie's, 1885); Henry Wagner, London (sale, Christie's, 1925); Maitland F. Griggs Collection, New York (acquired in Italy, 1926).

EXHIBITIONS: Manchester, 1857; London, Burlington House, 1877; London, New Gallery, 1893–94; New York, Century Association, 1930.

BIBLIOGRAPHY: G. F. Waagen, *Treasures of Art in Great Britain,* London, 1854, *2,* p. 462 (as Taddeo di Bartolo); R. Offner, *Studies in Florentine Painting,* New York, 1927, p. 33 (as Jacopo del Casentino, L.); Offner *Corpus,* sec. 3, vol. 2, pt. 2, p. 93 (as shop of Jacopo del Casentino); Berenson 1932, p. 272 (as Jacopo del Casentino); Berenson 1963, *1,* p. 102 (no change).

Because of its poor state, the panel is difficult to attribute. Its execution, though careful, is weak; it is possibly by a miniaturist. After cleaning even the shop of Jacopo del Casentino seems remote. Probably a provincial artist is involved here.

JACOPO DI CIONE (shop of?)

Jacopo di Cione was a younger brother, with Nardo, of Orcagna, from whom he received his training. He is believed to have been active ca. 1368–98, and was enrolled in the Florentine Painters' guild in 1369. He was also a partner of Niccolò di Pietro Gerini.

29. MADONNA AND CHILD ENTHRONED WITH SS. JOHN
 THE BAPTIST, NICHOLAS, DOROTHY, AND REPARATA;
 above, CRUCIFIXION, ca. 1380*

University purchase from James Jackson Jarves. 1871.16.

Egg tempera on panel. 118.9 × 59.2 cm. (46^{13}⁄₁₆ × 25⅝₁₆ in.).

CONDITION: Uncleaned, much darkened, evidently much rubbed and in several places repainted.

PROVENANCE: James Jackson Jarves Collection, Florence.

EXHIBITIONS: New York "Institute of Fine Arts," 625 Broadway, 1860 (as Giottino); New-York Historical Society, 1863 (as Giottino).

BIBLIOGRAPHY: Jarves 1860, p. 46 (as Giottino); Sturgis 1868, p. 39 (as Giottino); Sirén 1916, pp. 43–44 (as Jacopo di Cione); Offner 1927, pls. 17,

18 (as follower of Niccolò di Pietro Gerini); Berenson 1932, p. 332 (as divided between Mariotto di Nardo and Jacopo di Cione); Berenson 1963, *1*, p. 132 (as Mariotto).

Because of the presence of St. Reparata, this panel could possibly have come from the Florentine Duomo which was originally dedicated to that saint. The difference between the styles of Jacopo di Cione and Mariotto is considered today impossible to detect with anything like confidence; accordingly the older attribution is retained with question.

JACOPO DI CIONE (late follower of)

30. HOLY TRINITY WITH THE VIRGIN AND SS. MARY MAGDALEN, JOHN THE BAPTIST, AND JOHN THE EVANGELIST, ca. 1400 (?)*

University purchase from James Jackson Jarves. 1871.18.

Egg tempera on panel. 106.7 × 50.2 cm. (42 × 19¾ in.). Restored in 1915.

CONDITION: Much darkened; badly rubbed and evidently much repainted. Inscription on the base of frame is modern, as indeed appears to be the frame, though it has been called original.

PROVENANCE: James Jackson Jarves Collection, Florence.

EXHIBITIONS: New York "Institute of Fine Arts," 625 Broadway, 1860 (as Capanna [Puccio]), New-York Historical Society, 1863 (as Capanna [Puccio]).

BIBLIOGRAPHY: Jarves 1860, p. 44, no. 20 (as Puccio Capanna); Sturgis 1868, p. 37 (as Puccio Capanna); Sirén 1916, pp. 45–46 (as Jacopo di Cione workshop); Offner 1927, pp. 17–18 (as circle of Jacopo di Cione); Berenson 1932, p. 274, and 1963, *1*, p. 105 (as Jacopo di Cione with Niccolò di Pietro Gerini).

The composition was a popular one and occurs elsewhere among late followers of Jacopo di Cione (recorded in the Benson Collection and in the Vatican Pinacoteca).

JACOPO DI CIONE (shop of)

31. CORONATION OF THE VIRGIN, ca. 1375*

Gift of Hannah D. and Louis M. Rabinowitz. 1959.15.2.

Egg tempera on panel. 70.6 × 52.1 cm. (27^{13}⁄₁₆ × 20½ in.). Cleaned, 1959–60.

CONDITION: Poor; much rubbed with many losses from blistering. Severely planed down in back with heavy modern cradle; at bottom a modern addition of some three inches. Had been heavily repainted.

PROVENANCE: Rabinowitz Collection, Sands Point, Long Island.

BIBLIOGRAPHY: *Rabinowitz Coll.* 1945, pp. 7–8.

FLORENTINE SCHOOL (style of Jacopo di Cione)

32. NATIVITY AND RESURRECTION OF CHRIST, ca. 1390*

University purchase from James Jackson Jarves. 1871.17.

Egg tempera on panel. 26.7 × 87 cm. (10½ × 34¼ in.). Cleaned 1963–67.

CONDITION: Relatively good overall. Frame in part original.

PROVENANCE: James Jackson Jarves Collection, Florence; said to have come from the Rinuccini family in Florence.

EXHIBITIONS: New York "Institute of Fine Arts," 625 Broadway, 1860; New-York Historical Society, 1863 (both as Giottino).

BIBLIOGRAPHY: Jarves 1860, p. 46, no. 39 (as Giottino); Sturgis 1868, p. 39 (as Giottino); Sirén 1916, pp. 44–45 (as Jacopo di Cione); Offner 1927, pp. 17–18 (as "obscure late Trecento Florentine"); Berenson 1932, p. 332 (as Mariotto di Nardo); Berenson 1963, *1*, p. 132 (no change).

LORENZO DI NICCOLÒ (attributed to)

This artist, who is recorded as active for only a relatively brief period between 1392 and 1411, was the son of Niccolò di Pietro Gerini. He was his father's pupil and assistant, and is also known to have collaborated with Spinello Aretino.

33. SS. AUGUSTINE AND LUCY: Medallions with TWO EVANGELISTS, ca. 1400

University purchase from James Jackson Jarves. 1871.27.

Egg tempera on two panels. Overall, including frame: 110.7 × 64.5 cm. (43⁹⁄₁₆ × 25⅜ in.). Not cleaned.

CONDITION: Evidently fair to good; a deeply ingrained grime layer over both panels, with considerable repainting over that.

PROVENANCE: James Jackson Jarves Collection, Florence.

EXHIBITIONS: New York "Institute of Fine Arts," 625 Broadway, 1860; New-York Historical Society, 1863 (both times as by Orcagna).

BIBLIOGRAPHY: Jarves 1860, p. 45 (as Orcagna); Sturgis 1868, p. 36 (as Orcagna); Sirén 1916, pp. 72–73 (as Lorenzo di Niccolò); Berenson 1932, p. 303 (as Lorenzo di Niccolò); Berenson 1963, 1, p. 123 (no essential change). Part of the same altarpiece as 1871.28.

LORENZO DI NICCOLÒ (attributed to)

34. SS. AGNES AND DOMINIC: Medallions with TWO EVANGELISTS, ca. 1400

University purchase from James Jackson Jarves. 1871.28.

Egg tempera on panel. 111.1 × 64.1 cm. (43¾ × 25¼ in.). Part of the same ensemble as 1871.27, with identical provenance, exhibition data and bibliography; as far as can be judged without cleaning, very similar as to condition.

LORENZO DI NICCOLÒ (attributed to)

35. TWO DEACON SAINTS (probably SS. Lawrence and Stephen), ca. 1410*

Bequest of Maitland F. Griggs, B.A., 1896. 1943.216.

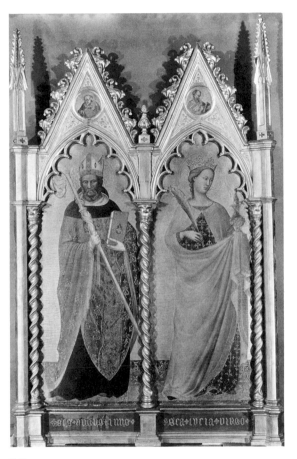

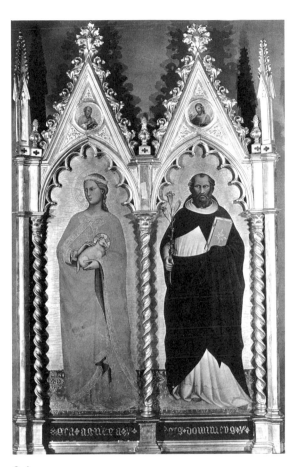

33 34

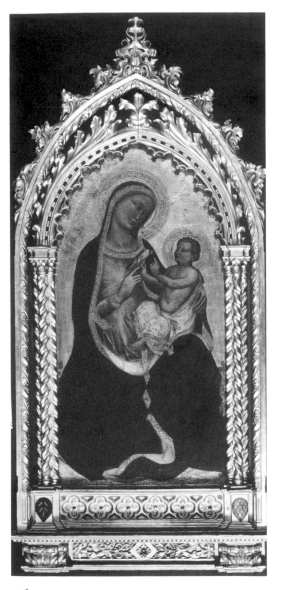

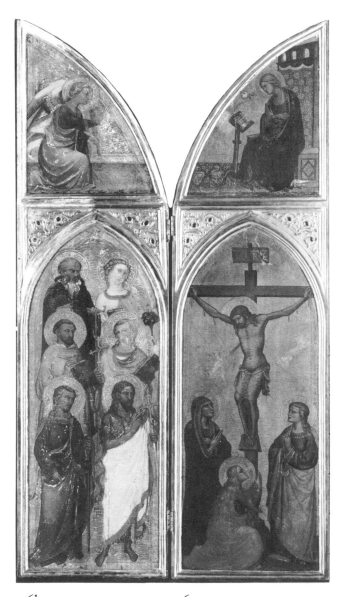

36a 36b 36c

Egg tempera on canvas (transferred from panel). 126 × 66.9 cm. (49⅝ × 26⁵⁄₁₆ in.). Partially cleaned 1968–69.

CONDITION: Difficult to judge; apparently much repainted.

PROVENANCE: Mrs. Benjamin Thaw, New York (sale, Galerie Georges Petit, Paris, 1922, as Sienese school); Maitland F. Griggs Collection, New York.

EXHIBITION: New York, Century Association, 1930 (as "Maestro del Bambino Vispo").

BIBLIOGRAPHY: Van Marle, 9 (1927), p. 198 (as "Maestro del Bambino Vispo," with incorrect location as in Museum of Fine Arts, Boston).

Unpublished opinions by Berenson (1925 *in litteris*) and Offner (lecture at Griggs residence in New York in 1925) suggest "Florentine School" and "Master close to Giovanni dal Ponte." The present attribution is tentative pending further examination and cleaning.

LORENZO DI NICCOLÒ AND ASSISTANT (?) (attributed to)

36a,b,c. MADONNA AND CHILD WITH SAINTS, ca. 1400

University purchase from James Jackson Jarves. 1871.26.

Egg tempera on panel. Tabernacle with folding wings.
 Central panel: 109 × 55.2 cm. (43¾ × 21¾ in.); l. wing: 141.3 × 37.8 cm. (55⅝ × 14⅞ in.); r. wing: 141.6 × 38.9 cm. (55¾ × 15⁵⁄₁₆ in.). Not cleaned except for test in r. panel.

CONDITION: Fair only; considerable repainting is present. The framing is all modern, and evidently the wings have been shaved back radically in section. There is no sure indication that the wings and the central panel were originally together.

PROVENANCE: James Jackson Jarves Collection, Florence.

EXHIBITIONS: New York "Institute of Fine Arts," 625 Broadway, 1860; New-York Historical Society, 1863 (both times as unknown Italian painter).

BIBLIOGRAPHY: Jarves 1860, p. 43, no. 18 (as school of Giotto); Sturgis 1868, p. 35 (as unknown Italian painter, school of Giotto); Sirén 1916, pp. 71–72 (as Lorenzo di Niccolò); Berenson 1932, p. 303 (r. wing as by Lorenzo, remainder by Niccolò di Pietro Gerini); Berenson 1963, *1*, p. 123 (no change).

Until the central panel is cleaned and the structure of the triptych as a whole is thoroughly studied it is not possible to give a firm attribution. The style of the central panel appears to be closer, however, to Lorenzo di Niccolò than to his father. The lateral panels appear to be by a different hand than the central panel. Evidently shopwork of a *retardataire* type.

MARIOTTO DI NARDO (attributed to)

Pupil of Nardo di Cione; active in Florence from 1394 to 1424; partner at one time of Lorenzo di Niccolò.

37. SCENES FROM THE LEGEND OF SS. COSMAS AND DAMIAN, ca. 1400*

University purchase from James Jackson Jarves. 1871.29.

Egg tempera on panel. 24.1 × 73.4 cm. (9½ × 28⅞ in.). Restored, 1915; not cleaned since.

CONDITION: Only fair to poor judging from the X-ray shadowgraph, the much overpainted surface, and the written report made in 1915 by Hammond Smith; damage is extensive along two seams running horizontally and a deep crack at l. running through the left-hand figure, which is mostly new; the remainder of the surface is reported as of 1915 as "considerably worn."

PROVENANCE: James Jackson Jarves Collection, Florence.

EXHIBITIONS: New York "Institute of Fine Arts," 625 Broadway, 1860; New-York Historical Society, 1863 (both times as Lorenzo di Bicci).

BIBLIOGRAPHY: Jarves 1860, p. 45, no. 33 (as Lorenzo di Bicci); Sturgis 1868, p. 41 (as Lorenzo di Bicci); Sirén 1916, pp. 75 (as Mariotto di Nardo);

Berenson 1932, p. 332 (as Mariotto di Nardo); Berenson 1963, *1,* p. 132 (no change).

Part of a predella, the panel must have stood below a panel representing SS. Cosmas and Damian who were patrons of the painters' guild, the physicians and the Medici. (See, for example, the large panel and two predella panels attributed to the "Master of the Rinuccini Chapel," now in Raleigh, North Carolina). The incidents from the legend of the two saints seen here are connected as a single narrative. The husband of a woman who had invoked the help of the saints against the temptation of the devil in the form of a priest had an incurably diseased leg; this the saints replaced by the healthy leg of a Moorish heretic who had just died. The l. half of the panel depicts the temptation of the woman and her rescue by angels from the devil who attempts to push her off her horse; the r. scene shows the miraculous operation, one of the earlier prefigurations, it might appear, of the human transplants of modern surgery.

"MASTER OF THE HORNE TRIPTYCH"

Anonymous artist parallel to Giotto with strong Roman characteristics (active ca. 1320–30).

38. MADONNA AND CHILD, ca. 1325*

Bequest of Maitland F. Griggs, B.A., 1896. 1943.204.

Egg tempera on panel. 79 \times 52.6 cm. (31⅛ \times 20¹¹⁄₁₆ in.). Not cleaned.

CONDITION: Evidently fair, but difficult to assess. The triangular summit at some period was truncated.

PROVENANCE: Maitland F. Griggs Collection, New York; acquired in 1924 in Florence from the dealer Volpi.

EXHIBITION: "Mostra Giottesca," Florence, 1937.

BIBLIOGRAPHY: Offner *Corpus,* sec. 3, vol. 2, pt. 2 (1930), pp. 221, 225, 226, 227; additional pl. 5 (as Pacino di Bonaguida); L. Venturi, pl. XXIX (as "Arte Giottesca").

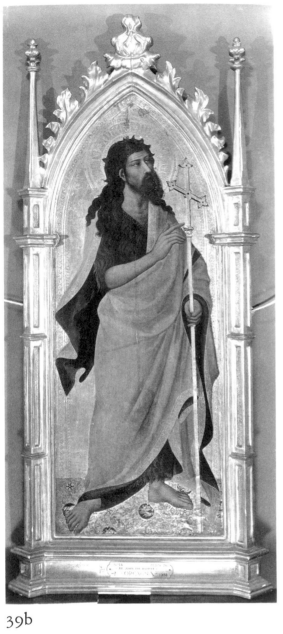

39b

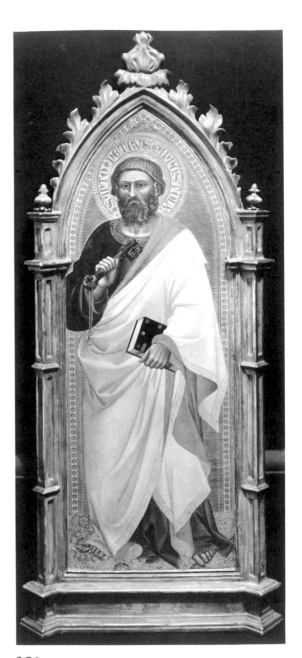

39a

In the Griggs Collection, while in New York, this panel was attributed to the "Master of the Horne Triptych," named from the distinctive style of a triptych in the Museo Horne, Florence. This was also the attribution given in the distinguished "Mostra Giottesca" in Florence in 1937. It is readopted here.

NARDO DI CIONE

Bernardo di Cione, called Nardo, one of three famous painter brothers, is first mentioned in 1343–46 as being a resident of the parish of S. Michele Visdomini in Florence, where he apparently had a workshop. His style seems to be rooted in that of Daddi, although he was probably a pupil of Maso and was influenced by his more famous brother, Andrea Orcagna, with whom he collaborated on the frescoes of the Strozzi Chapel of S. Maria Novella. Works attributed directly to Nardo are few in number and are based primarily on comparison to what work is thought to be by his hand in the Strozzi Chapel. He died in 1366.

39a,b. ST. PETER and ST. JOHN THE BAPTIST, ca. 1355–60

University purchase from James Jackson Jarves. 1871.13 and 1871.14.

Egg tempera on panel. St. Peter, 99.4 × 40 cm. (39⅛ × 15¾ in.); St. John, 99.1 × 39.7 cm. (39 × 15⅝ in.). Both panels restored in 1915; both cleaned, 1950–52.

CONDITION: Good to excellent; the surface of the St. John the Baptist, however, was damaged by a serious crack through the center of the panel; and there are losses which have been inpainted in the drapery and beard of the same figure. Losses in the St. Peter are minimal.

PROVENANCE: James Jackson Jarves Collection, Florence.

EXHIBITIONS: Both exhibited in New York, "Institute of Fine Arts," 625 Broadway, 1860, and the New-York Historical Society, 1863 (as Andrea Orcagna); St. Peter, only, exhibited, Worcester, Art Museum, "Condition Excellent," 1951; Northampton, Massachusetts, Smith College Museum of Art,

1956; Chicago, Art Institute, "Master Works from the Yale Collections," 1956 (as Nardo di Cione).

BIBLIOGRAPHY: Jarves 1860, pp. 45–46 (as Orgagna [sic]); Sturgis 1868, pp. 36–37 (as Andrea Orcagna); Jarves 1871, p. 15 (as Andrea Orcagna); Sirén 1916, pp. 39–40 (as Andrea Orcagna); Offner 1927, pp. 3, 16–17, 19 (as Nardo di Cione); Van Marle, 3 (1924), pp. 468, 474 (as Andrea Orcagna); R. Offner, *Corpus 4* (1960), pt. 2, pp. 61–63 (as Nardo di Cione); L. Venturi, pl. XLV (as Nardo di Cione); Berenson 1932, p. 382 (as Nardo di Cione); *Y.U.A.G.* 1952, pp. 16–17 (as Nardo di Cione); Berenson 1963, p. 152 (as Nardo di Cione).

These two panels are among the best-preserved works by Nardo and are outstanding examples of mid-Trecento painting. It has been suggested that the *Standing Madonna and Child* which belonged to the late Miss Tessie Jones, Balmville, New York, and the Jarves-Yale panels may be from the same polyptych. But the relative dimensions of the panels and of the figures within them make such a reconstruction highly improbable; the Jones Madonna is simply too small to have been the central panel of a polyptych of which the Jarves-Yale saints were flanking parts. The only possible conclusion today is that the Jarves-Yale panels and the Jones Madonna are from different polyptychs, the other sections of which are lost or unknown. The reverses of the Jarves-Yale panels are decorated with an insignia of four red lozenges arranged as a cross on a white ground. The heraldic problem has not been solved to date, but it has been suggested verbally that the insignia do not refer to a family but instead to an institution or organization such as one of the trade guilds of medieval Florence.

NICCOLÒ DI PIETRO GERINI (?)

He was active as of 1368 and died in 1415; he was trained in the Cione workshop and collaborated with Jacopo di Cione. Later he collaborated with his son, Lorenzo di Niccolò. All in all he appears today to have been the main exponent of Giottesque style in Florence in the last half of the Trecento.

40. ANNUNCIATION, ca. 1375

University purchase from James Jackson Jarves. 1871.21.

Egg tempera on panel. 108 × 29.5 cm. (42½ × 51 in.). Cradled and restored, 1929; Not cleaned since.

CONDITION: Evidently fair to good, though the panel has much darkened and was cut down on all sides.

INSCRIPTION: On book, MAGNIFICAT ANIMA MEA DOMI [NUM] (Luke 1:46, My soul doth magnify the Lord).

PROVENANCE: James Jackson Jarves Collection, Florence.

EXHIBITIONS: New York "Institute of Fine Arts," 625 Broadway, 1860; New-York Historical Society, 1863 (both times as Pietro Cavallini).

BIBLIOGRAPHY: Jarves 1860, p. 43, no. 15 (as Pietro Cavallini); Sturgis 1868, p. 33 (as Pietro Cavallini); Sirén 1916, pp. 55–56 (as Niccolò di Pietro Gerini); Berenson 1932, p. 395 (as Niccolò di Pietro Gerini); Berenson 1963, p. 160 (no change).

This is evidently an unusually well-painted and important example of its type: the traditional Florentine Trecento representation of the Annunciation. The style departs from that usually associated with Niccolò di Pietro Gerini in its solidity and abstract quality of form (see for example the angel). In this respect the panel's style appears to be closer to Orcagna or possibly even to very early Agnolo Gaddi. Until the picture is cleaned and further studied the problem of attribution to Gerini is left open.

GIOVANNI DI PIETRO DA NAPOLI (attributed to)

A painter of Neapolitan origin who must have soaked up Giotto's influence there in his youth. In 1402 he is recorded in partnership with Martino di Bartolommeo in Pisa. Not recorded after 1405.

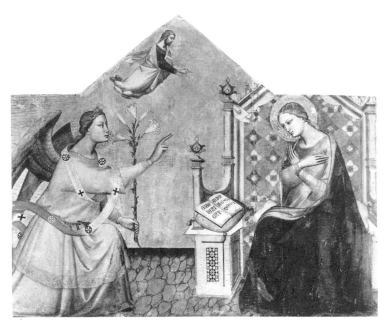

40

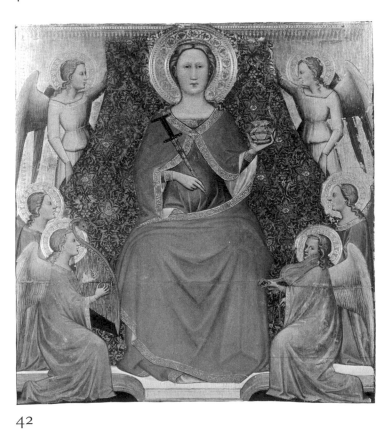

42

41. DEPOSITION FROM THE CROSS, ca. 1400 (?)*

University purchase from James Jackson Jarves. 1871.70.

Egg tempera on panel. 125.7 × 78.5 cm. (49½ × 30⅞ in.). Restored, 1915; cradled, retouched, 1930; restored, 1946.

CONDITION: At present obscured by repaints and heavy resinous varnish; upper portion above figures may be an addition.

PROVENANCE: James Jackson Jarves Collection, Florence.

EXHIBITIONS: New York "Institute of Fine Arts," 625 Broadway, 1860; New-York Historical Society 1863 (both times as Antonio Veneziano).

BIBLIOGRAPHY: Jarves 1860, p. 44, no. 19 (as Puccio Capanna); Sturgis 1868, p. 41 (as Antonio Veneziano); Sirén 1916, pp. 179–80 (as Michele di Matteo Lambertini); Offner 1927, pp. 42–43 (as Giovanni di Pietro da Napoli); H. Kauffmann, *Donatello,* Berlin, 1935, pp. 184, 254, pl. 36 (as Cecco di Pietro also active in Pisa in the 14th century).

The panel requires cleaning before a firmer attribution may be made. The style though reminiscent of Giovanni di Pietro's wooden forms seems to be a little earlier than his activity in Pisa. Consequently Kauffmann's suggestion (see above) is to be kept in mind.

GIOVANNI DI BARTOLOMMEO CRISTIANI

He was active mainly in Pistoia, though trained in Florence, 1367–98. The basis for knowledge of Giovanni's style is, (1) the *St. John the Evangelist Altarpiece* (dated 1370) in the church of S. Giovanni Fuorcivitas, Pistoia; (2) a signed *Madonna* in the Pinacoteca, Pistoia (no. 27); and (3) according to information received from the Metropolitan Museum of Art, a triptych in the Rivetti Collection, Isola Bella, signed and dated 1390. This recognizable personal style, slightly awkward and provincial, combines influences from Nardo di Cione (see above 1871.13 and 1871.14) with reminiscences of Giovanni's Florentine contemporary, Giovanni del Biondo (see above 1871.19).

42. ST. LUCY WITH ANGELS, ca. 1375

Bequest of Maitland F. Griggs, B.A., 1896. 1943.215.

Egg tempera on panel. 83.2 × 77.5 cm. (32¾ × 30½ in.). Cleaned, 1957.

CONDITION: On the whole good; some rubbing of drapery of angel at lower r.;
a deep crack running horizontally at the seated figure's knees was filled and in-
painted. The panel is not cradled, though it appears to have been reduced in
thickness.

PROVENANCE: Ex-Canessa Collection (sale, New York, 1924); Maitland
Griggs Collection, New York.

EXHIBITION: New York, Century Association, 1930.

BIBLIOGRAPHY: B. Berenson, in *Dedalo,* 5 (1931), pp. 1312, 1314 (as Gio-
vanni di Bartolommeo Cristiani, but wrongly listed as in the Ryerson Collection,
Chicago); Berenson 1963, *1,* p. 51 (as Giovanni di Bartolommeo Cristiani);
R. Offner, in *Mitteilungen des Kunsthistorischen Instituts in Florenz,* 7 (1956),
p. 192 (as Giovanni di Bartolommeo Cristiani).

The earliest attribution of this panel to Giovanni di Bartolommeo Cristiani was
evidently made verbally by Offner in a lecture at the home of Maitland F.
Griggs in 1925. In a letter in the curator's file dated March 2, 1961, Federico
Zeri called attention to the fact that 1943.215 is the central panel of an impor-
tant altarpiece, virtually a pendant of the *St. John Evangelist Altarpiece* of
1370. Four lateral panels from this retable from the legend of St. Lucy are in
the Metropolitan Museum of Art (H. B. Wehle, *A Catalogue of Italian, Span-
ish, and Byzantine Paintings,* Metropolitan Museum of Art, New York, 1940,
pp. 16–17). A fifth panel, representing the Communion of St. Lucy, was sold
at Sotheby's June 24, 1964 (no. 28); it has since reappeared on the New
York art market, according to information kindly transmitted by Mrs. Eliza-
beth Gardner of the Metropolitan Museum of Art. Figure 2 is a schematic re-
construction of the supposed original arrangement of the panels, including a
sixth panel (of unknown subject) which must be imagined as filling out the en-
semble.

Fig. 2. Supposed original arrangement of St. Lucy altarpiece (cat. no. 42). A, *St. Lucy at the Shrine of St. Agatha;* MMA 12.41.4. B, *St. Lucy Giving Alms;* MMA 12.41.3. C, *St. Lucy before Paschasius;* MMA 12.41.1. D, *St. Lucy Resisting Efforts to Move Her;* MMA 12.41.2. E, *The Communion of St. Lucy.* F, Missing.

NICCOLÒ DI TOMMASO

Painter in the following of Nardo di Cione; active by ca. 1355 (?); died 1405. Though trained in Florence, most of his activity was on commission in Pistoia. He was influenced by Giovanni da Milano with whose style his work has often been confused.

43. ST. JAMES, ca. 1370

Bequest of Maitland F. Griggs, B.A., 1896. 1943.235.

Egg tempera on panel. 54.6 × 34.8 cm. (21½ × 13 ¹¹⁄₁₆ in.). Cleaned 1960.

CONDITION: Of figure, good; original gesso and gold of background is missing and has been replaced by a neutral linen facing; a serious crack extending the length of the panel two inches from l. edge has been filled and an area of r. arm of the figure inpainted. This is the fragmentary upper half of a full-length figure from a polyptych.

PROVENANCE: Ex-Collection Henry Harris, London; via Durlacher Brothers, New York, to Maitland F. Griggs Collection, New York.

EXHIBITION: London, Burlington Fine Arts Club, 1920 (as Giovanni da Milano).

BIBLIOGRAPHY: R. Fry, *Catalogue of the Exhibition of Florentine Paintings before 1500 at the Burlington Fine Arts Club,* London, 1920, p. 15 (as Giovanni da Milano); R. Offner, *AiA, 13* (1924), p. 31 (as Niccolò di Tommaso); Van Marle, *5* (1925), p. 478 (infers Offner's attribution is possibly correct); R. Offner, *Studies in Florentine Painting,* New York, 1927, p. 113 (as Niccolò di Tommaso); Berenson 1932, p. 398 (as Niccolò di Tommaso); R. Offner, in *Mitteilungen des Kunsthistorischen Instituts in Florenz, 7* (1956), p. 191 (as Niccolò di Tommaso); Berenson 1963, *1,* p. 162 (as Niccolò di Tommaso).

Since Offner first published his opinion over 40 years ago that this panel was by the hand of Niccolò di Tommaso no one has questioned this attribution. The broad and rather thinly washed egg tempera technique, with muted colors, reflects the influence of fresco in which Niccolò was proficient. In Pistoia the ex-Convento del T contains his best known fresco cycle on themes from Genesis; our picture, 1943.235, is stylistically related to this cycle. It also bears a relationship to the Naples Museo S. Martino triptych of 1371. On this admittedly rather generalized basis of analogies it seems probable that 1943.235 should be dated in the neighborhood of 1370, i.e. in the early-to-middle period of the painter. The altarpiece from which this fragment came has not as yet been identified.

NICCOLÒ DI TOMMASO

44. LAST SUPPER, ca. 1375*

Gift of Richard Carley Hunt, L.L.B., 1908. 1937.200b.

Egg tempera on panel. Top, 27.9 × 53.5 cm. (11 × 21$\frac{1}{16}$ in.); bottom, 28 × 54 cm. (11 × 15$\frac{3}{16}$ in.). Cleaned in 1959.

CONDITION: On the whole good. The scene evidently decorated the front of a base for a tabernacle or crucifix (now lost)—not a predella piece as earlier published.

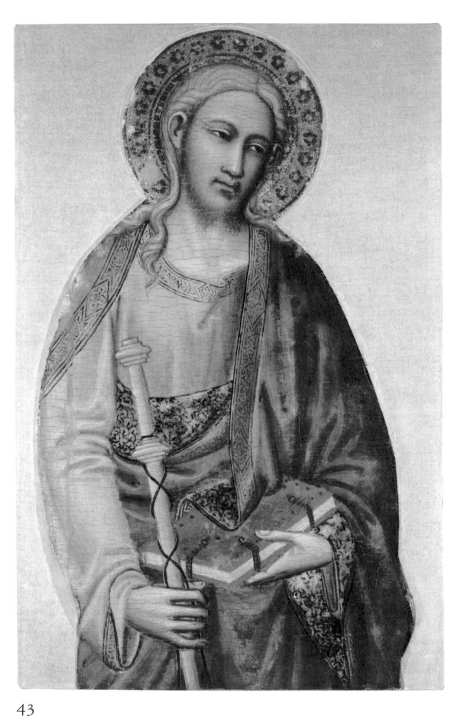

43

PROVENANCE: Same as for 1937.200a.

BIBLIOGRAPHY: *Y.U.A.G. Bulletin, 8* (February 1938); R. Offner, in *Mitteilungen des Kunsthistorischen Instituts in Florenz,* 7 (1956), p. 191.

1937.200a and 1937.200b came to the Art Gallery joined together as one unit, in a modern made-up design. They were separated in 1959.

NICCOLÒ DI TOMMASO (shop of)

45. ST. BRIDGET'S VISION OF THE NATIVITY, ca. 1375*

Bequest of Maitland F. Griggs, B.A., 1896. 1943.236.

Egg tempera on panel. 36.8 × 39.4 cm. (14½ × 15½ in.). Cleaned in 1966–67.

CONDITION: Poor; extensively rubbed. Remains of an inscription are barely visible curving over the Child.

PROVENANCE: Maitland F. Griggs Collection, New York.

BIBLIOGRAPHY: R. Offner, in *Mitteilungen des Kunsthistorischen Instituts in Florenz,* 7 (1956), p. 191.

Other versions located in the Johnson Collection, Philadelphia (no. 120) and in the Pinacoteca Vaticana, Rome.

Sienese School

ANDREA DI BARTOLO

The first reference to Andrea di Bartolo is from the year 1389 when he is reporting as collaborating in Siena with his father Bartolo di Fredi. He died in Siena in 1428. Andrea's work is frequently confused with that of his father as it occasionally is with that of Taddeo di Bartolo, an earlier Sienese painter also directly influenced by Bartolo di Fredi. His style represents the ultratraditional current in Sienese art at the beginning of the Quattrocento.

46. MADONNA AND CHILD WITH SAINTS, ca. 1405–10

Bequest of Maitland F. Griggs, B.A., 1896. 1943.248.

Egg tempera on panel. 87.9 × 67.6 cm. (34⅝ × 26⅝ in.). Cleaned, 1964.

CONDITION: Good, except for vertical crack partway down the center of the panel from the top, some rubbing in the Virgin's robe, and occasional flaking. The frame is original; part of the top of the frame has been broken, and one later replacement has now been removed.

PROVENANCE: Angeli Collection, Lucignano, Val di Chiana; Maitland F. Griggs Collection, New York; acquired in Italy, 1926.

EXHIBITION: New York, Century Association, 1930.

BIBLIOGRAPHY: Giacomo di Nicola, in *Rassegna d'arte senese, 14* (1921), fasc. 1, p. 14 (as Andrea di Bartolo); Van Marle, 5 (1925), pp. 234–35 (as follower of Giovanni di Niccolò); Berenson 1932, p. 9 (as Andrea di Bartolo); Berenson, *Pitture italiane del rinascimento,* Milan, 1936, p. 8 (as Andrea di Bartolo); Berenson 1968, *1,* p. 7 (as Andrea di Bartolo).

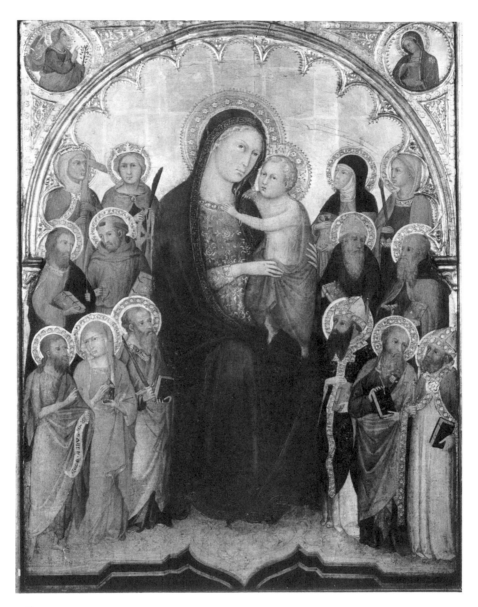

46

The Saints who surround the Virgin and Child in the Griggs Andrea di Bartolo number fourteen, double the sacred number seven which constitutes the group on each side. It is not always possible to identify all or even any of the saints in such a group, but in the case of the Andrea di Bartolo the identities of most can be specified. The saints in the group on the l. are (from l. to r., beginning with the bottom row): SS. John the Baptist, Mary Magdalen, Paul, James the Greater, Francis, Helen, and Catherine of Alexandria. On the r. they are SS. Augustine (?), John the Evangelist, Ambrose (?), Paul the Hermit (?), Anthony Abbot, Catherine of Siena, and Agatha. The two Annunciation figures in the roundels at the top of the panel exhibit an awkwardness and roughness of handling that suggests the hand of a lesser assistant.

BARNA DA SIENA (follower of; Giovanni d'Asciano?), mid XIV century

47. ST. JOHN THE EVANGELIST, ca. 1350

Bequest of Maitland F. Griggs, B.A., 1896. 1946.12.

Egg tempera on panel. 70.8 × 31.3 cm. (27⅞ × 12⁵⁄₁₆ in.). Cleaned in 1960.

CONDITION: With the exception of several small losses and scratches on hand, book, and coat, excellent. Brilliant green underpainting revealed under flesh tones of neck.

PROVENANCE: Ex-Collection Edward Hutton, London; Maitland F. Griggs Collection, New York and New Haven.

BIBLIOGRAPHY: J. Pope-Hennessy, in *BurlM*, 88 (1946), pp. 35–37 (as Giovanni d'Asciano); Berenson 1968, p. 405 (as Simone Martini follower).

In his article of 1946 (see above) Pope-Hennessy attributed our panel together with that of the Strauss *Madonna,* now in the Museum of Fine Arts, Houston, a panel that has a similar summit, to Barna's chief assistant at S. Gimignano, Giovanni d'Asciano, first mentioned by Vasari. Some doubts as to the validity of that conclusion have since appeared (see for example Volpe, in *Arte antica e*

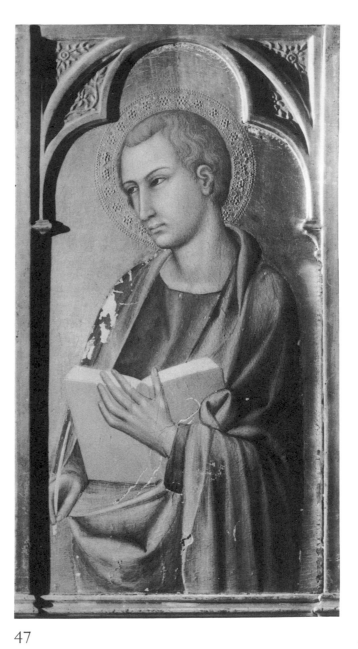

47

moderna, 10 [1960] pp. 149–58); the present attribution is tentatively returned to a follower of Barna until the question is more clearly defined.

BARTOLO DI MAESTRO FREDI (attributed to)

He was born ca. 1330; died 1410. A continuer of the stylistic current of the Lorenzetti and influenced by Barna.

48. VIRGIN ANNUNCIATE, ca. 1375*

Bequest of Maitland F. Griggs, B.A., 1896. 1943.247.

Egg tempera on panel. 69.5 × 33 cm. (27⅜ × 13 in.). Cleaned 1958.

CONDITION: Fair only; heavy losses in the Virgin's robe which had been completely repainted. The frame appears to be in part original, but the inscription on the base is modern.

INSCRIPTION: On book, ECCE VIRGO CONCIPIET ET PARIET FILIUM ET VO [CABITUR NOMEN EIUS EMMANUEL] (Isaiah 7:14, Behold a virgin shall conceive and bear a son [and his name shall be called Emmanuel]).

PROVENANCE: Ex-Collection Charles Butler, Warren Wood, Hatfield, Massachusetts; Maitland F. Griggs Collection, New York; acquired ca. 1924.

BIBLIOGRAPHY: Berenson 1968, *1,* p. 30 (as Bartolo di Maestro Fredi).

The panel appears to have been the right half of a small private devotional diptych representing the Annunciation. The present attribution follows Offner's verbal opinion expressed in a lecture in 1924 when he ascribed the panel to Bartolo di Fredi (though with question).

DUCCIESQUE MASTER, early XIV century

Duccio di Boninsegna, active from 1278 to his death in 1318–19 was the central figure in the formation of the Sienese school. He had a prominent workshop in Siena and unrivaled influence.

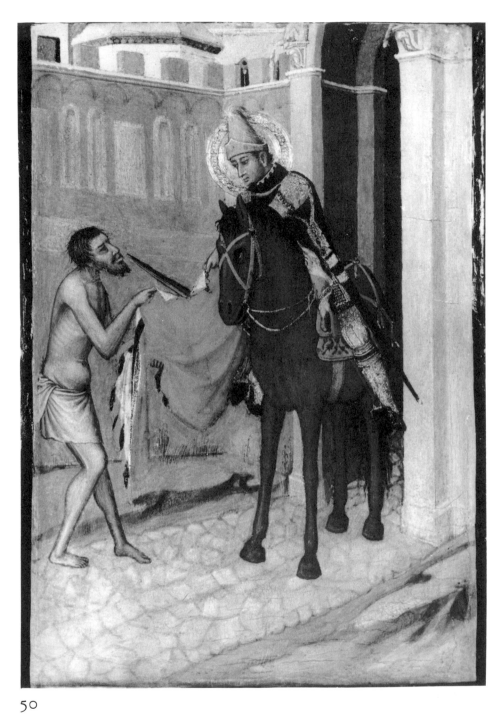

50

49a,b. DIPTYCH, MADONNA AND CHILD ENTHRONED, and CRUCIFIXION, ca. 1325*

University purchase from James Jackson Jarves. 1871.10a,b.

Egg tempera on panel. *Madonna and Child Enthroned,* 33.3 × 22.5 cm. (13⅛ × 8¹¹⁄₁₆ in.); *Crucifixion,* 33.3 × 22 cm. (13⅛ × 8⅝ in.). Both panels were restored in 1915; the *Crucifixion,* only, was cleaned in 1967.

CONDITION: Fair to good; there had been a good deal of regilding; considerable abrasion in the flesh tones, and there have been losses in the group to the r. in the *Crucifixion.* The reverses of both panels have been recut and battens added in a crude cradling system, evidently done before treatment recorded in 1930.

PROVENANCE: James Jackson Jarves Collection, Florence.

EXHIBITIONS: New York "Institute of Fine Arts," 625 Broadway, 1860; New-York Historical Society, 1863 (both times as Duccio).

BIBLIOGRAPHY: Jarves 1860, p. 44, no. 21 (as Duccio); Sturgis 1868, pp. 27–28 (as Duccio); Sirén 1916, pp. 31–33 (as follower of Duccio); Offner 1927, pp. 4, 11 (as in Duccio's manner); Berenson 1932, p. 524 (as Segna di Bonaventura); Berenson 1968, *1,* p. 83 (as Segna di Bonaventura).

A related *Crucifixion* is present in a triptych in the Christian Art Museum in Esztergom, Hungary; a *Crucifixion* evidently by the same hand as that responsible for our panels was pointed out in 1950 by Millard Meiss as then also in New York (*in litteris*). A larger *Madonna* now in Asciano (Museo) is related.

AMBROGIO LORENZETTI (attributed to)

Ambrogio Lorenzetti seems to have been younger than his brother Pietro, but nevertheless to have produced more advanced work which demonstrates his awareness of contemporary Florentine artistic trends. Active in Florence as well as in Siena from 1319 to his death in 1348, Ambrogio is best known for his monumental frescoes and great altarpieces which, despite their scale, evidence great delicacy of touch. His small panels demonstrate his superb capacity to

animate graceful figures in gentle movement through surprisingly advanced and complex spatial structures.

50. ST. MARTIN AND THE BEGGAR, ca. 1340–45

University purchase from James Jackson Jarves. 1871.11.

Egg tempera on panel. 29.8 × 20.3 cm. (11¾ × 8³⁄₁₆ in.). Cleaned 1952–53.

CONDITION: Good, except for some rubbing evident on the stone archway out of which the saint has ridden and slight abrasion diagonally l. above the saint's head.

PROVENANCE: James Jackson Jarves Collection, Florence.

EXHIBITIONS: New York "Institute of Fine Arts," 625 Broadway, 1860; New-York Historical Society, 1863 (both times as Dello Delli).

BIBLIOGRAPHY: Jarves 1860, p. 49, no. 56 (as Dello Delli); Sturgis 1868, pp. 51–52, no. 46 (as Dello Delli); Berenson, *Central Italian Painters of the Renaissance,* 2d ed. New York and London, 1902, p. 252 (as Simone Martini); F. Mason Perkins, in *Rassegna d'arte senese, 1* (1905), pp. 74, 76 (as follower of Bartolo di Fredi); Sirén 1916, pp. 35–36 (as Simone Martini); Offner 1927, pp. 4–5, 38 (as Lippo Vanni); B. Berenson, *Studies in Medieval Painting,* New Haven, 1930, p. 58 (as Simone Martini); Berenson 1932, p. 534 (as Simone Martini); F. Zeri, in *Paragone, 2* (1951), pp. 52–54 (as Ambrogio Lorenzetti); G. Moran, in *Y.U.A.G. Bulletin, 31* (1967), pp. 28–39 (as Ambrogio Lorenzetti); Berenson 1968, *1,* p. 221 (as Lorenzetti imitator, close to Lippo Vanni).

As shown in the Bibliography above, the variety of attributions connected with the Jarves *St. Martin* over the past century has been unusually large. A recent scholarly investigation has yielded more fruitful results. Begun in 1953 with the cleaning of the panel at Yale, the inquiry continued by testing the published hypothesis of Federico Zeri and the verbal suggestion by Millard Meiss that the panel's origin might be more distinguished than had previously been supposed, and might in fact be closely connected with Ambrogio Lorenzetti. Inten-

sive study of the picture revealed that it indeed must have been, as Zeri has suggested, the companion piece to a panel of similar dimensions, showing a scene from the Life of St. Nicholas, today in the Louvre. The study further indicated that these two smaller pieces must have formed the side wings to a larger panel. A careful reconstruction demonstrated that this panel was undoubtedly none other than Ambrogio Lorenzetti's *Small Maestà* now in the Pinacoteca Nazionale in Siena. An honors thesis written by Gordon Moran, Yale B.A., 1960, with information kindly supplied by Enzo Carli, Director of the Pinacoteca Nazionale in Siena, showed how these three panels, two of which represent charitable works, together formed a small portable altar for the Ospedale della Scala, the foremost charitable institution of 14th-century Siena.

PIETRO LORENZETTI AND ASSISTANT

The brother of Ambrogio Lorenzetti, Pietro was active in Siena from about 1320, the date of his first authenticated work, to his death in 1348, probably from the plague. His style shows influence from his great Sienese forebears Duccio and Simone Martini, as well as from the sculptor Giovanni Pisano. He is best known for his frescoes at Assisi, though among his panel paintings a high ranking must be accorded the large altarpiece that he painted in 1329 for S. Maria del Monte Carmelo, Siena's church of the Carmelite Order.

51a,b,c. ST. ANDREW, ST. JAMES THE GREATER, and A PROPHET, 1329

Gift of Hannah D. and Louis M. Rabinowitz. 1959.15.1.

Egg tempera on panel. St. Andrew, 36.8 × 21.6 cm. (14½ × 8½ in.); St. James the Greater, 37.1 × 22.2 cm. (14⅝ × 8¾ in.); A Prophet, 18 × 26 cm. (7⅛ × 10¼ in.). Cleaned, 1959.

CONDITION: Good except for a crack across the panel showing the Prophet; abrasion on the l. of the St. Andrew panel, some flaking of the gold and loss of flesh tints in the St. Andrew and the Prophet.

INSCRIPTIONS: On backgrounds flanking figures of the saints, (S) A̅N̅ ; S. I̅A̅.

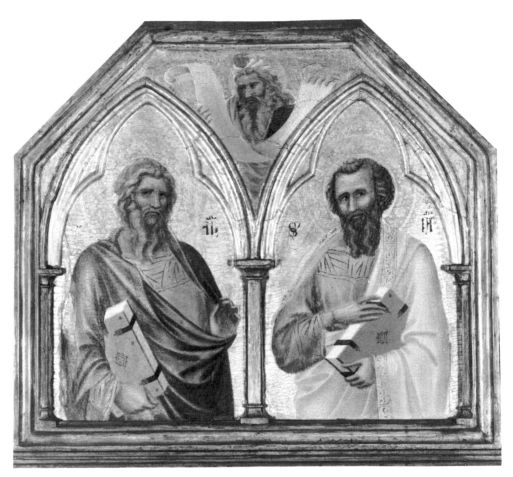

51

PROVENANCE: S. Maria del Monte Carmelo, Siena, until the 19th century; Rabinowitz Collection, Sands Point, Long Island, via E. and A. Silberman Galleries (no intervening ownership on record).

EXHIBITION: New York, E. and A. Silberman Galleries, 1955.

BIBLIOGRAPHY: *Rabinowitz Coll.* 1945, pp. 3–4; E. Carli, *Capolavori dell'arte senese,* Florence, 1947, p. 44; Brandi, in *BdA,* ser. 4, *33* (1948), p. 69; E. Carli, *Les Siennois,* Paris, 1957, p. 38; *Rabinowitz Coll.* 1961, pp. 12–13 (all references above give Pietro Lorenzetti as the artist except for the last which names Pietro Lorenzetti and assistant); Berenson 1968, *1,* p. 219 (as Ambrogio Lorenzetti).

These panels formed part of Pietro Lorenzetti's most important single commission, the great altarpiece for S. Maria del Monte Carmelo in Siena (see above). The central panel of the altar was moved in the 16th century to the Oratory of Sant'Ansano in Castelnuovo Berardenga, close to Siena, then to Sant'Ansano a Dofana; today in the Pinacoteca, Siena. The four predella scenes are now in the Pinacoteca, Siena, as well. That museum also preserves the two other panels of Saints with a Prophet that, according to the reconstruction of the altar by DeWald (see *Rabinowitz Coll.* 1945, pp. 3–4), flanked the Rabinowitz panels on both sides. These remained with the Carmelites in Siena until the 19th century, but exactly when they left the ownership of the Carmelites or through whose hands they passed has not yet been discovered. An interesting aspect of 1959.15.1 is that while the St. Andrew and the Prophet were apparently done by the master himself, the companion saint seems to be by the hand of an assistant; this is a type of division of labor that occurred frequently in Medieval and early Renaissance workshops.

PIETRO LORENZETTI (shop of)

The collaboration of Pietro with his younger brother Ambrogio on various commissions accounts for echoes of the styles of both in works attributable to assistants in the shop rather than to either master himself.

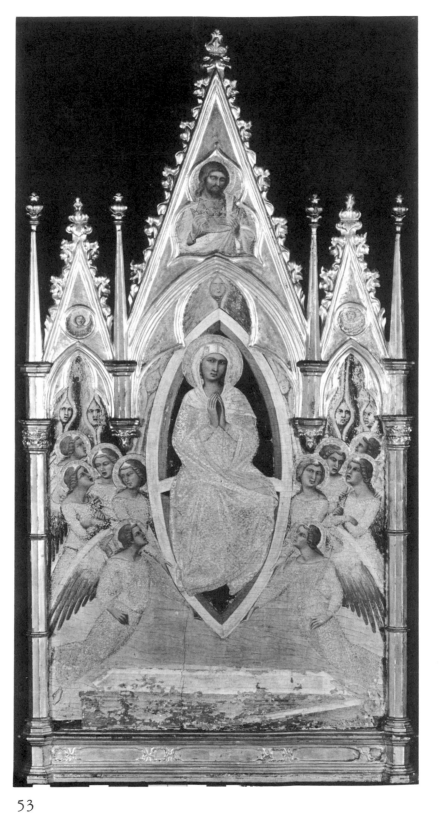

53

52. MADONNA, ca. 1330*

Gift of Maitland F. Griggs, B.A., 1896. 1942.323.

Egg tempera on panel. 33 × 29.7 cm. (13 × 11$^{11}/_{16}$ in.). Cleaned in 1958.

CONDITION: On the surface poor; extensively rubbed, especially in the flesh tones; only the undercoat of the Virgin's blue robe remains. But as a document of technique the panel has great interest as a rare example of homogeneous underpainting.

PROVENANCE: Maitland F. Griggs Collection, New York.

BIBLIOGRAPHY: Berenson 1932, p. 293 (as Pietro Lorenzetti); Berenson 1968, *I*, p. 219 (as Ambrogio Lorenzetti?).

Originally this panel was undoubtedly part of a predella; no direct connection with any documented work by Pietro Lorenzetti has as yet been established.

LUCA DI TOMMÈ

He is documented as having been active in Siena, Pisa and Umbria, from 1356–89. Although his origin and training are not yet clearly defined, the artist seems to have been influenced in his earlier works by Pietro Lorenzetti. He collaborated with the Sienese miniaturist Niccolò di Ser Sozzo Tegliacci on a large polyptych, now in the Galleria Nazionale, Siena, and these early works also strongly reflect elements of Niccolò's miniaturist style. His later painting demonstrates an interest in the work of Simone Martini.

53. ASSUMPTION OF THE VIRGIN, ca. 1355–60

University purchase from James Jackson Jarves. 1871.12.

Egg tempera on panel. 121.6 × 62.2 cm. (47⅞ × 24½ in.) excluding original frame. Restored 1915; cradled and restored 1929; cleaned, 1954.

CONDITION: Good, although damage by flaking is evident in the tomb and in the gold of the Virgin's mantle and the robes of some of the angels. Losses in the tomb have been indicated by slight inpainting. No other inpainting has been done.

PROVENANCE: James Jackson Jarves Collection, Florence. Formerly on an altar in the Oratorio dal Pedere Gazzaja near Arezzo (?) until 1818; in that year, the Bishop of Arezzo granted the owners permission to remove the panel to the private family chapel in Siena (according to a now lost record on the back of the panel, recorded by James Jackson Jarves).

EXHIBITIONS: New York "Institute of Fine Arts," 625 Broadway, 1860; Boston, Williams and Everett's Gallery, "Jarves's Collection of Old Masters," 1861–62; New-York Historical Society, 1863 (each time as Sienese school, ca. 1350).

BIBLIOGRAPHY: Jarves 1860, p. 46, no. 40 (as Sienese school, ca. 1350); Sturgis 1868, p. 40, no. 38 (as Sienese school, ca. 1350); F. M. Perkins, in *Rassegna d'arte,* 9 (1909), p. 145 (as Luca di Tommè); Sirén 1916, pp. 36–37 (as Luca di Tommè); Van Marle, 2 (1924), p. 481 (as Luca di Tommè); L. Venturi, pl. LXXXIV (as Luca di Tommè); Berenson 1932, p. 313 (as Luca di Tommè); M. Meiss, *Painting in Florence and Siena after the Black Death,* Princeton, 1951, and New York, 1964, pp. 21–24 (as Luca di Tommè); P. Toesca, *Il Trecento,* Turin, 1951, pp. 594–95 (as Niccolò Tegliacci and Lippo Vanni); F. Zeri, in *Paragone,* 9 (1958), p. 9 (as Luca di Tommè); M. Meiss, in *AB, 45* (1963), p. 48 (as Luca di Tommè); Berenson 1968, *1,* p. 225 (as Luca di Tommè, late).

The present dimensions of the panel and its superb gabled frame are original. Its subject, the Assumption of the Virgin, was a particularly popular one with the Sienese, for it depicts Mary in majesty both as Queen of Heaven, and as queen and patroness of their beloved Siena. One of the principal sources of Luca's *Assumption* was the *Caleffo dell'Assunta* by Niccolò di Ser Sozzo Tegliacci, today preserved in Siena's Archivio di Stato. Luca undoubtedly became acquainted with this work during his brief but fruitful partnership with Niccolò, which appears to have ended in 1363.

LUCA DI TOMMÈ

54. CRUCIFIXION AND SAINTS, ca. 1375*

Bequest of Maitland F. Griggs, B.A., 1896. 1943.246.

Egg tempera on panel. 27.3 × 201.1 cm. (10¾ × 81⅛ in.). Partially cleaned in 1967.

CONDITION: In the central section poor; elsewhere good. The frame and almost a third of the central panel are modern and repainted to imitate an old surface. Twenty-two inches of the panel at the l. extremity are left uncleaned as a record of the "restoration."

PROVENANCE: Ex-Canessa Collection (sale, New York, 1924) (as school of Simone Martini); whence it passed directly to the Maitland F. Griggs Collection, New York.

BIBLIOGRAPHY: F. M. Perkins, in *Rassegna d'arte senese, 17* (1924), p. 15 (as Luca di Tommè); R. Van Marle, in *La Diana,* 6 (1931), p. 170 (as Luca di Tommè); Berenson 1932, p. 313 (as Luca di Tommè); Berenson 1968, *1,* p. 225 (no change).

Despite problems of condition, the style of the panel is a good example of the master's late middle period. It may have been part of an altar now in Pisa. The saints from l. to r. are: St. Francis, the Virgin, St. John the Evangelist, St. Dominic.

LUCA DI TOMMÈ AND ASSISTANT (?)

55. MADONNA AND CHILD WITH SAINTS, ca. 1370–75*

Bequest of Maitland F. Griggs, B.A., 1896. 1943.245.

Egg tempera on panel. 61.7 × 49.7 cm. (24⁵⁄₁₆ × 19⁹⁄₁₆ in.). Cleaned in 1958.

CONDITION: The lower third, approximately, of the composition is missing. However, guide lines incised on the back of the panel for placement of original

supporting battens provide the necessary indication for the original height. A good deal of the original frame is present. The lower portion, about one third of the total height, has recently been extended in unfinished walnut. Surface condition, except for blue of Virgin's robe, is very good.

PROVENANCE: Maitland F. Griggs Collection, New York.

EXHIBITION: New York, Century Association, 1930.

BIBLIOGRAPHY: F. M. Perkins, in *Rassegna d'arte senese,* 17 (1924), p. 15 (as Luca di Tommè); Berenson 1932, p. 313 (as Luca di Tommè); Berenson 1968, *1,* p. 225 (as Luca di Tommè studio).

The painting appears to reflect the late middle period of the master's style when he was at the head of a thriving studio; on the basis of style alone, the intervention of an assistant seems likely here. The saint on the Virgin's right is possibly the warrior patron of the city of Siena, St. Victor; the one on her left, distinguished by the banner bearing the city's black and white device, is St. Ansanus, deriving from the left-hand lateral panel of the Simone Martini *Annunciation* in the Uffizi.

MARTINO DI BARTOLOMMEO (attributed to)

The painter was trained in Siena, but was at first active in Pisa and Lucca. He returned to Siena in 1408 and worked there until his death in 1434–35. Recorded also as painter of wood sculpture, in particular that of Jacopo della Quercia.

56. SAVIOR IN BENEDICTION, ca. 1410*

Gift of Maitland F. Griggs, B.A., 1896. 1942.322.

Egg tempera on panel. 38.9 × 39 cm. (15⁵⁄₁₆ × 15⅜ in.). Cleaned in 1964.

CONDITION: Good to excellent; the frame is original except for bottom edge.

INSCRIPTION: On the book, EGO SUM LUX MUNDI ET VIA VERITAS ET VITA QU[I] SEGUITUR ME NON AB[I]TANT (AMBULAT) I [N] TENEB [RIS SED HABEBIT LUMEN VITAE] (John 8:12; John 14:6, I am the Light of the

World and the Way, the Truth and the Life; he who follows me shall not live (walk) in darkness, but will have the light of life).

PROVENANCE: Maitland F. Griggs Collection, New York.

BIBLIOGRAPHY: Berenson 1968, *1*, p. 246 (as Martino di Bartolommeo).

This panel was probably originally the summit of a large crucifix.

MARTINO DI BARTOLOMMEO (attributed to)

57. EPISCOPAL SAINT; in gable above, FRANCISCAN MONK, ca. 1415*

Bequest of Maitland F. Griggs, B.A., 1896. 1943.252.

Egg tempera on panel. 155 × 41 cm. (61 × 16⅛ in.). Not cleaned.

CONDITION: Evidently fairly good, though surfaces have darkened and gilt has become dull. Elements of original framing are present.

PROVENANCE: Maitland F. Griggs Collection, New York.

BIBLIOGRAPHY: Berenson 1932, p. 333 (as Martino di Bartolommeo).

Belonged to same altarpiece as did 1943.253, below. Attributed verbally, in a lecture given in 1924 by Offner to the Florentine school, early 15th century, "out of the tradition of Bernardo Daddi." The present attribution is still tentative.

MARTINO DI BARTOLOMMEO (attributed to)

58. ST. CATHERINE, in gable above, DEACON SAINT, ca. 1415*

Bequest of Maitland F. Griggs, B.A., 1896. 1943.253.

Egg tempera on panel. 154.3 × 39.5 cm (60¾ × 15⁹⁄₁₆ in.). Cleaned 1968.

CONDITION: On the whole good; some scattered losses overall; some parts of original frame missing. PROVENANCE and BIBLIOGRAPHY: See above, 1943.252.

"MASTER OF CITTÀ DI CASTELLO"

The temporary name of this painter who was a follower of Duccio and Ugolino di Nerio da Siena was taken from his most impressive altarpiece now in the Pinacoteca Communale of Città di Castello—a small Tuscan center midway between Siena, Florence and Arezzo. The "Master of Città di Castello" was active in the first half of the Trecento. It is possible that he may be identified with Ugolino's younger brother and onetime assistant.

59. ST. PETER (?), ca. 1325

Bequest of Maitland F. Griggs, B.A., 1896. 1943.242.

Egg tempera on panel. 71.8 × 35.9 cm. (28¼ × 14⅛ in.). Cleaned, 1964.

CONDITION: Good; some losses throughout from earlier blistering. A modern repainted strip was removed from the bottom of the panel, and part of the arched frame discovered also to be modern was removed. The keys which the saint held in the uncleaned state were found to be a modern addition.

PROVENANCE: Duke of Turin (?) (from Griggs records); Maitland F. Griggs Collection, New York; acquired before 1925.

EXHIBITIONS: New Haven, Yale University, Gallery of Fine Arts, 1926 (as "Master of Città di Castello"); New York, Century Association, 1930 (as follower of Ugolino da Siena).

BIBLIOGRAPHY: R. Van Marle, in *Rassegna d'arte senese, 19* (1926), p. 4 (as Ugolino da Siena); R. Offner, in *Y.U.A.G. Bulletin, 1* (1926), p. 5 (as "Master of Città di Castello"); Berenson 1932, p. 344 (as "Master of Città di Castello"); C. Brandi, *Duccio,* Florence, 1951, p. 149 (as "Master of Città di Castello"); S. A. Fehm, in *Y.U.A.G. Bulletin, 31* (1967), pp. 17–27, also translated into Danish in *Meddelelser fra Ny Carlsberg Glyptothek, 24* (1961); L. Vertova, in *BurlM, 109* (1967), pp. 668–71 (the last three as "Master of Città di Castello"); Berenson 1968, *1,* p. 249 (as "Master of Città di Castello"; companion to *St. Francis* in the Lanckoronski Collection, Vienna).

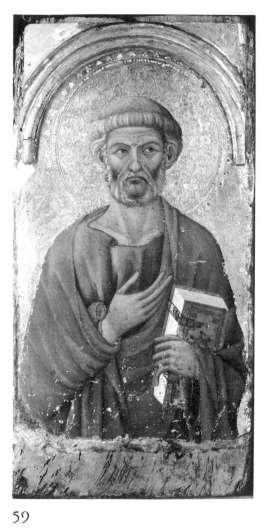

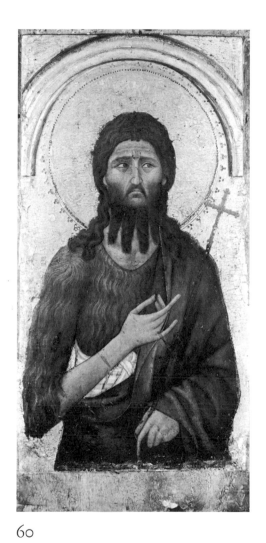

59

60

One of a pair of saints now in the Yale collections (see also, below 1943.243).
According to research by S. A. Fehm (see above) the Yale panels together
with the earliest *Madonna* now belonging to the Ny Carlsberg Glyptothek in
Copenhagen and still another panel in Vienna recently published by L. Ver-
tova belonged to the same altarpiece. Fehm's reconstruction calls for a central
Madonna flanked on either side by two saints, and so far this arrangement seems
to be borne out as the most likely one. This altarpiece, which need not have
been made for a church in Città di Castello, but might equally well have been
destined for a church in Siena, appears to have been one of the painter's most
ambitious projects.

"MASTER OF CITTÀ DI CASTELLO"

60. ST. JOHN THE BAPTIST, ca. 1325

Bequest of Maitland F. Griggs, B.A., 1896. 1943.243.

Egg tempera on panel. 72.4 × 35.7 cm. (28½ × 13⅞ in.). Not cleaned.

CONDITION: Evidently good, apparently quite similar to that of its companion
1943.242, above. The modern additions to the surface as well as to the framing
have been left intact for comparison with 1943.242 in its cleaned condition.

PROVENANCE, EXHIBITIONS, and BIBLIOGRAPHY: See above, 1943.242.

"MASTER OF THE OVILE MADONNA" ("Ugolino Lorenzetti")

Temporary name for an anonymous master whose style lies between that of
Ugolino da Siena and the Lorenzetti. The reconstruction of his oeuvre by
Berenson (who provided the name "Ugolino Lorenzetti") differs slightly from
that of DeWald (who proposed the name "The Master of the Ovile Madonna"
from a painting in San Pietro d'Ovile, Siena). The name "Master of the Fogg
Nativity" is also sometimes given to this artist.

61. MADONNA AND CHILD ENTHRONED WITH TWO ANGELS, ca. 1340*

Bequest of Maitland F. Griggs, B.A., 1896. 1943.244.

Egg tempera on panel. 69 × 60.2 cm. (27$\frac{3}{16}$ × 23$\frac{11}{16}$ in.). Cleaned in 1959.

CONDITION: Poor; only the upper half of the composition is present; there are numerous losses, particularly in the blues.

PROVENANCE: Maitland F. Griggs Collection, New York; acquired from Durlacher Brothers, New York, ca. 1923.

BIBLIOGRAPHY: E. T. DeWald, in *Art Studies, 1* (1923), p. 52 (as "Master of the Ovile Madonna"); L. Venturi, pl. LXXI (as "Ovile Master"); Berenson 1968, *1,* p. 435 (as "Ugolino Lorenzetti"; companion to Pisa Museum panel, Ss. Michael, Agatha, Catherine and Bartholomew). (Note: the sometimes cited reference in Berenson 1932, p. 293, does not appear to apply to 1943.244.)

This picture formed part of the central panel of a now dispersed polyptych which may have included four panels containing images of saints at present in the Museo Nazionale di S. Matteo, Pisa. The type of the Madonna may be reintegrated from the large enthroned *Madonna* (Alinari 36616) in the Siena Pinacoteca.

NICCOLÒ DI SEGNA (attributed to)

Active in Siena in the first half of the Trecento. In 1331 a document proves he was by then an independent painter. He had previously assisted his more famous father, Segna di Bonaventura.

62. MADONNA AND CHILD, ca. 1330–35

Gift of Hannah D. and Louis M. Rabinowitz. 1959.15.17.

Egg tempera on panel. 106.2 × 71.4 cm. (45¾ × 28⅛ in.). Cleaned in 1955 and 1968.

CONDITION: Only fair; a deep separation occurs on both l. and r. sides of the central group; losses of gilt and of pigment in the areas surrounding the figures of the saints, particularly on the r. The frame is modern.

PROVENANCE: Monastery of Sant' Eugenio, near Siena, until about 1912; Dan Fellows Platt Collection, Englewood, New Jersey; Hannah D. and Louis M. Rabinowitz Collection, Sands Point, Long Island.

EXHIBITIONS: Washington, D.C., Phillips Memorial Gallery, "Functions of Color," 1941; New York, E. and A. Silberman Galleries, 1955.

BIBLIOGRAPHY: B. Berenson, *Central Italian Painters of the Renaissance,* New York and London, 1897, p. 163 (as Duccio); C. H. Weigelt, *Duccio,* Leipzig, 1911, p. 190 (as possibly Segna di Bonaventura); F. M. Perkins, in *AiA, 8* (1920), p. 199 (as school of Duccio); Van Marle, 2 (1924), p. 143 (as follower of Segna di Bonaventura); C. H. Weigelt, *Sienese Painting of the Trecento,* New York, 1930, p. 72 (school of Duccio); L. Venturi, pl. XXIII (as follower of Duccio); Berenson 1932, p. 523 (as Segna di Bonaventura); G. H. Edgell, *A History of Sienese Painting,* New York, 1932, p. 64 (as a contemporary of Ambrogio Lorenzetti); *Rabinowitz Coll.* 1945, pp. 1–2 (as follower of Duccio); *Rabinowitz Coll.* 1961, pp. 7, 11, as (Niccolò di Segna ?); Berenson 1968, *1,* p. 393 (as Segna di Bonaventura).

Niccolò di Segna's documented *Madonna and Child* in the Chapel of S. Galgano at Monte Siepi, near Siena (1336) and the signed and dated *Crucifix* in the Pinacoteca Nazionale, Siena (1345), form the basis for the present attribution. Although this majestic panel has in the past been attributed to Duccio or to his school the *Madonna* represents a strain of painting in Siena quite different from Duccio's. The artist, very possibly Niccolò di Segna, inherited many of Segna di Bonaventura's stylistic conventions, while the human aspect of representing the Madonna nursing the Child reflects an idea popularized in Siena by Ambrogio Lorenzetti in his *Madonna del Latte* of about 1330 in S. Francesco, Siena. The small-scale lateral saints can be identified as follows: l., SS. Ambrose (a bishop with flagellum) and Mary Magdalen; r., possibly SS. James the Less and Mary of Egypt (?).

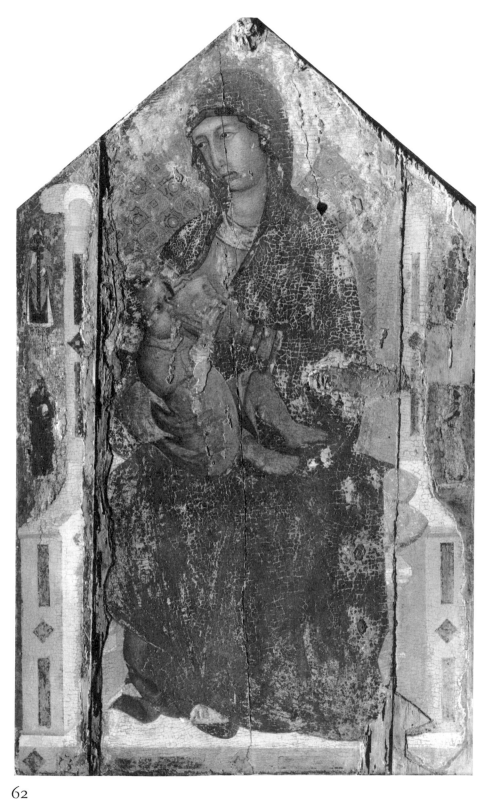

62

SIENESE SCHOOL (following of Simone Martini?), mid-XIV century

63. BUST OF A DEACON SAINT, ca. 1350*

Acquired by exchange for the Griggs Collection. 1945.250.

Fresco. 32.4 × 60 cm. (12¾ × 23⅝ in.). A fragment.

CONDITION: Poor; much rubbed.

PROVENANCE: Vicomte Henri de Saint-Levé d'Aguerre, Paris; Alphonse Kann, Paris; Brummer Gallery, New York; acquired from Joseph Brummer in 1945.

BIBLIOGRAPHY: Unpublished.

The early history of the painting is not known, but it is believed to have been for some time in the possession of the Vicomte de Saint-Levé whose family originated in the south of France in Aguerre. Perhaps the fragment came originally from Provence and may have been part of a larger ensemble such as that painted by Simone Martini and followers in Notre Dame des Doms, Avignon. According to information provided by Joseph Brummer in 1945 (*in litteris*) the fragment while in France was always attributed to Simone Martini.

SIENESE SCHOOL (BARNA DA SIENA?)

A mysterious Sienese painter, evidently at first a follower of Simone Martini and Lippo Memmi, Barna da Siena is prominently mentioned by Vasari though not known directly through documents of his time. He was responsible, with assistance, for decoration of one wall of the nave of the Collegiata in S. Gimignano on which today all attributions to his hand must largely be based. This personal style, mingling expressive characterization with great elegance and fluidity of line, makes of Barna, whoever he may have been, one of the four or five greatest masters of the Sienese Trecento.

64. ST. JOHN THE EVANGELIST, ca. 1340–45

Bequest of Maitland F. Griggs, B.A., 1896. 1943.239.

Egg tempera on panel. 104.9 × 44.6 cm. (41½ × 17⁹⁄₁₆ in.). Cleaned 1960.

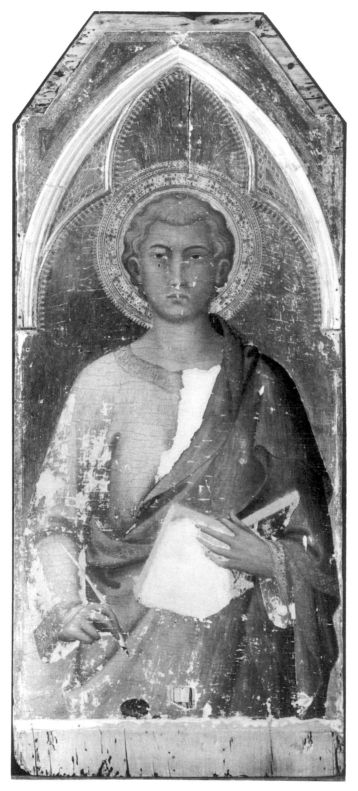

64

CONDITION: Except for glaring losses in drapery of chest and book held in l. hand, it must be said to be reasonably good. Scattered losses are found in the r. arm drapery and one small loss over the r. eye; a deep crack runs longitudinally down into the halo and head near the center of the central lobe of the panel's arch. Upper elements of the Gothic frame with ornamental motives in red, blue and remains of silver foil are still present. At least an inch, however, perhaps more, of the gesso and paint surface at the base is missing; this area of the panel must have been in some part covered by the original frame, probably with an inscription identifying the subject, as is normal in fully preserved altarpieces of this date in Sienese art.

PROVENANCE: Believed to have come from the high altar of the Vallombrosan Church of S. Paolo a Ripa d'Arno in Pisa; Giulio Sterbini, Rome; Mrs. Benjamin Thaw, New York (sale, Galerie Georges Petit, Paris, 1922); Lord Duveen of Millbank; from him by purchase (before 1925) to Maitland F. Griggs, New York.

EXHIBITIONS: New York, Kleinberger Galleries, "Italian Primitives," 1917; New York, Century Association, 1930; New York, World's Fair, 1939; Boston, Museum of Fine Arts, "Arts of the Middle Ages," 1940 (all as Simone Martini).

BIBLIOGRAPHY: A. Venturi, in *L'Arte, 8* (1905), p. 426 (as Simone Martini); Van Marle, 2 (1924), pp. 173, 184, 185, 186 (as Simone Martini); L. Venturi, pl. XVI (as Simone Martini); Berenson 1932, p. 534 (as Simone Martini); F. Zeri, in *BurlM, 94* (1952), p. 321 (as Lippo Memmi); C. Volpe, in *Arte antica e moderna, 10* (1960), pp. 150, 157 (as Lippo Memmi); G. Coor-Achenbach, in *Pantheon, 19* (1960), pp. 126 ff. (as Lippo Memmi [?]); F. R. Shapley, *Paintings from the Samuel H. Kress Collection, Italian Schools, XIII–XV Century,* London, 1966, p. 49 (as Memmi or Memmi and assistant); Berenson 1968, *1,* p. 269 (as Lippo Memmi).

Besides the Yale picture a number of panels possibly from the same altarpiece have been recognized in the Louvre, Metropolitan Museum of Art, the National Gallery of Art, Siena Pinacoteca, the Douai Museum, and the Lindenau Museum in Altenburg; the original central Madonna has more tentatively been

identified with one in the German State Museum in Berlin-Dahlem. It is generally thought today that the panels of saints were originally parts of the high altar of the Vallombrosan (Benedictine) Church of S. Paolo a Ripa d'Arno in Pisa, which Vasari states in his *Life* of Simone Martini was signed by Simone's close associate, Lippo Memmi.

Whether this would entail an attribution of our *St. John Evangelist* to Memmi is problematical. Collaboration was far more the rule than the exception in large altarpieces of this kind. Memmi's own hand has been doubted for our *Evangelist* (see Coor-Achenbach above), and this was the final unpublished opinion of Richard Offner (made verbally to Michael Mallory, then an honors student in art history at Yale). Oertel (in *Frühe italienische Malerei in Altenburg,* 1961) tentatively attributed three smaller panels of saints to a follower of Barna, and LaClotte also thought of Barna in connection with the associated Douai *Christ Blessing* (*De Giotto à Bellini,* Musée de l'Orangerie, Paris, 1956, p. 2).

On stylistic grounds, and for reasons of outstanding quality in the preserved portions, Barna's name may legitimately be raised in relation to the Griggs-Yale *Evangelist.* The attribution is provisionally made here. It implies that the young Barna was one of a team of artists who worked with Memmi. The beautiful *Madonna* from Lucignano, now Pinacoteca, Siena, is perhaps the closest of all extant Madonnas on panel to the style of our *Evangelist.* Interestingly enough, Carli has recently and quite independently related the Lucignano panel to Barna (in *Paragone, 14* (1963), pp. 34–35). In the light of continuing scholarly research, the question of the authorship of the Yale *Evangelist* must be regarded as still unsettled.

SIENESE SCHOOL (attributed to)

65. CHRIST AS MAN OF SORROWS, roundel in the crowning member of a picture frame, ca. 1400*

Gift of Dr. Lillian Malcove. 1960.71.

Egg tempera on wood. Diameter of roundel, 14.6 cm. (4¾ in.). Cleaned 1968.

CONDITION: Good; small cracks across the body of Christ.

PROVENANCE: Dr. Lillian Malcove, New York.

BIBLIOGRAPHY: Jerrold Ziff, in *AB, 39* (1957), p. 138, n. 1; illustration on page facing.

Although possibly painted during the early years of the 15th century, stylistically the roundel more strongly suggests the Trecento. It is accordingly placed in the 14th century section of the present catalogue.

A panel to which the frame was attached, a St. John the Evangelist attributed to Andrea Vanni, is now in the Fogg Art Museum, Cambridge, Massachusetts.

TADDEO DI BARTOLO

He was the pupil of Bartolo di Fredi whom, with Paolo di Giovanni Fei, he succeeded as the dominant force in Sienese painting of the first quarter of the Quattrocento. Born ca. 1362; died 1422.

66. ST. JEROME, ca. 1390

Bequest of Maitland F. Griggs, B.A., 1896. 1943.250.

Egg tempera on panel. 55.8 × 36 cm. (22 × 14³⁄₁₆ in.). Left uncleaned in earlier restored state.

CONDITION, PROVENANCE, and BIBLIOGRAPHY: See below, 1943.251.

TADDEO DI BARTOLO

67. ST. JOHN THE BAPTIST, ca. 1390

Bequest of Maitland F. Griggs, B.A., 1896. 1943.251.

Egg tempera on wood panel. 56 × 36 cm. (22¹⁄₁₆ × 14³⁄₁₆ in.). Cleaned in 1966–67.

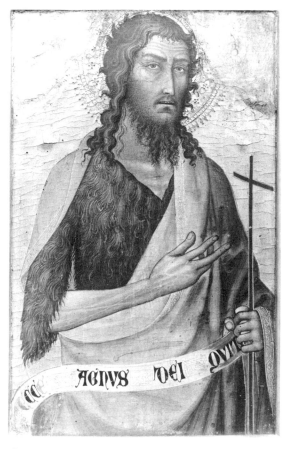

67

66

CONDITION: Fair to good; losses in gold background at upper r. and l.; the arched top of the panel at one time removed so that the halo is truncated at top of head. It is impossible to state whether figure was originally half- or full-length. Where preserved the surface is in very good state.

PROVENANCE: Maitland F. Griggs Collection, New York.

BIBLIOGRAPHY: Berenson 1932, p. 522 (as early Taddeo di Bartolo); F. M. Perkins, in U. Thieme and F. Becker, *Allgemeines Lexikon der bildenden Künstler,* Leipzig, 1938, *32,* p. 396 (as Taddeo di Bartolo); S. Symeonides, *Taddeo di Bartolo,* Siena, 1965, pp. 34, 196–97 (as early Taddeo di Bartolo); Berenson 1968, *1,* p. 420 (as Taddeo di Bartolo, early).

Belonged to same altarpiece as did our 1943.250 above.

TADDEO DI BARTOLO (with assistance?)

68. CHRIST AS SAVIOR, ca. 1410*

Bequest of Maitland F. Griggs, B.A., 1896. 1943.249.

Egg tempera on wood panel. 66.2 × 34.8 cm. (26⅟₁₆ × 13¹¹⁄₁₆ in.). Cleaned in 1951.

CONDITION: Fair; much rubbed. A deep longitudinal crack running from the top of the panel into the head of Christ has been filled.

INSCRIPTION: On book, EGO SUM VIA ET VERITAS ET VITA (John 14:6, I am the way, the truth and the life).

PROVENANCE: Maitland F. Griggs Collection, New York; acquired from Edward Hutton, in England, 1923.

EXHIBITION: New York, Century Association, 1930.

BIBLIOGRAPHY: R. Van Marle, in *La Diana, 6,* p. 172 (as Taddeo di Bartolo); Berenson 1968, *1,* p. 420 (as Taddeo di Bartolo).

The composition recurs frequently in the oeuvre of Taddeo di Bartolo; there is likely to be a good deal of shopwork in such panels.

Umbrian School

TUSCAN OR UMBRIAN SCHOOL, XIV century

69. RESURRECTION (in the initial letter *A*), manuscript illumination, ca. 1340

Gift of Robert Lehman, B.A., 1913, in the name of Mr. and Mrs. Albert E. Goodhart. 1954.7.1.

Body color and gilt on parchment. Illuminated page from a choir book. 56.4 × 39.8 cm. (22¾₆ × 15¹¹⁄₁₆ in.).

CONDITION: Good; but has been somewhat repainted since it was reproduced in 1904 (see discussion below).

PROVENANCE: Stated in 1925 to have come originally from the Convento S. Niccolò, Pisa, then the Pinacoteca, Pisa, for a time and Enrico Righi, Siena; Lehman Collection, New York (acquired in Paris, 1953).

EXHIBITIONS: "Arte antica a Siena," Siena, 1904; New London, Lyman Allyn Museum, 1959; Hartford, Wadsworth Atheneum, "Exhibition . . . in Honor of Richard Offner," 1965.

BIBLIOGRAPHY: P. d'Ancona, in *L'Arte* (1904), p. 381 (as Sienese school); C. Lupi, in *L'Arte antica senese* (1904), pp. 398, 425 (as Sienese school in Pisa); Van Marle, 5 (1925), pp. 277–78 (Pisan under strong Sienese influence); S. Wagstaff, catalogue, *An Exhibition of Italian Panels and Manuscripts from the Thirteenth to the Fourteenth Centuries in Honor of Richard Offner,* Hartford, Wadsworth Atheneum, 1965, pp. 51–52 (as Pisan).

This page has been somewhat cut down; the illuminations comprise (1) the

69

initial A and (2) some grotesque figures influenced by northern Gothic art in the rather elaborate floral ornament. The page is from an antiphonary and the words and notes are those indicated for the beginning of the Response after the First Lesson for the Office of Matins of Easter Sunday.

The problem of attribution is complex and by no means settled today. Van Marle (see above) believed the page to have belonged to a group of choral books that originated in the monastery (Convento) of S. Niccolò in Pisa; but the details of the provenance evidently do not prove conclusively a Pisan origin. The page as a whole is closest in style to a page from an antiphonary again with an initial A, but depicting Christ Enthroned rather than the Resurrection, now in the Cleveland Museum of Art. This has been catalogued as "Florentine, ca. 1350," though the basis for such a classification is not at all clear; for an illustration, see W. M. Milliken, *Pages from Medieval and Renaissance Illuminated Manuscripts from the X to the XVI Centuries,* Berkeley, 1963, p. 21. Mirella Levi d'Ancona has recently expressed her view that the page is Pisan and close to Traini (verbally to Wagstaff in 1965—see above). Millard Meiss has, on the other hand, given verbally to the compiler his opinion that the style could well be that of a Sienese miniaturist working in Umbria rather than close to Traini in Pisa. In view of his extensive work on Traini, this opinion of Meiss is striking and is retained here as a strong possibility for further study.

UMBRIAN SCHOOL

70. Processional Cross, CRUCIFIXION AND SAINTS, ca. 1300

Bequest of Maitland F. Griggs, B.A., 1896. 1943.238.

Egg tempera on panel. 51.8 × 37.5 cm. (20⅜ × 14¾ in.). Recently cleaned.

CONDITION: Excellent; what appears to be the face is in better condition, with fewer losses than the opposite side. The crucifix is painted with virtually identical motifs on both face and reverse.

PROVENANCE: Maitland F. Griggs Collection (see below), New York; acquired in Paris, 1926.

70a

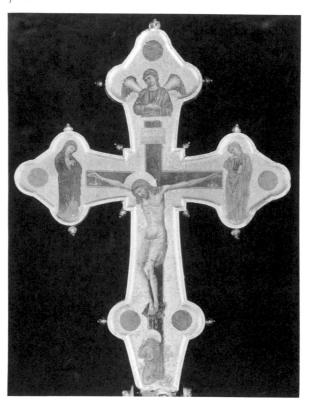

70b

BIBLIOGRAPHY: Berenson 1932, p. 141 (as follower of Cavallini); Berenson 1968, *1*, p. 83 (as Cavallini follower influenced by Duccio); Garrison 1949, 448, p. 178 (as "Processional Cross Master," northern Umbrian); F. Bologna, *Early Italian Painting; Romanesque and Medieval Art,* Princeton, New Jersey, 1964, p. 96 (as "Processional Cross Master").

According to information given verbally by Maitland Griggs, this rare example of a painted processional crucifix was believed by Offner to be Sienese, datable to very early in the 14th century. The saints at the base of the cross on both sides wear Franciscan habits (probably SS. Francis and Clara); the commission must have been for a Franciscan establishment, possibly in Assisi. Garrison ascribes the cross to an artist "trained in the Assisi ambient," whom he calls the "Processional Cross Master," active in the northern Umbrian region of Perugia and Assisi and showing strong Cimabuesque and Cavallinesque features. Ferdinando Bologna, accepting this attribution, points to evidence of influence of Umbrian miniaturists (of Deruta and Salerno). A cross similar to the Griggs-Yale example but more Giottesque and slightly later in style, is in the Cleveland Museum of Art. Closer in style to the Griggs-Yale cross is the double faced processional cross with *Flagellation* and *Crucifixion* in the Galleria Nazionale dell'Umbria, Perugia. This was confirmed in a recent study by Gerda Kunkel, Case-Western Reserve University.

North Italian Schools

SIMONE DEI CROCEFISSI

Simone di Filippo di Benvenuto is mentioned in documents from 1355 to 1399. As his nickname indicates he was famous in his day for his emotional, warmly colored interpretations of the Passion, particularly devotional panels of the Crucifixion. He was a follower of Vitale da Bologna, and was a leader of Bolognese painting in the second half of the 14th century.

71. CRUCIFIXION AND CORONATION OF THE VIRGIN, ca. 1370

Gift of Hannah D. and Louis M. Rabinowitz. 1959.15.3.

Egg tempera on panel. 57.1 × 66.8 cm. (22½ × 26⁵⁄₁₆ in.). Not cleaned.

CONDITION: Only fair. The panel has evidently been considerably repainted; in particular the upper portions of the Christ on the Cross, the robe of the Virgin and several of the busts of Christ and the apostles in a row below the main scenes.

INSCRIPTION: On cross, I. N. R. I.; much restored.

PROVENANCE: Rabinowitz Collection, Sands Point, Long Island.

BIBLIOGRAPHY: *Rabinowitz Coll.* 1945, pp. 9–10 (as Simone dei Crocefissi); *Rabinowitz Coll.* 1961, p. 52 (no change).

"DALMASIO" (attributed to)

"Dalmasio" (Dalmasio di Jacopo Scannabecchi) is the name given by scholars to a shadowy but evidently extremely gifted Bolognese painter, apparently

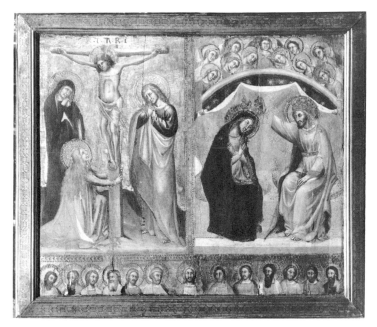

71

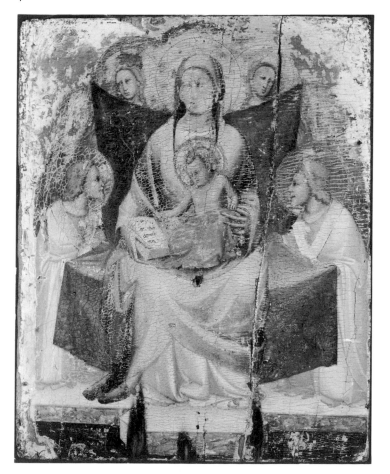

72

trained in Bologna under the influence of Giotto or Giotto's immediate follow-
ing. Born ca. 1325(?), he may have died as early as ca. 1375 (his will was made
in 1373.) His only surviving recorded commission (1359) is for a painting
done for S. Giovanni Fuorcivitas in Pistoia. Evidently he had a bottega in Pi-
stoia as well as in Bologna. Brother-in-law of the Bolognese artist Simone dei
Crocefissi (see preceding entry), his work has often been confused until recently
with that of his more famous, slightly older contemporary Vitale da Bologna.

72. MADONNA AND CHILD WITH ANGELS, ca. 1340 (?)

Bequest of Maitland F. Griggs, B.A., 1896. 1943.260.

Egg tempera on panel. 51.1 × 40 cm. (20⅛ × 15¾ in.). Cleaned 1964–67.

CONDITION: Poor, much rubbed; a vertical crack extends down the whole r.
side of the panel, and this has been plugged on the reverse with a new strip of
wood let into the original wood. There are no less than three disfiguring
scars from candle burns in the lower central portion of the face of the panel.
The entire surface had been extensively repainted; the repaints have been re-
moved, but no effort has been made to inpaint the losses. Cleaning has revealed
that the summit of the panel was originally a polylobed arch.

INSCRIPTION: On book held by Virgin, largely illegible, but the words DOMIN
. . . and ME . . . appear on two separate lines of the left-hand page.

PROVENANCE: Maitland F. Griggs Collection, New York; acquired in Italy,
1926.

EXHIBITIONS: New York, Century Association, 1930 (as Romagnole Mas-
ter, Bologna ca. 1350); Bologna, "Mostra della Pittura Bolognese del '300,"
1950 (as "Dalmasio").

BIBLIOGRAPHY: R. Longhi, in catalogue, *Mostra della Pittura Bolognese del
'300,* Bologna, 1950, pp. 15, 29 (as "Dalmasio"); R. Longhi, in *Paragone,*
I (1950), pp. 11–13 (as "Dalmasio"); W. Suida, *European Paintings from
the Samuel H. Kress Collection,* Seattle Art Museum, 1954, p. 22 (as "Dal-
masio").

Despite its poor condition, this painting reveals the hand of a distinguished master. The composition possesses a monumentality and suggestion of scale far beyond the modest proportions of the actual panel; the drawing of the figures is sure, the drapery style fully plastic yet detailed, the color scheme delicate. If by "Dalmasio," as it clearly appears to be, this *Madonna with Angels* is far more Tuscan in style than the *Crucifixion* in the Bologna Pinacoteca and the almost caricatural *Flagellation* in the Kress Collection in the Seattle Art Museum, both of which are key works in "Dalmasio's" oeuvre as currently reconstructed. The unusual dignity of the Yale panel's style bespeaks a phase of strong Tuscan influence which ultimately derives from Giotto. Whether "Dalmasio" ever had first hand contact with Giotto is open to question. But the question is in itself a serious one. It may serve to open up stronger hypotheses on the various phases of the artist's career; and it may lead to a fruitful consideration of "Dalmasio's" relationship to the altarpiece designed by Giotto, but mainly executed by assistants which is now in the Pinacoteca at Bologna. It is possible that the young "Dalmasio" was one of those Bolognese assistants, but this bit of speculation is offered at the moment with all possible warning to the unwary.

BOLOGNESE SCHOOL, XIV century

73. MADONNA AND CHILD (in the initial letter *C*), manuscript
 illumination, ca. 1340*

Purchased, on the Maitland F. Griggs Fund, in Florence. 1955.27.4.

Body color and gilt on parchment. Page from a manuscript (choral book). 48.6 × 35.5 cm. (19⅛ × 14 in.).

CONDITION: Excellent.

PROVENANCE: Bruscoli, Florence, 1955.

BIBLIOGRAPHY: Unpublished.

Other pages evidently from the same manuscript were acquired shortly after 1955 by the Coggeshall family from Kraus (New York).

SCHOOL OF RIMINI, first half XIV century

74. SCENES FROM THE LIVES OF CHRIST AND ST. JOHN THE
 BAPTIST, ca. 1330 (?)

University purchase from James Jackson Jarves. 1871.9.

Egg tempera on panel; gabled tabernacle triptych with shutters. 45.3 × 67.9
cm. (17⅞ × 26¹¹⁄₁₆ in.) overall. Cleaned 1965–68.

CONDITION: On the whole good; damage is mainly losses in gilt and silver foil
and from some rubbing of pigment.

PROVENANCE: James Jackson Jarves Collection, Florence.

EXHIBITIONS: New York "Institute of Fine Arts," 625 Broadway, 1860; New-
York Historical Society, 1863 (both times as unknown Italian painter, 12th
century).

BIBLIOGRAPHY: Jarves 1860, p. 42 (as unknown Italian painter, 12th cen-
tury); Sturgis 1868, p. 9 (as unknown Italian painter, 12th century); Sirén
1916, pp. 29–30 (as Romagnole follower of Giotto); Offner 1927, pp. 41–
42 (as Romagnole Master); Van Marle, 4 (1924), p. 298 (as Riminese after
a series by Cavallini); Garrison 1949, 345, p. 131 (as Umbrian or Marchigian
with North Umbrian influence, 1320–30).

The closest analogy in style to this tabernacle is the small gabled panel with five
scenes attributed to the school of the Marches now in the Lehman Collection,
New York. The Jarves-Yale panel, while perhaps more elaborate in its ico-
nography, is nonetheless distinctly more provincial in style where manuscript
influence is also apparent. Ultimately, the sources for the imagery of the scenes
appear to go back in the main to Umbria and Assisi. The appearance of scenes
from the Life of St. John the Baptist relates the tabernacle to a regional group
isolated as Romagnole or Marchigian by both Coletti and Brandi (L. Coletti,
I Primitivi, etc., Novara, 1947, p. 18; C. Brandi, *Mostra della pittura riminese
del trecento* [catalogue], Rimini, 1935, p. 23); one of these, a small predella
(?) panel with the Beheading of the Saint, Dance of Salome and Herod's Feast
is in the Lehman Collection, New York.

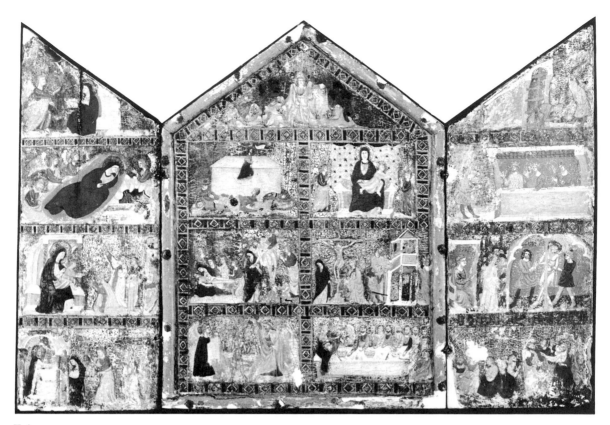

74

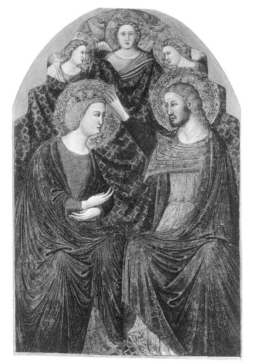

75

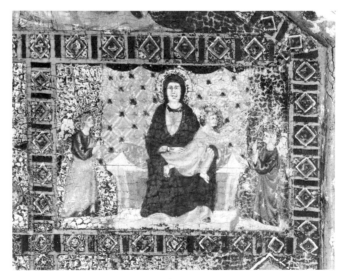

74, detail

SCHOOL OF RIMINI ("Master of the Life of St. John the Baptist"?)

75. CORONATION OF THE VIRGIN, ca. 1350

Gift of Hannah D. and Louis M. Rabinowitz. 1959.15.14.

Egg tempera on panel. 93.7 × 58.8 cm. (36⅞ × 23⅛ in.). Not cleaned.

CONDITION: Fair only. The surface has been considerably repainted overall.

PROVENANCE: Richard M. Hurd Collection, New York; Rabinowitz Collection, Sands Point, Long Island.

BIBLIOGRAPHY: Berenson 1932, p. 44 (as Giovanni Baronzio); *Rabinowitz Coll.* 1961, p. 55 (as school of Rimini); Berenson 1968, *1,* p. 363 (as Giovanni Baronzio da Rimini, "Hurd Coronation").

The change of attribution from Baronzio to school of Rimini is in line with recent scholarship on Baronzio, who was only one of a number of 14th-century painters working in and around Rimini in much the same style, in large part derivative from Giotto. Acc. No. 1959.15.14 is closest in style to the anonymous Riminese "Master of the Life of St. John the Baptist" (see F. R. Shapley, *Paintings from the Samuel H. Kress Collection, Italian Schools, XIII–XV Century,* London, 1966, pp. 68–69; especially fig. 184).

Venetian School

PAOLO VENEZIANO

He appears today in the light of history as the most influential Venetian painter of the 14th century. He was active ca. 1325–58. His style remains true to Byzantine precepts though it is evident that he was consciously breaking away from them. He was active as a designer of mosaics for S. Marco and, as a painter, headed a large and evidently flourishing bottega.

76a,b. ST. MARY MAGDALEN and ST. JOHN THE BAPTIST, ca. 1335

Gift of Hannah D. and Louis M. Rabinowitz. 1959.15.4a,b.

Egg tempera on panel. Magdalen, 58.3 × 24 cm. ($22^{15}/_{16}$ × $9^{7}/_{16}$ in.); St. John, 59 × 23.2 cm. ($23\frac{1}{4}$ × $9\frac{1}{8}$ in.). Both cleaned, 1959.

CONDITION: On the whole good; some loss of pigment along horizontal cracks in both panels; these cracks have been filled and inpainted. The wood in each panel has been planed down for modern cradling; the cradling members have been removed and the horizontal cracking has been stabilized for the time being.

INSCRIPTIONS: St. Mary Magdalen, MARIA M̄, in red to right of head; St. John, remains of name in red to right of head; on scroll, in black, ECCE AGNV(S) DEI . ECCE QUI TOL (L)IS PEC(C)ATA (MUNDI).

PROVENANCE: Said to have come from the Museo Guidi in Faenza; Rabinowitz Collection, Sands Point, Long Island.

BIBLIOGRAPHY: *Rabinowitz Coll.* 1945, pp. 11–12 (as Paolo Veneziano); Berenson 1957, *1,* p. 128; *Rabinowitz Coll.* 1961, pp. 14–15.

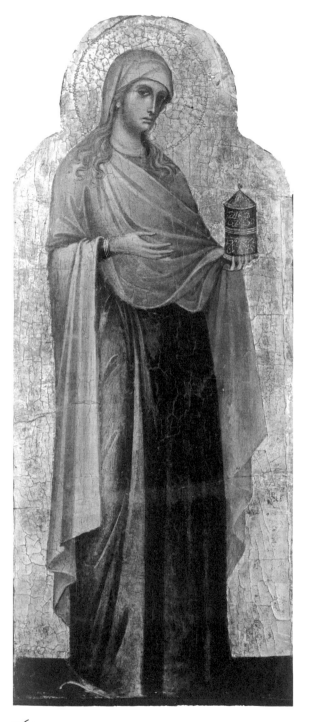

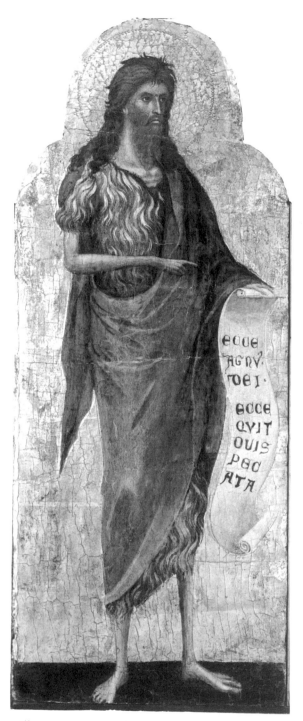

76a

76b

These two beautiful panels are excellent examples of the haunting early attempts on the part of Paolo Veneziano and his associates to establish a local Venetian mode based on the Byzantine. Elements of Byzantine style are evident in the elongated, emaciated types, particularly that of the St. John. But the inscriptions have changed from Greek to Latin, and the line has more tension and elasticity than that one usually finds in 14th-century Byzantine panel icons. The altarpiece to which the two panels now at Yale originally belonged has not as yet been reconstructed by scholars, but the literature contains a considerable number of parallel representations of the saints (St. John in the Worcester Museum polyptych, in the Lehman Collection, New York [fragment], and in the S. Severino polyptych). The Magdalen type appears in the Chioggia polyptych given to Paolo (half figure). The blue and white faience jar held by the Magdalen is decorated with a Kufic inscription and must represent a Near Eastern importation.

XV–EARLY XVI CENTURY

Florentine School

"PSEUDO–AMBROGIO di BALDESE" (?) AND ASSISTANTS

The artist's name is not known; he is considered to have been a close associate, if not the identical personality, of the painter Ambrogio di Baldese who is recorded in partnership with Niccolò di Pietro Gerini in connection with frescoes in the Bigallo in Florence. These frescoes, now preserved in the interior of the Bigallo, are dated by style as in the early years of the 15th century and show the influence of Agnolo Gaddi.

77. MADONNA ENTHRONED WITH SAINTS; l. wing, SS. PETER AND ALBERT; r. wing, SS. PAUL AND ANTHONY ABBOT; 1420 (?)

University purchase from James Jackson Jarves. 1871.22.

Egg tempera on panel. 218.4 × 251.4 cm. (86 × 99 in.) including frame (modern). Restored partially 1915; restored 1928; cleaned, 1950–52.

CONDITION: In general good. The robe of the Madonna has suffered a great deal and the paint surface in that area is subject to severe blistering; the remainder, however, is in good to excellent condition.

PROVENANCE: James Jackson Jarves Collection, Florence; reported to have been purchased from the Convent of S. Martino alle Selve at Signa, near Florence.

EXHIBITIONS: New York "Institute of Fine Arts," 625 Broadway, 1860; New-York Historical Society, 1863 (both times as school of Siena); Y.U.A.G. "Rediscovered Italian Paintings," 1952 (as attributed to Ambrogio di Baldese).

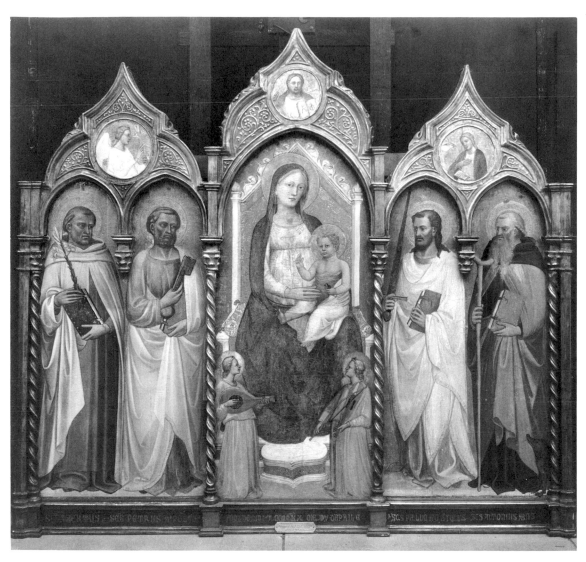

77

BIBLIOGRAPHY: Jarves 1860, p. 46 (as school of Siena); Sturgis 1868, p. 29 (unknown Sienese painter); Jarves 1871, p. 13 (as the same); O. Sirén, *BurlM*, *14* (1909), p. 326 (as Ambrogio di Baldese); Sirén 1916, pp. 57–60 (as the same); Offner 1927, pp. 19–20 (as follower of Agnolo Gaddi); Berenson 1932, p. 195 (as so-called Baldese); Berenson 1963, *1*, p. 219 (as the same).

A small Madonna and Child by the same hand as that responsible for the central panel of this large Triptych is in the Worcester Art Museum where it has recently been catalogued by Martin Davies as "ascribed to the 'Pseudo-Ambrogio di Baldese' (?)." The Yale panels are not homogeneous as to style; in addition to the master of the central panel, one painter did the saints to the l. and another, more progressive in style, did those at the r. A fourth painter did the roundels above. The frame is modern, and so of course is the inscription at its base, but it is virtually certain that it repeats the inscription on the original frame which would then have run as follows: SCS ALBERTUS. SCS PETRUS APOSTOL./ANNO DOMINI MCCC(C)XX DIE XV APRILE/SCS PAULUS APOSTOLUS. SCS ANTONIUS ABBAS.

The presence of St. Albert, a patron of the Carmelite Order, would indicate that the altarpiece was made for the Church of S. Maria del Carmine in Florence. Its size and the presence of such prominent Parte Guelfa saints as Peter and Paul would suggest that it was at one time placed on the high altar. The church was consecrated in 1421, and the conjunction of that date with that of the altarpiece (presumably of 1420) is most suggestive. Presumably, also after the fire of 1771 in the Carmine, the altarpiece was sequestrated and could well have ended up in nearby Signa at S. Martino alle Selve, where Jarves reports it came from in the 19th century. This pedigree is still full of conjecture; it is hardly possible to affirm that the altarpiece was that of the Carmine, but the conclusion is certainly an attractive one which at present is being investigated further in Florence.

FRA ANGELICO (close follower or associate of)

Guido di Pietro, called Angelico is now believed to have been born close to 1400; died 1455. One of the leading painters of Florence, with a large bottega

and following, centering activity on programs for the Dominican convents in Fiesole and S. Marco, Florence. Active also in Orvieto and Rome 1447–55.

78. VISIONS OF POPE INNOCENT AND ST. DOMINIC, ca. 1445*

Edwin A. Abbey Memorial Collection. 1937.343.

Egg tempera on panel. 33.2 × 41.9 cm. (13⅟₁₆ × 16½ in.). Cleaned 1967.

CONDITION: Rather poor; much rubbed, with some small paint and gesso losses. Wood support consists of two parts joined. A graffito monogram (NCP [?]) at one time was incised near center.

PROVENANCE: Edwin A. Abbey Collection, London.

BIBLIOGRAPHY: Unpublished.

Undoubtedly part of a still unidentified predella sequence. The composition and drawing, on the basis of original underpainting still present, indicate a commission of high quality and importance. The possibility of Angelico's own hand is conceivable, but at present far from provable.

"ANGHIARI MASTER" (shop of)

The name for a cassone painter who with his workshop was active in Florence in the second half of the Quattrocento. It was first given by Schubring from the subject of a key painting depicting the Battle of Anghiari. This master had a large following and was evidently both popular and prolific. His style is heavier, with a noticeably greater debt to Uccello, than that of his rival Apollonio di Giovanni (see 1871.33).

79. BATTLE AT THE GATES OF ROME, ca. 1470

Gift of Maitland F. Griggs, B.A., 1896. 1942.324.

Egg tempera on panel. 62.3 × 178.8 cm. (24½ × 70⅜ in.). Panel for a marriage chest. Not cleaned.

CONDITION: Evidently fair. There is evidence of customary scratches and rubbing to be found in this type of object; losses are uniformly repainted.

PROVENANCE: New York art market (?); the picture was not part of the Maitland F. Griggs Collection, New York.

BIBLIOGRAPHY: Unpublished.

The subject matter is interesting for the view of Rome at the upper l., and just below it for the rather rarely depicted incident of the weighing of the sword (from Livy, story of Camillus) with the representation of Quattrocento scales.

APOLLONIO DI GIOVANNI (shop of)

Florentine miniaturist and cassone painter active in the mid-15th century; he died in 1465. Celebrated as the "Tuscan Apelles" in an epigram written between 1458 and 1464 by the Florentine humanist Ugolino Verino, Apollonio with his partner Marco del Buono headed what appears to have been the most fashionable cassoni decorating firm in Florence in its day.

80. TOURNAMENT IN PIAZZA S. CROCE, ca. 1460–65

University purchase from James Jackson Jarves. 1871.33.

Egg tempera on panel. 45.1 × 153 cm. (17¾ × 60¼ in.). Not cleaned.

CONDITION: Evidently only fair, judging by numerous scratches and heavy repainting over much of the surface, particularly in the center portion where wear and rubbing in this type of picture is normally most severe. The panel once decorated the face of a marriage chest.

INSCRIPTIONS: As far as can be read on the bridles of horses, from l. to r., SCIPIONE, FRANCESCO, CARLOTTO, SER NOCCO (?) ... , AGNOLO.

PROVENANCE: James Jackson Jarves Collection, Florence.

EXHIBITIONS: New York "Institute of Fine Arts," 625 Broadway, 1860; New-York Historical Society, 1863 (both times as Dello Delli).

BIBLIOGRAPHY: Jarves 1860, p. 49 (as Dello Delli); Sturgis 1868, pp. 51–52 (as Dello Delli); M. Logan, in *Gazette des Beaux-Arts*, ser. 3, 26 (1901), p. 335 (as "Compagno di Pesellino" bottega); W. Rankin, in *BurlM, 11* (1907),

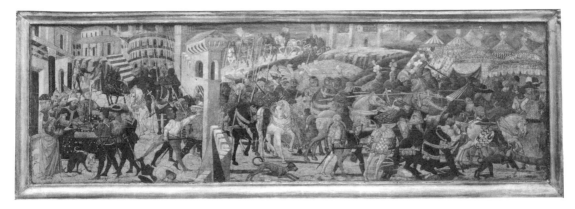

79

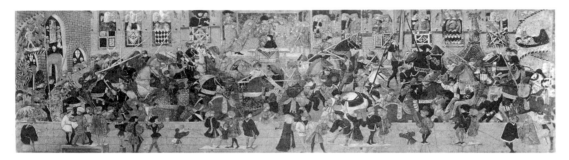

80

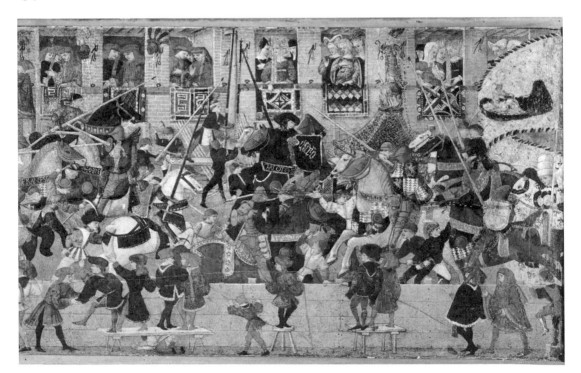

80, detail

p. 131 (as possibly same hand as for Jarves Aeneid cassoni); F. J. Mather, in *Yale Alumni Weekly, 23* (1914), p. 969 (as Florentine, 1450–60); Sirén 1916, pp. 83–84 (as Florentine, ca. 1440); P. Schubring, *Cassoni,* Leipzig, 1923, *1,* p. 253 (as "Master of the Tournament of S. Croce"); Offner 1927, pp. 6, 27–30 (as shop of the "Virgil Master"); Van Marle, *10* (1928), pp. 551, 554 (as studio of the "Virgil Master"); Berenson 1932, p. 347 (as "Master of the Jarves Cassoni"); W. and E. Paatz, *Die Kirchen von Florenz,* Frankfort, 1940, *1,* pp. 671, 700 (concerns facade of S. Croce shown in painting); W. Stechow, in *Bulletin of the Allen Memorial Art Museum,* Oberlin College, *1* (1944), p. 17 (as not by master of Aeneid panels whom he identifies as in the shop of Marco del Buono and Apollonio di Giovanni); Berenson 1963, *1,* p. 18 (as Apollonio di Giovanni).

The authorship of this panel, as can be seen from the Bibliography above, has been for some time a matter of controversy. The first step toward a reasonable solution of the problem of attribution came in Mrs. Berenson's (Mary Logan's) article of 1901 in which she proposed that the bottega responsible for the Tournament and Aeneid panels (for these see below, 1871.34–35) was that responsible also for the illuminations of a manuscript Aeneid in the Laurenziana, Florence. Once this idea was assimilated, it went through various modifications and occasional rejections until Stechow of Oberlin, in 1944, and Gombrich of the Warburg Institute, London, in 1955, identified the master of Laurenziana Aeneid miniatures, and by inference the head of the shop that produced the Jarves Aeneid cassoni, as a certain Apollonio di Giovanni who was in partnership with Marco del Buono in one of the most important of the Florentine cassoni decorating firms of the Quattrocento. For stylistic reasons the authorship of the Jarves-Yale Tournament panel cannot have been precisely the same as that of the Aeneid panels; in fact it is possible that the Tournament panel was not a product of the same bottega, though roughly contemporary. Its date appears at present to hinge on a controversial representation of a gilded statue (?) of St. Louis of Toulouse on the facade of S. Croce seen at the extreme l. side of the panel. This may represent Donatello's statue of St. Louis of Toulouse which during the 1460s was moved from the niche of the Parte Guelfa on Or

S. Michele to S. Croce in order to make way for Verrocchio's group of Christ and St. Thomas commissioned in 1466 by the Mercanzia who had taken over the niche from the Parte Guelfa by 1463. Professor H. W. Janson (*The Sculpture of Donatello,* Princeton, 2 (1957), p. 48, n. 1.) has maintained that what appears on our panel is a painted representation of the saint rather than Donatello's statue; on the other hand the painted decoration of the Quattrocento facade as discussed independently by W. and E. Paatz (see Bibliography above) does not offer support to such a painted representation of a gilded statue. The question still needs further clarification, but it must be stated here that there is nothing in the style of the picture which would argue against a date as late as 1465, or even 1470. The tournament represented has not been conclusively identified. The banners of the opposing forces in this mock battle carry devices of "Time" on the l. and "Truth" (?) on the r. It has been suggested verbally to the compiler that the identity of the Francesco in the tournament might be Francesco Sforza (died 1466).

APOLLONIO DI GIOVANNI (shop of)

81. ADVENTURES OF AENEAS (1) THE SHIPWRECK OF AENEAS, ca. 1460–65

University purchase from James Jackson Jarves. 1871.34.

Egg tempera on panel. 48.4 × 163.2 cm. (19½ × 64¼ in.). Cradled, 1928–29; cleaned, 1951.

CONDITION: Fair only. Much damage by abrasion and scratches to the center portion of the composition with rather large losses in the area of the lion and the foliage behind, which have all been inpainted. The areas at panel's sides, both l. and r., are, in contrast, in remarkably good state.

INSCRIPTIONS: At l., twice in connection with Juno, GIUNONE; in connection with winds, GRECO, LEVANTE, ORIENTE, LIBECIO, MEZODI; near Neptune, NET at r.; twice in connection with figures of Venus, Aeneas and Achates, VENERE, ENEA, ACHATE (the second ENEA rubbed out).

PROVENANCE: James Jackson Jarves Collection, Florence.

EXHIBITIONS: New York "Institute of Fine Arts," 625 Broadway, 1860; New-York Historical Society, 1863 (both times as Paolo Uccello); Y.U.A.G., "Rediscovered Italian Paintings," 1952.

BIBLIOGRAPHY: Jarves 1860, p. 49 (as Paolo Uccello); Sturgis 1868, pp. 50–51 (as Paolo Uccello); M. Logan, in *Gazette des Beaux-Arts,* ser. 3, 26 (1901), p. 335 (as "Compagno di Pesellino," painter of Virgil manuscript of the Riccardiana); Sirén 1916, pp. 87–89 (as Florentine painter ca. 1450, identical with the miniaturist of the Virgil manuscript of the Riccardiana); P. Schubring, *Cassoni,* Leipzig, 1923, *1,* pp. 113, 275 (as "Dido Master"); Offner 1927, pp. 6, 27–30 (as shop of the "Virgil Master"); Berenson 1932, p. 347 (as "Master of the Jarves Cassoni"); W. Stechow in *Bulletin of the Allen Memorial Art Museum,* Oberlin College, *1* (1944), pp. 14–17, 20 (as Marco del Buono and/or Apollonio di Giovanni); E. H. Gombrich, in *Journal of the Warburg and Courtauld Institutes, 18* (1955), pp. 17–19, 23–24 (as Apollonio di Giovanni); Berenson 1963, *1,* p. 18 (as Apollonio di Giovanni).

The course of scholarship with regard to this panel is identical with that described for the Tournament panel, 1871.33, just above, except that the identity of subject matter of the Riccardiana Virgil Codex illumination and of this panel with its companion, 1871.35, set up an immediate relationship between the two. The epigram written on Apollonio by Ugolino Verino and included in his collection of epigrams in verse called *Flametta* specifies the action represented on this panel and one of the incidents shown in its companion as follows (in the translation by Gombrich):

> Once Homer sang of the walls of Apollo's Troy burned on Greek pyres and again Virgil's great work proclaimed the wiles of the Greeks and the ruins of Troy. But certainly the Tuscan Apelles Apollonius now painted burning Troy better for us. And also the flight of Aeneas and the wrath of iniquitous Juno, with the rafts tossed about, he painted with wondrous skill; no less the threats of Neptune, as he rides across the high seas and bridles and stills the swift winds. He painted how Aeneas, accompanied by his faithful Achates enters Carthage in disguise; also his departure and the

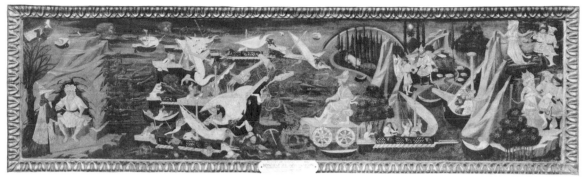

81

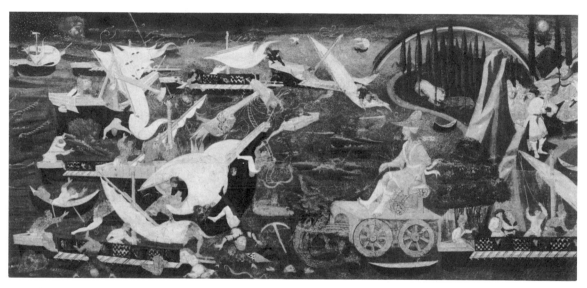

81, detail

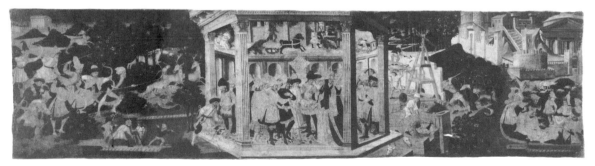

82

funeral of unhappy Dido are to be seen on the painted panel by the hand of
Apollonius.

1871.34 shows at the l. Juno arranging with Aeolus to set loose the winds,
which in personified form and labeled churn up the storm that destroys Aeneas'
fleet. In the center rides the calming figure of Neptune; at the r., the storm over,
Aeneas and Achates with their companions come to shore; finally Aeneas and
Achates meet with Venus disguised as a huntress; then as she is recognized as a
goddess by her gait, she leaves them to their rather mildly expressed astonish-
ment. After cleaning, the figure style of the Jarves-Yale panel does not seem to
achieve the delicacy of the related Xerxes in Oberlin (which Gombrich called
bottega work), yet it lacks something of the vigor of the Riccardiana Virgil
Codex illuminations (which Gombrich gave, with the Jarves-Yale panels, to
Apollonio himself). It is extremely likely that Apollonio did the Riccardiana
Codex illuminations himself, as Gombrich convincingly presents the case. If this
is so, we feel that the Jarves-Yale cassone panels are most probably derivations
designed by Apollonio and very possibly, though not certainly, executed by him,
incorporating some, but not all, of the incidents that Verino described in the fa-
mous and evidently lost "painted panel" (*picta tabella*) that he wrote was "by
the hand of Apollonio" (*Apolloni . . . manu*). The date of ca. 1460 given to
the Jarves-Yale *Aeneid* panels follows Gombrich's reasoning with regard to the
dating of the Virgil in the Riccardiana and its relation to the Jarves-Yale pic-
tures on *Aeneid* themes. The attributions of these and other cassone panels that
have been associated with the hand or the bottega of Apollonio di Giovanni are
currently under review by Miss Ellen Callmann, whose doctoral dissertation at
New York University deals with this topic; the compiler has welcomed her
opinions which in the main are followed in this catalogue.

APOLLONIO di GIOVANNI (shop of)

82. ADVENTURES OF AENEAS (2) AENEAS AT CARTHAGE, ca. 1460–65

University purchase from James Jackson Jarves. 1871.35.

Egg tempera on panel. 49.2 × 162.6 cm. (19⅜ × 64 in.), not including frame. Not cleaned.

CONDITION: Only fair; probably worse than its companion, 1871.34. The surface is extensively repainted and the gilt of the "pictures" represented in the central temple is completely renewed.

INSCRIPTIONS: CARTAGINE, to r. of city being built; (AS)CANIO beside boy at center of seated group at r.; ACHILLE (twice) and PRIAMO in paintings depicting Trojan War in central temple; COLONIA, CASTEL S. AGNOLO, S. MARIA RI (*sic*) TONDA, and below on pediment, M. AGRIPPA . L. F. C. IN . . . , all in the view of Rome.

PROVENANCE, EXHIBITIONS, and BIBLIOGRAPHY: See above, 1871.34.

By the same hand, as far as can be judged from its present state, as that responsible for the companion panel. In this panel the story of the *Aeneid* is carried on from the incident shown in 1871.34. At the l. Aeneas and his band are shown engaged in a hunt; in the central section of the composition Aeneas meets Dido in the Temple at Carthage, a city shown as still being built under a series of paintings depicting the triumph of Achilles and the rise of the Wooden Horse in the Trojan war. At the r. under a view of the city of Rome, and in the center of a group seated on the ground beside a stream which must be the Tiber, Ascanius, Aeneas' son is shown expounding from a book. The imagery of this panel is particularly interesting in that it shows (1) a Renaissance reconstruction of antique paintings, as described verbally by Virgil in the *Aeneid;* (2) the machines and tools used in the Quattrocento building trade; and (3) an unusually complete symbolic view of Rome which includes the Colosseum, Trajan's (?) Column, the Castello Sant'Angelo, the Ara Coeli and the medieval Capitol and a fine view, including the antique inscription of the facade, of the Pantheon.

APOLLONIO DI GIOVANNI (shop of ?)

83. MEETING OF SOLOMON AND THE QUEEN OF SHEBA, ca. 1460–65

University purchase from James Jackson Jarves. 1871.36.

Egg tempera on panel. 45.1 × 150.8 cm. (17¾ × 59⅜ in.). These measurements include additional strips .9 cm. wide applied on all four sides of the panel. Restored and apparently cradled 1915. Not cleaned.

CONDITION: Fair only at best. The entire surface appears to be coarsened and dulled with repaints and the gilding that meets the eye is all evidently modern. At the time of the restoration in 1915 it was found that the surface was badly battered and disfigured by scratches; a serious crack runs through the extreme r. side with attendant damage to the figures, which have been largely repainted.

PROVENANCE: James Jackson Jarves Collection, Florence.

EXHIBITIONS: New York "Institute of Fine Arts," 625 Broadway, 1860; New-York Historical Society, 1863 (both times as style of Piero della Francesca).

BIBLIOGRAPHY: Jarves 1860, p. 51, no. 61 (as style of Piero della Francesca); Sturgis 1868, p. 65 (as in the manner of Piero della Francesca, or perhaps Benozzo Gozzoli); M. Logan, in *Gazette des Beaux-Arts,* ser. 3, 26 (1901), p. 335 (as shop of Pesellinesque painter ["Compagno di Pesellino"] of the Riccardiana Virgil Codex); Sirén 1916, pp. 91–92 ("Cassone Master," for him identical with "Aeneid Master"); P. Schubring, *Cassoni,* Leipzig, 1923, *1,* p. 267 (as "Cassone Master," for him different from "Aeneid Master"); Offner 1927, pp. 6, 27–28 (as shop of the "Virgil Master"); Van Marle, *10* (1928), p. 551 (as "Virgil Master"); Berenson 1932, p. 347 ("Master of the Jarves Cassoni"); W. Stechow, in *Bulletin of the Allen Memorial Art Museum,* Oberlin College, *1* (1944), p. 17 (as shop of Marco del Buono and Apollonio di Giovanni); E. Gombrich, in *Journal of the Warburg and Courtauld Institutes, 18* (1955), p. 21 (as workshop of Apollonio di Giovanni); Berenson 1963, *1,* p. 18 (as Apollonio di Giovanni ["Master of the Jarves Cassoni"]).

Because of the panel's heavily repainted state, it would be difficult to go beyond a very general attribution to a shop. The consensus of published opinion certainly indicates that of Apollonio di Giovanni, though the principle of the design of this panel is very different from that of our 1871.34–35. The scene depicted is fairly frequently used in marriage chest and marriage salver imagery

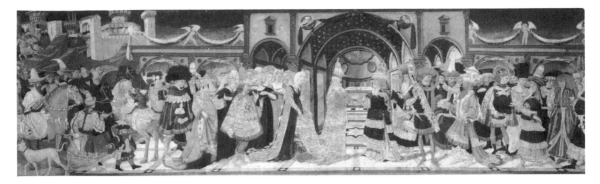

83

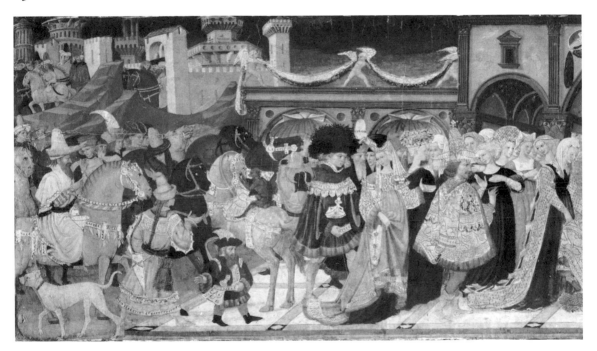

83, detail

in Florence; it derives from two Biblical sources: I Kings, 10 and II Chronicles, 9.

ARCANGELO DI COLA DA CAMERINO (attributed to)

Mentioned in documents 1416–29. Umbro-Tuscan in activity, which at times paralleled that of Gentile da Fabriano. Recorded in Città di Castello, Florence, and Rome, as well as in Camerino.

84. MADONNA AND CHILD WITH ANGELS, ca. 1425*

Gift of Maitland F. Griggs, B.A., 1896. 1937.10.

Egg tempera on panel. 121 × 69.3 cm. (47⅝ × 27½ in.). Cleaned in 1957–58.

CONDITION: Poor; extensively rubbed, particularly in flesh tones, though much remains of blue of Madonna's robe. Longitudinal split through center at joints of two sections of the panel. Previously repaired and extensively repainted.

PROVENANCE: Maitland F. Griggs Collection, New York; acquired from Julius Böhler, Munich, 1929.

EXHIBITION: New York, Century Association, 1930.

BIBLIOGRAPHY: A. Colasanti, in *BdA, 1* (June 1922), pp. 539–45; B. Berenson, *Dedalo, 10* (1929), no. 3, illus., p. 137; Berenson, *International Studio, 93,* illus., p. 23 (as Arcangelo di Cola da Camerino); Berenson 1932, p. 33 (as Arcangelo di Cola da Camerino); Berenson 1968, *1,* p. 20 (no change).

BARTOLOMMEO DI GIOVANNI

An eclectic, probably a pupil of Domenico Ghirlandaio, whom he at one time assisted; for a time incorporated by Berenson into his "Alunno di Domenico." Influenced by Botticelli, Filippino Lippi, and Piero di Cosimo. Active ca. 1480–1510.

85. PENANCE OF ST. JEROME, ca. 1500–10*

University purchase from James Jackson Jarves. 1871.53.

Egg tempera on panel. 94.1 × 58 cm. (37$\frac{1}{16}$ × 22$\frac{13}{16}$). Restored 1915; cradled and restored 1929 by Durham; cleaned 1955.

CONDITION: Flesh and dark tones considerably rubbed; background largely intact, as is emblem of lion with book.

PROVENANCE: James Jackson Jarves Collection, Florence.

EXHIBITIONS: New York "Institute of Fine Arts," 625 Broadway, 1860; New-York Historical Society, 1863 (both as Castagno).

BIBLIOGRAPHY: Jarves 1860, p. 49 (as Andrea del Castagno); Sturgis 1868, p. 53 (as Andrea del Castagno); Sirén 1916, pp. 141–42 (as Bartolommeo di Giovanni); Berenson 1932, p. 7 (as "Alunno di Domenico," i.e. Bartolommeo di Giovanni); Berenson 1963, *1*, p. 26 (as Bartolommeo di Giovanni).

BIAGIO D'ANTONIO (attributed to)

Born in Florence; active 1470–90 in Faenza. An assistant to Domenico Ghirlandaio in 1470s in Florence. Influenced by Verrocchio.

86. CRUCIFIXION, ca. 1480*

University purchase from James Jackson Jarves. 1871.51.

Egg tempera on wood panel. 55.2 × 38.4 cm. (21¾ × 15⅛ in.). Partially cleaned in 1914; cleaned 1960–67.

CONDITION: Rubbing of flesh tones is uneven, revealing technique from lowest layer to finished surface; background and sky in relatively good state.

INSCRIPTION: At top of cross, INRI.

PROVENANCE: James Jackson Jarves Collection, Florence.

EXHIBITIONS: New York "Institute of Fine Arts," 625 Broadway, 1860; New-York Historical Society, 1863 (both as Mantegna).

BIBLIOGRAPHY: Jarves 1860, p. 54 (as Andrea Mantegna); Sturgis 1868, pp. 56–57 (as Andrea Mantegna); Sirén 1916, pp. 137–38 (as "Pseudo-Verrocchio").

Formerly attributed to "Pseudo-Verrocchio," a shadowy anonymous follower of Verrocchio who in recent years has declined in scholarly usefulness as file drawer; the present convincing attribution is due to Everett Fahy.

SANDRO BOTTICELLI (close follower of)

Alessandro dei Filipepi, called Botticelli, was born in Florence in 1445; he died there in 1510 after one of the most brilliant careers of the entire century. Trained as a goldsmith, then a pupil of Fra Filippo Lippi, he was successively influenced by Antonio Pollaiuolo and Verrocchio, but in every case maintained his own individuality and style which can be recognized, though not always truly understood, by every first-year student of the history of art. He was a favored artist of the Medici and worked in 1480–81 for Pope Sixtus IV. In his late years he became an ultrareligious follower of Savonarola. His following in Florence must have been considerable, not only among laymen but among artists, and his school is still being sorted out.

87. MADONNA AND CHILD, ca. 1495

University purchase from James Jackson Jarves. 1871.50.

Egg tempera on panel. 83.2 × 55.5 cm. (32¾ × 21⅞ in.). Restored, 1915; cradled 1930; cleaned, 1954.

CONDITION: Fair to good; the surface has been rubbed with loss of pigment particularly on the hands of the Virgin and much of the figure of the Child. What remains in these areas, however, provides an unusually graphic idea of the method of drawing and underpainting.

EXHIBITIONS: New York "Institute of Fine Arts," 625 Broadway, 1860; New-York Historical Society, 1863 (both times as Botticelli); Northampton, Massachusetts, Smith College Museum of Art, 1956; Chicago Art Institute, "Masterworks from the Yale Collections," 1956.

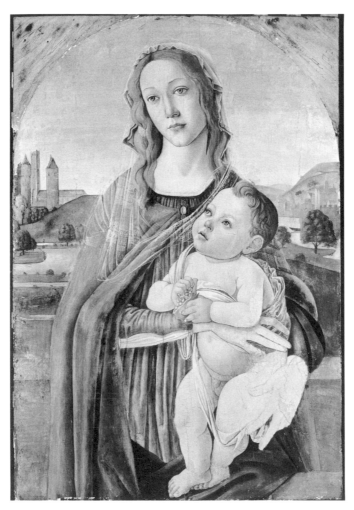

87

BIBLIOGRAPHY: Jarves 1860, p. 52 (as Botticelli); Sturgis 1868, p. 69 (as Botticelli); Jarves 1871, p. 22 (as Botticelli); Rankin 1895, pp. 147–48 (as school of Botticelli); H. P. Horne, *Sandro Botticelli,* 1908, p. 118 (as school of Botticelli); Sirén 1916, pp. 135–38 (as pupil of Botticelli); Y. Yashiro, *Sandro Botticelli,* 1925, p. 235 (as contemporary copy); Van Marle, *12* (1931), pp. 238–39, p. 244 (as pupil of Botticelli); Berenson 1932, p. 104 (as studio work); Berenson 1963, *1,* p. 37 (as studio work).

The still unidentified follower of Botticelli who painted this picture was sufficiently close to the master to deserve the title of pupil. One senses here the devotion of the fervent learner who wishes to reproduce, to the best of what is after all still a limited ability, the earlier successful achievement of the master. The style of the Madonna is closely derived from Botticelli's most beautiful creation of the 1480s, but with a rather self-conscious and slightly prim affectation. The background with its horizontal accents contrasted with spiky architectural motives is most characteristic of this still anonymous follower, whose work has been tentatively brought together by Van Marle and earlier to some extent by Sirén.

FLORENTINE SCHOOL (manner of Andrea di Giusto)

Andrea di Giusto was active in Florence ca. 1420–50; he died in 1455. He worked with Masaccio and Bicci di Lorenzo in an assistant's role. In the last phase of his career he was much influenced by Fra Angelico.

88. AGONY IN THE GARDEN, ca. 1435*

University purchase from James Jackson Jarves. 1871.32.

Egg tempera on panel. 29.2 × 40.3 cm. (11½ × 15⅝ in.). Restored, 1915; cleaned, 1965.

CONDITION: In general fair to good; serious losses at corners and in tree at r. The corners at the r. side were lobed. Old nails left at edges.

PROVENANCE: James Jackson Jarves Collection, Florence.

EXHIBITIONS: New York "Institute of Fine Arts," 625 Broadway, 1860; New-York Historical Society, 1863 (both times as school of Taddeo Gaddi).

BIBLIOGRAPHY: Jarves 1860, p. 45, no. 29 (as school of Taddeo Gaddi); Sturgis 1868, p. 38 (as school of Taddeo Gaddi); Sirén 1916, p. 81 (as manner of Andrea di Giusto).

Originally a predella panel. The altarpiece is still unidentified.

FLORENTINE SCHOOL, XV century

89. PENANCE OF ST. JEROME AND ST. FRANCIS RECEIVING THE STIGMATA, ca. 1485*

University purchase from James Jackson Jarves. 1871.44.

Egg tempera on panel. 39.5 × 29.9 cm. (15⁵⁄₁₆ × 11¾ in.). Restored, 1915; cleaned 1959.

CONDITION: Good, although slightly rubbed in the darks. Modern frame removed.

PROVENANCE: James Jackson Jarves Collection, Florence.

EXHIBITIONS: New York "Institute of Fine Arts," 625 Broadway, 1860; New-York Historical Society, 1863 (both times as school of Umbria).

BIBLIOGRAPHY: Jarves 1860, p. 48, no. 52 (as school of Umbria); Sturgis 1868, p. 58 (as unknown painter of the Umbrian school); Sirén 1916 (as Francesco Botticini); Van Marle, *12* (1931), p. 412 (as Jacopo del Sellaio with considerable question); Berenson 1932, p. 527 (as Sellaio, with question); Berenson 1963, *1*, p. 198 (no change).

The recent cleaning has revealed more than ever the poverty of talent betrayed by the painter, whose provinciality of style and outlook might place him, as Jarves evidently was convinced, even outside the Florentine school.

FLORENTINE SCHOOL, XV century

90. MAN OF SORROWS, ca. 1470*

Gift of Hannah D. and Louis M. Rabinowitz. 1959.15.9.

Egg tempera on wood panel. 36.5 × 34 cm. (14⅜ × 13⅜ in.). Not cleaned.

CONDITION: Evidently poor; the body of Christ has been built out by additions and the whole fragment suffers from repainting.

PROVENANCE: Rabinowitz Collection, Sands Point, Long Island.

BIBLIOGRAPHY: L. Venturi, in *Art Quarterly,* 7 (1944), p. 23; *Rabinowitz Coll.* 1945, pp. 21–25.

Part of the central portion of a Pietà with a symbolic representation of the Passion (as reconstructed by the late Lionello Venturi; see above). Other parts have been recorded in the following collections: two, Budapest, Baron F. Hatvany Collection; two, London, Thomas Agnew Galleries; and two, St. Germain-en-Laye, Alphonse Kahn Collection. At one time 1959.15.9 was attributed to Andrea del Castagno; this can no longer possibly be sustained.

FLORENTINE SCHOOL (Domenico di Michelino?)

A minor master whose work is beginning to attract increasing interest. Born 1417; died 1491. He was apprenticed to a Florentine cassone painter named Michelino and for a period of time after 1440 was a prominent member of Fra Angelico's bottega. By 1465 when he painted the well-known fresco of Dante in the Florentine Duomo he was already well out of the stylistic orbit of Angelico. He then seems to have come under the influence of Fra Filippo Lippi and Pesellino and became more inclined to a modified realism.

91. ANNUNCIATION, ca. 1440

Gift of Hannah D. and Louis M. Rabinowitz. 1959.15.6.

Egg tempera on panel. 18.4 × 28.6 cm. (7¼ × 11¼ in.). Not cleaned.

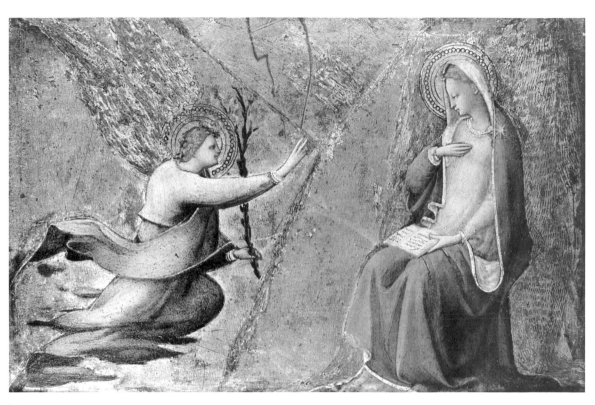

91

CONDITION: Of the figures, excellent. However, the rectangular shape of the composition as at present is made up of three pieces of panel which were evidently taken from two wings or shutters of a small devotional altarpiece or picture. The Madonna decorated the summit of the right wing or shutter, the angel the summit of the left.

PROVENANCE: Ex-Albertini Collection, Pistoia (according to dealer's record); Sir Charles Townley Collection, England, 1877; Lady Crosslay, Yeovil, Somerset, England; thence via E. and A. Silberman Galleries, New York, to the Rabinowitz Collection, Sands Point, Long Island.

EXHIBITION: Washington, D.C., Phillips Memorial Gallery, "Functions of Color," 1941.

BIBLIOGRAPHY: *Rabinowitz Coll.* 1945, p. 15 (as Filippo Lippi); *Rabinowitz Coll.* 1961, pp. 18–19 (as Florentine Master ca. 1430–40).

In the 1961 publication (see above) on the Rabinowitz Collection paintings at Yale this charming example of an unknown Florentine painter's style was tentatively given to an anonymous master close to the so-called "Master of the Griggs Crucifixion." Earlier the panel had been attributed less plausibly to the young Filippo Lippi. At this writing the influence of Fra Angelico, while still not preponderant, appears stronger than it did. In type and drapery style, particularly that of the Virgin, the artist seems to be closest to the assistant of Fra Angelico responsible for the Prado *Annunciation* predella whom modern scholarship is inclined to recognize as Domenico di Michelino. A fragment of what appears to have been part of the same ensemble, depicting Christ with a Crown, is in the Royal Collection at Hampton Court. The pose of the Virgin duplicates that of the Virgin seated under a Ghibertesque canopy in an Annunciation now in the Gallery of the Courtauld Institute, formerly in the Gambier-Parry Collection (Highnam Court) and believed to be by the so-called "Master of the Bargello Tondo." The date of our panel is given as ca. 1440 at the beginning of Angelico's influence on Domenico di Michelino, supposing of course that the latter was indeed the artist.

FLORENTINE (?) SCHOOL (imitator of Castagno)

Andrea di Bartolo di Simone called Castagno is believed to have been born in the environs of Florence somewhat earlier than 1423. He died in 1457. In addition to Florence he was active in Venice and had great influence in northern Italy as well as in Florence.

92. DORMITION OF THE VIRGIN, ca. 1460

University purchase from James Jackson Jarves. 1871.38.

Egg tempera on panel. 28.1 × 69.2 cm. (11⅟₁₆ × 27¼ in.). Restored 1915; cleaned 1957.

CONDITION: A deep crack running horizontally through the central portion has been filled and inpainted. Otherwise, the surface is in a very good state.

PROVENANCE: James Jackson Jarves Collection, Florence.

EXHIBITIONS: New York "Institute of Fine Arts," 625 Broadway, 1860; New-York Historical Society, 1863 (both times as unknown Italian painter).

BIBLIOGRAPHY: Jarves 1860, p. 48, no. 51 (as school of Umbria); Sturgis 1868, p. 58 (as unknown Italian painter); Sirén 1916, pp. 97–98 (as follower of Andrea del Castagno); Berenson 1932, p. 195 (as crude imitator of Castagno).

Evidently a provincial eclectic painter is involved here; it is quite possible he was not of Florentine origin.

FLORENTINE SCHOOL, early XV century

93. MARRIAGE SALVER, ca. 1420–25

Gift of Hannah D. and Louis M. Rabinowitz. 1959.15.8.

Egg tempera on panel. Diameter, 57.8 cm. (22¾ in.). Not cleaned.

CONDITION: Fair only, but quite good for this type of functional object. There are repaints evident in all parts of the picture.

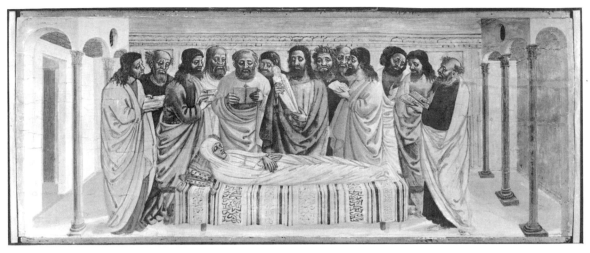

92

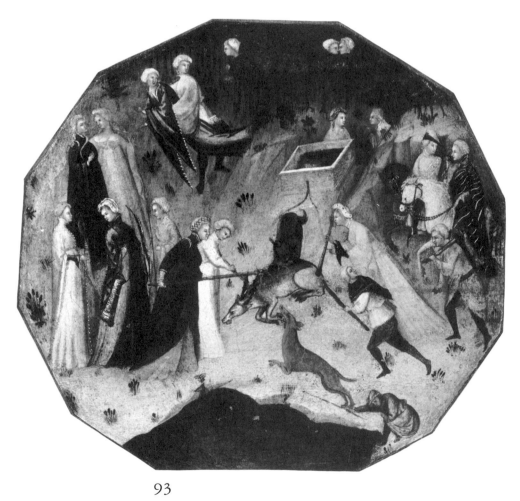

93

PROVENANCE: Rabinowitz Collection, Sands Point, Long Island.

BIBLIOGRAPHY: *Rabinowitz Coll.* 1945, p. 19; *Rabinowitz Coll.* 1961, p. 15.

The style of this salver is characterized by the free composition, courtly cos-
tumes and allegorical subject matter of the International Gothic Style which
captivated Florentine taste in the first third of the Quattrocento. Several panels
for marriage chests and at least one other salver, in the Metropolitan Museum,
New York, are sufficiently close in style to our salver to suggest that they came
from the same bottega, so far not identified by name.

FLORENTINE SCHOOL, early XV century

94. BEARDED SAINT (in the initial letter C), manuscript illumination, ca.
 1415*

Gift of Robert Lehman, B.A., 1913. 1957.42.

Body color and gold on parchment. Fragment cut out from a large manuscript
page. 11.4 × 14.1 cm. (4½ × 5⁹⁄₁₆ in.).

CONDITION: Excellent.

PROVENANCE: Lehman Collection, New York.

BIBLIOGRAPHY: Unpublished, so far as is known.

FLORENTINE SCHOOL, early XV century

95. SCENE FROM THE LEGEND OF S. GIOVANNI GUALBERTO,
 ca. 1410*

University purchase from James Jackson Jarves Collection. 1871.30.

Egg tempera on panel. 36.3 × 57.7 cm. (14⁵⁄₁₆ × 22¹³⁄₁₆ in.). Restored,
1915; cleaned 1963–68.

CONDITION: Poor; much rubbed and scratched with many losses of surface pig-
ment.

PROVENANCE: James Jackson Jarves Collection, Florence.

EXHIBITIONS: New York "Institute of Fine Arts," 625 Broadway, 1860; New-York Historical Society, 1863 (both as "Giacomo di Casentino" [sic]).

BIBLIOGRAPHY: Jarves 1860, p. 44, no. 26 (as Giacomo di Casentino); Sturgis 1868, pp. 38–39 (as Jacopo da Casentino); Sirén 1916, pp. 77–78 (as Giovanni dal Ponte); Berenson 1963, p. 68 (as Agnolo Gaddi).

FLORENTINE SCHOOL, early XV century

96. STORY OF FOUR SONS (?) ca. 1430*

Bequest of Maitland F. Griggs, B.A., 1896. 1943.218.

Egg tempera on wood panel. 31.4 × 109.1 cm. (12⅜ × 46⅞ in.). Cleaned in 1965–66.

CONDITION: Seriously rubbed with several losses in pigment.

PROVENANCE: Maitland F. Griggs Collection, New York.

BIBLIOGRAPHY: P. Schubring, in *Apollo, 3* (1926), p. 253.

The title of this panel, still very tentative, derives from Boccaccio.

FLORENTINE SCHOOL, mid-XV century

97. ENTHRONED MADONNA AND CHILD WITH SAINTS AND ANGELS, ca. 1450–60*

Edwin A. Abbey Memorial Collection. 1937.341.

Egg tempera on wood panel. 38.1 × 31.2 cm. (15 × 12⁵⁄₁₆ in.). Cleaned 1965.

CONDITION: Somewhat rubbed, but on the whole good. Two cracks down center.

INSCRIPTIONS: On book held by saint, TIMETE DEUM ET DATE ILLI HO-
NOREM QUIA VENIT [HORA IUDICII EIUS] (Rev. 14:7, Fear God, and give him
honor, for [the hour of his judgment] has come); on halo of the Madonna, AVE
MARISTELLA.

PROVENANCE: Edwin A. Abbey; presumably acquired in Europe, but at un-
known date.

BIBLIOGRAPHY: Unpublished.

The two Dominican saints may represent St. Peter Martyr (l.) and St. An-
toninus (r.)

FLORENTINE SCHOOL, mid-XV century

98. ANNUNCIATION, ca. 1455*

University purchase from James Jackson Jarves. 1871.40

Egg tempera on panel. 86.4 × 85.7 cm. (34 × 33¾ in.). Restored, 1915;
restored, 1928; cleaned, 1954.

CONDITION: Good; some rubbing with loss of surface layer of blue pigment of
Virgin's robe which had been heavily repainted earlier.

PROVENANCE: James Jackson Jarves Collection, Florence.

EXHIBITIONS: New York "Institute of Fine Arts," 625 Broadway, 1860; New-
York Historical Society, 1863 (both times as Benozzo Gozzoli).

BIBLIOGRAPHY: Jarves 1860, p. 51 (as Benozzo Gozzoli); Sturgis 1868, p. 61
(as Benozzo Gozzoli); Sirén 1916, pp. 101–05 (as Giusto d'Andrea); Beren-
son 1932, p. 388 (as Neri di Bicci copying Pesellino); Berenson 1863, p. 168
(no change).

The picture seems clearly not to be by Giusto d'Andrea; the relationship with
Pesellino suggests not so much a copy as a still unidentified follower.

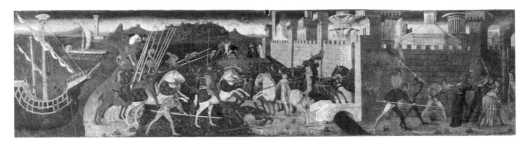

99

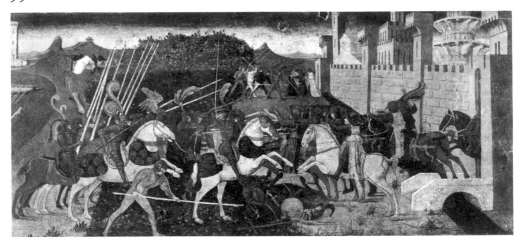

99, detail

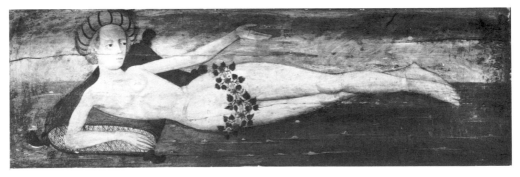

99, inside cover

FLORENTINE SCHOOL, second half XV century

99. Painted cassone: front panel, BATTLE OF HERACLIUS AND
 CHOSROES; side panels, FAITH and JUSTICE; inside of lid,
 RECLINING NUDE FEMALE FIGURE; ca. 1465–70

Gift of the Associates in Fine Arts. 1933.61.

Egg tempera on panel. Sight: front panel, 49.5 × 174.6 cm. (19½ × 68¾
in.); right panel, 41 × 53 cm. (16⅛ × 20⅞ in.); left panel, 40.8 × 52.4
cm. (16¹⁄₁₆ × 20⅝ in.); inside of lid, 52.8 × 170.5 cm. (20¾ × 67 in.).
Uncleaned.

CONDITION: Somewhat darkened, with a good deal of repainting.

PROVENANCE: Countess of Craven, England; Stora, Paris; Marie Sterner Gal-
leries, New York.

BIBLIOGRAPHY: T. Borenius, in *Festschrift Schubring,* Leipzig, 1929, pp. 1–9;
Theodore Sizer, in *Y.U.A.G. Bulletin,* 6 (June 1934).

Very few marriage chests such as this one have survived with their original
painted decoration on the inside of the lid. Two pairs of chests with such lids
have been recorded in England; two single lids, one in the Victoria and Albert
Museum and another in the Uffizi, are also in the literature.

FLORENTINE SCHOOL (?), second half XV century

100. ADORATION OF THE MAGI, ca. 1475*

Bequest of Maitland F. Griggs, B.A., 1896. 1943.223.

Egg tempera on panel. 71.2 × 51.6 cm. (28¹⁄₁₆ × 20⁵⁄₁₆ in.). Cleaned in
1964.

CONDITION: Fair only; rubbed in foreground area and in sky; losses in fore-
ground figures.

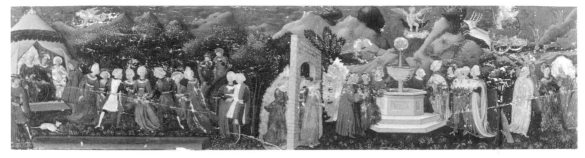

101

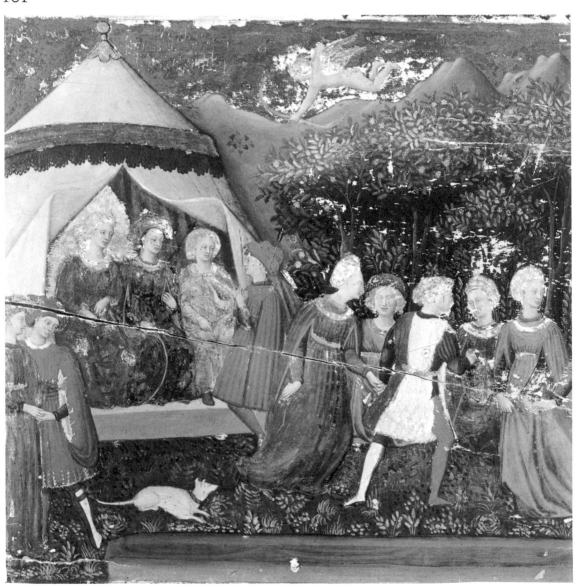

101, detail

PROVENANCE: Ex-Collection Mrs. Vivien, London (the Lord O'Hagen, the Countess of Carlisle and others—sale, Christie's 1922); Maitland F. Griggs Collection, New York.

EXHIBITIONS: London, New Gallery, 1893–94 (as Benozzo Gozzoli); New York, Century Association, 1930.

BIBLIOGRAPHY: Van Marle, *II* (1929), p. 238 (as school of Benozzo Gozzoli); Berenson 1932, p. 585 (as Giovanni Battista Utili da Faenza); Berenson 1963, *I*, p. 211 (no change).

A most difficult picture to place according to style since it contains reminiscences of so many artists; however, on technical evidence it is clearly of the period. There have been doubts as to its Italian origin (see, for instance, the shepherds).

FLORENTINE SCHOOL (follower of Paolo Schiavo?) first half XV century

101. ALLEGORY OF LOVE, ca. 1440

University purchase from James Jackson Jarves. 1871.67.

Egg tempera on panel. 39 × 146.4 cm. (15⅜ × 57⅝ in.). Restored, cradled, 1929–30; cleaned, 1966–67.

CONDITION: Fair to good; there are three serious horizontal cracks, evidently aggravated by the cradling; there is a good deal of rubbing with attendant surface losses, particularly in the gold and silver leaf.

PROVENANCE: James Jackson Jarves Collection, Florence. Said by Jarves to have come from the "Gallery of Prince Conti," so far unidentified by the compiler.

EXHIBITIONS: New York "Institute of Fine Arts," 625 Broadway, 1860; New-York Historical Society, 1863 (both times as Gentile da Fabriano).

BIBLIOGRAPHY: Jarves 1860, pp. 49–50 (as Gentile da Fabriano); Sturgis 1868, pp. 42–43 (as Gentile); Jarves 1871, p. 17 (as Gentile); W. Rankin,

in *BurlM,* 9 (1906), p. 288, and *11* (1907), pp. 340–41 (as style of Masaccio); Sirén 1916, pp. 171–73 (as follower of Gentile da Fabriano); Offner 1927, pp. 5, 22–27 (as Paolo di Stefano [Paolo Schiavo]); Van Marle, 8 (1927), p. 304 (as follower of Gentile da Fabriano); R. Longhi, in *Pinacoteca, 1* (1928), p. 36 (as Paolo Schiavo); Berenson 1932, p. 195 (as unknown Florentine; Paolo Schiavo ?); R. Van Marle, *Iconographie de l'art profane, allegories et symboles,* the Hague, 1932, pp. 430–31 (as Florentine ca. 1450); G. Pudelko, in Thieme-Becker, *Künstlerlexikon, 30* (1936), p. 47 (as Paolo Schiavo); Berenson 1963, *1,* p. 16 (as Paolo Schiavo?).

A companion panel for the decoration of a marriage chest (as our panel was originally intended to be used) is in the Museum of Fine Arts, Springfield, Massachusetts, with a provenance going back to the Ottley sale of 1847 (F. B. Robinson, in *Museum of Fine Arts Bulletin,* Springfield, Massachusetts, *28* [Feb.–Mar. 1962]). It depicts the story of Diana and Callisto. The Jarves-Yale panel is more general in its imagery than the one now in Springfield. Formerly called *The Garden of Love,* it should more properly be entitled *An Allegory of Love.* On the l. half of the composition is shown a courtly round dance in a flowery meadow which proceeds gracefully as the Lover and his mistress are simultaneously struck by arrows of blind Cupid (symbol of earthly, physical love). In the second scene, presided over by Cupid now without his blindfold (symbol of ideal love), the Lover is introduced by a shining goddess (Diana ?) through a gateway into a garden or meadow, in which take place the loves of the pagan gods Apollo and Daphne, Venus and Mars, as recounted by Ovid. At a fountain, three poets speak to one another (whether they are meant to represent the amatory poets of antiquity or, instead, Italian medieval poets of love it is not possible to state with confidence). On the opposite side of the fountain, an emperor with other armed and crowned figures signifying the great of the earth look up in attitudes of subjection to Cupid. At the far right the Lover is left lying in a barren, hilly landscape as Diana (?) driving a chariot drawn by two white hinds, takes the Beloved away with her. This most recent analysis of the subject matter, as put together by Paul Watson, stresses an opposition of unbridled physical love and the discipline of an ideal chastity, frequently found

expressed in the imagery of early 15th-century Florentine marriage chest deco-
ration and salvers (see for example 1959.15.8).

The questions raised with regard to the authorship of 1871.67 are not so
easily handled. At no time since Jarves first published the panel in 1860 has
there been a settled agreement as to the artist or bottega responsible for what
appears to be one of the masterpieces of early 15th-century secular painting in
Florence. The most recent attributions to Paolo Schiavo, or Paolo di Stefano as
the artist was also called, appear after the recent cleaning of the picture to be
unsatisfactory. From his attested work, Paolo was not capable of such delicacy
and charm both of visual presentation of the imagery and of drawing and color.
On the other hand it is possible that his bottega contained an artist of unusual
talent who did the panels now at Yale and Springfield for what must have been
a wedding between representatives of two Florentine families of great taste as
well as means. The present attribution reflects this possibility, but must be con-
sidered for the time being as provisional only.

DOMENICO GHIRLANDAIO

His real name was Domenico Corradi Bigordi, son of a goldsmith nicknamed
Ghirlandaio. Born 1449; died 1494. He was the most influential painter of the
late Quattrocento in Florence, the master of Michelangelo and the father of an-
other distinguished painter, Ridolfo Ghirlandaio.

102. PORTRAIT OF A LADY, ca. 1490

University purchase from James Jackson Jarves. 1871.52.

Fresco on a tile base. 50.6 × 36.2 (base) × 29.8 (top) cm. (19⅞ ×
14³⁄₁₆ (base) × 11¾ (top) in.). Cleaned and overrestored in 1932–33;
cleaned in 1967–68.

CONDITION: Fair to good; in 1967–68 a heavy waxy surface coat, with numer-
ous repaints, was removed, uncovering two horizontal cracks through the chin
and neck and a longtitudinal crack which evidently was the cause of some losses

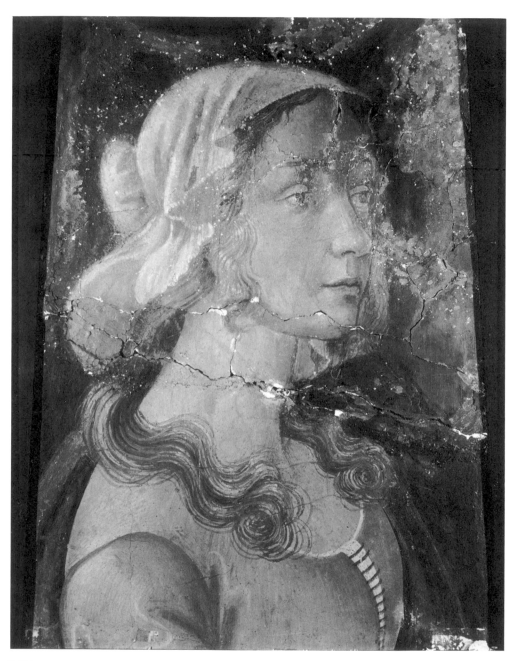

102

in the forehead and in the far side of the face. The condition of the lower portion is excellent.

PROVENANCE: James Jackson Jarves Collection, Florence. Said to represent a lady of the Tornabuoni family.

EXHIBITIONS: New York "Institute of Fine Arts," 625 Broadway, 1860; New-York Historical Society, 1863 (both times as Domenico Ghirlandaio).

BIBLIOGRAPHY: Jarves 1860, p. 54; Sturgis 1868, p. 68; Jarves 1871, p. 22; Sirén 1916, pp. 139–40; Offner 1927, pp. 6–7; Van Marle, *13* (1931), p. 102; Berenson 1932, p. 225; H. Tietze, ed., *Masterpieces of European Painting in America,* New York, 1939, no. 56 (all as Domenico Ghirlandaio).

The recent cleaning of this fragment has revealed conclusively a piece of the first quality in style and handling that appears to be autograph work of the master. A similar head is in the Musée Bonnat (no. 7) in Bayonne in southern France, and in the Museo Nazionale di S. Matteo, Pisa, is a larger fragment in much the same style. The original location of the fresco is not known, though it may have been either in a villa in Volterra or a house in Siena which Vasari records as decorated in fresco by Ghirlandaio (data from Everett Fahy). The earlier literature treating this fragment stressed, probably wrongly, a superficial resemblance to parts of the Tornabuoni frescoes in S. Maria Novella; so much so that at one time the Jarves fragment was considered either a "study" (which is clearly impossible) or a copy after a figure in S. Maria Novella (which the spontaneity and masterly quality of the technique evident in the Yale fragment hardly permit).

RIDOLFO GHIRLANDAIO (attributed to)

Son of Domenico Ghirlandaio; born, Florence, 1483; died there, after a long career with lessening artistic powers, in 1561. An exact contemporary of Raphael, he was influenced by the great Umbrian painter when the latter was in Florence at the beginning of the 16th century. Ridolfo later took on coloration from the aging Piero di Cosimo and such contemporaries as Bugiardini. Not a mere eclectic, he was a power in the development of high Renaissance art.

103. LADY WITH A RABBIT, ca. 1505

University purchase from James Jackson Jarves. 1871.72.

Egg tempera (?) or oil (?) on panel. 58.4 × 45.1 cm. (23 × 17¾ in.). Evidently cut down somewhat on the sides and certainly on the bottom. Restored, 1915; cleaned 1952–64.

CONDITION: Good. A crack extends longitudinally from the top of the panel into the r. side of the lady's face and breast. There is slight damage to both eyes; rubbing occurs on the back of the lady's r. hand and an abrasion on her l. shoulder; very slight losses in background have been inpainted, as well as the crack mentioned earlier.

PROVENANCE: James Jackson Jarves Collection, Florence; stated by Jarves to have been acquired from the Giovagnoli family who were the heirs of the Vitelli of Città di Castello.

EXHIBITIONS: New York "Institute of Fine Arts," 625 Broadway, 1860; New-York Historical Society, 1863 (both times as Francia); Chicago Art Institute, "A Century of Progress Exhibition of Painting and Sculpture," 1933; New York, Schaeffer Galleries, 1938; Y.U.A.G., "Rediscovered Italian Paintings," 1952; Brooklyn Museum and Hartford, Wadsworth Atheneum, "Take Care," 1954; Chicago Art Institute, "Masterworks from the Yale Collections," 1956; Northampton, Massachusetts, Smith College Museum of Art, 1956 (all, since 1863, as Piero di Cosimo).

BIBLIOGRAPHY: Jarves 1860, p. 55 (as Francia); Sturgis 1868, p. 64 (as Francia); Sirén 1916, pp. 185–88 (as Piero di Cosimo); Offner 1927, pp. 8, 36 (as Piero di Cosimo); C. Gamba, in *Dedalo,* 9 (1928–29), no. 2, p. 488 (as Ridolfo Ghirlandaio); L. Venturi, pl. CCCXXXVII (as Mariotto Albertinelli); Van Marle, *13* (1931), p. 360 (as Piero di Cosimo); Berenson 1932, p. 454 (as Piero di Cosimo); R. Langton Douglas, *Piero di Cosimo,* Chicago, 1946, pp. 73, 75 (as Piero di Cosimo); S. Freedberg, *Painting of the High Renaissance in Rome and Florence,* Cambridge, Massachusetts, 1961, *1,* pp. 78–79, 91 (as Ridolfo Ghirlandaio, 1508); Berenson 1963, *1,* p. 176 (as Piero di Cosimo).

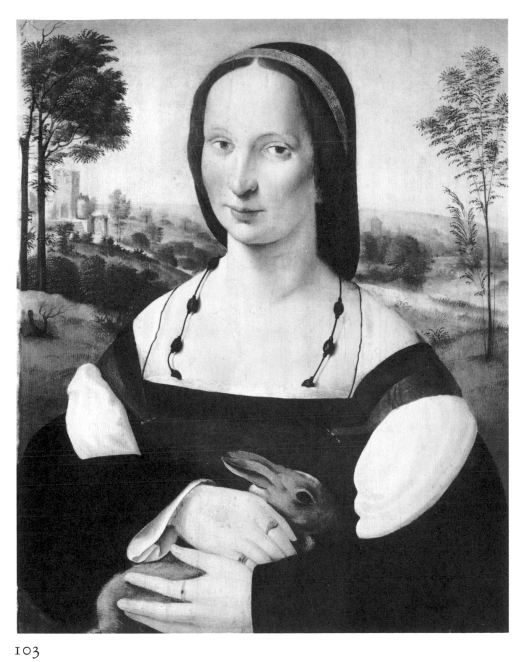

103

There are two outstanding questions which need some answer in connection with this beautiful and very well-known portrait. The first question centers on the painter's identity; the second on the subject. For many years while on exhibition in the Yale Art Gallery the picture bore the label of Piero di Cosimo. So many years indeed was this the case that the rather tardy and possibly controversial nature of the Piero di Cosimo attribution was gradually forgotten. After searching the early literature on the picture the compiler must conclude that the shift from Jarves' impossible attribution to Francia to a more possible but still undocumented attribution to Piero di Cosimo came first as a private verbal communication from Bernard Berenson to William Rankin about the year 1895 (see W. Rankin, *Notes on Three Collections of Old Masters,* Wellesley, Massachusetts, 1905, p. 12). Thereafter the attribution to Piero stuck tenaciously to the picture, with only two interesting disagreements on the part of Carlo Gamba and Lionello Venturi (see Bibliography, above). Gamba suggested, as the painter, Ridolfo Ghirlandaio, and Venturi offered with less plausibility the name of Mariotto Albertinelli, both painters younger than Piero di Cosimo who worked more easily in the early 16th century Florentine idiom of style. This the portrait appears clearly to express. The pose derives from Leonardo's *Mona Lisa* (of ca. 1504–06) and the drawing and color from Raphael prior to 1509. The artist who would most likely mingle so successfully these sources of inspiration is Ridolfo Ghirlandaio, and the recent (1961) reconstruction of his oeuvre by Freedberg, filling out Gamba's earlier suggestions with new insights, gives a new basis for the present attribution.

The other question, involving the identity of the subject, is at present more difficult to deal with. There is, however, a clue in Jarves' statement that the picture came from the Vitelli holdings. For a time the title of the picture was *The Princess Vitelli;* this was, for probably prudent historical reasons, dropped in favor of the more popular *Lady with a Rabbit.* But the rabbit is no casual genre-like adjunct; it is surely, following the tradition of the visual lore of antiquity, a symbol of love, even of *voluptas.* Moreover Jarves' version of the pedigree, though still requiring more checking, is not easily discarded. The portrait may represent not only a Vitelli lady but a Vitelli bride. The temporary eviction of

the family from their holdings in Città di Castello by the invasion of Cesare Borgia in 1502 may provide a terminus post quem for the portrait which was most probably painted a few years later in Florence. What remains to be explored is the history of the family and the connection between this picture and other possible Vitelli portraits in order to establish a terminus ante quem. This investigation is in progress. A date of as late as 1508 has been suggested in the literature; the date, ca. 1505, suggested here is altogether provisional.

GIOVANNI DAL PONTE (shop of)

Giovanni di Marco, called dal Ponte because his shop was situated close to the Ponte Vecchio in Florence. Born ca. 1385; died, Florence, apparently in 1437. Probably a pupil of Spinello Aretino and was also influenced by the International Style.

104. Cassone: Front panel, TWO ROMANTIC SCENES; side panels, PUTTI BEARING COATS OF ARMS, ca. 1430*

Gift of the Associates in Fine Arts. 1936.122.

Egg tempera on wood panel. Sight: front panel, 41.8 × 143.3 cm. (16½ × 56¾ in.); side panels, r., 41.9 × 49.5 cm. (16½ × 19½ in.), l., 41.6 × 50.2 cm. (16⅜ × 19¾ in.).

CONDITION: The chest is made-up, mostly modern; paintings not cleaned, the coats of arms darkened and much repainted; those on the side may be modern.

PROVENANCE: New York art market (?).

BIBLIOGRAPHY: G. H. Hamilton, in *Y.U.A.G. Bulletin* (Feb. 1937), pp. 47–48. The stemma (coat of arms) of the front panel was tentatively identified by Rufus G. Mather (*in litteris,* 1937) as a repainted version of that of the Becchi, Bocchi, Caccini, or Lapucci families of Florence. The imagery of the panel has not yet been identified.

GIOVANNI DAL PONTE

105a,b. ST. JAMES MAJOR AND RESURRECTION, and ST. JOHN
 THE BAPTIST AND CRUCIFIXION, ca. 1410

Gift of Hannah D. and Louis M. Rabinowitz. 1959.15.7a,b.

Egg tempera on panel. Saint James Major and Resurrection, 127.3 × 33 cm.
(50⅛ × 13⅛ in.); Saint John the Baptist and Crucifixion, 127.3 × 33.7
cm. (50⅛ × 13⅜ in.); the Saint James Major was cleaned in 1967.

CONDITION: Good overall, but some losses.

INSCRIPTION: Saint John the Baptist, scroll, ECCE ANGNUS (sic) D(E)I.

PROVENANCE: Rabinowitz Collection, Sands Point, Long Island.

EXHIBITIONS: New York, F. Kleinberger Galleries, "Loan Exhibition of Ital-
ian Primitives," 1917.

BIBLIOGRAPHY: O. Sirén and M. W. Brockwell, *Catalogue of a Loan Exhibi-
tion of Italian Primitives,* New York, 1917, p. 42 (see above); F. M. Perkins,
AiA, 9 (1921), p. 148; Van Marle, 9 (1927), p. 86; *Rabinowitz Coll.* 1945,
pp. 17–18; *Rabinowitz Coll.* 1961, pp. 16–17.

These panels originally were the wings of an altarpiece. While both reflect the
combination of delicacy and monumentality of late 14th-century style, the St.
James panel in particular shows new vitality and linear change indicative of the
Gothic "International Style" which came to Italy from the North.

GIOVANNI DAL PONTE (shop of)

106. GARDEN OF LOVE, ca. 1430*

Bequest of Maitland F. Griggs, B.A., 1896. 1943.217.

Egg tempera on panel. 50.8 × 167.2 cm. (20 × 65¹¹⁄₁₆ in.). Cleaned 1967–
68.

CONDITION: Poor; had been virtually completely repainted.

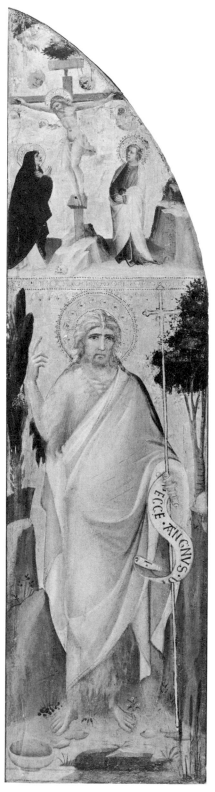

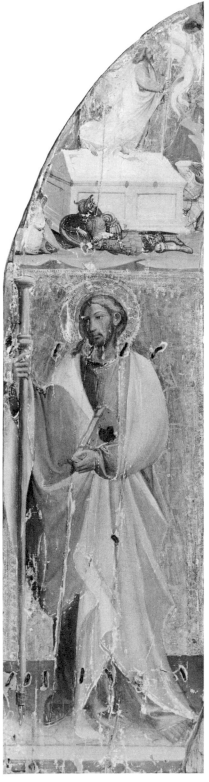

105b

105a

PROVENANCE: Maitland F. Griggs Collection, New York; acquired in Florence, 1927.

EXHIBITION: New York, Century Association, 1930.

BIBLIOGRAPHY: Berenson 1932, p. 250 (as Giovanni dal Ponte).

Since the recent cleaning the shop character of the panel is more evident.

FILIPPINO LIPPI (shop of ?)

Born ca. 1457, son of Fra Filippo Lippi; pupil of Botticelli. Died in 1504.

107. CHRIST ON THE CROSS, ca. 1495*

University purchase from James Jackson Jarves. 1871.56.

Egg tempera on panel. 35.5 × 25.5 cm. (13¾₁₆ × 10¹⁄₁₆ in.). Cradled and restored, 1915; cleaned and restored, 1929; cleaned, 1961–62.

CONDITION: Poor; much rubbed, with loss of most of flesh tints; the underdrawing, however, is virtually intact. A longitudinal crack just to l. of the corpus; dark background (the original) much rubbed.

INSCRIPTION: At top of cross, I N R I.

PROVENANCE: James Jackson Jarves Collection, Florence.

EXHIBITIONS: New York "Institute of Fine Arts," 625 Broadway, 1860; New-York Historical Society, 1863 (as Filippino Lippi).

BIBLIOGRAPHY: Jarves 1860, p. 52 (as Filippino Lippi); Sturgis 1868, p. 72 (as Filippino Lippi); Sirén 1916, pp. 149–50 (as Filippino); Offner 1927, p. 7 (as Filippino); Berenson 1932, p. 286 (as Filippino, L.); A. Scharf, *Filippino Lippi,* Vienna, 1935, pp. 48, 57, 107 (as Filippino ca. 1497); K. B. Neilson, *Filippino Lippi,* Cambridge, Massachusetts, 1938, pp. 148–49 (as possibly by Filippino or else the shop); Berenson 1963, *1,* p. 110 (still as Filippino, L.).

Since the most recent cleaning, the problem of attribution, whether to the master

or to the shop is paradoxically more difficult than ever. In quality the figure, though well drawn, appears to fall short of Filippino's own hand; this bears out Miss Neilson's earlier doubts before the cleaning (see Bibliography, above). Related panels are listed by Scharf (see above).

LORENZO DI CREDI (attributed to)

Born in 1456 and Verrocchio's pupil and most faithful follower; died in 1537.

108. CHRIST ON THE CROSS, ca. 1510*

University purchase from James Jackson Jarves. 1871.54.

Egg tempera on panel. 30.6 × 22.4 cm. ($12\frac{1}{16}$ × $8^{13}\!/_{16}$ in.).

CONDITION: Evidently somewhat rubbed with head of Christ much repainted. Precariously cradled. A long, late text on paper on the back offers no information of apparent value or immediate interest to the problem of attribution.

PROVENANCE: James Jackson Jarves Collection, Florence; the painting is said to have come from the "Borghese Palace" (sic) in Florence, according to Jarves.

EXHIBITIONS: New York "Institute of Fine Arts," 625 Broadway, 1860 (as Lorenzo di Credi); New-York Historical Society, 1863 (as by the same).

BIBLIOGRAPHY: Jarves 1860, p. 54, no. 83 (as Lorenzo di Credi); Sturgis 1868, p. 73 (as Lorenzo di Credi); Sirén 1916, pp. 141–42 (also as Lorenzo di Credi); Berenson 1932, p. 297 (as studio work [?], early); Berenson 1963, *I*, p. 116 (no change); G. dalli Regoli, *Lorenzo di Credi,* Florence, 1966, no. 198 (as shopwork).

A small devotional panel, perhaps even later than the date indicated, but on surface stylistic evidence seems to be by the master himself, here influenced by Albertinelli. The X-ray evidence for Credi's own hand is still inconclusive. Albertinelli was at one time suggested by F. Rossi and Van Marle (*in litteris*).

ZANOBI MACHIAVELLI

Born 1418; died 1479. He was a follower of Fra Angelico and is believed to have been an assistant of Benozzo Gozzoli; influenced also by Fra Filippo Lippi and Pesellino.

109. MADONNA AND CHILD WITH TWO ANGELS, ca. 1460*

Bequest of Maitland F. Griggs, B.A., 1896. 1943.224.

Egg tempera on panel. 80.8 × 56.2 cm. (31$^{13}/_{16}$ × 22⅛ in.). Cleaned in 1957–58.

CONDITION: Fair only. Rubbed in flesh tones, especially the mouth, eyes, and fingers of the Madonna and the eyes and mouth of the Child, which had been drastically repainted.

PROVENANCE: Paul Grand, Lyon; Edouard Aynard Collection, Lyon (sale Galerie Georges Petit, Paris, 1913); Maitland F. Griggs Collection, New York.

EXHIBITIONS: New York, Knoedler and Co., "Loan Exhibition of Primitives," 1929; New York, Century Association, 1930.

BIBLIOGRAPHY: M. Salmi, in *Rivista d'arte*, 9 (1936), p. 54; Berenson 1932, p. 320 (as Zanobi Machiavelli); Berenson 1963, *1*, p. 125 (no change).

A version very similar to our painting is noted by Berenson as in the Pallavicini Collection, Rome (Berenson 1963, *1*, p. 125; *2*, pl. 810).

"MASTER OF THE APOLLO AND DAPHNE LEGEND"

Anonymous follower of Domenico Ghirlandaio, active ca. 1480–1510. Parallel to and influenced by Bartolommeo di Giovanni.

110. DANIEL WITH TWO LIONS, ca. 1490*

Bequest of Maitland F. Griggs, B.A., 1896. 1943.227.

Egg tempera on panel. 58.1 × 54.1 cm. (22⅞ × 21$^{5}/_{16}$ in.). Uncleaned.

CONDITION: Evidently fair to good.

INSCRIPTION: On scroll, O INVETERATI NE VOSTRI MALI GIORNI . . . SAPPIATE COME EL GIUDICIO DI DIO VIENE SOPR(A) VO (O you who are mired in your evil days . . . know how the judgment of God comes upon [you]); source is the apocryphal text of the history of Susanna, Daniel 13:52, roughly translated.

PROVENANCE: Maitland F. Griggs Collection, New York.

BIBLIOGRAPHY: Van Marle, *13* (1931), p. 255 (as Bartolommeo di Giovanni); E. Fahy, Art Institute of Chicago, *Museum Studies 3* (1968), p. 29 (as "Master of the Apollo and Daphne Legend").

The temporary name of the "Master of the Apollo and Daphne Legend" is due to F. R. Shapley (*Paintings from the Samuel H. Kress Collection, Italian Schools, XIII–XV Century,* London, 1966, pp. 129–30). Everett Fahy has pointed out (see Bibliography, above) that this panel, traditionally called *Daniel and the Lions,* does not show the prophet in the lions' den but rather relates him to the story of Susanna. The inscription on his banderole contains the opening words of his denunciation of the first elder, as described in the apocryphal chapters appended to the Old Testament Book of Daniel. Two panels by the same hand in the Walters Art Gallery, Baltimore, illustrate the Susanna story and have the appearance of cassone panels. If this is the case, our picture may possibly have belonged with them as an end piece. Other panels on the Susanna story evidently from the same shop are in the Art Institute, Chicago, and the Walker Art Gallery, Liverpool.

"MASTER OF THE APOLLO AND DAPHNE LEGEND"

111. CREATION OF ADAM AND EVE, ca. 1500*

University purchase from James Jackson Jarves. 1871.49.

Oil or tempera on canvas. 78.4 × 155.6 cm. (30⅞ × 61¼ in.). Partially cleaned, 1950.

CONDITION: Fair to good; some rubbing; had been considerably repainted over the entire surface.

PROVENANCE: James Jackson Jarves Collection, Florence.

BIBLIOGRAPHY: Jarves 1860, p. 54, no. 84 (as Lorenzo di Credi); Sturgis 1868, pp. 73–74 (as Lorenzo di Credi); Sirén 1916, pp. 133–34 (as Jacopo del Sellaio); Berenson 1932, p. 327 (as Sellaio); Berenson 1963, *1*, p. 198 (no change); E. Fahy, in The Art Institute of Chicago, *Museum Studies, 3* (1968), p. 39 (as "Master of the Apollo and Daphne Legend").

"MASTER OF THE BORGHESE TONDO" (attributed to)

A late 15th- to early 16th-century follower of Domenico Ghirlandaio; probably not, as has been suggested, to be identified with the assistant mentioned by Vasari as Jacopo del Tedesco.

112. MADONNA AND CHILD WITH ST. JOHN THE BAPTIST AND TWO ANGELS, ca. 1500*

Bequest of Maitland F. Griggs, B.A., 1896. 1943.233.

Egg tempera on panel. Diameter, 85.4 cm. (33⅝ in.). Not cleaned.

CONDITION: Fair to good; three longitudinal cracks, of which the one in the center is the most serious.

PROVENANCE: Dan Fellows Platt Collection, Englewood, New Jersey; Maitland F. Griggs Collection, New York; entered 1923.

BIBLIOGRAPHY: F. M. Perkins, in *Rassegna d'arte, 11,* no. 1 (1911), pp. 2–3 (as Sebastiano Mainardi); Van Marle, *13* (1931), p. 381 (as school of Piero di Cosimo); G. de Francovich, in *BdA, 6* (1927), pp. 529–47 (as Jacopo del Tedesco).

At one time at the suggestion of Offner called "The Master of the Griggs Tondo." The present attribution has been suggested by Everett Fahy (*in litteris*).

"MASTER OF THE BUCKINGHAM PALACE MADONNA"
(attributed to)

Anonymous master active in the middle part of the century, close to Fra Angelico. The name is due to Roberto Longhi.

113. SS. ZENOBIUS, FRANCIS, AND ANTHONY OF PADUA, ca. 1450*

University purchase from James Jackson Jarves. 1871.31.

Egg tempera on panel. 76.5 × 47 cm. (30⅛ × 18½ in.). Cleaned 1967.

CONDITION: Except for gilt background and possibly halos which were found to be modern, good.

PROVENANCE: James Jackson Jarves Collection, Florence; said to have come from the monastery of S. Salvi, Florence. It was originally part of a triptych.

EXHIBITIONS: New York "Institute of Fine Arts," 625 Broadway, 1860; New-York Historical Society, 1863 (both times as Fra Angelico).

BIBLIOGRAPHY: Jarves 1860, p. 47, no. 41 (as Fra Angelico); Sturgis 1868, p. 46 (as Fra Angelico); Sirén 1916, pp. 79–80 (as Andrea di Giusto); Offner 1927, p. 5 (as influence of Angelico); Berenson 1963, p. 68 (as Domenico di Michelino).

Another panel containing figures of SS. Nicholas of Bari, Lawrence, and John the Baptist was once in the Sidney Collection, Richmond, and the Langton Douglas Collection, London. It is now in the Hyde Collection, Glens Falls, New York, having been purchased from Langton Douglas in 1940. The Hyde panel seems quite definitely to have flanked a central panel on the l. while the Jarves-Yale panel, 1871.31, was on the r. The central panel was doubtless a Madonna, probably somewhat in the style of one now in the University of Arizona, Tucson (Kress Collection). This suggestion has been made by Mrs. Robert Hatfield who is investigating the problem as an independent topic of research.

"MASTER OF THE CASTELLO NATIVITY"

The temporary name given by Berenson to an unknown painter influenced by Domenico Veneziano and Fra Filippo Lippi; his activity evidently fell within the third quarter of the 15th century.

114. MADONNA AND CHILD WITH TWO ANGELS, ca. 1465*

Bequest of Maitland F. Griggs, B.A., 1896. 1943.222.

Egg tempera on panel. 84.8 × 56.5 cm. (33⅜ × 22¼ in.). Partially cleaned 1968.

CONDITION: Evidently fair only; there was a good deal of repainting over the entire surface. The composition has been cut back along all four sides.

PROVENANCE: Ex-Collection Alexander Nesbit, London (1887); Henry Wagner, London (sale, Christie's, 1925, as Gentile da Fabriano); Langton Douglas Collection, London; Maitland F. Griggs Collection, New York (by 1925).

EXHIBITION: New York, Century Association, 1930.

BIBLIOGRAPHY: Van Marle, *11* (1929), pp. 300, 305 (as "Master of the Castello Nativity"); L. Venturi, pl. CXC (as "Master of S. Miniato"); Berenson 1932, p. 343 (as "Master of the Castello Nativity"); Berenson 1963, *1*, p. 142 (no change).

"MASTER OF THE CRAWFORD THEBAID" (attributed to)

The name is a provisional one for a still unidentified provincial, but interesting, master, active in the mid-15th century with characteristics of style bridging the Florentine and Sienese schools. The Crawford Thebaid from which the name derives is listed below.

115. SCENES FROM THE LIVES OF THE HERMITS OF THE THEBAID, ca. 1460*

University purchase from James Jackson Jarves. 1871.37.

Egg tempera on panel. 33.7 × 44.6 cm. (13¼ × 17⁹⁄₁₆ in.). Restored in 1915 and 1929; cleaned in 1960.

CONDITION: On the whole good to excellent; somewhat rubbed, but no serious losses except at edges. Cutdown fragment of a much larger unit (see below).

PROVENANCE: James Jackson Jarves Collection, Florence.

BIBLIOGRAPHY: Jarves 1860, p. 48, no. 48 (as school of Siena); Sturgis 1868, p. 55 (as unknown Sienese painter); Sirén 1916, pp. 93–95 (as "Carrand Master"); Berenson 1932, p. 102 (as "Carrand Master" and Neri di Bicci); A. Wolfe, in *Gazette des Beaux-Arts, 6,* no. 39 (1957), pp. 393–406 (as Sienese [?]); E. Callman, in *BurlM, 99* (1957), pp. 149–55 (as Florentine); E. Byam Shaw, *Paintings by the Old Masters at Christ Church,* Oxford, London, 1967, p. 40 (as "Master of the Crawford Thebaid").

Eight other similarly cut down fragments in the Zurich Kunsthaus, nine in Christ Church Library, Oxford, and one in the National Gallery of Scotland, once formed with the Jarves fragment a much larger whole depicting incidents in the Legend of the Thebaid Hermits of the early Church. The larger of two other panels in the collection of the Earl of Crawford and Balcarres, London, is closely related in style, and a large Thebaid in the Uffizi gives a good idea of the original appearance and program. The reconstructed unit with all the fragments including the Jarves panel was provided by Ellen Callmann in 1957 (see above, Bibliography). For the most recent extended discussion of the style and possible identity of our master (believed by Zeri to have been a certain Giuliano Amadei) see the catalogue notice of the Christ Church, Oxford, panels by E. Byam Shaw (see above, Bibliography).

LORENZO MONACO (close follower of)

Lorenzo Monaco was born Piero di Giovanni, but in 1391 on joining the Order of the Camaldolese at the monastery of S. Maria degli Angeli in Florence he took the name of Lawrence (Lorenzo). Though he came from Siena, his known

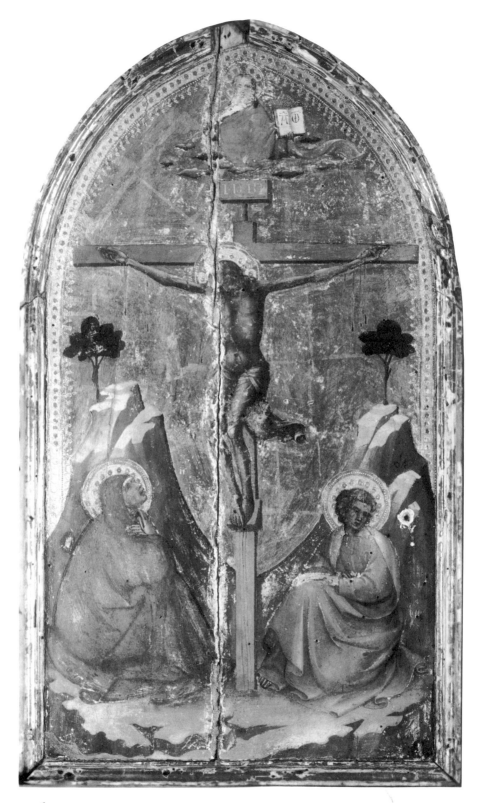

116

training and style seem basically Florentine, and as time went on took on strong Gothic coloration from the influence of the so-called International Style of the late Gothic. Perhaps the most important figure in Florentine painting from 1395 until 1420, he was largely responsible for the formation of the styles of Masolino and Fra Angelico and headed a large and most important manuscript illumination bottega at S. Maria degli Angeli. He was born ca. 1370 and died between 1422 and 1424.

116. CRUCIFIXION, ca. 1410–15 (?)

University purchase from James Jackson Jarves. 1871.24.

Egg tempera on panel. 64.9 × 37 cm. (25⁹⁄₁₆ × 14⁹⁄₁₆ in.) including the original frame. Recradled, restored, 1915; cleaned, 1966–68; cross members of cradling removed.

CONDITION: Fair only; a deep fissure runs the entire length of the panel, cutting into the figures of God the Father and the Crucified Christ below him; the surface losses fairly extensive through abrasion; the frame much damaged from worm tunneling. The surface had previously been almost completely retouched with resultant distortion of style in the principal areas of all the figures; on the other hand, the gold and punchwork of the halos was found to be in very good shape considering the state of the rest of the panel.

INSCRIPTIONS: On cross, I.N.R.I.; on book held by God the Father, $\overline{\text{A}}\ \overline{\Omega}$.

PROVENANCE: James Jackson Jarves Collection, Florence.

EXHIBITIONS: New York "Institute of Fine Arts," 625 Broadway, 1860; New-York Historical Society, 1863 (both times as Giotto); Brooklyn Museum, "European and American Landscape Painting," 1945–46.

BIBLIOGRAPHY: Jarves 1860, p. 43 (as Giotto); Sturgis 1868, p. 33 (as Giotto); W. Rankin 1895, p. 140 (as late Italian, then Giotto); F. M. Perkins, in *Rassegna d'arte senese, I* (1905), p. 76 (as school of Bartolo di Fredi); O. Sirén, *Don Lorenzo Monaco,* Strasbourg, 1905, pp. 102, 142, 191 (as Lorenzo

Monaco); Sirén 1916, pp. 67–69 (as Lorenzo Monaco); Offner 1927, pp. 5, 21–22 (as Lorenzo Monaco); Van Marle, 9 (1927), p. 147 (as Lorenzo Monaco); L. Venturi, pl. CXLII (as Lorenzo Monaco); Berenson 1932, p. 300 (as Lorenzo Monaco); G. Pudelko, in *BurlM*, *73* (1938), p. 248, n. 35 (not Lorenzo Monaco); Berenson 1963, *1*, p. 120 (still as Lorenzo Monaco).

This delightfully composed panel, with the shape of its Gothic broken-arch summit wittily repeated upside down in the interval between the conventionalized mountains of the landscape, has long been a favorite among scholars and public alike. It is, however, no longer possible to attribute it to the hand of Lorenzo Monaco. Recent cleaning has revealed what evidently was correctly suspected by Pudelko in 1936: that though the generic Gothicizing early 15th-century style in Florence represented most vividly by Lorenzo is without a doubt here in the panel, there are a number of characteristics that prevent a direct attribution to the master himself. These include the drawing of the rock forms (less sharp, more regular than those found in Lorenzo's accepted work), the figure style (bulkier and more placid than in the post-1400 work of Lorenzo) and the composition's emphatic symmetry (even to the precise balancing of the minuscule trees on the mountain tops of the background). Paradoxically, these characteristics which work against the hand of Lorenzo Monaco are in part premonitions of the radical change in Florentine style of about 1420–25 which culminated in the painting of Masaccio. In 1871.24 the monumentality of the design is to some extent countered by the execution and conception of the individual motifs; it is entirely possible that the painter may have had his main contact with Lorenzo Monaco in the field of manuscript illumination, for the style of our panel has similarities with the principal hand of the Bargello Codex E (see for example the detail in Berenson 1963 *1,* fig. 435). Accordingly, the panel is here given to an associate or close follower of Lorenzo Monaco with the intention of stressing the quality and relative independence of the painter but at the same time the close relationship to Lorenzo Monaco himself. *In litteris,* Marvin Eisenberg, who is preparing for publication his work of many years on Lorenzo Monaco, has placed our 1871.24 in the following of the master and after 1400.

LORENZO MONACO (remote follower of, or shop of Lorenzo di Niccolò Gerini ?)

117. ST. FRANCIS RECEIVING THE STIGMATA, ca. 1400*

University purchase from James Jackson Jarves. 1871.25.

Egg tempera on panel. 29 × 34.9 cm. (11⁷⁄₁₆ × 13¾ in.). Cradled and restored in 1915; cleaned 1957–58.

CONDITION: Good overall; some rubbing in dark areas. There is evidence that the original corners were cut back at some undetermined date.

PROVENANCE: James Jackson Jarves Collection, Florence.

EXHIBITIONS: New York "Institute of Fine Arts," 625 Broadway, 1860; New-York Historical Society, 1863 (both times as Agnolo Gaddi); Washington, D.C., Phillips Memorial Gallery, "Emotional Design in Painting," 1940 (as Lorenzo Monaco).

BIBLIOGRAPHY: Jarves 1860, p. 45, no. 30 (as Agnolo Gaddi); Sturgis 1868, pp. 37–38 (as Agnolo Gaddi); Sirén 1916, p. 69 (as probably assistant of Lorenzo Monaco); M. Boskovits, in *Antichità viva*, N. 6 (1968), pp. 22, 26 (as Mariotto di Nardo).

The most recent thinking on this panel tends to remove it from the Lorenzo Monaco orbit and into that of the Gerini. M. Boskovits (*in litteris*) attributes it to Mariotto di Nardo. It was at one time suggested (by Salmi) that the panel reflects the style of Ghiberti as a painter. The quality of the painting is reasonably high, and it is to be hoped that further study will confirm a named master for it. Possibly it belonged to the same predella as did the Gerinesque *Scene from the Life of St. Eligius* now in the museum of Rennes, France.

NERI DI BICCI

Born, Florence 1419; died there, ca. 1491. He was a pupil and close follower of his father, Bicci di Lorenzo. Influenced by Fra Angelico and Domenico Veneziano.

118. A SCENE FROM THE LEGEND OF ST. NICHOLAS OF BARI, ca. 1460*

University purchase from James Jackson Jarves. 1871.39.

Egg tempera on panel. 30.6 × 30.5 cm. (12⅛ × 12 in.). Restored and cradled, 1929; cleaned, 1952.

CONDITION: Good except for some rubbing and some cracking of the gesso on the l. portion of the panel. Candle burn in area of bed filled and inpainted.

PROVENANCE: James Jackson Jarves Collection, Florence.

EXHIBITIONS: New York "Institute of Fine Arts," 625 Broadway, 1860 (as Neri di Bicci); New-York Historical Society, 1863 (as Neri di Bicci); Y.U.A.G. "Rediscovered Italian Paintings," 1952 (as Neri di Bicci).

BIBLIOGRAPHY: Jarves 1860, p. 48, no. 53; Sturgis 1868, p. 60; Sirén 1916, pp. 99–100; Berenson 1932, p. 388 (all as Neri di Bicci).

It seems probable that this small panel was originally associated in a predella sequence with two other panels formerly in the Toscanelli Collection (sale, 1883) and the Spiridon Collection (sale, 1929), most recently recorded in 1944 in the possession of Elly Pintsch in Berlin (data from Frick Library).

NERI DI BICCI (shop of)

119. MADONNA ADORING THE CHILD, ca. 1465*

Bequest of Maitland F. Griggs, B.A., 1896. 1943.220.

Egg tempera on panel. 46.7 × 41.3 cm. (18⅜ × 16¼ in.). Cleaned, 1961–62.

CONDITION: Fair to good; somewhat rubbed in the sky area and lower part of Virgin's face.

PROVENANCE: Maitland F. Griggs Collection, New York; bought through Edward Hutton, London, ca. 1923.

EXHIBITION: New York, Century Association, 1930.

BIBLIOGRAPHY: Van Marle, *10* (1928), p. 546 (as school of Neri di Bicci); Berenson 1932, p. 388 (as Neri di Bicci); Berenson 1963, *1*, p. 156 (no change).

The design follows what was evidently a very popular composition in low relief by Desiderio da Settignano. A relatively large number of such paintings, all from the shop of Neri di Bicci, are known; of these the closest to our panel is in the Musée des Beaux-Arts, Dijon (no. 1646).

FRANCESCO PESELLINO (follower of)

120. MADONNA AND CHILD WITH ST. CATHERINE AND ANGELS, ca. 1460*

University purchase from James Jackson Jarves. 1871.43.

Egg tempera on panel. 167.4 × 92.1 cm. (65⅞ × 36¼ in.), including frame. Restored, 1915; partially cleaned, 1965–66.

CONDITION: On the whole good; some rubbing, particularly in the flesh tones. The frame is only in part original and the coat of arms is modern.

PROVENANCE: James Jackson Jarves Collection, Florence.

EXHIBITIONS: New York "Institute of Fine Arts," 625 Broadway, 1860; New-York Historical Society, 1863 (both times as Fra Diamante).

BIBLIOGRAPHY: Jarves 1860, p. 52 (as Fra Diamante); Sturgis 1868, p. 60 (as Fra Diamante); Sirén 1916, pp. 119–20 (as follower of Fra Filippo Lippi); Berenson 1932, p. 451 (as "Pseudo-Pier Francesco Fiorentino", perhaps after a lost Fra Filippo); Berenson 1963, *1*, p. 173 (no change).

Evidently closer to the model than the version of the Gambier-Parry Collection, now in the Courtauld Institute, London. The recent cleaning has removed modern overpainting which made the picture look much closer in style to the

shop of Fra Filippo Lippi than it is in reality. The present attribution is quite tentative (see Introduction).

FRANCESCO PESELLINO (follower of; "Pseudo-Pier Francesco Fiorentino"?)

121. MADONNA ADORING THE CHILD SUPPORTED BY ANGELS, ca. 1475 (?)*

Bequest of Maitland F. Griggs, B.A., 1896. 1943.226.

Egg tempera on wood panel. 108.3 × 58.1 cm. (42⅝ × 22⅞ in.). Cleaned, 1957–58.

CONDITION: Fair to good. A deep longitudinal crack in the panel at l.

INSCRIPTION: On rim of original frame, GLORIA IN EXCELSIS DEO ET IN TERRA PAX HOMINIBUS BONE VOLUNTATIS LAUDAMUS TE BENEDICIMUS TE ADORAMUS TE GLORIFICAMUS TE (Glory to God in the highest, and on earth peace to men of good will. We praise You, we bless You, we adore You, we glorify You. From the Gloria of the Ordinary of the Mass); at base, AVE MARIA GRATIA PLENA DOMINUS.

PROVENANCE: Maitland F. Griggs Collection, New York; acquired from Edward S. Hutton, London, in 1923.

EXHIBITION: New York, Century Association, 1930.

BIBLIOGRAPHY: Van Marle, 13 (1931), p. 435 (as Pier Francesco Fiorentino); Berenson 1932, p. 451 (as "Pseudo-Pier Francesco Fiorentino"); Berenson 1963, 1, p. 173 (as the same).

Uninspired shopwork; a rather remote commercialized derivation of the type exemplified by panels recorded in Gubbio and the Riccardi Palace, Florence, as well as in the Städelsche Kunstinstitut, Frankfurt (all reproduced by Van Marle; see above, pp. 432, 437, 440). In 1923 Offner expressed his opinion (*in litteris*) that the painter was the "Master of S. Miniato." The coat of arms in the frame is still under study.

FRANCESCO PESELLINO (follower of; "Pseudo-Pier Francesco Fiorentino"?)

122. MADONNA AND CHILD WITH TWO ANGELS, ca. 1460*

Bequest of Maitland F. Griggs, B.A., 1896. 1943.225.

Egg tempera on panel. 135.9 × 71.5 cm. (53½ × 28⅛ in.). Cleaned, 1957–58.

CONDITION: Good in general but flesh tones considerably rubbed.

INSCRIPTION: On base of original frame, AVE.MARIA.GRATIA.PLENA.

PROVENANCE: Ex-Collection Comte de Bourges (?) according to a label on reverse. Other labels indicate that the panel was in either Austria or Germany in the 19th century and in Austria after 1918 (stamp of Austrian Bundesdenkmalamt). Maitland F. Griggs Collection, New York.

EXHIBITION: New York, Century Association, 1930.

BIBLIOGRAPHY: Van Marle, *13* (1931), p. 447 (as Pier Francesco Fiorentino); Berenson 1932, p. 451 (as "Pseudo-Pier Francesco Fiorentino"); Berenson 1963, *1*, p. 175 (no change).

An attractive private devotional panel of ca. 1460–70. This painting appears to derive directly, according to Berenson, from a panel recorded in the Hainauer and Pratt Collections. It follows also the *Madonna and Child* in the Uffizi, dated 1459, ascribed by Berenson to his "Pseudo-Pier Francesco Fiorentino" whose oeuvre of remarkably variant personal styles steadily refers back to Pesellino or Fra Filippo Lippi models. The coat of arms on the frame is still under study.

ANTONIO POLLAIUOLO

Born probably in 1429, in Florence. With his considerably younger brother Piero (born in 1446) he was first trained as a goldsmith. By 1459 the brothers had left their father, Jacopo d'Antonio, to establish a shop of their own in Florence, and added painting and sculpture thereafter to the techniques they mainly practiced, often in collaboration. Antonio, accompanied by Piero, went to Rome

in 1484 to execute, with his brother's help, two large papal sepulchral monu-
ments in bronze, still in St. Peter's. They both died in Rome, Piero in 1496 and
Antonio in 1498. Antonio was cited on his own funeral monument as "pictor
insign(us)" ("an outstanding painter"—or perhaps, "outstanding as a
painter").

123. HERCULES AND DEIANIRA, ca. 1470

University purchase from James Jackson Jarves. 1871.42.

Egg tempera and oil (?) now on canvas (transferred from panel by J. Ho-
worth in Boston 1867). 54.6 × 80.8 cm. (21½ × 31³⁄₁₆ in.). Restored
under Jarves's direction first, then in 1915; cleaned 1952–62.

CONDITION: Far better than sometimes supposed, but severe losses caused, it
would seem, by the process of transfer from panel to canvas, are in group at l.
and in midriff of Hercules; these have been filled and inpainted. The remainder
was pockmarked by numerous minute wormholes, which have been filled and
inpainted also.

PROVENANCE: James Jackson Jarves Collection, Florence.

EXHIBITIONS: New York "Institute of Fine Arts," 625 Broadway, 1860; New-
York Historical Society, 1863; New York, Metropolitan Museum of Art,
"Loan Exhibition of the Arts of the Italian Renaissance," 1923; Cambridge,
Massachusetts, Fogg Art Museum, 1927–28; London, The Royal Academy,
Burlington House, "Exhibition of Italian Art," 1930; Chicago Art Institute,
"A Century of Progress Exhibition of Painting and Sculpture," 1933; Cleve-
land Museum of Art, "Twentieth Anniversary Exhibition," 1936; San Fran-
cisco, Palace of Fine Arts, "Golden Gate International Exposition," 1940;
Boston, Museum of Fine Arts, "1,000 Years of Landscape Painting, East and
West," 1945; Philadelphia, Museum of Art, "Diamond Jubilee Exhibition,"
1950 (in the exhibitions listed above, the attribution without exception was to
Antonio Pollaiuolo).

BIBLIOGRAPHY: Jarves 1860, p. 53; Sturgis 1868, p. 61; Jarves 1871, p. 21;
Rankin 1895, p. 148; M. Cruttwell, *Antonio Pollaiuolo,* London, 1907, pp.

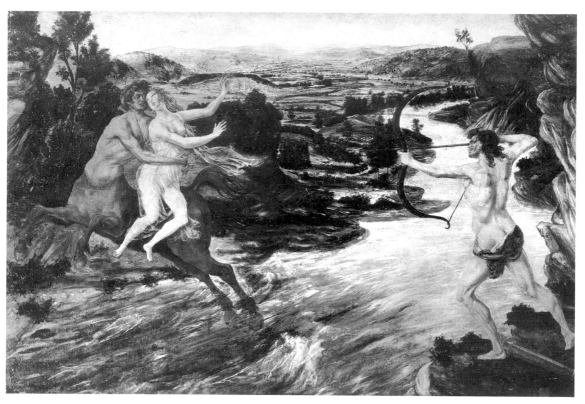

123

78–81; A. Venturi, *8,* part 1 (1911), p. 562; Sirén 1916, no. 42, pp. 111–17; Offner 1927, pp. 6, 30–34; Van Marle, *11* (1929), pp. 362–63; L. Venturi, pl. CLXXIV; Berenson 1932, p. 466; A. Sabatini, *Antonio e Piero del Pollaiuolo,* Florence, 1944, pp. 54, 84; G. Colacicchi, *Antonio del Pollaiuolo,* Florence, 1945, pp. 9–10, 23, 32; S. Ortolani, *Il Pollaiuolo,* Milan, 1948, pp. 106–08, 218–19; K. Clark, *Landscape Into Art,* London, 1949, p. 22; Berenson 1963, *1,* p. 179; L. Ettlinger, in *Encyclopedia of World Art,* New York, 1966, p. 419 (in the foregoing references, the attribution is uniformly to Antonio Pollaiuolo except for Sirén 1916, where the assistance of Piero, his brother is suggested).

At the time of the initial cleaning of the painting, Jarves discovered the figure of Deianira which had been covered entirely by a previous repainting. Severe damage to the panel by worm tunneling evidently persuaded Jarves to risk the transfer of the painting to canvas in 1867; this operation took place in Boston (as noted above). In the cleaning and restoration of 1915 it was discovered that the uplifted arm of Deianira had been changed from its original position. The arm was restored to its outstretched and evidently proper position at that time. In the most recent cleaning additional evidence was found confirming the change of 1915. The painting seems to be entirely by one hand which evidently is that of Antonio; stylistically, in the treatment of the figures and landscape, it is closest to the *Apollo and Daphne* in London. The two small panels rediscovered after World War II and now brought back to the Uffizi, *Hercules Slaying the Hydra* and *Hercules Slaying Antaeus,* are often compared to the *Hercules and Deianira.* But they are possibly by two different hands, and their relationship to the Jarves' *Hercules and Deianira* is still not entirely clear. Under no conditions, however, would it seem possible that all three were intended as parts of the same ensemble. In the recent cleaning a sliver of the original panel was found embedded in the gesso. This was analyzed by the Yale University Forestry School as a fruitwood, which was used instead of poplar for fine furniture. Very possibly the scene was one half of a cassone (marriage chest) front panel. The subject matter and high viewing point with the high horizon would suit this hypothesis. Though Jarves never indicated where he acquired the picture, its

provenance would most likely be Florence, and conceivably its original commission could have come from the Medici family, which as leader of Florentine policy in the last half of the 15th century was fond of identifying itself with the Hercules myths and associated imagery in art.

ANTONIO POLLAIUOLO (after)

124. HERCULES SLAYING ANTAEUS, ca. 1475*

Gift of Robert Lehman, B.A., 1913. 1946.317.

Egg tempera on panel. 43.5 × 30.5 cm. (17⅛ × 12 in.). Cleaned in 1952–53.

CONDITION: Poor; almost 50 percent of the surface is lost; the underpainting of the struggling figures is, however, almost completely present. The panel had been virtually completely repainted in all details.

PROVENANCE: Not recorded in the Y.U.A.G. curator's files before it was given by Robert Lehman in 1946.

BIBLIOGRAPHY: Unpublished.

This painting appears originally to have been a side panel of a marriage chest. The composition, rather freely rendered, may have been done from a lost engraving representing the Hercules and Antaeus theme, which appears on a panel generally given to Pollaiuolo himself, in the Uffizi. Conceivably, also, it might have been done after a lost composition on the same theme. Our picture reverses the Uffizi panel's composition, and this fact might be a telling argument for its derivation from a print. The coat of arms on the tree had been repainted; in its present authentic state it is unfortunately not decipherable.

ROSSELLO DI JACOPO FRANCHI

Pupil of Lorenzo Monaco; born 1376; died 1451. Charming *retardataire* minor master evidently with a large shop doing a thriving trade.

125. MADONNA AND CHILD WITH ST. JOHN THE BAPTIST, ST. PETER, AND TWO ANGELS, ca. 1440*

Bequest of Maitland F. Griggs, B.A., 1896. 1943.219.

Egg tempera on panel. 81.6 × 49.7 cm. (32⅛ × 19⁹⁄₁₆ in.). Cleaned in 1958–59.

CONDITION: Fair, uniformly rubbed. A later graffito, M S Å on head of cherub below the Virgin.

PROVENANCE: Ex-Canessa Collection (sale, New York, 1924); Maitland F. Griggs Collection, New York; acquired at Canessa sale.

BIBLIOGRAPHY: Van Marle, 9 (1927), pp. 56, 58 (as Rossello); Berenson 1932, p. 494 (as Rossello); Berenson 1963, p. 193 (as Rossello).

Evidently by the same hand as 1953.26.1. If not by Rossello, which they appear to be, both are by a prominent assistant, very close to the master, and on his design.

ROSSELLO DI JACOPO FRANCHI

126. ST. CATHERINE OF ALEXANDRIA, ca. 1430–40

Gift of Edward Hutton and Maitland Lee Griggs in memory of Maitland F. Griggs. 1953.26.1.

Egg tempera on panel. 81.6 × 14 cm. (32⅛ × 5½ in.). Uncleaned.

CONDITION: Very delicate, but with very few repaints.

PROVENANCE: Edward Hutton, England.

BIBLIOGRAPHY: Unpublished.

A decorative panel for the frame of a large altarpiece, possibly that of the high altar of S. Maria Novella, Florence, now in the Accademia delle Belle Arti in the same city. This suggestion, made verbally in 1968 by Ugo Procacci, is being investigated in Florence.

126

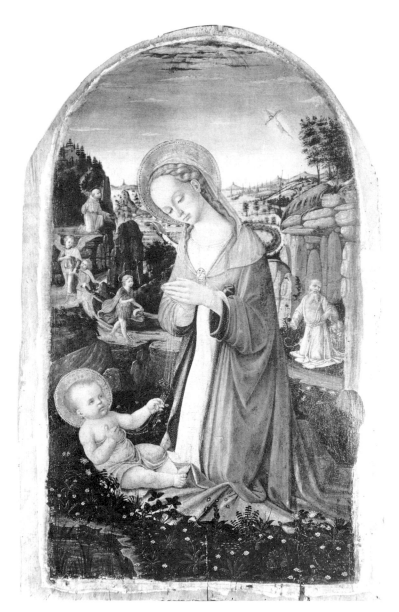

127

JACOPO DEL SELLAIO

He was the son of a saddler (hence "del Sellaio"); born, Florence 1441–42; died there, 1498. An eclectic artist, he may have begun as an assistant to Pesellino, but as time went on he was deeply influenced by Botticelli, Filippino Lippi, and to some extent by Ghirlandaio.

127. MYSTICAL ADORATION, ca. 1475

University purchase from James Jackson Jarves. 1871.45.

Egg tempera on panel. 97.5 × 60.7 cm. (38⅜ × 23⅞ in.). Cleaned 1967–68.

CONDITION: On the whole good; main damage is through rubbing in previous cleanings, particularly, as so often seems to have happened, in the flesh tints. The surface had been much darkened with varnish and a tough grime layer; it had been extensively repainted. Contrary to Sirén's statement (see Bibliography, below) the frame is not original.

PROVENANCE: James Jackson Jarves Collection, Florence.

EXHIBITIONS: New York "Institute of Fine Arts," 625 Broadway, 1860; New-York Historical Society 1863 (both times as Masolino da Panicale).

BIBLIOGRAPHY: Jarves 1860, p. 51 (as Masolino); Sturgis 1868, p. 47 (as Masolino); H. Mackowsky, in *Jahrbuch der Preussischen Kunstsammlungen*, 20 (1899), p. 271 (as Jacopo del Sellaio); Sirén 1916, pp. 125–28 (as Francesco Pesellino); Van Marle, *10* (1928), p. 513 (as "Compagno di Pesellino"); Berenson 1932, p. 527 (as Sellaio); Berenson 1963, *1*, p. 198 (no change).

The present attribution is based on Berenson's opinion, together with the visual evidence of the style (background particularly and types of figures). The reminiscences of Pesellino that evidently struck both Sirén and Van Marle are best explained as part of that artist's influence on the young Sellaio. This charming devotional panel, very light and clear in its tonality, contains mystical references to Christian doctrine and virtue in the little scenes of holy figures scat-

tered through the middle ground. To be seen are St. Francis Receiving the Stigmata, Tobias and the Angel, the Child St. John the Baptist and St. Jerome.

JACOPO DEL SELLAIO

128. ST. SEBASTIAN, 1479 (1480, new style)

University purchase from James Jackson Jarves. 1871.47.

Egg tempera on panel. 128.3 × 61.3 cm. (50½ × 24⅛ in.). Restored, 1915; restored, 1930; cleaned, 1959–60.

CONDITION: Fair to good; a good deal of rubbing overall, with losses in the saint and in the lower portion. The angel at upper r. is well preserved.

INSCRIPTION: FILII · BARTHOLOMI · D(A)NELIIS · DIE · P(RIMO) · FEBRVARII · M · CCCCLXXIX · HOC · OPUS · FIERI · FECERVN(T) (The sons of Bartolommeo Danieli had this work made, the first day of February, 1479).

PROVENANCE: James Jackson Jarves Collection, Florence.

EXHIBITIONS: New York "Institute of Fine Arts," 625 Broadway, 1860; New-York Historical Society, 1863 (both times as Filippino Lippi).

BIBLIOGRAPHY: Jarves 1860, p. 52 (as Filippino Lippi); Sturgis 1868, p. 72 (as Filippino Lippi); Sirén 1916, pp. 130–31 (as Jacopo del Sellaio); Van Marle, *12* (1931), pp. 376, 378 (as Sellaio); Berenson 1932, p. 527 (as Sellaio); Berenson 1963, *1*, p. 198 (no change).

The panel is an ex-voto, evidently in thanks for deliverance from the plague. The commissioners have not as yet been identified, nor the circumstances of the commission fully investigated.

JACOPO DEL SELLAIO

129. MYSTICAL NATIVITY, ca. 1490–95

Gift of Robert Lehman, B.A., 1913. 1946.314.

Egg tempera on panel. 35.1 × 63.3 cm. (13¹³⁄₁₆ × 24⁵⁄₁₆ in.). Cleaned 1965.

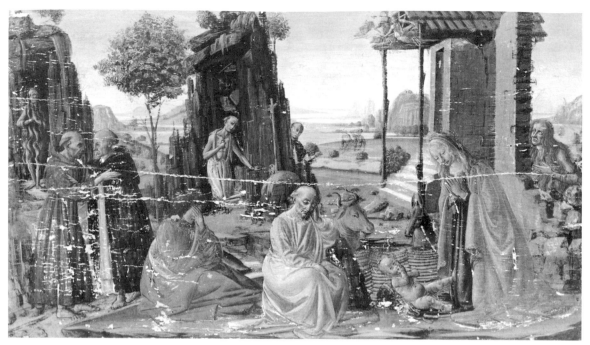

129

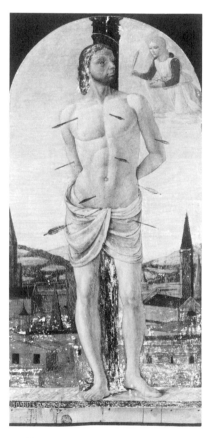

128

CONDITION: On the whole good. There is a long horizontal crack or scratch across the central area of the picture; scattered losses have occurred through flaking, the most serious at the lower l.; there is some loss of surface pigment through earlier rubbing, especially in the flesh tones. The rather coarse gilt ornamentation, such as the halos, was found to be a later addition and has been removed.

PROVENANCE: Ex-Collection of Philip Lehman, New York; Robert Lehman, New York.

BIBLIOGRAPHY: R. Lehman, *The Philip Lehman Collection, New York. Paintings,* Paris, 1928, no. 13 (as Sellaio); Berenson 1932, p. 527 (Sellaio ?); Berenson 1963, *1,* p. 198 (no change).

Evidently originally part of a predella which because of its complex subject matter probably occupied the central position. Beside the Holy Family in the foreground broods a seated figure of a saint (?) in deep meditation; to the l., St. Francis and St. Dominic embrace, with the hermit-saint Onophrius behind them; in the center kneels St. Jerome (beardless) and peering from behind a rocky formation is a Dominican (St. Peter Martyr ?); at the r., behind the Virgin, St. Mary Magdalen; in the extreme r. background two shadowy little figures representing the shepherds of the Nativity. The painting is more appropriately called a "Mystical Nativity" than an "Adoration"; it has much of the spirit, though of course not the style, that infuses the beautiful late *Mystical Nativity* by Botticelli in the National Gallery, London, and is best dated in the 1490s at the time of Savonarola's influence on Florence, which the London painting is generally considered to reflect. The quality of the Lehman-Yale panel is high. If it is not by Sellaio himself, it must be by an unusually gifted *anonimo* in the bottega.

JACOPO DEL SELLAIO

130. THE STORY OF ACTAEON (2), ACTAEON AND THE HOUNDS, ca. 1485

University purchase from James Jackson Jarves. 1871.48.

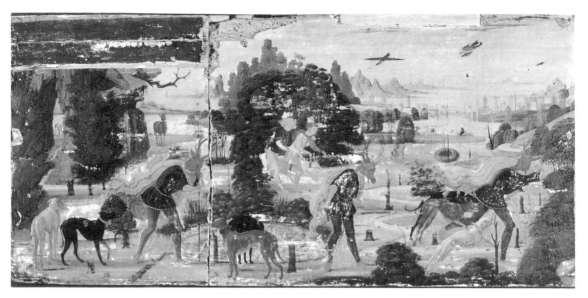

130

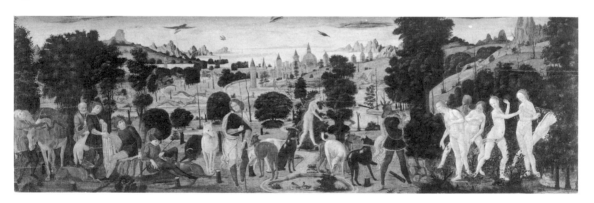

131

Egg tempera on wood panel. 55.3 × 116.8 cm. (21¾ × 46 in.). Restored, 1915; cleaned, 1955–60.

CONDITION: Poor; much rubbed overall. The panel at one time had been sawed in three pieces. The left-hand third, depicting the metamorphosis of Actaeon into a stag was reattached to the central portion which shows Actaeon in flight from his hounds; apparently at the same time new pieces of wood were inserted at upper l. and along the top where there was evidently disastrous worm tunneling; the whole was then repainted in drastic fashion.

PROVENANCE: James Jackson Jarves Collection, Florence.

EXHIBITIONS: New York "Institute of Fine Arts," 625 Broadway, 1860; New-York Historical Society, 1863 (both times as Piero di Cosimo).

BIBLIOGRAPHY: Jarves 1860, p. 52 (as Piero di Cosimo); Sturgis 1868, pp. 72–73 (as Piero di Cosimo); Sirén 1916, p. 131–33 (as Jacopo del Sellaio); Berenson 1932, p. 327 (as Sellaio); Berenson 1963, *I*, p. 198 (no change).

The right-hand third of the panel, which had evidently been severed before Jarves bought the reunited central and left-hand fragments, represents the death of Actaeon after his hounds attacked him. It was published by F. J. Mather in *Antiques, 12* (1927), pp. 298–99; at present on anonymous loan to the Yale Art Gallery (1.4.1952). The pendant to this panel which provides the first part of the Story of Actaeon is 1952.37.1 (see below).

JACOPO DEL SELLAIO

131. THE STORY OF ACTAEON (1), DIANA AND ACTAEON, ca. 1485

Maitland F. Griggs Fund. 1952.37.1.

Egg tempera on panel. 53.6 × 171.1 cm. (21⅛ × 67⅜ in.). Not cleaned.

CONDITION: Evidently fair to good though there are three serious cracks running horizontally, evidently caused by faulty cradling. A good deal of repainting over the whole surface.

PROVENANCE: Lord Southesk, Scotland; acquired in Italy in the 19th century.

BIBLIOGRAPHY: Berenson 1963, p. 198 (as Sellaio).

This is the companion panel to our 1871.48, which depicts the concluding episode in the Story of Actaeon who, after witnessing Diana and her nymphs bathing nude, was turned into a stag and attacked by his own hounds.

JACOPO DEL SELLAIO (shop of?)

132. AGONY IN THE GARDEN, ca. 1480*

Bequest of Maitland F. Griggs, B.A., 1896. 1943.229.

Egg tempera on wood panel. 14 × 39.1 cm. (5½ × 15⅜ in.). Cleaned in 1963.

CONDITION: Excellent.

PROVENANCE: Maitland F. Griggs Collection, New York.

BIBLIOGRAPHY: Van Marle, *13* (1931), p. 420 (as school of Francesco Botticini).

From the same predella as 1943.230, 1943.231, and 1943.232 (see below). The back of each panel is inscribed with a Roman numeral, I–IV. The artist was possibly also a follower of Ghirlandaio; the style shows affinities with that of a miniature painter such as Attavante in Domenico Ghirlandaio's studio (Everett Fahy, *in litteris*).

JACOPO DEL SELLAIO (shop of?)

133. WAY TO CALVARY, ca. 1480*

Bequest of Maitland F. Griggs, B.A., 1896. 1943.230.

Egg tempera on panel. 14 × 38.4 cm. (5½ × 15⅛ in.). Not cleaned.

CONDITION: Evidently precisely the same as for 1943.229.

PROVENANCE and BIBLIOGRAPHY: Same as for 1943.229.

JACOPO DEL SELLAIO (shop of?)

134. RESURRECTION, ca. 1480*

Bequest of Maitland F. Griggs, B.A., 1896. 1943.231.

Egg tempera on wood panel. 14 × 37.9 cm. (5½ × 14¹⁵⁄₁₆ in.). Cleaned in 1963.

CONDITION: Excellent.

PROVENANCE and BIBLIOGRAPHY: Same as for 1943.229.

JACOPO DEL SELLAIO (shop of?)

135. NOLI ME TANGERE, ca. 1480*

Bequest of Maitland F. Griggs, B.A., 1896. 1943.232.

Egg tempera on panel. 14 × 38.2 cm. (5½ × 15¹⁄₁₆ in.). Cleaned in 1963.

CONDITION: Excellent.

PROVENANCE and BIBLIOGRAPHY: Same as for 1943.229.

JACOPO DEL SELLAIO (close follower of)

136. MADONNA AND CHILD WITH ANGELS SEATED ON
 CLOUDS, ca. 1490*

University purchase from James Jackson Jarves. 1871.46.

Egg tempera on panel. 107.8 × 67.3 cm. (42⁷⁄₁₆ × 26½ in.). Restored, 1915; cradled, 1930; cleaned in 1968–69.

CONDITION: On the whole good; considerable rubbing and some losses in the Virgin's robe. In 1915 a crack in the center of the panel was noted.

PROVENANCE: James Jackson Jarves Collection, Florence.

EXHIBITIONS: New York "Institute of Fine Arts," 625 Broadway, 1860; New-York Historical Society, 1863 (both times as Cosimo Rosselli).

BIBLIOGRAPHY: Jarves 1860, p. 52 (as Cosimo Rosselli); Sturgis 1868, p. 67 (as Cosimo Rosselli); Sirén 1916, pp. 129–30 (as Sellaio); Van Marle, *12* (1931), p. 409 (as Sellaio); Berenson 1932, p. 527 (as Sellaio); Berenson 1963, *I*, p. 123 (still as Sellaio).

Evidently not by Sellaio, though the style is that of an artist in his orbit. A *Madonna in the Clouds* and a *Virgin in Adoration*, both in the Museo della Collegiata at Empoli, appear to be the most important paintings by this still unidentified artist (data due to Everett Fahy).

JACOPO DEL SELLAIO (remote follower of)

137. NATIVITY AND CRUCIFIXION, ca. 1480*

Bequest of Maitland F. Griggs, B.A., 1896. 1943.228.

Egg tempera on panel. Inside frame, 75 × 52.6 cm. (29½ × 20¹¹⁄₁₆ in.). Cleaned in 1959–60.

CONDITION: Fair to good; somewhat rubbed, especially in flesh tones. A deep longitudinal crack to l. of Virgin.

INSCRIPTION: On base of original frame, AVE.MARIA.GRATIA.PLENA.

PROVENANCE: Maitland F. Griggs Collection, New York.

BIBLIOGRAPHY: Unpublished.

Since cleaning, the provincial character of the style is more than ever evident. The panel had previously been given in 1927 by F. M. Perkins (*in litteris*) and Offner (verbally) to Sellaio.

"TOMMASO" (Giovanni Cianfanini?) (attributed to)

It was Berenson who, in 1932, gave the temporary name of "Tommaso" to an unknown Verrocchio follower, parallel to Lorenzo di Credi who much influ-

enced his style. Later scholarship has suggested that this painter may be identical with Giovanni Cianfanini.

138. BAPTISM OF CHRIST, ca. 1500*

University purchase from James Jackson Jarves. 1871.55.

Egg tempera on canvas. 64.3 × 109.6 cm. (25⁵⁄₁₆ × 43⅛ in.). Cleaned in 1966–67.

CONDITION: Good overall, few losses. Previously transferred from wood to canvas.

PROVENANCE: James Jackson Jarves Collection, Florence.

EXHIBITIONS: New York "Institute of Fine Arts," 625 Broadway, 1860; New-York Historical Society, 1863 (both times as manner of Andrea Verrocchio).

BIBLIOGRAPHY: Jarves 1860, p. 53 (as manner of Verrocchio); Sturgis 1868, (as possibly by a follower of Verrocchio); Sirén 1916, pp. 145–47 (as by a follower of Lorenzo di Credi); Berenson 1932, p. 578 (as "Tommaso"); Berenson 1963, p. 208 (as "Tommaso"; wrongly listed as a predella panel); G. dalli Regoli, *Lorenzo di Credi,* Florence, 1966, p. 191, n. 238 (as "Maestro della Conversazione di S. Spirito" [Giovanni Cianfanini?]).

Sienese School

BENVENUTO DI GIOVANNI

His full name was Benvenuto di Giovanni di Meo del Guasto; he was born in 1436, and his signed and dated works extend from 1466 to 1509. After 1490 he was often assisted by his son Girolamo di Benvenuto; he died ca. 1518.

139. MADONNA AND CHILD WITH TWO ANGELS, ca. 1480

University purchase from James Jackson Jarves. 1871.64.

Egg tempera on panel. 107.1 × 64.5 cm. (42³/₁₆ × 25⅜ in.). Restored in 1915, at which time several cracks in panel were filled; cleaned in 1960.

CONDITION: Superficially rubbed, with losses in flesh tones, but overall condition is fairly good.

PROVENANCE: James Jackson Jarves Collection, Florence.

EXHIBITIONS: New York "Institute of Fine Arts," 625 Broadway, 1860; New-York Historical Society, 1863; (both times as Matteo da Siena).

BIBLIOGRAPHY: Jarves 1860, p. 53 (as Matteo da Siena); Sturgis 1868, p. 57–58 (as Matteo da Siena); Sirén 1916, p. 160–64 (as Benvenuto di Giovanni for the first time); Offner 1927, p. 41 (as Benvenuto); Berenson 1932, p. 77 (as Benvenuto); B. B. Fredericksen and D. D. Davisson, *Benvenuto di Giovanni, Girolamo di Benvenuto: A Summary Catalogue of Their Paintings in America*, J. Paul Getty Museum, 1966, p. 32 (as Benvenuto); Berenson 1968, *1*, p. 40 (as Benvenuto).

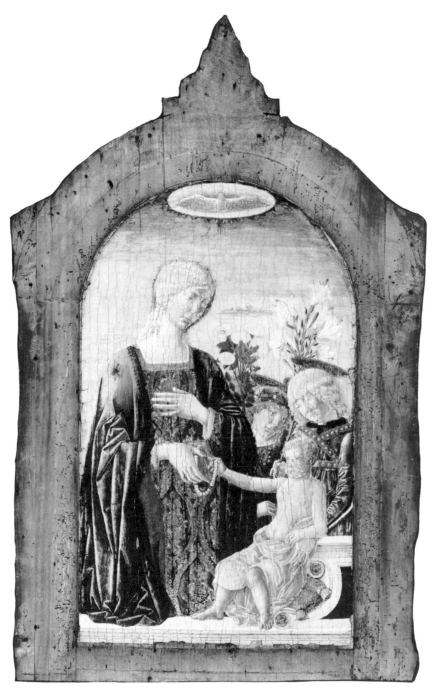

139

The painting contains a remarkable iconographic feature, that of the Christ Child shown as a Roman emperor. Since Sirén's attribution in 1916 there has been no question in the literature of Benvenuto's authorship. The panel is no longer in its original frame, though the base for it is present.

BENVENUTO DI GIOVANNI

140. ST. PETER MARTYR, ca. 1475*

Gift of Robert Lehman, B.A., 1913. 1946.316.

Egg tempera on wood panel. 23.5 × 26.2 cm. (9¼ × 10⁵⁄₁₆ in.). Cleaned 1965–68.

CONDITION: Fair to good; a crack runs through the figure below the shoulders, with some attendant losses. There had been a little regilding and some retouching of the face and palm held in the r. hand.

PROVENANCE: Lehman Collection, New York.

BIBLIOGRAPHY: Berenson 1932, p. 77 (as Benvenuto di Giovanni); Van Marle, *16* (1937), p. 416 (as Benvenuto di Giovanni); B. B. Fredericksen and D. D. Davisson, *Benvenuto di Giovanni, Girolamo di Benvenuto: A Summary Catalogue of Their Paintings in America,* J. Paul Getty Museum, 1966, p. 25 (as Benvenuto di Giovanni); Berenson 1968, *1,* p. 40 (as Benvenuto di Giovanni).

Three similar panels from the same series are known. One, depicting St. Bernardino, is in the Lehman Collection, New York, and two, depicting St. Dominic and Christ blessing, are in the William Rockhill Nelson Gallery of Art, Kansas City, Missouri. The series formed a predella with, probably, the Christ blessing as the central figure, and a fifth half figure (missing).

BENVENUTO DI GIOVANNI (shop of)

141. MADONNA AND CHILD WITH SAINTS AND ANGELS, ca. 1485*

Bequest of Maitland F. Griggs, B.A., 1896. 1943.256.

Egg tempera on panel. Sight, 74.9 × 43.5 cm. (29½ × 17⅛ in.). Cleaned in 1953.

CONDITION: Poor; many losses, clear through original gesso. The picture had been all but completely overpainted.

PROVENANCE: Maitland F. Griggs Collection, New York.

BIBLIOGRAPHY: Berenson 1932, p. 253 (as Girolamo di Benvenuto in Benvenuto's shop and on cartoon by Benvenuto); Van Marle, *16* (1937), p. 422 (as Girolamo di Benvenuto); B. B. Fredericksen and D. D. Davisson, *Benvenuto di Giovanni, Girolamo di Benvenuto: A Summary Catalogue of Their Paintings in America,* J. Paul Getty Museum, 1966, p. 27 (as Benvenuto di Giovanni); Berenson 1968, *1,* p. 187 (as Girolamo di Benvenuto).

In a lecture of 1925 Offner verbally attributed the panel to Benvenuto di Giovanni. The present attribution follows his view in part, but the recent cleaning clearly indicates an assistant's hand as present.

GUIDOCCIO COZZARELLI (shop of)

Guidoccio di Giovanni di Marco Cozzarelli was born in 1450, and as a young man was pupil and evidently an assistant of Matteo di Giovanni. There is some confusion even today as to attribution between the two men. Cozzarelli was also a fine miniature painter. He died in 1516–17.

142. MADONNA AND CHILD, ST. CATHERINE AND A FEMALE SAINT, ca. 1490*

Bequest of Maitland F. Griggs, B.A., 1896. 1943.258.

Egg tempera on panel. 58.4 × 42.4 cm. (22⁵⁄₁₆ × 16⁹⁄₁₆ in.). Cleaned in 1957.

CONDITION: On the whole good; rubbed but showing no serious losses.

PROVENANCE: Ex-Collection Carlo Angeli, Lucignano, Italy; Maitland F. Griggs Collection, New York; acquired through Edward Hutton from Italy in 1926.

EXHIBITION: New York, Century Association, 1930.

BIBLIOGRAPHY: R. Van Marle, in *La Diana,* 6 (1931), p. 175 (as Guidoccio Cozzarelli); Berenson 1932, p. 158 (as Guidoccio Cozzarelli).

In a lecture of 1927, Offner verbally attributed the painting to a Sienese contemporary imitating Cozzarelli. A similar composition with SS. Catherine and John the Baptist is reported in the Pedulli Collection, Florence. Evidently our 1943.258 follows a formula invented by Cozzarelli but used in various ways by members of the workshop.

GUIDOCCIO COZZARELLI (attributed to)

143. NATIVITY (in the initial letter *R*), manuscript illumination, ca. 1480–85*

Gift of Robert Lehman, A.B., 1913, in the name of Mr. and Mrs. Albert E. Goodhart. 1954.7.3.

Body color and gilding on parchment. 27.8 × 23.4 cm. (11 × 9¼ in.). Fragment cut from a page.

CONDITION: Good; some loss of gilding in border.

PROVENANCE: Lehman Collection, New York (acquired in Paris, 1953).

BIBLIOGRAPHY: Unpublished, so far as is known.

A notation by Pietro Toesca in the curator's file, dated September 1935, suggests the possibility that the artist may have been Matteo di Giovanni but leans toward the firmer attribution to Cozzarelli. The latter is documented as working on the illumination of the Siena Cathedral antiphonaries in 1481; our 1954.7.3 appears to have been cut from such a choir book.

FRANCESCO DI GIORGIO AND NEROCCIO DEI LANDI

The collaboration of Neroccio di Bartolommeo di Benedetto dei Landi and Francesco di Giorgio Martini produced some of the most poetic paintings of the

Sienese Renaissance. Neroccio, born in 1447, was eight years younger than Francesco di Giorgio, but he was nevertheless notably more conservative in his artistic taste. While Francesco assimilated the new trends of contemporary Florence, architectural and sculptural as well as painterly, Neroccio always retained in his style reminiscences of his great Sienese predecessors Duccio and Simone Martini. It was probably to uphold his conservative but charmingly lyrical style that Sano di Pietro agreed to arbitrate for him when his association with Francesco di Giorgio ended in 1475. Neroccio continued to paint for another quarter of a century, until his death in 1500. Francesco di Giorgio outlived him by only two years.

144. ANNUNCIATION, 1468/9–75

University purchase from James Jackson Jarves. 1871.63.

Egg tempera on panel. Lunette shaped, 48.3 × 128.7 cm. (19 × 50⅝ in.). Restored, 1915; cleaned, 1954–56.

CONDITION: Good except for cracking, especially through center, and extensive loss of azurite pigment on the robe of the Madonna. The robe had been completely repainted in black. After the most recent cleaning, the losses have been inpainted in the area of the robe, suggesting its original coloring of blue.

PROVENANCE: James Jackson Jarves Collection, Florence.

EXHIBITIONS: New York "Institute of Fine Arts," 625 Broadway, 1860; New-York Historical Society, 1863 (both times as Pietro Pollaiuolo, attributed to); London, The Royal Academy, Burlington House, "Exhibition of Italian Art," 1930 (as Neroccio); New York, Century Association, 1935 (as Neroccio); Boston, Museum of Fine Arts, "Arts of the Middle Ages," 1940 (as Neroccio); St. Louis, City Art Museum, 1947 (as Neroccio); New York, Wildenstein, Inc. "Italian Heritage," benefit for CRIA, 1967, no. 7 (as Francesco di Giorgio and Neroccio).

BIBLIOGRAPHY: Jarves 1860, p. 53, no. 76 (Piero Pollaiuolo); Sturgis 1868, p. 62, no. 65 (as Pietro [sic] Pollaiuolo); W. Rankin 1895, p. 148 (as not by Piero Pollaiuolo); Berenson, *Central Italian Painters of the Renaissance,*

New York and London, 1897, p. 156 (as Neroccio); F. M. Perkins, in *Rassegna d'arte senese, 1* (1905), p. 77 (as Neroccio); Sirén 1916, pp. 161–62 (as Neroccio); Offner 1927, pp. 4, 7, 40–41 (as Neroccio); L. Venturi, pl. CCXXIV (as Neroccio); Berenson 1932, p. 390 (as Neroccio); G. H. Edgell, *A History of Sienese Painting,* New York, 1932, p. 247 (as Neroccio); Van Marle, *16* (1937), pp. 262, 286, 292–95 (as Neroccio and Francesco di Giorgio); J. Pope-Hennessy, *Sienese Quattrocento Painting,* Oxford, 1947, pp. 22–23 (as Neroccio); Gertrude Coor, *Neroccio de' Landi,* Princeton, 1961, pp. 43, 171 (as Neroccio); *The Italian Heritage,* CRIA, Wildenstein, Inc., New York, 1967, no. 7 (as Francesco di Giorgio and Neroccio); Berenson 1968, *1,* p. 292 (as Neroccio).

From the recent X rays of the *Annunciation* it is beyond question that two hands are present in the work; moreover, the familiar styles of both Neroccio and Francesco di Giorgio are clearly discernible in each. From this evidence of the collaboration of the two artists, the panel can now be dated to the six-year period, between approximately 1469 and 1475, of their partnership. The composition plays off in a striking way Neroccio's serene poetry in the figure of the withdrawn yet receptive Virgin against Francesco di Giorgio's dominant activation of the pictorial space in the freely brushed figure of the angel. To Francesco di Giorgio also may be ascribed the intriguing neoclassical frieze behind the figures, which connects the active and passive areas of the composition as well as the architectural details of walls, columns, and throne, and the spatial construction in one-point perspective. This panel with its arched summit was intended to be placed over an altarpiece resembling the one by Vecchietta in Pienza Cathedral; surmounting this is a very similar *Annunciation* from which our 1871.63 probably derives.

BERNARDINO FUNGAI (?) (imitator of)

Fungai's full name was Bernardino Cristofano di Niccolò d'Antonio di Pietro da Fonghaia. He was born in Siena in 1460 and died there in 1516. Berenson called him a pupil of Giovanni di Paolo but noted the influence upon his later work of such Umbrians as Signorelli and Perugino.

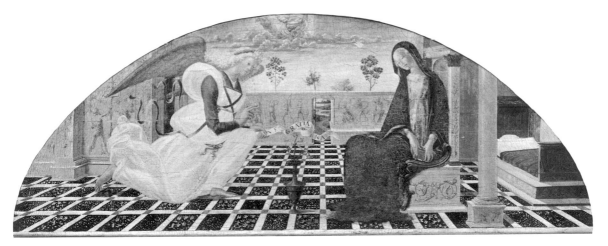

144

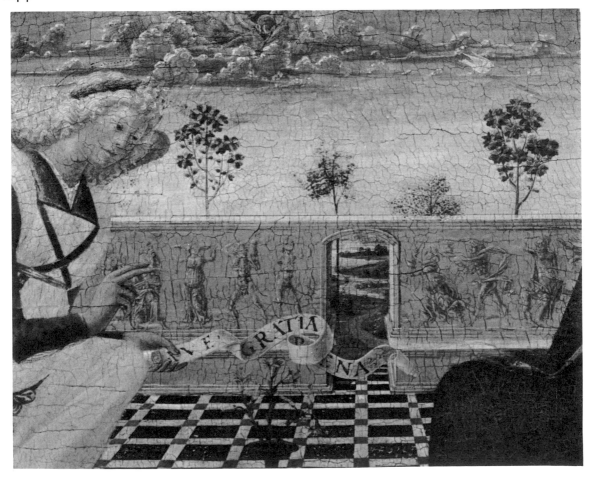

144, detail

145a,b. ANNUNCIATION, ca. 1495*

Bequest of Maitland F. Griggs, B.A., 1896. 1943.257a,b.

Egg tempera on panel. Angel, 32.4 × 20.8 cm. (12¾ × 8³⁄₁₆ in.); Virgin, 32.3 × 21.1 cm. (12¹¹⁄₁₆ × 8⁵⁄₁₆ in.). The Angel was cleaned in 1966, the Madonna in 1968.

CONDITION: Fair to good; rubbed in several places and losses of pigment in the background with additional losses in the gilt border.

PROVENANCE: Maitland F. Griggs Collection, New York.

EXHIBITION: New York, Century Association, 1930.

BIBLIOGRAPHY: Berenson 1932, p. 158 (as Guidoccio Cozzarelli); Van Marle, *16* (1937), p. 467 (as Bernardino Fungai); Berenson 1968, *1*, p. 151 (as Fungai).

Since the recent cleaning of both panels, the style emerges as one most likely to belong to a weak studio follower of Fungai in Siena, or possibly even that of a more provincial imitator.

GIROLAMO DI BENVENUTO (Girolamo di Benvenuto di Giovanni del Guasta)

Born in 1470, in Siena, he seems to have worked with his father, Benvenuto di Giovanni, from an early date and to have collaborated on a number of works. He died in 1524, just six years after his father.

146. LOVE BOUND BY MAIDENS, ca. 1500*

University purchase from James Jackson Jarves. 1871.65.

Egg tempera on wood panel. Twelve-sided, 66.5 cm. (26³⁄₁₆ in.). Restored 1915; cleaned in 1960.

CONDITION: On the whole good, although some losses are scattered over the surface. A separation crack runs through the center. Had been much repainted.

PROVENANCE: James Jackson Jarves Collection, Florence.

EXHIBITIONS: New York "Institute of Fine Arts," 625 Broadway, 1860; New-York Historical Society, 1863; (both as Pinturicchio).

BIBLIOGRAPHY: Jarves 1860, p. 53 (as Pinturicchio); Sturgis 1868, p. 66 (as Pinturicchio); Sirén 1916, pp. 165–66 (as Girolamo di Benvenuto); Offner 1927, p. 7 (as Girolamo di Benvenuto); Berenson 1932, p. 253 (as Girolamo di Benvenuto); Van Marle, *16* (1937), pp. 422–24 (as Girolamo di Benvenuto); B. B. Fredericksen and D. D. Davisson, *Benvenuto di Giovanni, Girolamo di Benvenuto: A Summary Catalogue of Their Paintings in America,* J. Paul Getty Museum, p. 32 (as Girolamo di Benvenuto); Berenson 1968, *1,* p. 187 (as Girolamo di Benvenuto).

After Sirén (see above) the attribution to Girolamo di Benvenuto has remained stable. The reverse side of the panel shows the coat of arms of the Piccolomini family combined with that of the Griselli (?). This panel was certainly a marriage salver on which wedding gifts were presented. The original frame is lost, though the basis for attachment on the panel is present.

GIROLAMO DI BENVENUTO (imitator of ?)

147. NATIVITY, ca. 1510*

Bequest of Maitland F. Griggs, B.A., 1896. 1943.259.

Egg tempera on panel. 59.9 × 45.4 cm. (23⁹⁄₁₆ × 17⅞ in.). Restored in 1944; cleaned in 1959.

CONDITION: Poor; much rubbed; the faces of the Virgin and St. Joseph had been completely repainted. The frame is original.

PROVENANCE: From an unknown English (?) collection (sale of the collections, Duke of Westminster and others, Christie's, 1924, name of owner not given); Maitland F. Griggs Collection, New York.

BIBLIOGRAPHY: Van Marle, *16* (1937), p. 421 (as Girolamo di Benvenuto); B. B. Fredericksen and D. D. Davisson, *Benvenuto di Giovanni, Girolamo di Benvenuto: A Summary Catalogue of Their Paintings in America,* J. Paul Getty Museum, 1966, p. 33 (as Girolamo di Benvenuto).

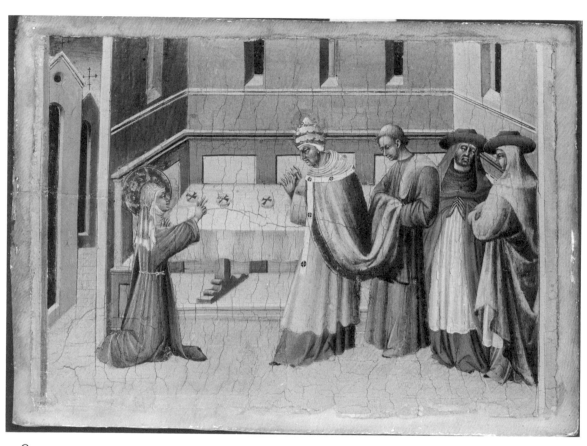

148

In the sale of 1924, the panel was listed as by Bernardino Fungai. Fredericksen and Davisson place the picture late, "probably after 1510." It would seem to be an early 16th-century piece based on Girolamo's ideas but more provincial by a good margin than even some of his studio followers' work.

GIOVANNI DI PAOLO

Giovanni di Paolo was born in Siena about 1403, and as a young man probably studied under Paolo di Giovanni Fei. Later, like his contemporary Sano di Pietro, he came strongly under the influence of Sassetta. By 1428 he was a member of the Guild of Saint Luke in Siena, and throughout his long career produced many works illustrating biblical and legendary scenes popular with the Sienese. He died in Siena in 1482.

148. ST. CLARA OF ASSISI BLESSING THE BREAD BEFORE POPE
 INNOCENT IV, ca. 1460

University purchase from James Jackson Jarves. 1871.59.

Egg tempera on panel. 21.6 × 30.1 cm. (8½ × 11⅞ in.). Cleaned 1950–52.

CONDITION: Good except for some cracking and the repainting above the Pope's head. Losses of paint around the edges of the panel where it was once covered by a frame have been inpainted in neutral tones.

PROVENANCE: James Jackson Jarves Collection, Florence.

EXHIBITIONS: New York "Institute of Fine Arts," 625 Broadway, 1860; New-York Historical Society, 1863 (both times as Giovanni di Paolo).

BIBLIOGRAPHY: Jarves 1860, p. 47, no. 45; Sturgis 1868, p. 55, no. 51; F. M. Perkins, *Rassegna d'arte senese, 1* (1905), pp. 76–77; Sirén 1916, pp. 155–56; Offner 1927, pp. 7, 39–40; S. L. Faison, Jr., *Y.U.A.G. Bulletin, 7,* no. 1 (Feb. 1936), p. 13; J. Pope-Hennessy, *Giovanni di Paolo,* London, 1937, p. 172; *Y.U.A.G.* 1952, p. 29; *Verzeichnis der Ausgestellten Gemälde des 13 bis 18. Jahrhunderts im Museum Dahlem,* Berlin, 1964, p. 53 (all as Giovanni di Paolo); Berenson 1968, *1,* p. 178 (as Giovanni di Paolo; companion to Berlin and Houston panels).

The scene follows the account of an incident in the Life of St. Clara ascribed to Thomas of Celano. At the time of an illness she was nourished only by the sacrament—shown here in the form of three loaves on the table, with a cross on each. The Yale panel was once part of a predella which showed, beside this scene, three other scenes from the life of St. Clara. Two of these, *The Investiture of St. Clara* by St. Francis and *St. Clara Saving a Ship in Distress,* which were, before World War II, in the Fuld Collection, Frankfurt-am-M., and the Reiling Collection, Mainz, are now held by the Staatliche Museum, Dahlem (West Germany). The third, *St. Clara Resuscitating a Child Mauled by a Wolf,* formerly in the Percy S. Straus Collection, New York, is now in the Museum of Fine Arts, Houston.

GIOVANNI DI PAOLO (shop of ?)

149. A TRIUMPH OF LOVE (?), ca. 1475*

Gift of Maitland F. Griggs, made anonymously, 1926. 1926.9.

Monochrome fresco fragment, ochre and white, with touches of red and green. 77.4 × 101.6 cm. (30½ × 40 in.).

CONDITION: Good, though somewhat cracked; cracks refilled and retouched.

INSCRIPTION: Below neck of female to left of central figure, ARTEMISIA.

PROVENANCE: Maitland F. Griggs Collection, New York; no earlier history available.

BIBLIOGRAPHY: S. L. Faison, Jr., in *Y.U.A.G. Bulletin, 7,* no. 1 (Feb. 1936), pp. 11–13.

Petrarch included Artemisia, widow of Mausolus and the legendary patroness of the famous Mausoleum of Halicarnassus, among the heroines of his *Triumph of Love* in the sequence of his *Trionfi.* She is very possibly shown here with Mausolus. Erwin Panofsky, *in litteris,* suggested that the figure at the extreme l. "might well be a Theseus." Another monochrome fresco, a *Last Supper,* attributed to Giovanni di Paolo by Brandi, is in the Convent of Sant' Agostino,

Monticiano; such secular subjects at this date in Siena are of extreme rarity. It is possible that the follower of Giovanni di Paolo who was responsible for the fragment at Yale was the chief assistant in the artist's last period (ca. 1460–82), Giacomo del Pisano, still a somewhat shadowy personality but to whom paintings much in the style of the Yale fragment have been attributed. (See F. R. Shapley, *Paintings from the Samuel H. Kress Collection, Italian Schools, XIII–XV Century,* London, 1966, p. 150, in discussion of a *Madonna and Angels* now in Madison, Wisconsin.)

GIOVANNI DI PAOLO (shop of)

150. MADONNA AND CHILD WITH SS. JEROME AND BARTHOLOMEW, ca. 1450*

Bequest of Maitland F. Griggs, B.A., 1896. 1943.255.

Egg tempera on wood panel. 53.6 × 40.6 cm. (21⅛ × 16 in.), including frame. Cleaned in 1953.

CONDITION: Excellent; only one tiny loss of pigment. Frame is original.

PROVENANCE: Dr. Cottin, Paris; Maitland F. Griggs Collection, New York.

EXHIBITIONS: New York, Century Association, 1930; Chicago Art Institute, "Masterworks from the Yale Collections," 1956.

BIBLIOGRAPHY: Van Marle, 9 (1927), p. 430 (as Giovanni di Paolo); Berenson 1932, p. 246 (as Giovanni di Paolo); J. Pope-Hennessy, *Giovanni di Paolo,* London, 1937, pp. 28–29, 52, 73 (as Giovanni di Paolo, ca. 1436); Berenson 1968, *1,* p. 178 (as Giovanni di Paolo).

The panel seems to be later than ca. 1436 and closer to the style illustrated by Pope-Hennessy in his pl. 14, a *Madonna and Child* of 1453 in the Metropolitan Museum of Art. In a lecture in 1927 Offner described the panel as "formula of Giovanni di Paolo, but not his style." The present attribution to the shop, ca. 1450, is based on that stylistic analysis, which after cleaning seems more than ever plausible.

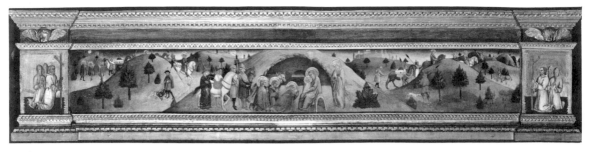

152

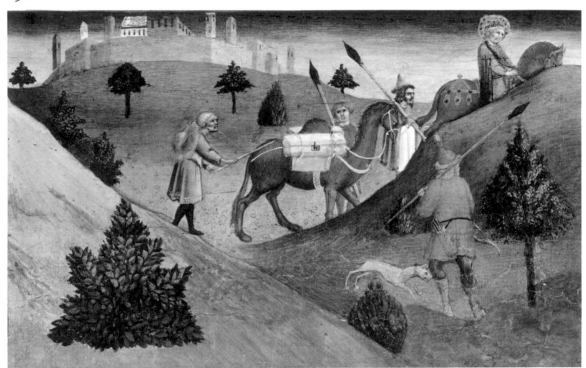

152, detail

152, detail

SIENESE SCHOOL, XV century

151. NATIVITY (in the initial letter *P*), manuscript illumination, ca. 1480*

Gift of Robert Lehman, B.A., 1913, in the name of Mr. and Mrs. Albert E. Goodhart. 1954.7.5.

Body color and gilt on parchment. Fragment cut from a page of a choral book. 59.7 × 42.6 cm. (23½ × 16¾ in.).

CONDITION: Good to excellent.

PROVENANCE: Lehman Collection, New York (acquired in Paris, 1953).

BIBLIOGRAPHY: Unpublished, so far as is known.

In a note of 1935 now in the curator's file Toesca wrote his opinion that the fragment is clearly Sienese and belongs to the same type of illuminated choir book as those on exhibition in the Piccolomini Library in the Siena Cathedral. The style is close to that of Cozzarelli.

SANO DI PIETRO

His real name was Ansano di Pietro di Mencio. Born in Siena in 1406, Sano studied first with Taddeo di Bartolo and subsequently was strongly influenced by Sassetta. Bernard Berenson has also connected him with the "Osservanza Master" with whom Sassetta has sometimes been identified. Sano's apprenticeship ended in 1428 when he executed his first commission, a painted model for the upper portion of the baptismal font of S. Giovanni. Later a highly popular and prolific painter, Sano filled commissions for the decoration of many of Siena's most important buildings. A large and active workshop grew up around him enabling him to fulfill an undiminished demand for his work. After an unusually long career, Sano died in Siena in 1481.

152. ADORATION OF THE MAGI, ca. 1450

University purchase from James Jackson Jarves. 1871.61.

Egg tempera on panel. 21 × 178.5 cm. (8¼ × 70¼ in.). Restored, 1915; restored and cradled 1931–32; restored 1944–45 by Riportella, New York.

CONDITION: Obscured by repaints and heavy resinous varnish, but except in lower central area appears to be good.

PROVENANCE: James Jackson Jarves Collection, Florence.

EXHIBITIONS: New York "Institute of Fine Arts," 625 Broadway, 1860; New-York Historical Society, 1863 (both times as Sano).

BIBLIOGRAPHY: Jarves 1860, p. 47, no. 43; Sturgis 1868, p. 54; F. M. Perkins, in *Rassegna d'arte senese, 1* (1905), p. 76; Sirén 1916, pp. 158–59; E. Gaillard, *Un Peintre siennois au XVe siècle: Sano di Pietro,* Chambéry, 1923; Offner 1927, p. 7; Berenson 1932, p. 500; Berenson 1968, *1,* p. 376 (all as Sano di Pietro).

This *Adoration* formed the predella to an altarpiece of which the main panel has not yet been identified. The frame on the *Adoration* is modern, but the two small panels flanking the scene appear to be original. They depict praying members of the Bianchi, a brotherhood which drew its name from the white robes and cowls worn by its adherents.

SANO DI PIETRO (shop of)

153. CORONATION OF THE VIRGIN, ca. 1450

University purchase from James Jackson Jarves. 1871.60.

Egg tempera on panel. 75.5 × 62.2 cm. (29¾ × 24½ in.). Restored and cradled 1915; recradled and restored 1929; cleaned, 1960.

CONDITION: Generally very good, except for slight rubbing in flesh tones and some of the angels' halos.

PROVENANCE: James Jackson Jarves Collection, Florence.

EXHIBITIONS: New York "Institute of Fine Arts," 625 Broadway, 1860; New-York Historical Society, 1863 (both times as Sano di Pietro).

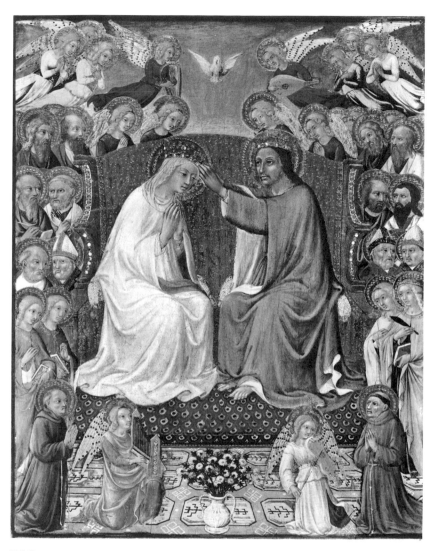

153

BIBLIOGRAPHY: Jarves 1860, p. 47, no. 44; J. J. Jarves, *Art Studies,* New York, 1861, pl. 6, p. 227, engraved by Stanghi; Sturgis 1868, p. 54; Jarves 1871, p. 19; Rankin 1895, p. 143; F. M. Perkins, in *Rassegna d'arte senese,* *1* (1905), p. 76; J. A. Crowe and G. B. Cavalcaselle, *A History of Painting in Italy,* 5, ed. T. Borenius, London, 1914, p. 174; Sirén 1916, pp. 157–58; E. Gaillard, *Un Peintre siennois au XV siècle: Sano di Pietro,* Chambéry, 1923, pp. 174, 204; Van Marle, 9 (1927), p. 521; Offner 1927, p. 7; Berenson 1932, p. 500; G. H. Edgell, *A History of Sienese Painting,* New York, 1932, p. 212; Berenson 1968, *1,* p. 376 (all as Sano di Pietro).

The Coronation of the Virgin was one of the most popular subjects with the Sienese since the Virgin was the patroness of their city-state. In the Jarves *Coronation* the four patron bishop-saints of Siena are present as well as S. Bernardino, first head of the Order of the Franciscan Observants, who was canonized in 1450. Sano di Pietro portrayed this subject in some of his best-known works such as the monumental pictures in the Pinacoteca and the Sala di Biccherna of the Palazzo Pubblico in Siena (1445). However, while the Jarves *Coronation* is closely connected with Sano's style and compositional type, the figures lack the kind of elegance that generally characterizes his work.

SANO DI PIETRO (shop of)

154. MARTYRDOM OF A BISHOP, ca. 1460*

University purchase from James Jackson Jarves. 1871.62.

Egg tempera on panel. 21 × 38.7 cm. (8½ × 15½ in.). Cradled, cleaned, restored in 1915; cleaned in 1956.

CONDITION: In general good, except for rubbing in the faces and the legs of the figure furthest to the l.; scattered scratches.

PROVENANCE: James Jackson Jarves Collection, Florence.

EXHIBITIONS: New York "Institute of Fine Arts," 625 Broadway, 1860; New-York Historical Society, 1863 (both times as Giovanni di Paolo, attributed to).

BIBLIOGRAPHY: Jarves 1860, p. 48 (as Giovanni di Paolo, attributed to); Sturgis 1868, p. 55 (as Giovanni di Paolo, attributed to); Sirén 1916, pp. 159–60 (as close follower of Sano di Pietro); Berenson 1932, p. 246 (as Giovanni di Paolo); Berenson 1968, *1*, p. 178 (as the same).

The Jarves *Martyrdom,* evidently a fragment of a predella, is clearly closer to the manner of Sano, especially to his miniature style, than to that of Giovanni di Paolo to whom the picture had earlier been attributed. However, the rather squat, weakly-modeled figures indicate that the picture must be shopwork rather than by the master's own hand.

SANO DI PIETRO (shop of)

155. MADONNA AND CHILD WITH SAINTS AND ANGELS, ca. 1470*

Bequest of Maitland F. Griggs, B.A., 1896. 1943.254.

Egg tempera on panel. 60.5 × 45.1 cm. (23¹³⁄₁₆ × 17¾ in.). Cleaned in 1954.

CONDITION: Fair; losses in Virgin's blue robe, evidently caused by early cleaning with harsh alkali. The frame is evidently original; original gilt background and punchwork of halos in fine state.

INSCRIPTIONS: On Virgin's halo, AVE GRATIA PLENA DOMINUS TE(CUM) (Luke 1:28); St. Bernardino's tablet, [IH (S], much rubbed.

PROVENANCE: Dan Fellows Platt Collection, Englewood, New Jersey; Maitland F. Griggs Collection, New York.

BIBLIOGRAPHY: Van Marle, 9 (1927), p. 527, n. 2 (as school of Sano).

A bottega variant of a most popular composition which Sano evidently originated.

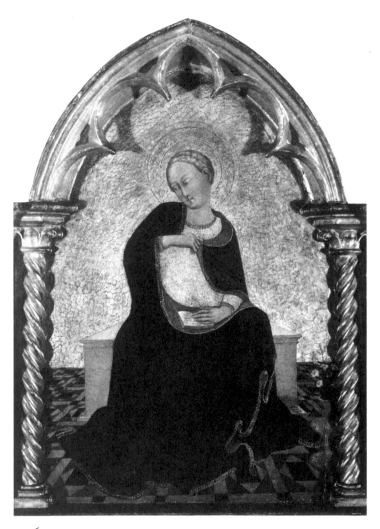

156

STEFANO DI GIOVANNI (called Sassetta)

Stefano di Giovanni di Consolo da Cortona was born about the beginning of the 15th century. In which Sienese workshop his earliest training took place is a matter of speculation. Sassetta's first important commission was the altarpiece of 1423–26 for the Arte della Lana (Siena's wealthy wool-making guild). From the completion of that work until his death in 1450, Sassetta painted primarily in Siena; the major commissions were the *Madonna of the Snows* for the Duomo (1430–32) and the polyptych for the high altar of the Church of S. Francesco at Borgo S. Sepolcro (completed 1444). He had a large bottega with many followers; the most prominent of his pupils were Sano di Pietro and Vecchietta.

156. VIRGIN ANNUNCIATE, ca. 1430

Gift of Hannah D. and Louis M. Rabinowitz. 1959.15.5.

Egg tempera on panel. 80 × 54.6 cm. (31½ × 21½ in.). Not cleaned.

CONDITION: From observation of infrared photographs of the panel, only fair. There seems to have been extensive overpainting in the area of the Madonna's robe and the tiled floor, as well as a vertical abrasion on the panel's r. side. The frame around the panel is modern, as is the inscription.

PROVENANCE: Believed to have been in Italy, perhaps at Chiusdino, until 1936; Ex-Collection Langton Douglas, London; Dan Fellows Platt, Englewood, New Jersey; Rabinowitz Collection, Sands Point, Long Island.

EXHIBITIONS: New York, E. and A. Silberman Galleries, 1955.

BIBLIOGRAPHY: F. M. Perkins, in *Rassegna d'arte, 12* (1912), p. 196; Giacomo de Nicola, in *BurlM, 23* (1913), pp. 277–83; Van Marle, 9 (1927), pp. 334, 357; L. Venturi, pl. CXI; Berenson 1932, p. 512; G. H. Edgell, *A History of Sienese Painting,* New York, 1932, p. 192; Berenson, *Pitture italiane del rinascimento,* Milan, 1936, p. 440; J. Pope-Hennessy, *Sassetta,* London, 1939, pp. 27, 53; *Rabinowitz Coll.* 1945, pp. 13–14; J. Pope-Hennessy, *Sienese Quattrocento Painting,* London, 1947, p. 25; J. Pope-Hennessy, in

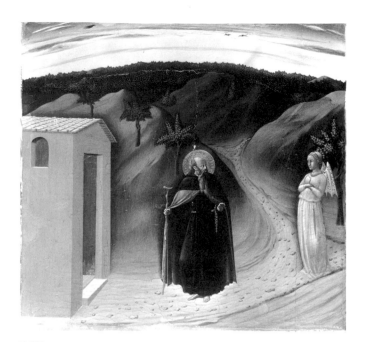

157

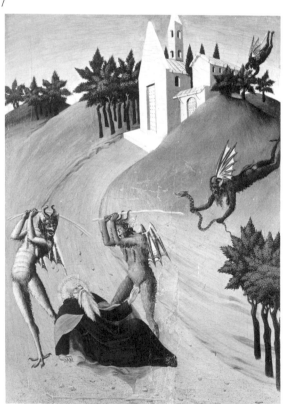

158

BurlM, 98 (1956), pp. 365–70; F. Zeri, in *BurlM, 98* (1956), pp. 36–39; E. Carli, *Sassetta e il Maestro dell'Osservanza,* Milan, 1957, pp. 9–13; *Rabino-witz Coll.* 1961, pp. 22–23 (all as Sassetta); Berenson 1968, *1,* p. 386 (calls the panel the companion to the Massa Marittima *Angel*).

It would appear redundant to try to verbalize the combination of delicate lyricism and majestic elegance with which Sassetta has imbued this *Virgin Annunciate.* With her humble yet articulate pose, the graceful sweep of her robe and above all her receptive expression, the Madonna tenderly sums up Sassetta's religious and esthetic attitudes. This panel once formed part of the altarpiece of the *Madonna of the Snows* painted by Sassetta between 1430 and 1432 for the Chapel of St. Boniface in the Cathedral of Siena. That altar remained intact in the cathedral until late in the 16th century, but the parts were subsequently dispersed. What was, on convincing visual evidence, the companion angel to this Madonna is now in Massa Marittima, a small center to the southwest of Siena. The central panel and predella are in the Contini-Bonacossi Collection in Florence.

SASSETTA (?) OR "OSSERVANZA MASTER"

The "Osservanza Master" is so called from the large unsigned altarpiece in the Church of the Osservanza (in the environs of Siena) which appears to be a major work by a still unidentified Sienese painter associated with Sassetta. The temporary name of this artist, first proposed by Graziani following a lead provided by Longhi, had been steadily gaining acceptance over the past decade, particularly among Italian scholars.

157. TEMPTATION OF ST. ANTHONY, ca. 1430 (?)

University purchase from James Jackson Jarves. 1871.57.

Egg tempera on panel. 37.7 ×40.1 cm. (14⅞ × 15¹³⁄₁₆ in.). Restored, 1915; cradled, restored, 1928; cleaned and inpainted, 1950–52.

CONDITION: In most areas of the surface, good; however, a serious crack extends longitudinally through the landscape behind the saint and the figure of

the saint with chipping and loosening of the pigment near it. A complete loss of pigment in a broad stretch of the sky and trees at the horizon was repainted in the 19th (?) century, with a fanciful horizon of trees and the equally fanciful addition of several birds in the sky; smaller losses occurred in the little hut at the l. These losses have been inpainted and, in 1950–52, a reconstruction of the horizon area, based on traces of the original pigment found in microscopic quantities in the gesso cracks, was attempted. The style of inpainting permits a clear differentiation between original and reconstructed areas.

PROVENANCE: James Jackson Jarves Collection, Florence.

EXHIBITIONS: New York "Institute of Fine Arts," 625 Broadway, 1860; New-York Historical Society, 1863 (both times as Sassetta); Y.U.A.G., "Rediscovered Italian Paintings," 1952 (as Sassetta); Chicago Art Institute, "Masterworks from the Yale Collections," 1956 (as Sassetta); Northampton, Massachusetts, Smith College Art Museum, 1956 (as Sassetta).

BIBLIOGRAPHY: Jarves 1860, p. 48 (as Sassetta); Sturgis 1868, p. 53 (as Sassetta); B. Berenson, in *BurlM, 3* (1903), p. 180 (as Sassetta); Sirén 1916, pp. 152–54 (as Sassetta); Van Marle, 9 (1927), pp. 319–20 (as Sassetta); Offner 1927, pp. 7, 39–40 (as Sassetta); E. K. Waterhouse, in *BurlM, 59* (1931), pp. 108, 112, 113 (as Sassetta); Berenson 1932, p. 512 (as Sassetta); J. Pope-Hennessy, *Sassetta,* London, 1939, pp. 70–71, 74–77, 82, 83, 85, 86, 92, 115 (as Sassetta); R. Longhi, in *Critica d'arte, 5* (1940), pp. 188–89 (not Sassetta); A. Graziani, in *Proporzioni, 2* (1948), pp. 76, 83, 84 (as "Osservanza Master"); C. Brandi, *Quattrocentisti senesi,* Milan, 1949, pp. 79, 255, 256, 284 (as "Osservanza Master"); C. Seymour, Jr., in *Journal of the Walters Art Gallery, 15–16* (1952–53), pp. 32–45, 97 (as Sassetta ?); J. Pope-Hennessy, in *BurlM, 98* (1956), pp. 364–66, 368, 369 (as Sassetta); E. Carli, *Sassetta e il Maestro dell' Osservanza,* Milan, 1957, pp. 104–121 (as "Osservanza Master"); F. R. Shapley, *Paintings from the Samuel H. Kress Collection, Italian Schools, XIII–XV Century,* London 1966, p. 142 (as Sassetta and assistant); Berenson 1968, *1,* p. 253 (as "Osservanza Master"—"see Washington").

This panel (with 1871.58, following) belonged to what evidently was a major but still undated Sienese altarpiece on the subject of St. Anthony and incidents from his legend. The upper portion of the central panel of the saint is usually recognized as a fragment now in the Louvre. The other extant smaller panels are scattered, outside the Yale University Art Gallery, among the Lehman Collection, New York; the National Gallery, Washington, D.C. (Kress Collection); and the Staatliche Museum in Dahlem; in all, eight panels from the saint's legend have come to light.

To treat at all adequately the question of the attribution of 1871.57 and 1871.58 would involve a lengthy study. The most recent discussion of the extensive bibliography is in F. R. Shapley (see above, pp. 141–43). In most ways the total scholarly situation surrounding the *St. Anthony* altarpiece has not changed essentially since the visual evidence after the cleaning of the Jarves-Yale panels was published some years ago in the *Journal of the Walters Art Gallery* (see above). The attribution given here leans away, as can be seen, from Sassetta toward the still mysterious and intriguing "Osservanza Master." If a clean-cut and definite choice had to be made between the two, the latter attribution, i.e., to the "Osservanza Master," would receive the compiler's vote. The question is in so controversial a state at present that the matter is better left with a provisional conclusion. Most scholars of Sienese painting have taken their own positions in any event; for students and the public the freedom to choose among conflicting views that is suggested by our attribution has certain evident advantages.

SASSETTA (close follower of; Sano di Pietro?)

158. ST. ANTHONY TORMENTED BY DEMONS, ca. 1430 (?)

University purchase from James Jackson Jarves. 1871.58.

Egg tempera on panel. 47.5 × 34.3 cm. (18$\frac{11}{16}$ × 13$\frac{1}{2}$ in.). Restored, cradled 1928; cleaned, 1950–52.

CONDITION: With the exception of a long candle burn in the central lower area, excellent; the candle burn has been inpainted in such a way that it is differentiated from the original adjacent areas.

PROVENANCE: As above for 1871.57.

EXHIBITIONS: As above for 1871.57 except for the following additions: Boston, Museum of Fine Arts, "Arts of the Middle Ages," 1940; Brooklyn Museum, "European and American Landscape Painting," 1945–46.

BIBLIOGRAPHY: References as above for 1871.57 except: Jarves 1860 (as Sienese school, ca. 1440); Sturgis 1868 (as Sienese school, 1425–50).

After the cleaning of 1950–52, it became evident that Jarves had been correct initially in separating the hands responsible for 1871.57 and 1871.58. The latter is apparently by a follower of the master, whether Sassetta (?) or the "Osservanza Master," responsible for the *Temptation* (1871.57). The identity of this follower is not clear. The young Sano di Pietro has been suggested; this might well end up as the most plausible of the presently considered possibilities.

North Italian Schools

GIOVANNI BATTISTA BERTUCCI (attributed to)

An eclectic artist who was a native of Faenza, he was called Bertucci the Elder. He was influenced by the Umbrians as well as the Florentines. In recent years he has been identified with Giovanni Battista Utili, who is believed to have been active in the last years of the Quattrocento and during the first quarter of the Cinquecento. He is first mentioned in documents in 1503; the last mention is in 1516.

159. MADONNA AND CHILD WITH SAINTS, ca. 1505*

University purchase from James Jackson Jarves. 1871.92.

Oil on panel. 54.5 × 34.1 cm. (21⁷⁄₁₆ × 13⁷⁄₁₆ in.). Cradled, restored, 1915; uncleaned.

CONDITION: On the whole, good; some cupping of the pigment and repaint appears in the area of the Madonna's robe; elsewhere cupping of the paint surface is quite evident, but with as yet no serious losses.

INSCRIPTION: On scroll of bishop-saint to left, c⁵s (added?).

PROVENANCE: James Jackson Jarves Collection, Florence.

EXHIBITIONS: New York "Institute of Fine Arts," 625 Broadway, 1860; New-York Historical Society, 1863 (both times as Lo Spagna).

BIBLIOGRAPHY: Jarves 1860, p. 56 (as Lo Spagna); Sturgis 1868, p. 79 (as Lo Spagna); Sirén 1916, pp. 225–26 (as Bertucci); Offner 1927, p. 8 (as Bertucci); Berenson 1932, p. 82 (as Bertucci); Berenson 1968, *I*, p. 51 (no change).

The attribution to Bertucci appears relatively sure. A comparable signed work of 1506 in Faenza was mentioned by Sirén. The composition appears to reproduce or to follow closely one by the Umbrian painter Pinturicchio.

GIROLAMO DA CREMONA (most probably with Liberale da Verona)

North Italian painter who was active in Siena from 1467 to 1483 according to the documents. He is best known for his miniatures, on a monumental scale for that genre, in the choir books of Siena Cathedral, now preserved in the Piccolomini Library.

160. NATIVITY, ca. 1473*

University purchase from James Jackson Jarves. 1871.71.

Egg tempera transferred from panel to canvas. 66 × 42.1 cm. (26 × 16⅝ in.). Restored 1915; cleaned, 1961.

CONDITION: On the whole good. There are scattered small losses and some abrasion from rubbing. The transfer was made by J. Howorth in Boston, 1867, and shows the same technique as that of the Pollaiuolo *Hercules and Deianira* (see no. 123, above).

PROVENANCE: James Jackson Jarves Collection, Florence.

EXHIBITIONS: New York "Institute of Fine Arts," 625 Broadway, 1860; New-York Historical Society, 1863 (both as Squarcione).

BIBLIOGRAPHY: Jarves 1860, p. 52 (as Squarcione); Sturgis 1868, p. 56 (still as Squarcione); Rankin 1895, p. 149 (for the first time as Girolamo da Cremona); Sirén 1916, pp. 181–82, and Offner 1927, p. 41 (as Girolamo da Cremona); Berenson 1932, p. 132 (as Girolamo da Cremona); R. Longhi, in *Paragone, 6,* no. 65 (May 1955), p. 3 (suggests Liberale da Verona); C. del Bravo, in *Paragone, 11,* no. 129 (Sept. 1960), p. 31 (as Liberale with Girolamo); F. Zeri, in *BdA, 48* (1964), p. 41 (again to Girolamo); C. del Bravo, *Liberale da Verona,* Florence, 1967, p. CX (as Liberale); Berenson 1968, *1,* p. 190 (as Girolamo).

For a large miniature attributed to Girolamo, see no. 161 below. Though Lon-
ghi's argument for a change in attribution to Liberale da Verona (a younger
contemporary) is persuasive in a general way, it seems wiser to retain with a
question the older view recently reargued by Zeri (see above), with the strong
probability, as suggested by del Bravo in 1960 (see above), that Liberale
worked in collaboration with Girolamo on this panel, as it is known they did in
their manuscript miniature production.

GIROLAMO DA CREMONA (attributed to)

161. GOD THE FATHER (in the initial letter *O*), manuscript
illumination, ca. 1465–70*

Gift of Robert Lehman, B.A., 1913, in the name of Mr. and Mrs. Albert E.
Goodhart. 1954.7.2.

23.9 × 19.4 cm. (9 7/16 × 7⅝ in.). Fragment cut from a page.

CONDITION: Good to excellent.

PROVENANCE: Lehman Collection, New York (acquired in Paris, 1953).

BIBLIOGRAPHY: Unpublished, so far as is known.

"MASTER OF THE ASSUMPTION OF MARY MAGDALEN"
(attributed to)

A still anonymous Ferrarese painter, whose temporary name is taken from his
most important work, an *Assumption of the Magdalen* in the Pinacoteca Fer-
rara. He is considered to have been active at the end of the Quattrocento and
first quarter of the Cinquecento.

162. CRUCIFIXION, ca. 1510–15

Bequest of Maitland F. Griggs, B.A., 1896. 1943.261.

Egg tempera (?) transferred to a new panel. 102.4 × 74.9 cm. (40⁵⁄₁₆ × 29½ in.). Cleaned, 1950.

CONDITION: Good to excellent, except for a serious crack running through the figure of Christ which has been filled and inpainted. A pediment by a totally different hand, which clearly never had any historical connection with the panel, has been removed; see no. 168 of this catalogue, 1943.261a.

INSCRIPTION: Repeating an authentic one (?) on frame, barely legible with many doubts, as follows, AP . XX . DEC (V?) . GNO . 144 (?) FERAR OP (L?)

PROVENANCE: Ex-Santini Collection, Ferrara; Canessa Collection (sale New York, 1924); Maitland F. Griggs Collection, New York.

BIBLIOGRAPHY: A. Venturi, in *L'Arte*, 6 (1903), pp. 141–42 (as "Master of the Egyptian Magdalen"); A. Venturi, 7, pt. 3 (1914), pp. 826–28 (as Ercole Grandi); F. Filippini, in *BdA*, *11* (1917), p. 57, n. 3 (as Michele Costa with question); Berenson 1932, p. 267 (as Ercole Grandi); R. Longhi, *Officina Ferrarese*, Florence, 1956, pp. 67, 107, 226 (as "Master of the Assumption of Mary Magdalen"); Berenson 1968, *1*, p. 133 (as Ferrarese-Bolognese, 1480–1525; "same hand as Ferrara 'Assumption of St. Mary of Egypt'" [an iconographical change from the more familiar identification as St. Mary Magdalen]).

The panel is a most interesting example of the fusion of North European, primarily Flemish, trends and motifs with Italian, particularly the pale distant landscape and the delicate gestures of the Virgin and St. John which are dependent on the style of the Ferrarese Ercole Roberti and also of Francia. Our painting at least since 1914 has been associated in the literature with the *Magdalen in Glory (Assumption of the Magdalen)* in Ferrara and the question of its attribution hinges on what one believes to be the personality responsible for the Ferrara painting. The present attribution follows that of Longhi (see above) who for plausible reasons has argued against the authorship of Ercole Grandi for the painting in Ferrara, and instead has supplied the temporary name of "Master of the Assumption of Mary Magdalen."

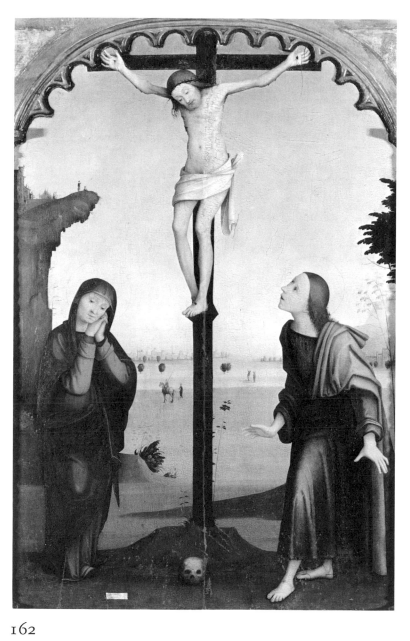

162

MARCHIGIAN SCHOOL, mid-XV century

163. MADONNA AND CHILD WITH SAINTS, ca. 1450*

Bequest of Maitland F. Griggs, B.A., 1896. 1943.266.

Egg tempera on panel. Panel within frame 80.3 × 104.8 cm. (31⅝ × 41¼ in.). Cleaned in 1958.

CONDITION: Poor; much rubbed. The frame is original.

PROVENANCE: Maitland F. Griggs Collection, New York.

BIBLIOGRAPHY: Unpublished.

The attribution is based on Offner's verbal opinion given in a lecture in 1927.

BARTOLOMMEO DEGLI ERRI (attributed to)

Younger brother of Agnolo degli Erri, and active from ca. 1460 in Modena. In 1462–66 he collaborated with Agnolo on a large altarpiece now in the Modena Museum. He was also responsible for work on two large altars for S. Domenico in Modena: one on the subject of St. Dominic, the other on St. Thomas Aquinas (see below).

164. BIRTH OF ST. THOMAS AQUINAS, ca. 1470

University purchase from James Jackson Jarves. 1871.41.

Egg tempera on panel. 44 × 32.7 cm. (17⁵⁄₁₆ × 12⅞ in.). Cleaned in 1961.

CONDITION: A good deal of rubbing, but no serious losses, except along a long crack to the l. of the stairs with resulting danger to fragment; the summit was originally a polylobed arch.

PROVENANCE: James Jackson Jarves Collection, Florence.

EXHIBITIONS: New York "Institute of Fine Arts," 625 Broadway, 1860; New-York Historical Society, 1863 (both times as Masaccio).

BIBLIOGRAPHY: Jarves 1860, p. 51 (as Masaccio); Sturgis 1868, pp. 49–50 (as Masaccio, repeating Jarves' theory that the panel was originally part of the Carmine polyptych in Pisa, mentioned by Vasari); Sirén 1916, pp. 107–10 (as

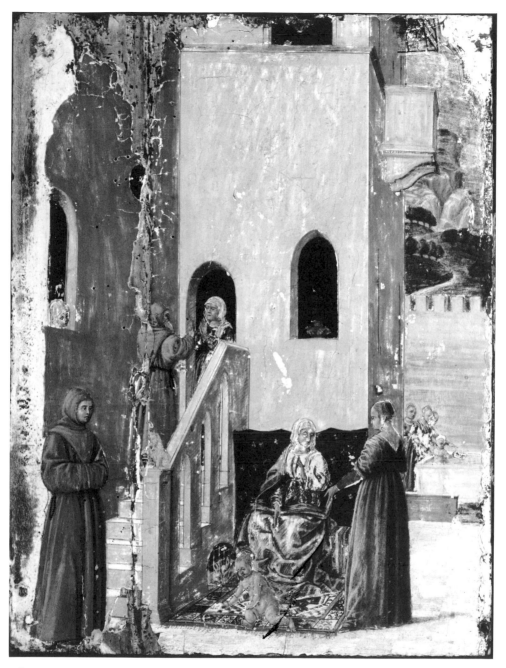

164

Alessio [sic] Baldovinetti); B. Berenson, *Three Essays in Method,* New Haven, 1927, pp. 2 ff. (as Domenico Morone); Berenson 1932, p. 376 (as Domenico Morone); R. Longhi, *Officina Ferrarese, Ampliamenti,* Ferrara, 1940, p. 39, n. 3 (referring to Yale and other related paintings as a group, as Erri brothers); C. L. Ragghianti, in *La Critica d'arte, 4* (1939), part II, pp. 1 ff. (with related panels, as Erri brothers); A. M. Chiodi, in *Commentari, 2* (1951), pp. 19, 21 (as Bartolommeo degli Erri); R. Longhi, *Officina Ferrarese,* new ed., Florence, 1956, p. 219 (as Bartolommeo degli Erri); Berenson 1968, *1,* p. 281 (as Domenico Morone).

Related panels are in the following collections: *St. Thomas Aquinas Aided by St. Peter and St. Paul,* Metropolitan Museum of Art, New York; *St. Thomas Aquinas and St. Louis, King of France,* Paravicini Collection, Paris; *St. Thomas Disputing; Christ Gives His Approval From the Altar;* and *Vision of Fra Paolino of Aquila,* both in the M. H. de Young Museum, San Francisco (Kress Collection); *St. Thomas Preaching,* National Gallery of Art, Washington, D.C. These all evidently belonged, with 1871.41, to the *Altarpiece of St. Thomas Aquinas* in S. Domenico, Modena, 1466–74.

IL FRANCIA

Francesco di Marco di Giacomo Raibolini, called Il Francia, was born ca. 1450 in Bologna. He was trained as a goldsmith and was active as a painter mainly in and around Bologna from about 1485 until his death in 1517. His most ambitious work is now preserved in Bologna, along with two large altarpieces now in the Louvre and the National Gallery, London. His style is an offshoot of Perugino's and Pinturicchio's. In or about 1500 he evidently had considerable influence on the young Raphael.

165. GAMBARO MADONNA, 1495

Gift of Hannah D. and Louis M. Rabinowitz. 1959.15.10.

Oil (?) and egg tempera (?) on panel. 75 × 54.8 cm. (29½ × 21⁹⁄₁₆ in.). Cleaned, 1959.

CONDITION: Excellent; a rather deep fissure, however, extends from the top of

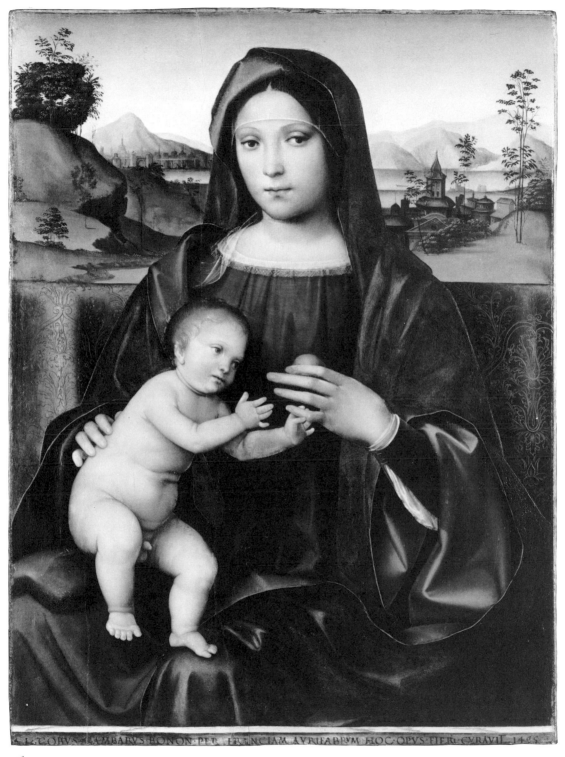

JACOBVS · LAMBARVS · BONON · PER · FRANCIAM · AVRIFABRVM · HOC · OPVS · FIERI · CVRAVIT · 1495

165

the panel down some eight inches along the l. side of the Virgin's head; this has been filled and inpainted. Earlier repaints were removed in 1959 including a veil over the Christ Child's genitals.

INSCRIPTION: At base of panel, IACOBUS GAMBARVS. BONON (ENSIS). PER. FRANCIAM. AURIFABRVM. HOC. OPVS. FIERI. CVRAVIT, 1495. (Jacopo del Gambaro of Bologna had this work made by Francia, the goldsmith, in 1495).

PROVENANCE: Lord Dudley, London; Marchese di Pulce Doria, Naples; Quincy Adams Shaw, Boston; Rabinowitz Collection, Sands Point, Long Island.

BIBLIOGRAPHY: G. F. Waagen, *Kunstwerke und Künstler in England,* Berlin, 1838, 2, p. 204; J. A. Crowe and G. B. Cavalcaselle, *A History of Painting in North Italy,* London, 1912, 2, p. 274; A. Venturi, 7 (1914), p. 881; *Rabino-witz Coll.* 1945, pp. 29–31; *Rabinowitz Coll.* 1961, pp. 28–29; Berenson 1968, *1,* p. 148; note, all name Francia as the artist.

As the inscription indicates, Francia painted this *Madonna and Child* for his friend and fellow member of the Goldsmiths' Guild in Bologna, Jacopo del Gambaro, in the year 1495. A good deal of the goldsmith's sense of exquisite form is evident in the superb precision of the drawing and the jewel-like brilliance of the coloring, while the feathery trees, the minute detail of the distant landscape with its remarkable atmospheric effects show influences from the north which evidently earned the artist his nickname. The painting has all the monumentality and dignity of Francia's contemporary altarpieces, but there is a special intimacy and naturalness in the Child's movement as he reaches for the apple (symbolizing the Fall of Man whose Original Sin he is to redeem). In the earlier literature the inscription with Gambaro's name and the date was mistakenly connected with a totally different picture and led to a great deal of confusion. The story has been sorted out and clearly analyzed by L. Venturi (see above). Our picture is now recognized as one of the finest of Francia's documented works.

LUDOVICO BREA DA NIZZA (?) (attributed to)

Brea (1448–1523) was a Piedmontese painter who grew up in Franco-Flemish traditions. Active in Liguria, he was influenced in his development by a North Italian painter such as Foppa.

166. VISITATION, ca. 1500*

Bequest of Maitland F. Griggs, B.A., 1896. 1943.262.

Egg tempera panel. 25.7 × 42.5 cm. (10⅛ × 16¾ in.). Cleaned, 1967.

CONDITION: Poor; much rubbed and evidently much repainted earlier. Sizeable strips of new paint, hidden by the framing, had been added at both top and bottom edges.

PROVENANCE: Maitland F. Griggs Collection, New York; acquired 1929.

EXHIBITION: New York, Century Association, 1930.

BIBLIOGRAPHY: Berenson 1932, p. 111 (as Ludovico Brea da Nizza); Berenson 1968, *1*, p. 63 (no change).

Since the cleaning of the panel the style looks more North Italian than Ligurian. The present attribution follows the published opinion of Berenson and the unpublished opinions of Offner and L. Venturi (in Griggs Collection notes) but with a large question mark until further study may be made. The following panel, 1943.263, formed part of the same predella as did 1943.262.

LUDOVICO BREA DA NIZZA (?) (attributed to)

167. CHRIST AMONG THE DOCTORS, ca. 1500*

Bequest of Maitland F. Griggs, B.A., 1896. 1943.263.

Egg tempera on wood panel. 26.7 × 42.5 cm. (10½ × 16¾ in.). Uncleaned.

CONDITION: Evidently the same as that of 1943.262.

PROVENANCE and BIBLIOGRAPHY: Part of the same predella series as 1943.262.

NORTH ITALIAN (?) SCHOOL, XV century

168. CHRIST IN GLORY, ca. 1460*

Bequest of Maitland F. Griggs, B.A., 1896. 1943.261a.

Egg tempera on panel. 23.4 × 62.3 cm. (9⅛ × 24½ in.). Partially cleaned 1960.

CONDITION: On the whole good; though some rubbing in flesh tints and beard.

INSCRIPTION: On open book pages, EGO SUM LUX MUNDI QUI . . . AMBU-
LAT IN LUC(E) NON . . .

PROVENANCE and EXHIBITION: Same as for 1943.261 to which it was attached
while in the Griggs Collection.

BIBLIOGRAPHY: Unpublished.

This panel obviously has nothing historically or esthetically to do with 1943.261.
At some unspecified time, but evidently before the Canessa sale of 1924, it was
placed on the top of the larger picture's frame as a kind of pediment.

NORTH ITALIAN (?) SCHOOL, XV century

169a,b,c,d. In four initial letters, *O, S, U, E,* manuscript illumination, ca. 1470*

Gift of Robert Lehman, B.A., 1913, in the name of Mr. and Mrs. Albert E.
Goodhart. 1954.7.7a,b,c,d.

Body color and gilt on parchment. Fragments cut from pages. (a) 9.8 × 11.3
cm. (3⅞ × 4⁷⁄₁₆ in.); (b) 9.4 × 10.6 cm. (3¹¹⁄₁₆ × 4⅜ in.); (c) 10
× 11 cm. (4 × 4⅜ in.); (d) 10 × 10.9 cm. (4 × 4⁵⁄₁₆ in.).

CONDITION: Excellent.

PROVENANCE: Lehman Collection, New York (acquired in Paris, 1953).

BIBLIOGRAPHY: Unpublished, so far as is known.

NORTH ITALIAN SCHOOL, XV century

170a,b,c,d. In four initial letters, *E, D, O, C* or *A,* manuscript illumination, ca.
1460*

Gift of Robert Lehman, B.A., 1913, in the name of Mr. and Mrs. Albert E.
Goodhart. 1954.7.6a,b,c,d.

Body color and gilt on parchment. Fragments cut from pages of a manuscript. (a) 8.2 × 8 cm. (3¼ × 3⅛ in.); (b) 7.6 × 9 cm. (3 × 3⁹⁄₁₆ in.); (c) 8.3 × 9.2 cm. (3¼ × 3⅝ in.); (d) 7.8 × 8.8 cm. (3¹⁄₁₆ × 3⁷⁄₁₆ in.).

CONDITION: Good.

PROVENANCE: Lehman Collection, New York (acquired in Paris, 1953).

BIBLIOGRAPHY: Unpublished, so far as is known.

1954.7.6c represents a king (David?), and 1954.7.6d an angel with a timbrel; possibly the initials originally decorated a psalter.

NORTH ITALIAN (?) SCHOOL, XV century

171a,b,c,d,e,f. In six initial letters, *U, E, S, G, B, B*, manuscript illumination, ca. 1470*

Gift of Robert Lehman, B.A., 1913, in the name of Mr. and Mrs. Albert E. Goodhart. 1954.7.8a,b,c,d,e,f.

Body color and gilt on parchment. Fragments cut from pages of a manuscript. (a) 8.2 × 8.6 cm. (3¼ × 3⅜ in.); (b) 7.3 × 8.8 cm. (2⅞ × 3½ in.); (c) 8.4 × 8.6 cm. (3⁵⁄₁₆ × 3⅜ in.); (d) 8.6 × 9 cm. (3⅜ × 3⁹⁄₁₆ in.); (e) 9.2 × 9.9 cm. (3⅝ × 3¹⁵⁄₁₆ in.); (f) 8.8 × 8.8 cm. (3⁷⁄₁₆ × 3⁷⁄₁₆ in.).

CONDITION: Excellent.

PROVENANCE: Lehman Collection, New York (acquired in Paris, 1953).

BIBLIOGRAPHY: Unpublished, so far as is known.

Umbrian School

GENTILE DA FABRIANO

Born in Fabriano ca. 1370 and recorded as working in Venice by 1408, where he painted an altarpiece and worked on frescoes in the Hall of the Great Council in the Doges' Palace. In 1421 Gentile was admitted to the Confraternity of St. Luke in Florence. He was active in that city until 1425, producing his most important works. By 1427, after passing through Siena and Orvieto, he was in Rome working on frescoes for the Basilica of St. John Lateran for Pope Martin V. He died in Rome that same year.

172. MADONNA AND CHILD, ca. 1424–25

University purchase from James Jackson Jarves. 1871.66.

Egg tempera on panel. 91.4 × 62.9 cm. (36 × 24¾ in.). The picture was superficially cleaned in 1890; cleaned again with considerable repainting in 1915; cleaned and inpainted, with removal of a half-inch wood strip at bottom in 1950–52.

CONDITION: Quite good, although there has been some damage along top and bottom of panel from an early removal of nails, and from early overcleaning. The head and robe of the Madonna have suffered. The panel was also cut down at some early date on all four sides, the greatest loss apparently occurring at the bottom.

INSCRIPTION: Signature, lower l., GENT[ILE DA (?)] FABRIANO.

PROVENANCE: James Jackson Jarves Collection, Florence.

EXHIBITIONS: New York "Institute of Fine Arts," 625 Broadway, 1860; New-

172

York Historical Society, 1863 (both times as Gentile): Cleveland, Museum of Art, "Twentieth Anniversary Exhibition," 1936; Y.U.A.G., "Rediscovered Italian Paintings," 1952.

BIBLIOGRAPHY: Jarves 1860, p. 51; Sturgis 1868, p. 45; Jarves 1871, p. 17; A. Colasanti, *Gentile da Fabriano,* Bergamo, 1909, p. 58; Sirén 1916, pp. 167–70; Van Marle, *8* (1927), pp. 26–30, 201; Offner 1927, pp. 7, 43; L. Venturi, pl. CIX; Berenson 1932, p. 221; A. Colasanti, *Italian Painting of the Quattrocento in the Marches,* Florence and Paris, 1932, p. 16; *Y.U.A.G. Bulletin,* 1952, pp. 8, 22–23; L. Grassi, *Tutta la pittura di Gentile da Fabriano,* Milan, 1953, pp. 42, 64, 71; R. Krautheimer and T. Krautheimer-Hess, *Ghiberti,* Princeton, 1956, p. 146; L. Berti, *Masaccio,* Milan, 1964, p. 63; Berenson 1968, *1,* p. 164.

In some ways, historically, this is the most important painting among the early Italian pictures at Yale. It is the only mature work by Gentile which bears his signature. The recent cleaning revealed the presence of a bright red pillow under the Child's r. foot; the window sill and the inscription on the halo of the Madonna were found to be later additions. In its present condition the painting is stylistically much closer to the artist's Florentine period than to his earlier North Italian-Venetian phase as previously proposed (see above, Van Marle). Although delicately drawn and executed the painting has a monumental quality which reflects the innovations of Masaccio after 1422, while the foliage motif running through the architecture has been related to the ornament used by Ghiberti in the North Doors of the Baptistery, finished in 1424 (see above, R. Krautheimer). The painting stands chronologically between Gentile's *Strozzi Altarpiece* of 1423 now in the Uffizi and his frescoed *Madonna and Child* of 1426 in the Orvieto Duomo; it is accordingly dated 1424–25.

FIORENZO DI LORENZO

He was born about 1440 in Perugia where he entered the painters' guild between 1463 and 1469. His activity, on the whole surprisingly poorly documented for a major Umbrian painter, was evidently confined to Perugia. Flor-

173

175

entine aspects of his style may be the result of his collaboration for a time with the young Perugino who had close Florentine connections. Fiorenzo lived on well into the 16th century, dying between 1522 and 1525 in Perugia.

173. PENANCE OF ST. JEROME, ca. 1485

University purchase from James Jackson Jarves. 1871.68.

Egg tempera on panel. 48.5 × 30.5 cm. (19⅛ × 12 in.). Cradled and restored, 1929; cleaned, 1955–57.

CONDITION: Good to excellent; there is a fairly sizeable loss in the sky to the r. of the crucifix which has been filled and inpainted; some rubbing in the darks; a long scratch across the crucifix.

PROVENANCE: James Jackson Jarves Collection, Florence; there is a wholly unsubstantiated claim made by Jarves that the picture came from the guardaroba of Duke Cosimo de' Medici, evidently based on a passage in Vasari's *Life* of Fra Filippo Lippi.

EXHIBITIONS: New York "Institute of Fine Arts," 625 Broadway, 1860; New-York Historical Society, 1863 (both times as Filippo Lippi); New York, Durlacher Brothers, "Paintings and Sculpture of St. Jerome," 1945 (as Fiorenzo di Lorenzo).

BIBLIOGRAPHY: Jarves 1860, p. 51 (as Filippo Lippi); Sturgis 1868, p. 59 (as Filippo Lippi); Jarves 1871, p. 20 (as Filippo Lippi); Rankin 1895, pp. 144–45 (as Fiorenzo di Lorenzo); Sirén 1916, pp. 175–76 (as Fiorenzo di Lorenzo); Offner 1927, p. 8 (as Fiorenzo di Lorenzo); Berenson 1932, p. 193 (as Fiorenzo di Lorenzo); Van Marle, *14* (1933), pp. 182, 192 (as Fiorenzo di Lorenzo); Berenson 1968, *1*, p. 134 (as Fiorenzo di Lorenzo).

This small, strongly painted devotional panel is closest in style and type of the saint to a roundel of the same subject in the predella of the Monteluce *Adoration of the Shepherds* now in the Galleria Nazionale, Perugia. The date of ca. 1480–85 is in accord with the slightly more developed style of the signed and dated tabernacle frame of 1487 also in the Galleria Nazionale, Perugia.

PINTURICCHIO

His real name was Bernardino di Betto Biagio (ca. 1454–1513). He entered the painters' guild in Perugia in 1481 and between 1480 and 1482 worked in collaboration with Perugino in the Sistine Chapel. From 1486 to his death he was mainly active in the employ of the popes in Siena and in Rome.

174. MADONNA AND CHILD WITH SAINTS, ca. 1490–95*

Gift of Hannah D. and Louis M. Rabinowitz. 1959.15.16.

Egg tempera on panel. 42.6 × 32.5 cm. (16¾ × 12¹³⁄₁₆ in.). Uncleaned.

CONDITION: Evidently good; some repaints particularly on the St. Francis and perhaps some renewing of the gilt in the inscription and halos.

INSCRIPTION: Two small tablets suspended from a thin gold and red garland, AVE MRIA (sic).

PROVENANCE: Quincy Shaw Collection, Boston; thence by Mrs. Pauline Shaw Fenno and E. and A. Silberman Galleries to the Rabinowitz Collection, Sands Point, Long Island.

BIBLIOGRAPHY: *Rabinowitz Coll.* 1961, p. 55 (as Pinturicchio).

It seems likely that this small devotional panel was painted in Rome when the artist was just beginning the decoration of the Borgia apartments in the Vatican. The charming detail of the classical relief, with motifs taken from antique marine subjects frequently found on sarcophagi, is characteristic of the artist's style of drawing as well as of the taste of the period 1490–95.

PIETRO PERUGINO (close follower of)

His real name was Pietro Vanucci. He was born in Perugia in 1445, but was educated as a painter in Florence in the workshop of Verrocchio. He was for a time Raphael's teacher. After a long career, with a large following in Umbria, he died in 1523.

175. NATIVITY, ca. 1505–10

Bequest of Maitland F. Griggs, B.A., 1896. 1943.265.

Egg tempera on panel. 40.6 × 30.8 cm. (16 × 12⅛ in.). Cleaned in 1954. The panel has been cut down on all sides but most evidently at the top.

CONDITION: Of the painted surface, good to excellent; some rubbing of the delicate trees in the background; a longitudinal crack on the l. has been filled and inpainted.

PROVENANCE: Maitland F. Griggs Collection, New York; acquired in Paris, 1927.

EXHIBITION: New York, Century Association, 1930.

BIBLIOGRAPHY: Van Marle, *14* (1933), p. 406 (as school of Perugino).

A drawing in the British Museum (1895–9–15–594) can be identified as the cartoon for this painting; the composition derives from Perugino's *Nativity* fresco in the Cambio, Perugia. A *Resurrection* in London (private collection) from what appears to be the same predella and by the same hand is published as Raphael by Fernando Bologna ("Un'altra 'Resurrezione' giovanile di Raffaello," *Studies in the History of Art Dedicated to William E. Suida on His Eightieth Birthday,* London, 1959, pp. 180–85).

PERUGINO (follower of; Sinibaldo Ibi?)

Sinibaldo Ibi was evidently a pupil of Perugino and was active mainly in Gubbio up to 1527 when he joined the guild in Perugia. Death date unknown.

176. BAPTISM, ca. 1510 (?)*

University purchase from James Jackson Jarves. 1871.93.

Egg tempera on panel. 54.7 × 41.8 cm. (21½ × 16½ in.). Restored, cradled, 1915; uncleaned.

CONDITION: Evidently poor; has been rubbed badly and was repainted thoroughly; many repaints were removed in 1915.

PROVENANCE: James Jackson Jarves Collection, Florence; said by Jarves to have been acquired by him from the Badia, Florence.

EXHIBITIONS: New York "Institute of Fine Arts," 625 Broadway, 1860; New-York Historical Society, 1863 (both times as Perugino).

BIBLIOGRAPHY: Jarves 1860, p. 55, n. 94 (as Perugino); Sturgis 1868, p. 66 (as Perugino); Sirén 1916, pp. 227–28 (as school of Perugino, most probably Sinibaldo Ibi); Offner 1927, p. 8 (attributed to Ibi).

Probably after the 1508 altarpiece by Ibi in Gubbio, if indeed it is by him. The panel is an eclectic and rather provincial reflection of Perugino and his ablest followers.

LUCA SIGNORELLI

He was born in Cortona in 1441, and while still in Umbria became a pupil of Piero della Francesca. After his affiliation with Piero at Arezzo he went to Florence where he was definitively influenced by Antonio Pollaiuolo and Verrocchio. He became one of the great masters of the human figure and of movement during the "Transition" between the latter years of the 15th century and the opening years of high Renaissance art. The last part of his career was spent at Cortona where he died in 1523.

177. ADORATION OF THE MAGI, ca. 1515

University purchase from James Jackson Jarves. 1871.69.

Egg tempera on panel. 35 × 43.8 cm. (13¾ × 17¼ in.). Restored, 1915; cradled, restored, 1928; cleaned, 1954.

CONDITION: Excellent; some rubbing of gilt details and one small chip on the Virgin's robe. A query of 1915 by the restorer Hammond Smith on the painting's authenticity was disproved by the X-ray evidence and the analyses made during cleaning in 1954.

PROVENANCE: James Jackson Jarves Collection, Florence; said by Jarves to have been acquired by him from the Bishop's Palace, Cortona.

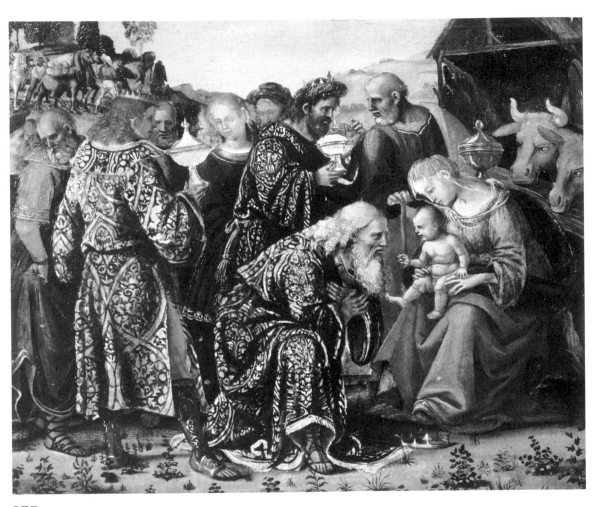

177

EXHIBITIONS: New York "Institute of Fine Arts," 625 Broadway, 1860; New-York Historical Society, 1863 (both times as Luca Signorelli).

BIBLIOGRAPHY: Jarves 1860, p. 53 (as Signorelli); J. J. Jarves, *Art Studies,* New York, 1861, pl. 1 opp. p. 273; Sturgis 1868, p. 64 (as Signorelli); M. Cruttwell, *Luca Signorelli,* London, 1899, p. 95 (as Signorelli); A. Venturi, *7, part 2* (1913), p. 409 (as shop of Signorelli); Sirén 1916, pp. 177–78 (as Signorelli); L. Dussler, *Luca Signorelli,* Berlin, 1927, p. 183 (as pupil of Signorelli); Offner 1927, p. 8 (as Signorelli); Berenson 1932, p. 532 (as Signorelli); Van Marle, *17* (1937), p. 100 (as Signorelli); Berenson 1968, *1,* p. 399 (as Signorelli, late).

This panel, it now seems certain, was originally part of the predella to which the *Nativity* in the Johnson Collection, of strikingly similar dimension and style, belonged (the Johnson Collection panel is recorded as measuring 13¼ × 16¾ inches). These two panels must, with a third now missing, have been part of an altarpiece in Cortona, for which the likeliest candidate from the point of view of width and of style is one commissioned in 1515 by Giovanni Sernini, who became Bishop of Cortona in the following year. The Sernini altarpiece was altered and enlarged in 1619 and seems then to have been moved to the Church of S. Domenico, where it now is in its changed state. Presumably in 1619 the predella panels remained in the Bishop's palace, exactly where Jarves claimed to have found the *Adoration of the Magi.* Because of the relatively small size of the original Sernini altarpiece, designed for private devotions, and because of the prominence of the commissioner, it seems likely that Signorelli would have executed most if not all of the work himself—or at least supervised it carefully and personally; it is therefore probable, given also the vivacity of the style, that 1871.69 is by Luca himself.

Venetian School

GIOVANNI BELLINI (follower of)

Giovanni was the son of the painter Jacopo Bellini. As a young man, Giovanni worked with his older brother, Gentile, in their father's shop in Venice. He was later influenced by his brother-in-law, Mantegna, and subsequently by Piero della Francesca and Flemish art. He lived between ca. 1430 and 1516. As a mature artist he trained the great Venetian innovators of the 16th century, Giorgione and Titian.

178. MADONNA AND CHILD, ca. 1475*

Gift of Hannah D. and Louis M. Rabinowitz. 1959.15.11.

Oil on panel. 33.5 × 27.3 cm. (13³⁄₁₆ × 10¾ in.). Cleaned in 1962–63.

CONDITION: Very poor; a much rubbed fragment, which had in modern times been built out and completely repainted. The modern wood surrounding the original fragment has been retained to show the extent and character of the "restoration."

PROVENANCE: Dan Fellows Platt Collection, Englewood, New Jersey; Rabinowitz Collection, Sands Point, Long Island.

BIBLIOGRAPHY: F. M. Perkins, in *BurlM, 15* (1909), p. 126; A. Venturi, *7,* part 4 (1915), p. 308; B. Berenson, in *AiA, 4,* no. 2 (Feb. 1916), p. 61; B. Berenson, *Venetian Painting in America,* New York, 1916, p. 74; S. Reinach, *Répertoire de Peintures, 5,* 1922, p. 285; G. Gronau, *Giovanni Bellini,* Stuttgart, 1930, p. 46; Berenson 1932, p. 70; L. Dussler, *Giovanni Bellini,* Frankfurt a. M., 1935, p. 146; Van Marle, *17* (1935), p. 249; Carlo Gamba, *Gio-*

vanni Bellini, Milan, 1937, p. 73; Berenson 1957, p. 32; F. Heinemann, *Giovanni Bellini e i Belliniani,* Venice, 1961, p. 4; (all as Giovanni Bellini).

Because of the panel's severe rubbing, the layers of underpainting and surface painting are now clearly visible. After the cleaning it has become evident that the hand of Giovanni Bellini himself is not present. Heinemann (see Bibliography, above) cites a "copy" as owned at one time by Prince Hohenzollern-Sigmaringen.

FRANCESCO BISSOLO (attributed to)

First recorded in 1492 when, as a pupil of Giovanni Bellini, he was working with Marco Marziale and Vincenzo Catena in the Doge's Palace, Venice. He remained essentially a Bellini follower for the rest of his sparsely recorded activity to 1531. He died in 1554. The paintings of his pupil, Pietro degli Ingannati, are often confused with his; the line between the two men can seldom be easily drawn.

179. MADONNA AND CHILD WITH SAINTS AND DONORS, ca. 1505

University purchase from James Jackson Jarves. 1871.94.

Oil on panel. 63.8 × 99 cm. (25⅛ × 39 in.). Restored, 1915 and 1929; cleaned, 1967.

CONDITION: On the whole reasonably good. After cleaning off the older and modern repaints, losses were revealed mainly in the drapery of St. John and in the face of the Virgin; some rubbing in the sky and landscape to the r. These losses were inpainted in 1968.

PROVENANCE: James Jackson Jarves Collection, Florence.

EXHIBITIONS: New York "Institute of Fine Arts," 625 Broadway, 1860; New-York Historical Society, 1863 (both times as Marco Basaiti).

BIBLIOGRAPHY: Jarves 1860, p. 58 (as Basaiti); Jarves 1871, p. 23 (as Basaiti); Sturgis 1868, p. 71 (as Basaiti); Rankin 1895, p. 150 (as probably

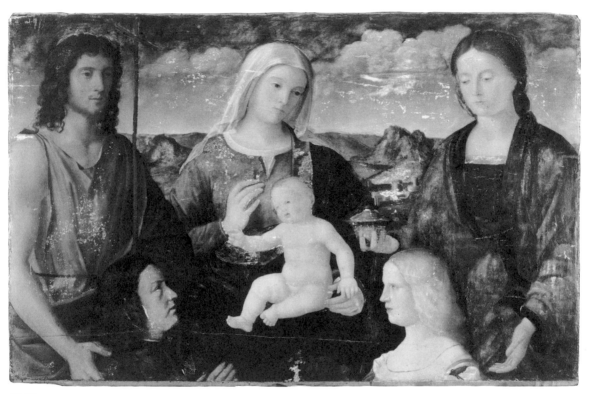

179

Francesco Bissolo); Sirén 1916, pp. 229–30 (as Bissolo); B. Berenson, *Venetian Painting in America,* New York 1916, p. 262 (as possessing "affinities with Pietro degli Ingannati"); Berenson 1932, p. 269 (as Pietro degli Ingannati); G. Gronau, in *L'Arte,* N.S. 4 (1933), p. 424 (as anonymous Venetian); Berenson 1957, *I,* p. 40 (as Pietro degli Ingannati); F. Heinemann, *Giovanni Bellini e i Belliniani,* Venice, 1961, p. 164 (as "Amico di Girolamo da Santa Croce").

The picture is quite evidently of fine quality and close in idea and many facets of style to Giovanni Bellini. The motif of the Madonna and Child appears to be derived from a lost painting by Bellini of which other echoes are extant. The general type of the composition is best known through Bellini's *Giovannelli Madonna and Saints* of ca. 1500–05 (now in the Accademia, Venice), while it is closest in detail to Bellini's *Virgin and Child with SS. Michael and Veronica and Two Donors* in the London National Gallery (no. 3083). The London picture has most recently been dated ca. 1500 (M. Davies, *London National Gallery, the Earlier Italian Schools,* 2d ed. London, 1961, pp. 84–85). Whether or not our 1871.94 may surely be considered as by Bissolo depends on a firmer definition of his style and career than is at present obtainable from the literature. The line to be drawn between Bissolo and Pietro degli Ingannati, for only one example, is extremely tenuous; and it is entirely possible that there are overlaps in their currently attributed oeuvres. What one can say with some confidence is that the Jarves-Yale painting is of sufficient quality and closeness to Giovanni Bellini to make an attribution to Bissolo at this time the most logical of the various options available.

CARLO CRIVELLI

He was born in Venice, apparently into a family of painters, ca. 1430. In 1457 he was sentenced for adultery and left Venice soon after his prison term was up; he evidently never returned to his native city, but instead worked in Padua and above all in the Marches, where he left traces of his activity in Fermo, Massa, Ascoli (1473–78), Camerino, Macerata and Fabriano among other places. In 1490 he received from Ferdinand II of Naples the title of *Miles* (knight) and

Miles Laureatus appears with his signature from 1493 to his death in 1495. His powerful personal style developed from that of the Vivarini in Venice; for a time Pietro Alemanno, also a strong painter, was associated with him.

180. ST. PETER, 1472 (?)

Gift of Hannah D. and Louis M. Rabinowitz. 1959.15.15.

Egg tempera on panel. 29.4 × 21.5 cm. (11⁹⁄₁₆ × 8⁷⁄₁₆ in.). Cleaned 1966; a later strip on the r. edge attached by old nails has been removed and the nails left in place.

CONDITION: Excellent, except for some rubbing in the gold background. Traces of brushwork left unfinished at bottom evidently were to be covered by the original frame, which is now lost.

PROVENANCE: Marinucci Collection, Rome; Rabinowitz Collection, Sands Point, Long Island.

BIBLIOGRAPHY: Berenson 1957, p. 70; *Rabinowitz Coll.* 1961, p. 26; F. Zeri, in *Arte antica e moderna, 13* (1961), p. 3; P. Zampetti, *Carlo Crivelli,* Milan, 1961, pp. 75–77.

This unusually vigorous half-length figure was evidently originally part of a predella series of apostles and saints for a large and complicated altarpiece. Zampetti (see above) has postulated that it belonged to one of Crivelli's greatest works of this kind—the so-called *Erickson Polyptych,* a reconstructed work named after the *Madonna* of 1472 formerly in the Erickson Collection, New York, and now in the Linsky Collection, New York. Other panels similar to the Yale panel that are believed to have been associated with it in the *Erickson Polyptych* are recorded in Milan (Museo del Castello Sforzesco, *St. John Evangelist and St. Bartholomew*) and Amsterdam (Proehl Collection, *St. Andrew*). Zeri added to this list in 1961 a *Blessing Christ* which at that time he recorded as being in the Kress Collection in El Paso, Texas (not included, however, in F. R. Shapley, *Paintings from the Samuel H. Kress Collection, Italian Schools XIII–XV Century,* London, 1966). For the remaining elements of the *Erickson Polyptych* see Zampetti (above).

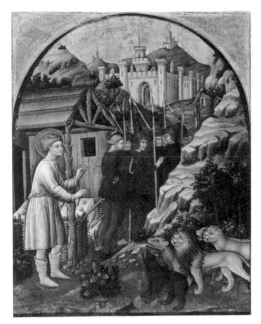

182

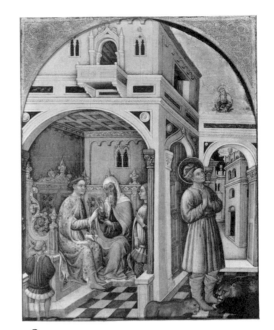

183

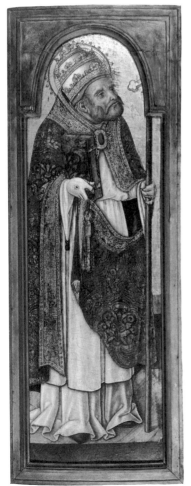

181

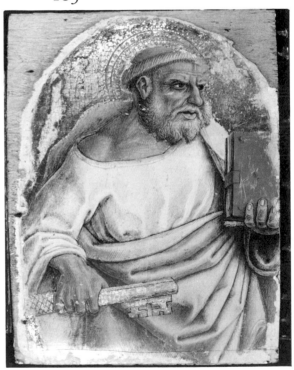

180

VITTORIO CRIVELLI

He was a follower of Carlo Crivelli, a more original talent and stronger artist; Vittorio was active mainly in Venice and the Veneto from ca. 1480 to his death in 1501.

181. ST. PETER, ca. 1490

Gift of Robert Lehman, B.A., 1913. 1946.313.

Egg tempera on panel. 102.2 × 33.5 cm. (41¼ × 13⁹⁄₁₆ in.). Not cleaned.

CONDITION: Evidently good, except for wearing of gold ornament on cope and book and some repaints on cope. The panel at one time was damaged at the lower l.

BIBLIOGRAPHY: Berenson 1932, p. 164 (as Vittorio Crivelli); Van Marle, *18* (1936), p. 84 (as Vittorio Crivelli); Berenson 1957, *1,* p .72 (no change).

FRANCESCO DEI FRANCESCHI (attributed to)

This painter is a rather shadowy Venetian who was a follower of the far better-known Giambono. He was active in the middle decade of the 15th century.

182. FLIGHT OF THE SOLDIERS SENT TO CAPTURE ST. MAMMAS, ca. 1450

Gift of Louis M. Rabinowitz. 1946.72.

Egg tempera on panel. 47.6 × 35.7 cm. (18¾ × 14¹⁄₁₆ in.). Uncleaned.

CONDITION: Apparently good, though some repainting is evident overall.

PROVENANCE: J. Annan Bryce, London; W. H. Woodward, London; Rabinowitz Collection, Sands Point, Long Island; acquired through Knoedler & Company, New York, in 1946.

EXHIBITIONS: London, Burlington Fine Arts Club, 1912; London, The Royal Academy, Burlington House, "Exhibition of Italian Art," 1930; on loan, Boston, Museum of Fine Arts, 1939–45.

BIBLIOGRAPHY: R. Fry, in *BurlM*, 20 (1912), pp. 346 ff. (as Giambono); G. Fiocco, in *Dedalo,* 5 (1924), p. 451 (as Francesco dei Franceschi); E. Sandberg-Vavalà, in *BurlM,* 51 (1927), pp. 215 ff. (as Francesco dei Franceschi); W. G. Constable, *Paintings by Italian Masters in the Possession of William Harrison Woodward,* Oxford, 1928, pp. 17–18 (attributed to Giambono); E. Sandberg-Vavalà, in *BurlM,* 76 (1940), p. 156, no. 9 (still as Francesco dei Franceschi).

FRANCESCO DEI FRANCESCHI (attributed to)

183. ST. MAMMAS THROWN TO THE BEASTS, ca. 1450

Gift of Louis M. Rabinowitz. 1946.73.

Egg tempera on panel. 47.6 × 35.4 cm. (18¾ × 13¹⁵⁄₁₆ in.).

CONDITION: Similar to that of 1946.72.

PROVENANCE, EXHIBITIONS, and BIBLIOGRAPHY: See above, 1946.72.

Part of same altarpiece as 1946.72.

TITIAN (attributed to)

Tiziano Vecelli, called Titian, was born at Pieve di Cadore, on the mainland near Venice. Most scholars today feel that the date of birth was approximately 1487 rather than 1477 as Vasarian tradition has it. He began, it is believed, in the studio of Giovanni Bellini, but left Bellini's immediate circle by 1505 to work with Giorgione, who was to become his true master and chief inspiration. Titian's career was an unusually long and productive one; he was active as a dominant genius of 16th-century Venetian painting until his death in 1576, probably in his ninetieth year.

184. CIRCUMCISION, ca. 1510

University purchase from James Jackson Jarves. 1871.95.

Oil on panel. 36.6 × 79.4 cm. (14⁷⁄₁₆ × 31¼ in.). Restored 1915; restored and cradled 1928; cleaned 1968.

CONDITION: In detail, poor to fair. The surface suffers from much rubbing, flaking, and loss of what may have been original glazes. The damage is uneven. In some cases (heads of priest and followers in the center) only the first rough sketch layer remains; in other cases (head of Virgin and draped arm of witness holding a jar at the l.) the color and impasto are virtually intact. It must be said that the main lines of the composition are in no way obscured or broken and that the basic color scheme is undoubtedly present.

PROVENANCE: James Jackson Jarves Collection, Florence.

EXHIBITIONS: New York "Institute of Fine Arts," 625 Broadway, 1860; New-York Historical Society, 1863 (both times as Giorgione); Baltimore, Johns Hopkins University, "Giorgione and his Circle," 1942 (as Giorgione).

BIBLIOGRAPHY: Jarves 1860, p. 58 (as Giorgione); Sturgis 1868, p. 70 (as Giorgione); Sirén 1916, p. 231–32 (as Cariani); Offner 1927, p. 8 (as Cariani); Berenson 1932, p. 573 (as Titian); Berenson 1957, *1*, p. 84 (as Giorgione); F. Heinemann, *Giovanni Bellini e i Belliniani,* Venice, 1961, p. 25 (as Mancini [?]).

This small but monumentally designed panel has been accorded a bewildering sequence of attributions, ranging from the original one by Jarves (Giorgione) to Sirén's and Offner's suggestion of Cariani; and subsequently, following a cleaning of the picture in 1928 at Berenson's suggestion, to Titian. (Berenson wrote to Theodore Sizer on Feb. 19, 1928, "The ideal would be to begin with cleaning off all and sundry repaints . . . the feeling in my bones is that it [the picture] may have been painted by Titian toward 1510.") Berenson's attribution to Titian was published in his "Lists" of 1932, but with the most recent publication of "Lists" (1957) the wheel came full circle and the attribution was back once more where it started, with Jarves, to Giorgione. The latest independent publication (1961) strikes out implausibly into a new realm of second-rate "Belliniani."

The Jarves-Yale *Circumcision* belongs to a group of pictures, including the Prado *Gypsy Madonna* and *Christ and the Adulteress* in Glasgow, together with a fragment from it, the *Head of a Man* in the collection of Arthur Sachs, in which the styles of the young Titian and Giorgione overlap. Today what one

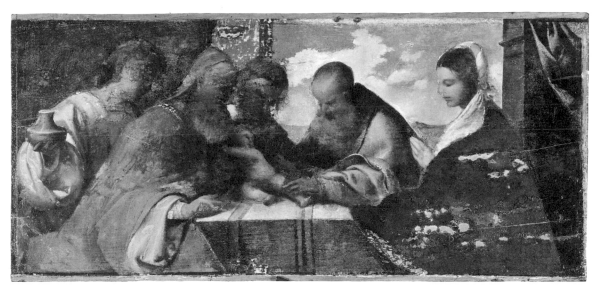

184

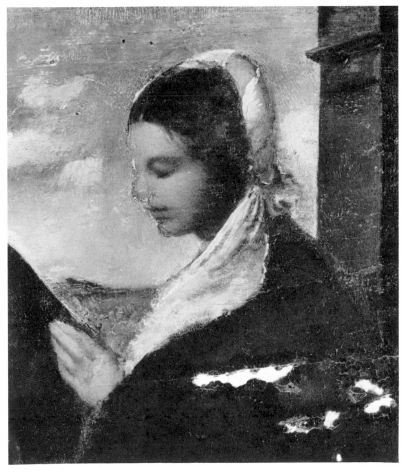

184, detail

thinks about the authorship of the group seems largely to determine one's lean-
ing toward our attribution to Titian or alternatively to Giorgione; it must be
said that in the last decade critical opinion has tended to return the group to
Giorgione. Since the most recent cleaning of 1871.95, however, the evidence
of style more strongly suggests Titian's hand and also, the compiler suggests,
his mind. Besides the previously published parallels with the Glasgow paint-
ing there are also analogies to Titian's very early autograph frescoes of 1511 in
the Scuola del Santo, Padua. Despite differences both of scale and technique, the
stylistic likenesses are striking; for example, the head of the bearded man to
the l. of St. Anthony in the *Miracle of the Speaking Babe,* the method of sketch-
ing in the figures in the distance of the *Miracle of the Jealous Husband,* and the
profile of the mother in the *Miracle of the Irascible Son* (A. Morassi, *Tiziano.
Gli Affreschi della Scuola del Santo a Padova,* Milan, 1961, pls. 10, 15, 26
respectively). Giorgione died in 1510 and the Santo frescoes may be taken as
Titian's first essay completely on his own. Our 1871.95 has the monumentality
of Titian's fresco style, and though the composition goes back to a Bellinesque
model (National Gallery, London, no. 1455), the simplifications and large
rhythms of both form and color that were to characterize Titian's independent
work seem to be quite definitely present though in much smaller format than is
usual for him. Possibly the commission for 1871.95 was received by Giorgione
while Titian was in his studio (before 1510). But the layout and execution are
more characteristic of the younger man than of Giorgione. This has seemingly
been corroborated by the X-ray evidence. The exact date of the picture, how-
ever, and the program into which it fitted are as yet undetermined; and no at-
tribution at present would be likely to be accepted without some dissenting voice.

VENETIAN (?) SCHOOL, early XV century

185. A PROPHET IN PRAYER (in the initial letter *I*), manuscript
 illumination, ca. 1420*

Gift of Robert Lehman, B.A., 1913, in the name of Mr. and Mrs. Albert E.
Goodhart. 1954.7.4.

Body color and gilt on parchment. 23.2 × 15.7 cm. (9⅛ × 6¾₆ in.). Fragment cut from a page.

CONDITION: Excellent.

PROVENANCE: Lehman Collection, New York (acquired in Paris, 1953).

BIBLIOGRAPHY: Unpublished, so far as is known.

In a note by Toesca (as above) in the curator's files the Venetian origin of the fragment is suggested. It does appear likely, though more study is needed to make a confident affirmation.

BARTOLOMMEO VIVARINI

Born in 1431–32, he was active between 1450 and 1491. He was initially a pupil of his brother Antonio Vivarini with whom he collaborated beginning in 1450. Influenced by Mantegna and Giovanni Bellini, he was a prolific painter, though not of the same stature as his more famous contemporaries, the Bellini. He died some time after 1491.

186. MADONNA AND CHILD, ca. 1465

Gift of Hannah D. and Louis M. Rabinowitz. 1959.15.12.

Egg tempera on panel. 116.2 × 65.4 cm. (45¾ × 25¾ in.). Cleaned in 1959.

CONDITION: Good; some loss of gold over the entire surface. The panel has been cut down on the top and probably along the sides. It may be assumed that the summit was originally a broken Gothic arch.

PROVENANCE: R. I. Nevin Collection, Rome (sale, Rome, 1907); Ellis Collection, Chicago; Dan Fellows Platt Collection, Englewood, New Jersey; Rabinowitz Collection, Sands Point, Long Island.

EXHIBITIONS: New York, E. and A. Silberman Galleries, 1955.

BIBLIOGRAPHY: F. M. Perkins, *Rassegna d'arte, 8* (1908), p. 145; A. Venturi,

7, part 3 (1914), p. 326; B. Berenson, *Venetian Paintings in America,* New York, 1916, p. 14; L. Venturi, pl. CCLVII; Berenson 1932, p. 601; Van Marle, *18* (1936), p. 106; B. Fleischman, in U. Thieme and F. Becker, *Allgemeines Lexikon der Bildenden Künstler, 34* (1940), p. 451; *Rabinowitz Coll.* 1945, p. 35; Berenson 1957, *1,* p. 202; *Rabinowitz Coll.* 1961, pp. 24–25; all above references are to Bartolommeo Vivarini.

The panel was once the center of a polyptych. In its original shape the round arch would have provided additional space for what is now a crowded composition. The tall pyramidal composition and compact design of details are characteristic of the painter's best work. Other Vivarini Madonnas similar to the Rabinowitz panel are those of 1471 in the Colonna Collection, Rome, and of 1478 in S. Giovanni in Bragora, Venice. Such comparisons would indicate that this *Madonna* belongs to the artist's early-middle period. The remaining elements of the original polyptych have not as yet been identified.

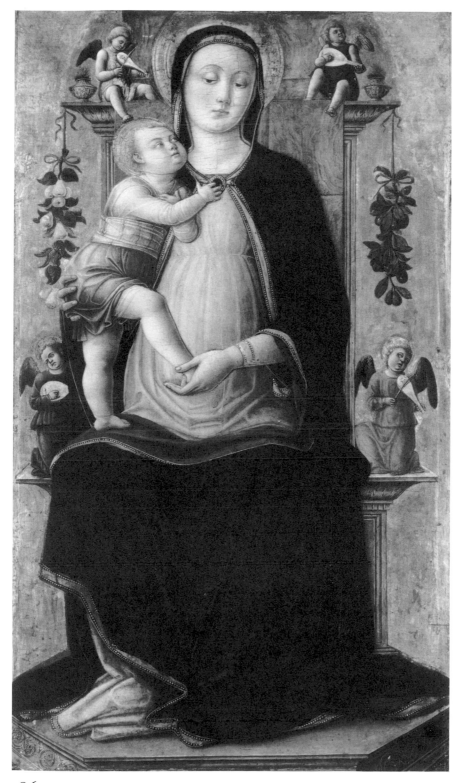

186

APPENDIXES

Concordance of Early Italian Paintings in the Jarves Collection

By Numbers and Attributions—1860–1968

Jarves 1860	*Sturgis 1868*	*Sirén 1916*
No. 1 Triptych: *Descent of Christ into Limbo, Transfiguration, Seven Scenes from the History of Moses* [*Transfiguration, Wanderings of the Israelites, Descent of Christ into Hades*] Ca. 1200	No. 7 Unknown artist 13th century	1871.113 Italo-Byzantine artist 15th century
No. 2 *The Annunciation* Unknown Byzantine artist, same hand as above Ca. 1200	No. 8 Unknown artist 13th century	1871.111 Italo-Byzantine artist Not by same hand as above
No. 3 *The Miraculous Apparition of SS. Mercurius and Catherine* Unknown Byzantine artist, same hand as above Ca. 1200	No. 9 Unknown artist 13th century	1871.112 Italo-Byzantine artist Not by same hand as above 15th century
No. 4 *The Nativity* [*Birth of the Savior*] Unknown Byzantine artist Style of 11th century and after	No. 2 Unknown Byzantine artist 12th century	1871.109 Italo-Byzantine artist Early 15th century
No. 5 *Madonna and Child* Unknown Byzantine artist 13th–14th century	No. 10 Unknown Byzantine artist 13th century	1871.110 Italo-Byzantine artist Early 15th century

Offner 1927	*Berenson 1932*	*Present Catalogue 1968*
1871.113	1871.113	1871.113
Not included	Not included	Not included
1871.111	1871.111	1871.111
Not included	Not included	Not included
1871.112	1871.112	1871.112
Not included	Not included	Not included
1871.109	1871.109	1871.109
Not included	Not included	Not included
1871.110	1871.110	1871.110
Not included	Not included	Not included

Jarves 1860	*Sturgis 1868*	*Sirén 1916*
No. 7 *St. George Killing the Dragon* [*St. George and the Dragon*] Unknown Byzantine artist Style of 12th and 13th centuries	No. 6 Unknown Byzantine artist	1871.108 Byzantine artist Possibly active in Italy, 14th century
No. 8 *Christ and the Virgin Enthroned* *with Angels* Unknown Greco-Italian artist 1190–1216	No. 5 Unknown artist Early 13th century	1871.19 Giovanni del Biondo
No. 9 *Crucifixion, Deposition,* *Mourning over Body of* *Christ [Crucifixion, Depo-* *sition, Entombment]* Unknown early Italian artist	No. 1 Unknown Italian artist 11th century	1871.1 Bonaventura Berlinghieri
No. 10 *Triptych: 19 scenes* Unknown artist 12th century	No. 4 Unknown Italian artist 12th century	1871.9 Romagnole Master (Giotto follower)
No. 11 *Triptych: Madonna, Cruci-* *fixion, Archangel Michael,* *Two Saints* Unknown early Italian artist	No. 3 Unknown Italo-Byzantine artist	1871.4 Margaritone d'Arezzo (school of)
No. 12 *The Crucifixion* Giunta da Pisa	No. 11 Giunta da Pisa	1871.2 Guido da Siena
No. 13 *Madonna Enthroned between* *SS. Peter and Leonard* *[Altarpiece of Seven* *Compositions]*	No. 12 Margaritone d'Arezzo	1871.3 Margaritone d'Arezzo
No. 14 *Madonna and Child with Saints* Cimabue	No. 13 Cimabue	1871.5 Deodato Orlandi

Offner 1927	*Berenson 1932*	*Present Catalogue 1968*
1871.108 Not included	1871.108 Not included	1871.108 Not included
1871.19 Giovanni del Biondo	1871.19 Giovanni del Biondo	1871.19 Giovanni del Biondo
1871.1 Tuscan Master Ca. 1250	1871.1 Not included	1871.1 Tuscan school 13th century
1871.9 Romagnole painter Ca. 1350	1871.9 Not included	1871.9 School of Rimini First half 14th century
1871.4 Florentine Master Ca. 1270	1871.4 Not included	1871.4 "Magdalen Master"
1871.2 Guido da Siena (shop of)	1871.2 Guido da Siena	1871.2 Guido da Siena (shop of)
1871.3 "Magdalen Master"	1871.3 Not included	1871.3 "Magdalen Master"
1871.5 Not included	1871.5 Not included	1871.5 Tuscan School (Pisa?) Ca. 1290

Jarves 1860	*Sturgis 1868*	*Sirén 1916*
No. 15 *The Annunciation* Pietro Cavallini	No. 19 Pietro Cavallini	1871.21 Niccolò di Pietro Gerini
No. 16 *The Entombment* Giotto	No. 17 Giotto	1871.8 Taddeo Gaddi
No. 17 *The Crucifixion* Giotto	No. 18 Giotto	1871.24 Lorenzo Monaco
No. 18 Triptych: *Madonna and Child* *with Saints, the Crucifixion,* *and the Annunciation* *[Madonna, Annunciation,* *Crucifixion]* Giotto (school of)	No. 22 School of Giotto Ca. 1325	1871.26 Lorenzo di Niccolò
No. 19 *Deposition from the Cross* *[Descent from the Cross]* Puccio Capanna (d. 1334)	No. 37 Antonio Veneziano Ca. 1320–88	1871.70 Michele di Matteo Lambertini (?)
No. 20 *The Trinity with Saints* *[The Trinity]* Puccio Capanna (d. 1334)	No. 27 Puccio Capanna	1871.18 Jacopo di Cione
No. 21 Diptych: *Crucifixion,* *Madonna* Duccio	No. 14 Duccio	1871.10 Duccio (follower of)
No. 24 *The Vision of St. Dominic* *[SS. Paul and Peter Giving* *the Bible and Sword to* *St. Dominic]* Taddeo Gaddi	No. 20 Taddeo Gaddi	1871.6 Bernardo Daddi

Offner 1927	*Berenson 1932*	*Present Catalogue 1968*
1871.21 Niccolò di Pietro Gerini	1871.21 Niccolò di Pietro Gerini	1871.21 Niccolò di Pietro Gerini (?)
1871.8 Taddeo Gaddi	1871.8 Taddeo Gaddi	1871.8 Taddeo Gaddi
1871.24 Lorenzo Monaco	1871.24 Not included	1871.24 Lorenzo Monaco (close follower of)
1871.26 Not included	1871.26 Lorenzo di Niccolò and Niccolò di Pietro Gerini	1871.26 Lorenzo di Niccolò and assistant (attributed to)
1871.70 Giovanni di Pietro da Napoli	1871.70 Not included	1871.70 Giovanni di Pietro da Napoli (attributed to)
1871.18 Jacopo di Cione (circle of)	1871.18 Jacopo di Cione with Niccolò di Pietro Gerini	1871.18 Jacopo di Cione (late follower of)
1871.10 Duccio (follower of)	1871.10 Not included	1871.10 Ducciesque Master Early 14th century
1871.6 Bernardo Daddi	1871.6 Bernardo Daddi	1871.6 Bernardo Daddi

Jarves 1860	Sturgis 1868	Sirén 1916
No. 25 *SS. James, Julian, and the Archangel Michael* Taddeo Gaddi	No. 21 Taddeo Gaddi	1871.20 Starnina (?)
No. 26 *The Legend of St. Giovanni Gualberto* Giacomo (sic) di Casentino	No. 30 Jacopo da Casentino	1871.30 Giovanni dal Ponte
No. 27 *SS. Augustine and Lucia* Orcagna	No. 23 Orcagna	1871.27 Lorenzo di Niccolò
No. 28 *SS. Dominic and Agnes* Orcagna	No. 24 Orcagna	1871.28 Lorenzo di Niccolò
No. 29 *The Agony in the Garden* [*Christ's Agony in the Garden*] Taddeo Gaddi (school of)	No. 29 Taddeo Gaddi (school of)	1871.32 Andrea di Giusto
No. 30 *St. Francis Receiving the Stigmata* Agnolo Gaddi	No. 28 Agnolo Gaddi	1871.25 Lorenzo Monaco
No. 31 *The Crucifixion* Spinello Aretino (manner of)	No. 33 Spinello Aretino (manner of)	1871.7 Bernardo Daddi (manner of)
No. 32 *A Legendary Subject and St. Michael Fighting the Demon* [*Vision of Constantine and Fall of the Rebel Angels*] Spinello Aretino (school of)	No. 34 Spinello Aretino (manner of)	1871.23 Spinello Aretino (manner of)

Offner 1927	*Berenson 1932*	*Present Catalogue 1968*
1871.20 Agnolo Gaddi (associate of)	1871.20 Agnolo Gaddi	1871.20 Agnolo Gaddi
1871.30 Not included	1871.30 Agnolo Gaddi	1871.30 Florentine school Early 15th century
1871.27 Lorenzo di Niccolò	1871.27 Lorenzo di Niccolò	1871.27 Lorenzo di Niccolò (attributed to)
1871.28 Lorenzo di Niccolò	1871.28 Lorenzo di Niccolò	1871.28 Lorenzo di Niccolò (attributed to)
1871.32 Not included	1871.32 Not included	1871.32 Florentine school (manner of Andrea di Giusto)
1871.25 Not included	1871.25 Not included	1871.25 Lorenzo Monaco (remote follower of, or shop of Lorenzo di Niccolò Gerini?)
1871.7 Not included	1871.7 Not included	1871.7 Bernardo Daddi (follower of)
1871.23 Not included	1871.23 Not included	1871.23 Florentine school (style of Spinello Aretino)

Jarves 1860	*Sturgis 1868*	*Sirén 1916*
No. 33 *Miracle of SS. Cosmo and* *Damian* Lorenzo di Bicci	No. 36 Lorenzo di Bicci	1871.29 Mariotto di Nardo
No. 34 *St. John the Baptist* Orcagna	No. 25 Orcagna	1871.13 Nardo di Cione
No. 35 *St. Peter* Orcagna	No. 26 Orcagna	1871.14 Nardo di Cione
No. 36 *The Adoration of the Magi* *[Annunciation and Birth of* *the Saviour]* Simone Martini	No. 15 Simone Martini	1871.15 Orcagna
No. 37 Triptych: *Madonna and Child* *Enthroned with Saints* *[Madonna and Child with* *SS. Albertus, Peter, Paul, and* *Anthony; Redeemer and* *Annunciation* above] Sienese school 1370	No. 16 Sienese school	1871.22 Ambrogio di Baldese
No. 38 *Madonna and Child; SS. John* *the Baptist, Nicholas di Barri* (sic), *Dorothea, Reparata;* *Crucifixion* above Giottino (Tommaso di Stefano)	No. 31 Giottino	1871.16 Jacopo di Cione
No. 39 *The Birth and Resurrection of* *Christ* Giottino (Tommaso di Stefano)	No. 32 Giottino	1871.17 Jacopo di Cione

Offner 1927	*Berenson 1932*	*Present Catalogue 1968*
1871.29 Not included	1871.29 Mariotto di Nardo	1871.29 Mariotto di Nardo (attributed to)
1871.13 Nardo di Cione	1871.13 Nardo di Cione	1871.13 Nardo di Cione
1871.14 Nardo di Cione	1871.14 Nardo di Cione	1871.14 Nardo di Cione
1871.15 Florentine painter End of 14th century	1871.15 Giottesque Master (between Jacopo di Cione and Antonio Veneziano) After 1350	1871.15 Florentine school Ca. 1395–1400
1871.22 Agnolo Gaddi (follower of)	1871.22 Unknown Florentine (so-called "Baldese")	1871.22 "Pseudo-Ambrogio di Baldese" and assistants (?)
1871.16 Niccolò di Pietro Gerini (follower of)	1871.16 Mariotto di Nardo	1871.16 Jacopo di Cione (shop of ?)
1871.17 Florentine painter End of 14th century	1871.17 Mariotto di Nardo	1871.17 Florentine school (style of Jacopo di Cione)

Jarves 1860	*Sturgis 1868*	*Sirén 1916*
No. 40 *The Assumption of the Virgin* Sienese school Ca. 1350	No. 35 Sienese school Ca. 1350	1871.12 Luca di Tommè
No. 41 *SS. Zenobius, Francis of Assisi, and Anthony of Padua* Fra Angelico	No. 40 Fra Angelico	1871.31 Andrea di Giusto
No. 43 *The Adoration of the Magi* [*The Kings of the East*] Sano di Pietro	No. 49 Sano di Pietro	1871.61 Sano di Pietro
No. 44 *The Coronation of the Virgin* Sano di Pietro	No. 50 Sano di Pietro	1871.60 Sano di Pietro
No. 45 *St. Clara Blessing the Bread before Pope Innocent IV* [*St. Catherine of Siena Pleading before Pope Gregory XI*] Giovanni di Paolo	No. 51 Giovanni di Paolo	1871.59 Giovanni di Paolo
No. 46 *St. Anthony Tormented by Demons* Sienese school Ca. 1440	No. 53 Sienese school 1425–50	1871.58 Sassetta
No. 47 *The Temptation of St. Anthony* [*St. Anthony Tempted by the Devil in the Shape of a Woman*] Sassetta	No. 48 Sassetta	1871.57 Sassetta

Offner 1927	*Berenson 1932*	*Present Catalogue 1968*
1871.12 Luca di Tommè	1871.12 Luca di Tommè	1871.12 Luca di Tommè
1871.31 Fra Angelico (influence of)	1871.31 Domenico Michelino	1871.31 "Master of the Buckingham Palace Madonna" (attributed to)
1871.61 Sano di Pietro	1871.61 Sano di Pietro	1871.61 Sano di Pietro
1871.60 Sano di Pietro	1871.60 Sano di Pietro	1871.60 Sano di Pietro (shop of)
1871.59 Giovanni di Paolo	1871.59 Giovanni di Paolo	1871.59 Giovanni di Paolo
1871.58 Sassetta	1871.58 Sassetta	1871.58 Sassetta (close follower of, Sano di Pietro?)
1871.57 Sassetta	1871.57 Sassetta	1871.57 Sassetta (?) or "Osservanza Master"

Jarves 1860	*Sturgis 1868*	*Sirén 1916*
No. 48 *Scenes from the Life of a Holy Hermit [Exorcising of Evil Spirits]* Sienese school Ca. 1430	No. 54 Sienese school 1425–50	1871.37 "Master of the Carrand Triptych"
No. 50 *The Martyrdom of a Bishop by a Roman Emperor* Giovanni di Paolo	No. 52 Giovanni di Paolo	1871.62 Sano di Pietro
No. 51 *The Dormition of the Virgin [Death of the Virgin]* Unkown Umbrian artist Ca. 1425	No. 58 Umbrian school Before 1450	1871.38 Andrea del Castagno (follower of)
No. 52 *The Penance of St. Jerome, St. Francis Receiving the Stigmata [St. Jerome, St. Francis, Annunciation, Medici Arms on back]* Umbrian school Ca. 1450	No. 59 Umbrian school Before 1450	1871.44 Francesco Botticini
No. 53 *The Legend of St. Nicholas of Bari [Legend of S. Niccolo di Bari]* Neri di Bicci	No. 62 Neri di Bicci	1871.39 Neri di Bicci
No. 54 *The Penance of St. Jerome [St. Jerome]* Andrea del Castagno	No. 47 Andrea del Castagno	1871.53 Bartolommeo di Giovanni
No. 55 *Tournament in the Piazza S. Croce [Joust in Piazza S. Croce, Florence]* Dello Delli	No. 45 Dello Delli	1871.33 Florentine painter ca. 1440

Offner 1927	*Berenson 1932*	*Present Catalogue 1968*
1871.37 Not the "Carrand Master"	1871.37 Unknown Florentine (between "Carrand Master" and Neri di Bicci) 1420–65	1871.37 "Master of the Crawford Thebaid" (attributed to)
1871.62 Not included	1871.62 Giovanni di Paolo	1871.62 Sano di Pietro (shop of)
1871.38 Not included	1871.38 Florentine imitator of Castagno	1871.38 Florentine (?) school, imitator of Castagno
1871.44 Not included	1871.44 Jacopo del Sellaio (?)	1871.44 Florentine school 15th century
1871.39 Not included	1871.39 Neri di Bicci	1871.39 Neri di Bicci
1871.53 Not included	1871.53 "Alunno di Domenico" (Bartolommeo di Giovanni)	1871.53 Bartolommeo di Giovanni
1871.33 "Virgil Master" (shop of)	1871.33 "Master of the Jarves Cassoni"	1871.33 Apollonio di Giovanni (shop of)

Jarves 1860	*Sturgis 1868*	*Sirén 1916*
No. 56 *St. Martin Dividing His Cloak with a Beggar* Dello Delli	No. 46 Dello Delli	1871.11 Simone Martini
No. 57 *Story from the Aeneid [Stories from the Aeneid]* Paolo Uccello	No. 44 Paolo Uccello	1871.35 Florentine painter Ca. 1450
No. 58 *Aeneas and Dido* Uccello	No. 43 Uccello	1871.34 Florentine painter Ca. 1450
No. 59 *In the Garden of Love [Triumph of Love (cas- sone)]* Gentile da Fabriano	No. 38 Gentile da Fabriano	1871.67 Gentile da Fabriano (follower of)
No. 60 *Madonna and Child* Gentile da Fabriano	No. 39 Gentile da Fabriano	1871.66 Gentile da Fabriano
No. 61 *The Visit of the Queen of Sheba to Solomon (cassone)* Piero della Francesca (manner of)	No. 69 Piero della Francesca (manner of)	1871.36 Florentine painter Ca. 1450
No. 62 *The Annunciation* Benozzo Gozzoli	No. 63 Benozzo Gozzoli	1871.40 Giusto d'Andrea
No. 63 *The Virgin Adoring the Christ Child [Madonna Adoring Child; SS. Jerome, John the Baptist, Francis; Tobit and Angel; Almighty above]* Masolino da Panicale	No. 41 Masolino da Panicale	1871.45 Francesco Pesellino (follower of)

Offner 1927	*Berenson 1932*	*Present Catalogue 1968*
1871.11 Lippo Vanni	1871.11 Simone Martini	1871.11 Ambrogio Lorenzetti (attributed to)
1871.35 "Virgil Master" (shop of)	1871.35 "Master of the Jarves Cassoni"	1871.35 Apollonio di Giovanni (shop of)
1871.34 "Virgil Master" (shop of)	1871.34 "Master of the Jarves Cassoni"	1871.34 Apollonio di Giovanni (shop of)
1871.67 Paolo di Stefano	1871.67 Unknown Florentine (Paolo Schiavo?) 1420–65	1871.67 Florentine school (follower of Paolo Schiavo?) First half 15th century
1871.66 Gentile da Fabriano	1871.66 Gentile da Fabriano	1871.66 Gentile da Fabriano
1871.36 "Virgil Master" (shop of)	1871.36 "Master of the Jarves Cassoni"	1871.36 Apollonio di Giovanni (shop of?)
1871.40 Not included	1871.40 Francesco Pesellino (copy by Neri di Bicci)	1871.40 Florentine school Mid-15th century
1871.45 Not included	1871.45 Jacopo del Sellaio	1871.45 Jacopo del Sellaio

Jarves 1860	*Sturgis 1868*	*Sirén 1916*
No. 64 *The Birth of St. Thomas Aquinas [Birth of St. John the Baptist]* Masaccio	No. 42 Masaccio	1871.41 Baldovinetti
No. 65 *The Penance of St. Jerome [St. Jerome]* Fra Filippo Lippi	No. 60 Fra Filippo Lippi	1871.68 Fiorenzo di Lorenzo
No. 66 *Madonna with Angels and St. Catherine [Madonna in Adoration]* Fra Diamante	No. 61 Fra Diamante	1871.43 Fra Filippo Lippi (follower of)
No. 67 *Madonna Seated on Clouds [Madonna in Glory]* Cosimo Rosselli	No. 72 Cosimo Rosselli	1871.46 Jacopo del Sellaio
No. 68 *Actaeon and the Hounds [Story of Actaeon]* Piero di Cosimo	No. 82 Piero di Cosimo	1871.48 Jacopo del Sellaio
No. 69 *The Three Archangels [Three Archangels: Michael, Gabriel, Raphael with Tobit]* Piero di Cosimo	No. 83 Piero di Cosimo	1871.76 Franciabigio
No. 70 *The Nativity [Birth of the Savior]* Francesco Squarcione	No. 55 Francesco Squarcione	1871.71 Girolamo da Cremona

Offner 1927	*Berenson 1932*	*Present Catalogue 1968*
1871.41 Not included	1871.41 Domenico Morone	1871.41 Bartolommeo degli Erri (attributed to)
1871.68 Fiorenzo di Lorenzo	1871.68 Fiorenzo di Lorenzo	1871.68 Fiorenzo di Lorenzo
1871.43 Not included	1871.43 Pier Francesco Fiorentino (perhaps after a lost Fra Filippo)	1871.43 Francesco Pesellino (follower of)
1871.46 Not included	1871.46 Sellaio	1871.46 Sellaio (close follower of)
1871.48 Not included	1871.48 Sellaio	1871.48 Sellaio
1871.76 Not included	1871.76 Leonardo da Pistoia	1871.76 Not included
1871.71 Girolamo da Cremona	1871.71 Girolamo da Cremona	1871.71 Girolamo da Cremona (probably with Liberale da Verona)

Jarves 1860	*Sturgis 1868*	*Sirén 1916*
No. 72 *Madonna with the Pomegranate* [*Madonna and Child*] Sandro Botticelli	No. 74 Sandro Botticelli	1871.50 Sandro Botticelli (pupil of)
No. 73 *St. Sebastian* Filippino Lippi Dated 1479	No. 80 Filippino Lippi	1871.47 Jacopo del Sellaio
No. 74 *Christ on the Cross* [*The Dead* *Christ*] Filippino Lippi	No. 81 Filippino Lippi	1871.56 Filippino Lippi
No. 75 *The Rape of Deianira* [*Hercules* *killing Nessus*] Antonio Pollaiuolo	No. 64 Antonio Pollaiuolo	1871.42 Antonio Pollaiuolo
No. 76 *The Annunciation* Piero Pollaiuolo	No. 65 Piero Pollaiuolo	1871.63 Neroccio dei Landi
No. 77 *The Baptism of Christ* Andrea Verrocchio (manner of)	No. 66 Verrocchio (manner of)	1871.55 Lorenzo di Credi (follower of)
No. 78 *Madonna and Child* Matteo da Siena	No. 57 Matteo di Giovanni da Siena	1871.64 Benvenuto di Giovanni
No. 79 *Love Bound by Maidens* [*Triumph of Chastity*] Pinturicchio	No. 71 Pinturicchio	1871.65 Girolamo di Benvenuto

Offner 1927	*Berenson 1932*	*Present Catalogue 1968*
1871.50 Botticelli (follower of)	1871.50 Botticelli	1871.50 Botticelli (close follower of)
1871.47 Not included	1871.47 Sellaio	1871.47 Sellaio
1871.56 Filippino Lippi	1871.56 Filippino Lippi (L.)	1871.56 Filippino Lippi (shop of ?)
1871.42 Antonio with Piero Pollaiuolo	1871.42 Antonio Pollaiuolo	1871.42 Antonio Pollaiuolo
1871.63 Neroccio	1871.63 Neroccio	1871.63 Francesco di Giorgio and Neroccio
1871.55 Not included	1871.55 "Tommaso"	1871.55 "Tommaso" (Giovanni Cianfanini?)
1871.64 Benvenuto di Giovanni	1871.64 Benvenuto di Giovanni	1871.64 Benvenuto di Giovanni
1871.65 Girolamo di Benvenuto	1871.65 Girolamo di Benvenuto	1871.65 Girolamo di Benvenuto

Jarves 1860	*Sturgis 1868*	*Sirén 1916*
No. 80 *The Adoration of the Magi* Luca Signorelli	No. 67 Luca Signorelli	1871.69 Luca Signorelli
No. 81 *The Crucifixion* Andrea Mantegna	No. 56 Andrea Mantegna	1871.51 "Pseudo-Verrocchio"
No. 83 *The Crucifixion* Lorenzo di Credi	No. 84 Lorenzo di Credi	1871.54 Lorenzo di Credi
No. 84 *The Creation of Adam and Eve* Lorenzo di Credi	No. 85 Lorenzo di Credi (manner of)	1871.49 Jacopo del Sellaio
No. 87 *Portrait of a Lady [Portrait of a Lady of the Tornabuoni Family]* Domenico Ghirlandaio	No. 73 Domenico Ghirlandaio	1871.52 Domenico Ghirlandaio
No. 92 *Lady Holding a Rabbit [Portrait of Wife of Paolo (?) Vitelli]* Francesco Francia	No. 68 Francesco Francia	1871.72 Piero di Cosimo
No. 94 *The Baptism of Christ, Father above* Perugino	No. 70 Perugino	1871.93 Sinibaldo Ibi
No. 95 *Madonna, SS. John, Joseph of Arimathea, Dead Christ* Raphael Sanzio	No. 89 Raphael	1871.119 Unknown painter Ca. middle of the 19th century
No. 96 *Madonna and Child, St. John and Four Saints* Lo Spagna	No. 90 Lo Spagna	1871.92 Bertucci

Offner 1927	*Berenson 1932*	*Present Catalogue 1968*
1871.69 Signorelli	1871.69 Signorelli	1871.69 Signorelli (L.)
1871.51 Domenico Ghirlandaio	1871.51 Domenico Ghirlandaio (in part)	1871.51 Biagio d'Antonio (attributed to)
1871.54 Lorenzo di Credi	1871.54 Lorenzo di Credi (E.)	1871.54 Lorenzo di Credi (L., attributed to)
1871.49 Sellaio	1871.49 Sellaio	1871.49 "Master of the Apollo and Daphne Legend"
1871.52 Domenico Ghirlandaio	1871.52 Domenico Ghirlandaio	1871.52 Domenico Ghirlandaio
1871.72 Piero di Cosimo	1871.72 Piero di Cosimo	1871.72 Ridolfo Ghirlandaio (attributed to, E.)
1871.93 Sinibaldo Ibi	1871.93 Not included	1871.93 Perugino (follower of, Sinibaldo Ibi?)
1871.119 Not included	1871.119 Not included	1871.119 Not included 19th century
1871.92 Bertucci	1871.92 Bertucci	1871.92 Bertucci (attributed to)

Jarves 1860	*Sturgis 1868*	*Sirén 1916*
No. 107	No. 77	1871.95
The Circumcision	Giorgione	Giovanni Cariani
Giorgione		
No. 108	No. 78	1871.96
Venetian Nobleman with Two	Giorgione	Venetian painter
Women [Andrea Gritti and		Ca. 1510
his Sisters]		
Giorgione		
Ca. 1500		
No. 110	No. 79	1871.94
Madonna and Child with SS.	Marco Basaiti	Bissolo
John the Baptist, Mary		
Magdalen, and Two Donors		
[Virgin and Child, SS.		
Magdalen and John]		
Marco Basaiti		

Offner 1927	*Berenson 1932*	*Present Catalogue 1968*
1871.95 Cariani (style of)	1871.95 Titian (E.)	1871.95 Titian (E.) (attributed to)
1871.96 Not included	1871.96 Not included	1871.96 Not included
1871.94 Not included	1871.94 Pietro degli Ingannati	1871.94 Bissolo (attributed to)

Iconographical Guide

A. Religious Subjects

(*Indicates that the subject is secondary to the main theme of the painting referred to)

Adoration of the Magi

Florentine school (ca. 1395–1400)	1871.15
Sano di Pietro	1871.61
Luca Signorelli	1871.69
Florentine (?) school (15th century)	1943.223

Adoration of the Shepherds

See Nativity

Adoration of the Virgin

Jacopo del Sellaio	1871.45
Jacopo del Sellaio	1946.314
Neri di Bicci (shop of)	1943.220
Francesco Pesellino (follower of, "Pseudo-Pier Francesco Fiorentino"?)	1943.226

Agony in the Garden

Florentine school, Andrea di Giusto (manner of)	1871.32
Jacopo del Sellaio (shop of)	1943.229

Annunciation

Florentine school (ca. 1395–1400)*	1871.15
Niccolò di Pietro Gerini (?)	1871.21
"Pseudo-Ambrogio di Baldese" (?) and assistants*	1871.22
Lorenzo di Niccolò and assistant (attributed to)	1871.26
Florentine school, 15th century	1871.40
Francesco di Giorgio and Neroccio dei Landi	1871.63
Bernardino Fungai (imitator of)	1943.257a,b
Florentine school (15th century, Domenico di Michelino?)	1959.15.6

Annunciation to the Shepherds

Florentine school (ca. 1395–1400)*	1871.15

Assumption of the Virgin
 Luca di Tommè 1871.12

Baptism of Christ
 "Tommaso" (Giovanni Cianfanini ?) 1871.55
 Perugino (follower of, Sinibaldo Ibi ?) 1871.93

Christ Among the Doctors
 Ludovico Brea da Nizza (attributed to) 1943.263

Christ and the Virgin Enthroned
 Giovanni del Biondo 1871.19

Christ as Man of Sorrows
 Florentine school, 15th century 1959.15.9
 Sienese school (attributed to) (frame) 1960.71

Christ as Savior
 Martino di Bartolommeo (attributed to) 1942.322
 Taddeo di Bartolo 1943.249

Circumcision
 Titian (attributed to) 1871.95

Coronation of the Virgin
 Sano di Pietro (shop of) 1871.60
 Jacopo del Casentino (shop of) 1939.557
 Jacopo di Cione (shop of) 1959.15.2
 School of Rimini ("Master of the Life of St. John Baptist"?) 1959.15.14

Crucified Christ
 Filippino Lippi (shop of ?) 1871.56
 Luca di Tommè 1943.246

 with Magdalen Alone
 Lorenzo di Credi (attributed to) 1871.54

 with Virgin and St. John
 Tuscan school (13th century) 1871.1a
 Jacopo di Cione (shop of) * 1871.16
 Lorenzo Monaco (follower of) 1871.24
 Biagio d'Antonio (attributed to) 1871.51
 Jacopo del Sellaio (follower of) 1943.228
 "Master of the Assumption of Mary Magdalen" 1943.261
 Giovanni dal Ponte 1959.15.7b

with Virgin, SS. John and Magdalen
 Simone dei Crocefissi 1959.15.3

Crucifixion
 Guido da Siena (shop of) 1871.2
 Bernardo Daddi (follower of) 1871.7
 Ducciesque Master (early 14th century) 1871.10b
 Bicci di Lorenzo (shop of) 1937.200a
 Florentine school (14th century) 1937.342

Daniel (in relation to the Story of Susanna)
 "Master of the Apollo and Daphne Legend" 1943.227

Dormition of the Virgin
 Florentine (?) school (imitator of Castagno) 1871.38

Entombment (with St. John the Evangelist)
 Taddeo Gaddi 1871.8

Holy Trinity
 Jacopo di Cione (follower of) 1871.18

Lamentation
 Tuscan school (13th century) 1871.1c

Last Supper
 Niccolò di Tommaso 1937.200b

Lives of Hermits of Thebaid
 "Master of the Crawford Thebaid" 1871.37

Madonna and Child
 Alone

 Botticelli (close follower of) 1871.50
 Gentile da Fabriano 1871.66
 Taddeo Gaddi (shop of) 1943.205
 Bernardo Daddi (follower of) 1943.208
 Jacopo del Casentino (attributed to) 1943.209
 Florentine school (follower of Orcagna? 14th century) 1943.214
 Tuscan school (13th century) 1954.7.9
 Bolognese school (14th century) 1955.27.4
 Francia 1959.15.10
 Niccolò di Segna (attributed to) 1959.15.17
 Giovanni Bellini (follower of) 1959.15.11
 Bernardo Daddi (attributed to) 1965.124

with Angels

Ducciesque Master (early 14th century)	1871.10a
Jacopo del Sellaio (close follower of)	1871.46
Benvenuto di Giovanni	1871.64
Arcangelo di Cola da Camerino (attributed to)	1937.10
"Master of S. Martino" (attributed to)	1943.202
"Master of the Castello Nativity"	1943.222
"Dalmasio" (attributed to)	1943.260
Zanobi Machiavelli	1943.224
Francesco Pesellino (follower of)	1943.225
Francesco Pesellino (follower of)	1943.226
"Master of the Ovile Madonna"	1943.244

with Angels and Saints

"Pseudo-Ambrogio di Baldese" (?) and assistants	1871.22
Florentine School (15th century)	1937.341
Rossello di Jacopo Franchi	1943.219
"Master of the Borghese Tondo," (attributed to)	1943.233
Sano di Pietro (shop of)	1943.254
Benvenuto di Giovanni (shop of)	1943.256

with Saints

"Magdalen Master"	1871.3
"Magdalen Master"	1871.4
Tuscan school (Pisan ? 13th century)	1871.5
Jacopo di Cione (shop of?)	1871.16
Lorenzo di Niccolò and assistant (attributed to)	1871.26
Francesco Bissolo (attributed to)	1871.94
Luca di Tommè and assistant (?)	1943.245
Andrea di Bartolo	1943.248
Giovanni di Paolo (shop of)	1943.255
Guidoccio Cozzarelli (shop of)	1943.258
Marchigian school (15th century)	1943.266
Bernardino Pinturicchio	1959.15.16

Meeting of Solomon and Sheba

Apollonio di Giovanni (shop of?)	1871.36

Nativity

Florentine school (style of Jacopo di Cione)	1871.17
Girolamo da Cremona (with Liberale da Verona?)	1871.71

Jacopo del Sellaio (follower of) 1943.228
Niccolò di Tommaso (shop of) 1943.236
Girolamo di Benvenuto (imitator of) 1943.259
Pietro Perugino (follower of) 1943.265
Guidoccio Cozzarelli (attributed to) 1954.7.3
Sienese (15th century) 1954.7.5

Noli Me Tangere
Jacopo del Sellaio (shop of?) 1943.232

Resurrection
Florentine school (style of Jacopo di Cione) 1871.17
Jacopo del Sellaio (shop of?) 1943.231
Tuscan or Umbrian school (14th century) 1954.7.1
Giovanni dal Ponte 1959.15.7a

Visitation
Ludovico Brea da Nizza (? attributed to) 1943.262

Way to Calvary
Jacopo del Sellaio (shop of?) 1943.230

B. Saints

Agatha. Attributes: lance, breasts on a plate
Madonna and Child with Saints
Andrea di Bartolo 1943.248

Agnes. Attribute: lamb
SS. Agnes and Dominic
Lorenzo di Niccolò (attributed to) 1871.28

Albert. Attributes: lily, Carmelite habit
Madonna Enthroned with Saints
"Pseudo-Ambrogio di Baldese" (?) and assistants 1871.22

Ambrose. Attributes: Bishop's robes, scourge
Madonna and Child with 14 Saints
Andrea di Bartolo 1943.248

Andrew. Attribute: book
St. Andrew, St. James the Greater, and a Prophet
Pietro Lorenzetti and assistant 1959.15.1a

Anthony Abbot. Attributes: long white beard, dark grey habit, crutch
Madonna and Child with 14 Saints
Andrea di Bartolo 1943.248

St. Anthony Tormented by Demons
Sassetta (follower of, Sano di Pietro?) 1871.58

Temptation of St. Anthony
Sassetta (?) or "Osservanza Master" 1871.57

Madonna and Child with Saints
Lorenzo di Niccolò and assistant (attributed to) 1871.26

Crucifixion
Bernardo Daddi (follower of) 1871.7

pig, as attribute of St. Anthony

Coronation of the Virgin
Jacopo di Cione (shop of) 1959.15.2

Madonna Enthroned with Saints
"Pseudo-Ambrogio di Baldese" (?) and assistants 1871.22

Anthony of Padua. Attributes: Franciscan habit, flame in hand

SS. Zenobius, Francis, and *Anthony of Padua*
"Master of the Buckingham Palace Madonna" (attributed to) 1871.31

Nativity and Crucifixion (on frame)
Jacopo del Sellaio (remote follower of) 1943.228

St. Elizabeth of Hungary and St. Anthony of Padua
Florentine school (ca. 1380) 1943.210

Antoninus (?). Attribute: Dominican habit

Madonna and Child with Saints and Angels
Florentine school (ca. 1450–60) 1937.341

Augustine. Attributes: Bishop's robes over monastic robes

SS. Augustine and Lucy
Lorenzo di Niccolò (attributed to) 1871.27

Bartholomew. Attribute: knife

Madonna and Child with SS. Jerome and Bartholomew
Giovanni di Paolo (shop of) 1943.255

Bernard of Clairvaux. Attributes: Cistercian habit, book, pen

Madonna and Child with Saints
Lorenzo di Niccolò and assistant (? attributed to) 1871.26

Bernardine (San Bernardino). Attributes: old toothless man, Franciscan habit, book
with monogram of Christ in rays of light

Coronation of the Virgin
Sano di Pietro (shop of) 1871.60

Madonna and Child with Saints and Angels
Sano di Pietro (shop of) 1943.254

Bridget (of Ireland). Attribute: white veil
St. Bridget's Vision of the Nativity
Niccolò di Tommaso (shop of) 1943.236

Catherine of Alexandria. Attributes: crown, wheel

 Madonna and Child with St. Catherine and Angels
 Pesellino (follower of) 1871.43

 Madonna and Child with Saints
 Andrea di Bartolo 1943.248

 St. Catherine of Alexandria
 Martino di Bartolommeo (attributed to) 1943.253

 St. Catherine of Alexandria
 Rossello di Jacopo Franchi 1953.26.1

Catherine of Siena. Attributes: lily, Dominican habit

 Madonna and Child, St. Catherine and a Female Saint
 Guidoccio Cozzarelli (shop of) 1943.258

 Madonna and Child with Saints and Angels
 Sano di Pietro (shop of) 1943.254

Clara of Assisi. Attribute: habit of the poor Clares

 Madonna and Child with Saints
 Andrea di Bartolo 1943.248

 St. Clara of Assisi Blessing the Bread Before Pope Innocent IV
 Giovanni di Paolo 1871.59

 lily

 SS. Clara and Louis of Toulouse
 Florentine school (ca. 1380) 1943.211

Cosmas and Damian. Attribute: as twins, doctors of medicine

 Legend of SS. Cosmas and Damian
 Mariotto di Nardo (attributed to) 1871.29

Dominic. Attribute: Dominican habit

 Vocation of St. Dominic
 Bernardo Daddi 1871.6

 Visions of Pope Innocent and St. Dominic
 Fra Angelico (close follower or associate of) 1937.343

 Madonna and Child with Saints
 "Magdalen Master" 1871.4

 star on head

 SS. Agnes and Dominic
 Lorenzo di Niccolò (attributed to) 1871.28

lily as attribute of St. Dominic

 Predella: *Crucifixion and Saints*

 Luca di Tommè 1943.246

Dorothy. Attributes: wreath of roses, basket of roses and lilies

 Madonna and Child Enthroned

 Jacopo di Cione (shop of ?) 1871.16

 Madonna and Child with Saints

 Lorenzo di Niccolò and assistant (attributed to) 1871.26

Elizabeth (mother of John the Baptist)

 Visitation

 Ludovico Brea da Nizza (? attributed to) 1943.262

Elizabeth of Hungary. Attributes: Franciscan robes, roses

 St. Elizabeth of Hungary and St. Anthony of Padua

 Florentine school (ca. 1380) 1943.210

Flora. Attributes: Benedictine nun's habit, palm

 St. Flora

 Florentine school (style of Pacino di Bonaguida?) 1943.203

Francis. Attributes: Franciscan habit, stigmata

 Madonna and Child with Saints

 "Magdalen Master" 1871.4

 Madonna and Child and Saints

 Tuscan school (Pisa ? 13th century) 1871.5

 St. Francis Receiving the Stigmata

 Lorenzo Monaco (follower of, or shop of Lorenzo di Niccolò

 Gerini) 1871.25

 SS. Zenobius, Francis, and Anthony of Padua

 "Master of the Buckingham Palace Madonna" (attributed to) 1871.31

 Penance of St. Jerome and St. Francis Receiving the Stigmata

 Florentine school (15th century) 1871.44

 Nativity and Crucifixion

 Jacopo del Sellaio (remote follower of) 1943.228

 Crucifixion and Saints

 Luca di Tommè 1943.246

 Madonna and Child with Saints

 Andrea di Bartolo 1943.248

Mystical Nativity
Jacopo del Sellaio 1946.314
Madonna and Child with Saints
Pinturicchio 1959.15.16
Coronation of the Virgin
Sano di Pietro (shop of) 1871.60

Gabriel, Archangel. Attribute: lily
Adoration of Magi with *Annunciation*
Florentine school (ca. 1395–1400, frame) 1871.15
Madonna Enthroned with Saints (*Annunciation* in frame)
"Pseudo-Ambrogio di Baldese" (?) and assistants 1871.22
Annunciation
Niccolò di Pietro Gerini (?) 1871.21
Annunciation
Florentine school (Domenico di Michelino?) 1959.15.6
Annunciation at top of wings of *Madonna and Child with Saints*
Lorenzo di Niccolò and assistant (? attributed to) 1871.26

without lily
Annunciation
Florentine School (15th century) 1871.40

with scroll, AVE GRATIA PLENA
Annunciation
Francesco di Giorgio and Neroccio 1871.63

with olive branch
Angel of the Annunciation
Bernardino Fungai (?) (imitator of) 1943.257a

James the Greater, Apostle. Attributes: pilgrim's staff, purse, book
St. James
Niccolò di Tommaso 1943.235
St. James Major and Resurrection
Giovanni dal Ponte 1959.15.7a
Madonna and Child with Saints
Tuscan School (Pisa? 13th century) 1871.5
Madonna and Child with 14 Saints
Andrea di Bartolo 1943.248

Madonna and Child with Saints
Lorenzo di Niccolò and assistant (attributed to) 1871.26

Coronation of the Virgin
Jacopo di Cione 1959.15.2

with St. Andrew and a Prophet

St. Andrew, St. James the Greater, and a Prophet
Pietro Lorenzetti and assistant 1959.15.1b

with SS. Julian and Michael

SS. Julian, James, and Michael
Agnolo Gaddi 1871.20

with SS. Peter and John

Agony in the Garden
Jacopo del Sellaio (shop of?) 1943.229

Agony in the Garden
Florentine school (manner of Andrea di Giusto) 1871.32

Jerome. Attributes: as penitent, beating breast with stone, seminude

Madonna and Child with Saints and Angels
Benvenuto di Giovanni (shop of) 1943.256

lion

Mystical Adoration
Jacopo del Sellaio 1871.45

crucifix and cardinal's hat

Penance of St. Jerome and St. Francis receiving Stigmata
Florentine school (15th century) 1871.44

Penance of St. Jerome
Fiorenzo di Lorenzo 1871.68

Penance of St. Jerome
Bartolommeo di Giovanni 1871.53

cardinal's robes

Madonna and Child with SS. Jerome and Bartholomew
Giovanni di Paolo (shop of) 1943.255

St. Jerome
Taddeo di Bartolo 1943.250

Madonna and Child with Saints and Angels
Sano di Pietro (shop of) 1943.254

Madonna and Child with Saints
Pinturicchio 1959.15.16

John the Baptist. Attributes: adult, goat skin garment, rough hair, slender cross

St. John the Baptist
"Master of Città di Castello" 1943.243

Madonna and Child with Saints and Donors
Francesco Bissolo (attributed to) 1871.94

Holy Trinity
Jacopo di Cione (late follower of) 1871.18

Madonna and Child Enthroned
Jacopo di Cione (shop of?) 1871.16

Madonna and Child with Saints
Lorenzo di Niccolò and assistant (attributed to) 1871.26

St. John the Baptist
Nardo di Cione 1871.14

St. John the Baptist and Crucifixion
Giovanni dal Ponte 1959.15.7b

Madonna and Child with St. John the Baptist, St. Peter and Two Angels
Rossello di Jacopo Franchi 1943.219

St. John the Baptist
Paolo Veneziano 1959.15.4b

without cross (labeled)

Madonna and Child with Saints
Tuscan school (Pisa? 13th century) 1871.5

baptizing Christ

Baptism of Christ
Perugino (follower of, Sinibaldo Ibi?) 1871.93

Baptism of Christ
"Tommaso" (Giovanni Cianfanini?) (attributed to) 1871.55

with scroll, ECCE AGNUS DEI

Madonna and Child with Saints
Andrea di Bartolo 1943.248

St. John the Baptist
Taddeo di Bartolo 1943.251

as a child

Madonna and Child with Saints
Bertucci (attributed to) 1871.92

Penance of St. Jerome
Bartolommeo di Giovanni 1871.53

as child with scroll

Mystical Adoration
Jacopo del Sellaio 1871.45

Madonna and Child with St. John the Baptist
"Master of the Borghese Tondo" (attributed to) 1943.233

John the Evangelist. Attributes: beardless, with book and pen

St. John the Evangelist
Sienese school (Barna da Siena?) 1943.239

Madonna and Child with Saints
Lorenzo di Niccolò and assistant (? attributed to) 1871.26

St. John the Evangelist
Barna da Siena (follower of, Giovanni d'Asciano?) 1946.12

Agony in the Garden
Jacopo del Sellaio (shop of ?) 1943.229

Agony in the Garden
Florentine school (manner of Andrea di Giusto) 1871.32

Holy Trinity
Jacopo di Cione (late follower of) 1871.18

Crucifixion
Guido da Siena (shop of) 1871.2

Crucifixion, Deposition, Lamentation
Tuscan school (13th century) 1871.1

Nativity and Crucifixion
Jacopo del Sellaio (remote follower of) 1943.228

Madonna and Child with Saints
Lorenzo di Niccolò and assistant (? attributed to) 1871.26

Crucifixion
Bernardo Daddi (follower of) 1871.7

Crucifixion
Lorenzo Monaco (close follower of) 1871.24
Deposition
Giovanni di Pietro da Napoli (attributed to) 1871.70
Crucifixion
Ducciesque Master (early 14th century) 1871.10b
Processional Cross
Umbrian school (ca. 1300) 1943.238
Entombment
Taddeo Gaddi 1871.8
Crucifixion and Saints
Luca di Tommè 1943.246
Crucifixion (l. wing of *Madonna and Child* triptych)
"Magdalen Master" 1871.4
Crucifixion
Biagio d'Antonio (attributed to) 1871.51
Crucifixion; Madonna and Child Enthroned
Jacopo di Cione (shop of?) 1871.16

John Gualbert. Attribute: Vallombrosan habit, also in armor
Scenes from the Life of S. Giovanni Gualberto
Florentine school (15th century) 1871.30

Joseph.
Christ among the Doctors
Ludovico Brea da Nizza (? attributed to) 1943.263
Adoration of the Magi
Sano di Pietro 1871.61
Adoration of the Magi
Luca Signorelli 1871.69
Adoration of the Magi
Florentine school, ca. 1395–1400 1871.15
Nativity and Crucifixion
Jacopo del Sellaio (remote follower of) 1943.228
Nativity and Resurrection of Christ
Florentine school (style of Jacopo di Cione) 1871.17

Nativity
Girolamo di Benvenuto (imitator of?) 1943.259

Nativity
Girolamo da Cremona (with Liberale da Verona?) 1871.71

Nativity
Pietro Perugino (close follower of) 1943.265

Adoration of the Magi
Florentine school, ca. 1475 1943.223

Mystical Nativity
Jacopo del Sellaio 1946.314

Julian. Attribute: sword

SS. Julian, James, and Michael
Agnolo Gaddi 1871.20

Leonard. Attribute: deacon's robes

Madonna and Child with Saints
"Magdalen Master" 1871.3

Longinus. Attribute: carrying spear

Crucifixion
Guido da Siena (shop of) 1871.2

Crucifixion
Ducciesque Master (early 14th century) 1871.10b

mounted on horseback

Crucifixion
Bernardo Daddi (follower of) 1871.7

Louis of Toulouse. Attributes: bishop's robes over Franciscan habit, fleur-de-lis, crown at feet

St. Louis of Toulouse and St. Clara
Florentine school, ca. 1380 1943.211

Lucilla. Attribute: Benedictine nun's habit

St. Lucilla
Florentine school (style of Pacino di Bonaguida?) 1946.13

Lucy. Attribute: lamp with flame

SS. Augustine and Lucy
Lorenzo di Niccolò (attributed to) 1871.27

poniard
>St. Lucy with Angels
>Giovanni di Bartolommeo Cristiani 1943.215

Mammas. Shown as youth, with wild beasts
>Flight of the Soldiers Sent to Capture St. Mammas
>St. Mammas Thrown to the Beasts
>Francesco dei Franceschi (attributed to) 1946.72
> 1946.73

Martin. Attributes: mounted soldier, dividing cloak with beggar
>St. Martin and the Beggar
>Ambrogio Lorenzetti (attributed to) 1871.11

Mary Magdalen. Attributes: long hair, rich (often red) clothes, ointment box
>St. Mary Magdalen
>Paolo Veneziano 1959.15.4a
>Madonna and Child with Saints
>Andrea di Bartolo 1943.248
>Madonna and Child with Saints and Donors
>Francesco Bissolo (attributed to) 1871.94
>Christ on the Cross
>Lorenzo di Credi (attributed to) 1871.54
>Noli Me Tangere
>Jacopo del Sellaio (shop of ?) 1943.232
>Mystical Nativity
>Jacopo del Sellaio 1946.314
>Crucifixion
>Ducciesque Master (early 14th century) 1871.10b
>Lamentation
>Tuscan school (13th century) 1871.1c
>Crucifixion
>Guido da Siena (shop of) 1871.2
>Holy Trinity
>Jacopo di Cione (late follower of) 1871.18
>Madonna and Child with Saints
>Lorenzo di Niccolò and assistant (? attributed to) 1871.26

 Deposition
 Giovanni di Pietro da Napoli (attributed to) 1871.70
 Nativity and Crucifixion
 Jacopo del Sellaio (remote follower of) 1943.228

Mary Virgin. Attributes: red undergarment, blue robe
 Madonna and Child: See A: Religious Subjects
 Circumcision
 Titian (attributed to) 1871.95
 Madonna
 Florentine school (second half 14th century) 1943.212
 Sorrowing Virgin
 Pietro Lorenzetti (shop of) 1942.323
 Virgin Annunciate
 Bartolo di Maestro Fredi (attributed to) 1943.247
 Virgin Annunciate
 Sassetta 1959.15.5
 Coronation of the Virgin
 Jacopo del Casentino (shop of?) 1939.557
 Coronation of the Virgin
 Jacopo di Cione (shop of) 1959.15.2
 Dormition of the Virgin
 Florentine (?) school (Castagno, imitator of) 1871.38
 Crucifixion and *Coronation of the Virgin*
 Simone dei Crocefissi 1959.15.3
 Coronation of the Virgin
 Sano di Pietro (shop of) 1871.60
 Coronation of the Virgin
 School of Rimini ("Master of the Life of St. John the Baptist"?
 14th century) 1959.15.14
 Assumption of the Virgin
 Luca di Tommè 1871.12
 Christ and the Virgin Enthroned
 Giovanni del Biondo 1871.19
 with John the Evangelist
 Crucifixion (1. wing of *Madonna and Child* triptych)
 "Magdalen Master" 1871.4

Crucifixion
"Master of the Assumption of Mary Magdalen"
(attributed to) 1943.261
Crucifixion
Biagio d'Antonio (attributed to) 1871.51
Crucifixion
Tuscan school (mid-13th century) 1871.1a
Crucifixion and Saints
Luca di Tommè 1943.246
Processional Cross, *Crucifixion and Saints*
Umbrian school (ca. 1300) 1943.238
Entombment of Christ
Taddeo Gaddi 1871.8

with SS. Mary Magdalen and John
Madonna and Child with Saints
Lorenzo di Niccolò and assistant (attributed to) 1871.26
Deposition
Giovanni di Pietro da Napoli (attributed to) 1871.70
Crucifixion
Lorenzo Monaco (follower of) 1871.24
Crucifixion
Bernardo Daddi (follower of) 1871.7
Nativity and Crucifixion
Jacopo del Sellaio (remote follower of) 1943.228
Mystical Nativity
Jacopo del Sellaio 1946.314
Holy Trinity
Jacopo di Cione (late follower of) 1871.18
Crucifixion
Guido da Siena (shop of) 1871.2
Deposition, Lamentation
Tuscan school (13th century) 1871.1b,c
with Gabriel. *See* Gabriel
with Elizabeth
Visitation
Ludovico Brea da Nizza (?) (attributed to) 1943.262

with Joseph. *See* Joseph

Michael, Archangel. Attributes: sword, globe with cross

 SS. Julian, James, and Michael
 Agnolo Gaddi 1871.20

 standing on dragon
 Madonna and Child with Saints
 "Magdalen Master" 1871.4
 A Legendary Subject and St. Michael Fighting the Demon
 Florentine school (style of Spinello Aretino) 1871.23

Nicholas. Attributes: purses of gold secretly given to the penniless girls

 A Scene from the Legend of St. Nicholas of Bari
 Neri di Bicci 1871.39

 three balls, bishop's robes
 Madonna and Child Enthroned with Saints
 Jacopo di Cione (shop of ?) 1871.16

Onophrius. Attributes: nude with long hair, beard

 Mystical Nativity
 Jacopo del Sellaio 1946.314

Paul, Apostle. Attributes: balding, pointed beard, sword

 Madonna Enthroned with Saints
 "Pseudo-Ambrogio di Baldese" (?) and assistants 1871.22
 Madonna and Child with Saints
 Andrea di Bartolo 1943.248
 Madonna and Child with Saints and Angels
 Sano di Pietro (shop of) 1943.254
 Madonna and Child with Saints
 Marchigian school (15th century) 1943.266

Peter, Apostle. Attributes: short hair and beard (usually white), keys

 St. Peter (?)
 "Master of Città di Castello" 1943.242
 St. Peter (as Pope)
 Vittorio Crivelli 1946.313
 St. Peter
 Carlo Crivelli 1959.15.15

Coronation of the Virgin
Sano di Pietro (shop of) 1871.60
Virgin and Child with Saints
Marchigian school (15th century) 1943.266
Madonna and Child with Saints
Rossello di Jacopo Franchi 1943.219
St. Peter
Nardo di Cione 1871.13
Madonna and Child with Saints
Tuscan school (Pisa ? 13th century) 1871.5
Madonna Enthroned with Saints
"Pseudo-Ambrogio di Baldese" (?) and assistants 1871.22

with SS. James and John
Agony in the Garden
Jacopo del Sellaio (shop of ?) 1943.229
Agony in the Garden
Florentine school (manner of Andrea di Giusto) 1871.32

scenes from his life
Madonna and Child with Saints
"Magdalen Master" 1871.3

Peter, Martyr. Attributes: Dominican habit, knife in head
St. Peter Martyr
Benvenuto di Giovanni 1946.316
Enthroned Madonna and Child with Saints and Angels
Florentine school (15th century) 1937.341
Mystical Nativity
Jacopo del Sellaio 1946.314
(probably) *Madonna and Child* (r. wing of triptych)
"Magdalen Master" 1871.4

Raphael, Archangel. Attributes: Tobias, fish, ointment box
Mystical Adoration
Jacopo del Sellaio 1871.45

Reparata. Attributes: crown, palm, cross
Madonna and Child Enthroned with Saints
Jacopo di Cione (shop of ?) 1871.16

Sebastian. Attributes: nude, pierced with arrows
 St. Sebastian
 Jacopo del Sellaio 1871.47
Thomas Aquinas
 Birth of St. Thomas Aquinas
 Bartolommeo degli Erri (attributed to) 1871.41
Zenobius. Attribute: bishop's robes
 SS. *Zenobius, Francis, and Anthony of Padua*
 "Master of the Buckingham Palace Madonna"
 (attributed to) 1871.31

C. Secular and Humanistic Subjects

Achates

Adventures of Aeneas (1) *The Shipwreck of Aeneas*
Apollonio di Giovanni (shop of) 1871.34

Adventures of Aeneas (2) *Aeneas at Carthage*
Apollonio di Giovanni (shop of) 1871.35

Actaeon

The Story of Actaeon (2) *Actaeon and the Hounds*
Jacopo del Sellaio 1871.48

The Story of Actaeon (1) *Diana and Actaeon*
Jacopo del Sellaio 1952.37.1

Aeneas

Adventures of Aeneas (1) *The Shipwreck of Aeneas*
Apollonio di Giovanni (shop of) 1871.34

Adventures of Aeneas (2) *Aeneas at Carthage*
Apollonio di Giovanni (shop of) 1871.35

Aeolus

Adventures of Aeneas (1) *The Shipwreck of Aeneas*
Apollonio di Giovanni (shop of) 1871.34

Antaeus

Hercules Slaying Antaeus
Antonio Pollaiuolo (after) 1946.317

Apollo

Allegory of Love
Florentine school (first half 15th century;
Paolo Schiavo, follower of ?) 1871.67

Arms (stemma)

 Calimala of Florence (eagle)

 Populo of Florence (red cross on argent)

 A Tournament in Piazza S. Croce
 Apollonio di Giovanni (shop of) 1871.33

 Piccolomini Family of Siena (three crescents on sable)

 Love Bound by Maidens
 Girolamo di Benvenuto 1871.65

Artemisia

 A Triumph of Love (?)
 Giovanni di Paolo (shop of?) 1926.9

Ascanius

 Adventures of Aeneas (2) *Aeneas at Carthage*
 Apollonio di Giovanni (shop of) 1871.35

Battle

 Battle of Heraclius and Chosroes
 Florentine school (second half 15th century) 1933.61
 Battle at the Gates of Rome
 "Anghiari Master" (shop of) 1942.324

Boccaccio (?), represented

 Allegory of Love
 Florentine school (first half 15th century;
 Paolo Schiavo, follower of?) 1871.67

Camillus, story of

 Battle at the Gates of Rome
 "Anghiari Master" (shop of) 1942.324

Carthage, represented

 Adventures of Aeneas (2) *Aeneas at Carthage*
 Apollonio di Giovanni (shop of) 1871.35

Centaur

 See Nessus

Chosroes

 Battle of Heraclius and Chosroes
 Florentine school (second half 15th century) 1933.61

Combat, single

 Two Romantic Scenes
 Giovanni dal Ponte (shop of) 1936.122

Court (legal), represented by judges and scribe

 A Tournament in Piazza S. Croce
 Apollonio di Giovanni (shop of) 1871.33

Dance

 Allegory of Love
 Florentine school (first half 15th century;
 Paolo Schiavo, follower of?) 1871.67
 Garden of Love
 Giovanni dal Ponte (shop of) 1943.217

Dante (?)

 Allegory of Love
 Florentine school (first half 15th century;
 Paolo Schiavo, follower of?) 1871.67

Daphne

 Allegory of Love
 Florentine school (first half 15th century;
 Paolo Schiavo, follower of?) 1871.67

Deianira

 Hercules and Deianira
 Antonio Pollaiuolo 1871.42

Diana

 Story of Actaeon (1) Diana and Actaeon
 Jacopo del Sellaio 1952.37.1
 Marriage Salver
 Florentine school (15th century) 1959.15.8
 Allegory of Love
 Florentine school (first half 15th century;
 Paolo Schiavo, follower of?) 1871.67

Dido

> *Adventures of Aeneas* (2) *Aeneas at Carthage*
> Apollonio di Giovanni (shop of) 1871.35

Faith, personified

> *Battle of Heraclius and Chosroes*
> Florentine school (second half 15th century) 1933.61

Florence, city of, represented

> *Hercules and Deianira*
> Antonio Pollaiuolo 1871.42

Hercules

> *Hercules and Deianira*
> Antonio Pollaiuolo 1871.42
>
> *Hercules Slaying Antaeus*
> Antonio Pollaiuolo (after) 1946.317

Hippocamp, image of

> *Madonna and Child with Saints*
> Pinturicchio 1959.15.16

Homer, scenes from *Iliad* of, represented as paintings

> *Adventures of Aenaeas* (2) *Aenaeas at Carthage*
> Apollonio di Giovanni (shop of) 1871.35

Hunt

> *Adventures of Aeneas* (2) *Aeneas at Carthage*
> Apollonio di Giovanni (shop of) 1871.35
>
> *Two Romantic Scenes*
> Giovanni dal Ponte (shop of) 1936.122
>
> *Marriage Salver*
> Florentine school (15th century) 1959.15.8

Iliad, scenes from, represented as paintings

> *Adventures of Aeneas* (2) *Aeneas at Carthage*
> Apollonio di Giovanni (shop of) 1871.35

Juno

> *Adventures of Aeneas* (1) *The Shipwreck of Aeneas*
> Apollonio di Giovanni (shop of) 1871.34

Justice, personified
> *Battle of Heraclius and Chosroes*
> Florentine school (second half 15th century) 1933.61

Love, rabbit as symbol of
> *Lady with a Rabbit*
> Ridolfo Ghirlandaio (attributed to) 1871.72

Allegory of
> *A Triumph of Love* (?)
> Giovanni di Paolo (shop of ?) 1926.9
>
> *Allegory of Love*
> Florentine school (first half 15th century;
> Paolo Schiavo, follower of ?) 1871.67
>
> *Garden of Love*
> Giovanni dal Ponte (shop of) 1943.217

personified as Amor
> *The Garden of Love*
> Florentine school (first half 15th century; Paolo Schiavo,
> follower of?) 1871.67
>
> *Love Bound by Maidens*
> Girolamo di Benvenuto 1871.65

Mars
> *Allegory of Love*
> Florentine school (first half 15th century; Paolo Schiavo,
> follower of ?) 1871.67

Neptune
> *Adventures of Aeneas* (1) *The Shipwreck of Aeneas*
> Apollonio di Giovanni (shop of) 1871.34

Nereid, symbol of immortality
> *Madonna and Child with Saints*
> Pinturicchio 1959.15.16

Nessus
> *Hercules and Deianira*
> Antonio Pollaiuolo 1871.42

Petrarch (?)
> *Allegory of Love*
> Florentine school (first half 15th century; Paolo Schiavo,
> follower of?) 1871.67

Roman Emperor
> *Battle at the Gates of Rome*
> "Anghiari Master" (shop of) 1942.324

Christ as
> *Madonna and Child with Saints and Angels*
> Benvenuto di Giovanni 1871.64

Rome, image of
> *Adventures of Aeneas* (2) *Aeneas at Carthage*
> Apollonio di Giovanni (shop of) 1871.35
> *Battle at the Gates of Rome*
> "Anghiari Master" (shop of) 1942.324

Sword, in the scales
> *Battle at the Gates of Rome*
> "Anghiari Master" (shop of) 1942.324

Theseus (?)
> *Triumph of Love* (?)
> Giovanni di Paolo (shop of ?) 1926.9

Time, personified
> *A Tournament in Piazza S. Croce*
> Apollonio di Giovanni (shop of) 1871.33

Tournament
> *A Tournament in Piazza S. Croce*
> Apollonio di Giovanni (shop of) 1871.33

Truth (?) personified
> *A Tournament in Piazza S. Croce*
> Apollonio di Giovanni (shop of) 1871.33

Venus
> *Adventures of Aeneas* (1) *The Shipwreck of Aeneas*
> Apollonio di Giovanni (shop of) 1871.34

Allegory of Love
Florentine school (first half 15th century; Paolo Schiavo,
follower of?) 1871.67

Virgil, scenes from *Aeneid*

Adventures of Aeneas (1) *The Shipwreck of Aeneas*
Adventures of Aeneas (2) *Aeneas at Carthage*
Apollonio di Giovanni (shop of) 1871.34
 1871.35

Virtues, personified

Battle of Heraclius and Chosroes
Florentine school (15th century) 1933.61

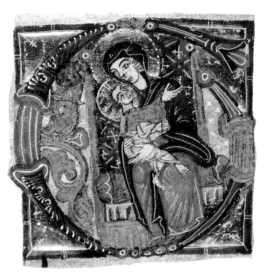

7

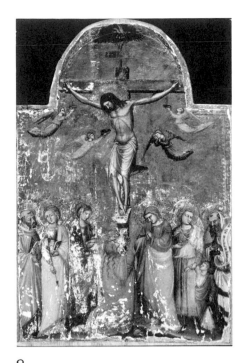

8

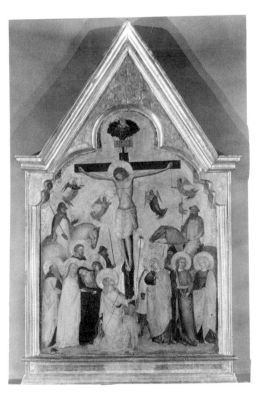

10

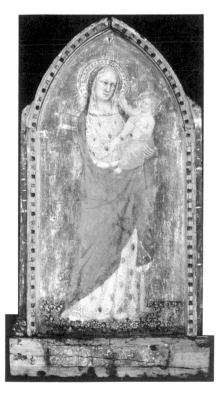

11

12

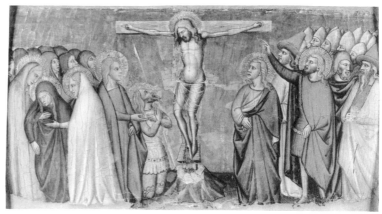

15

17

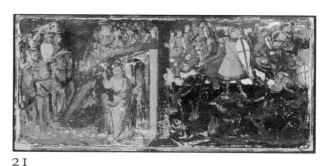

21

16

18

19

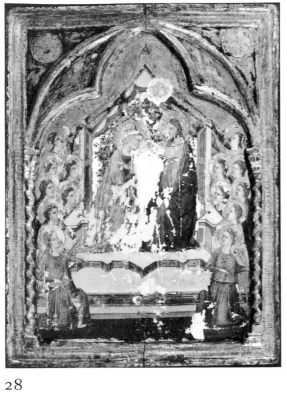

28

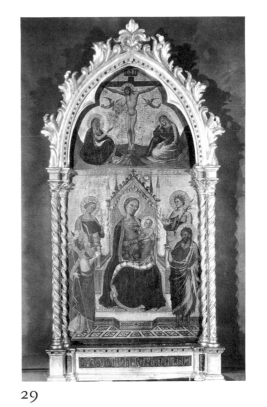

29

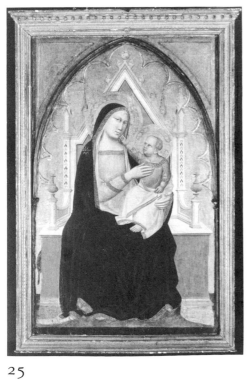

25

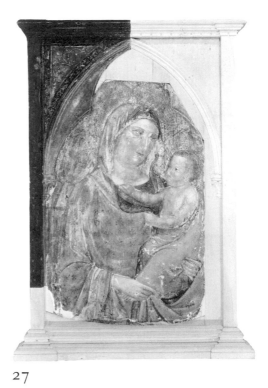

27

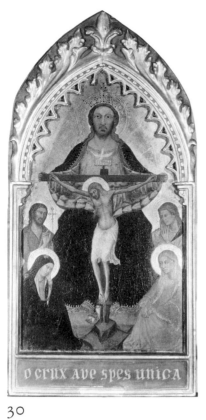

30

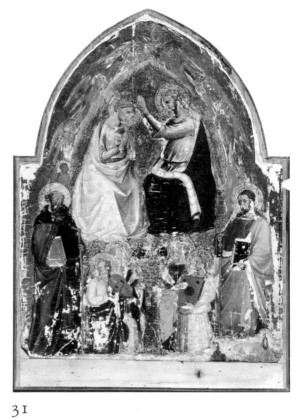

31

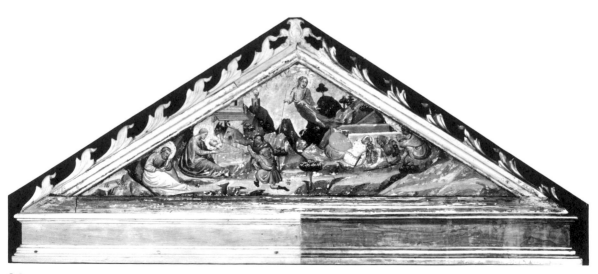

32

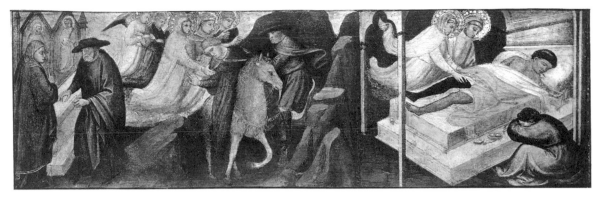

37

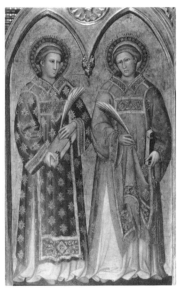

35

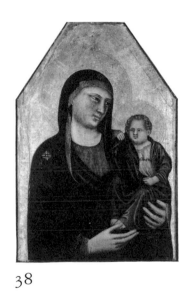

38

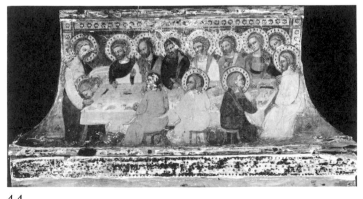

44

45

41

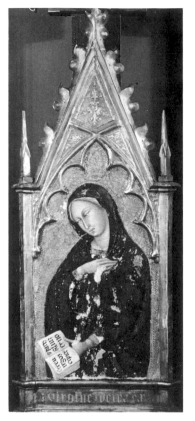

48

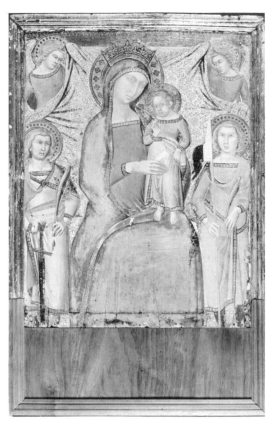

55

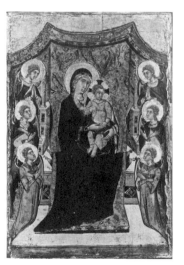

49a

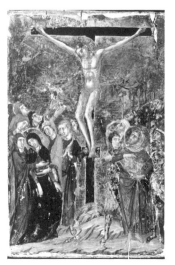

49b

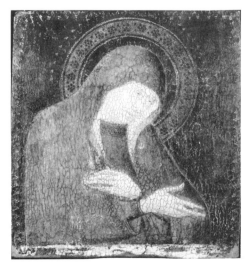

52

54

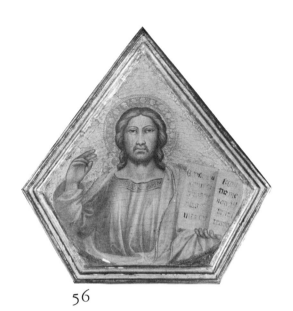

56

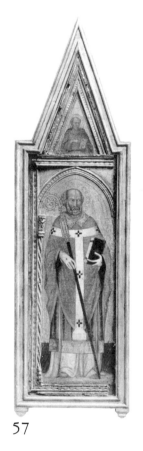

57

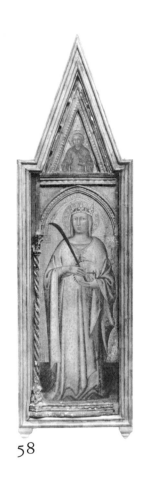

58

61

63

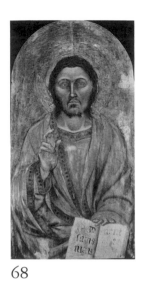

68

65

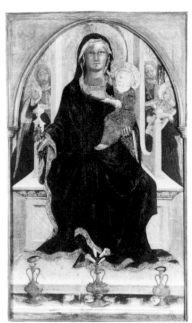

84

78

73

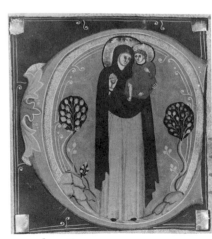

73, detail

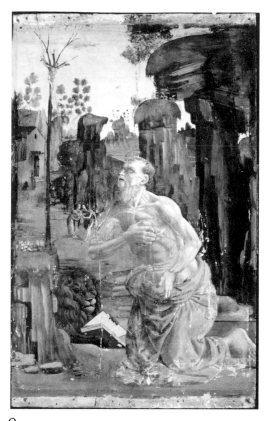

85

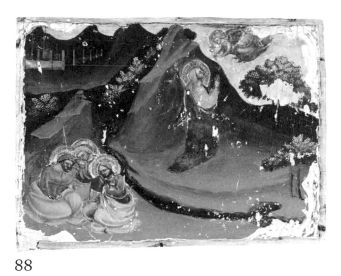

88

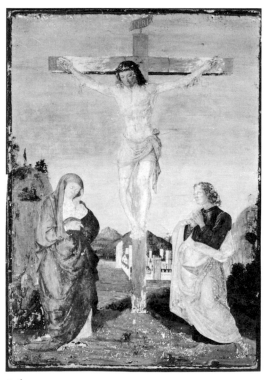

86

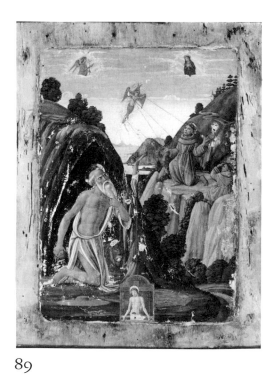

89

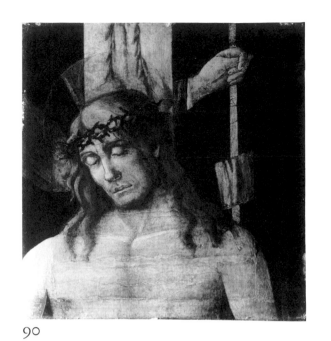

90

97

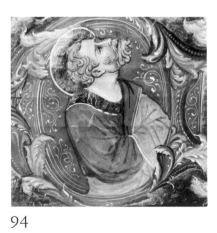

94

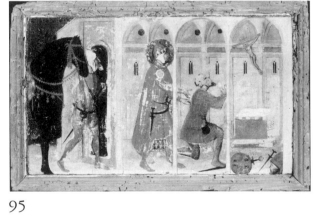

95

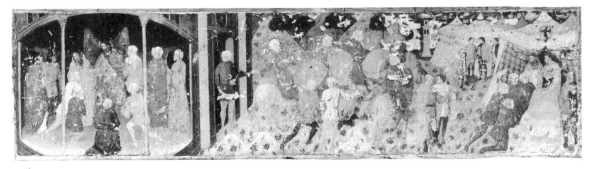

96

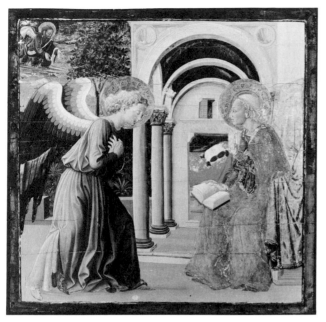

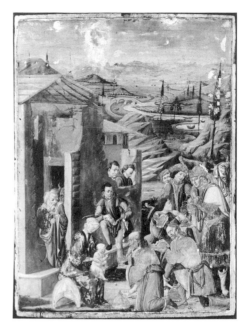

98 100

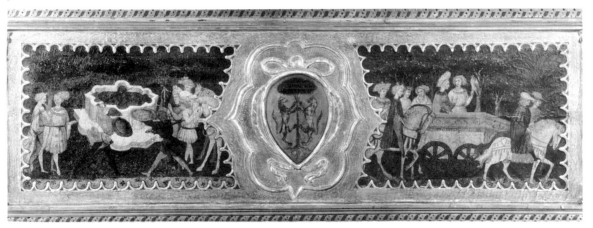

104

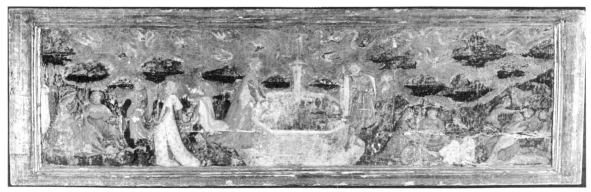

106

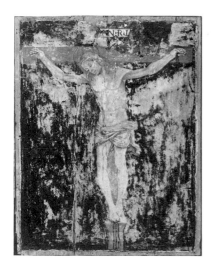

107

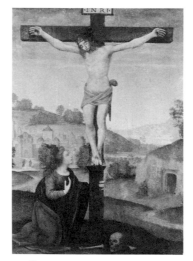

108

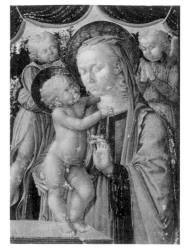

109

110

111

112

113

114

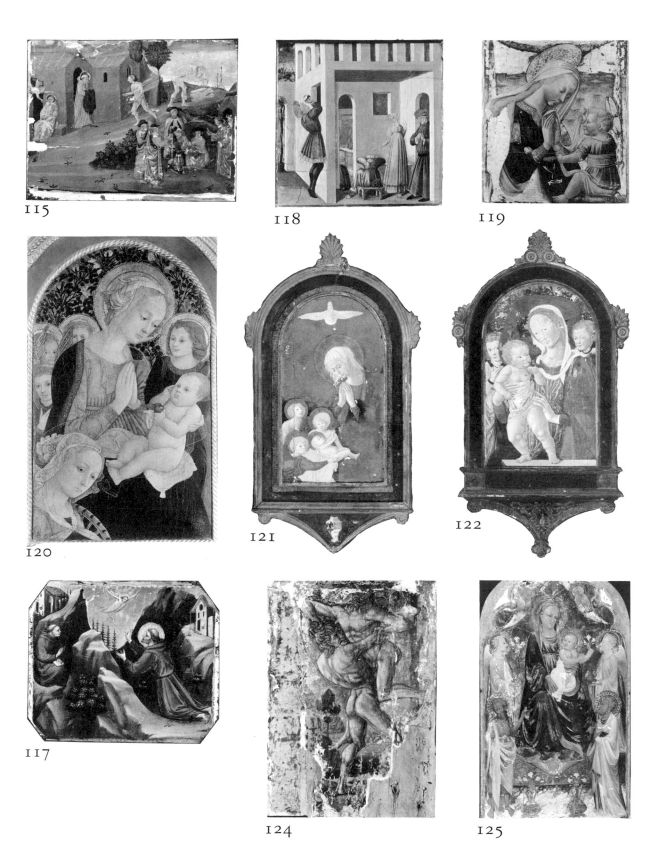

115

118

119

120

121

122

117

124

125

132

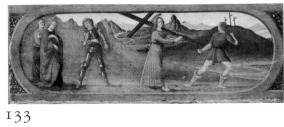

133

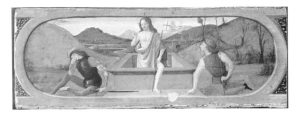

134

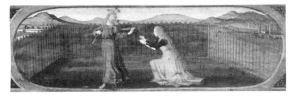

135

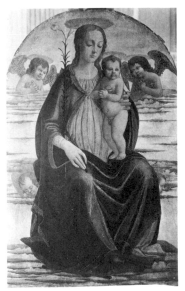

136

137

141

138

140

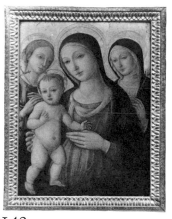

142

143

146

145a

145b

147

149

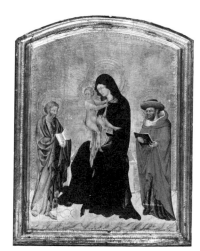

150

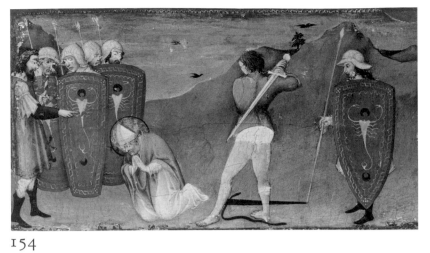

154

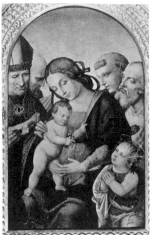

159

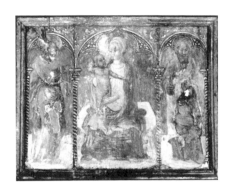

163

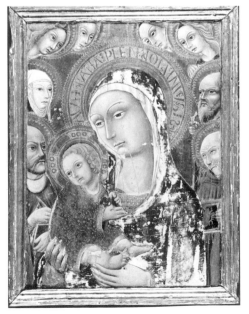

155

160

166

167

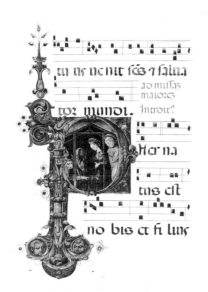

151

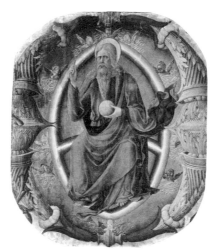

161

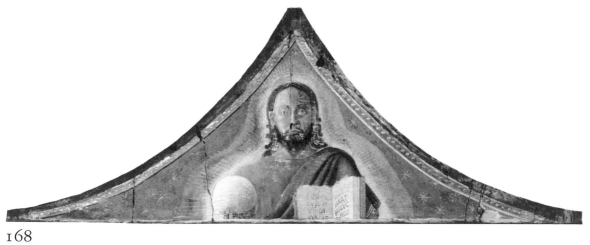

168

169a,b,c,d

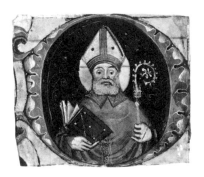

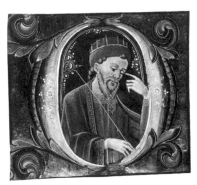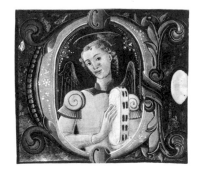

170a,b,c,d

171a,b,c,d,e,f

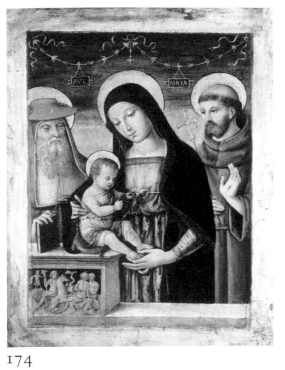

174

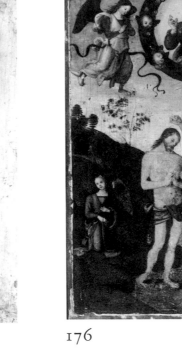

176

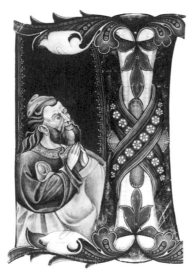

185

178

Index by Accession Number

Index by Artist's Name

Index by Collection or Donor